NEW SHOPS AND BOUTIQUES

NEW SHOPS AND BOUTIQUES

Marta Serrats

HARPER
DESIGN

An Imprint of HarperCollins*Publishers*

NEW SHOPS & BOUTIQUES
Copyright © 2004 by Harper Design and LOFT Publications

First published in 2004 by:
Harper Design,
An imprint of HarperCollinsPublishers
10 East 53rd Street
New York, NY 10022
Tel.: (212) 207-7000
Fax: (212) 207-7654
HarperDesign@harpercollins.com
www.harpercollins.com

Distributed throughout the world by:
HarperCollins International
10 East 53rd Street
New York, NY 10022
Fax: (212) 207-7654

HarperCollins books may be purchased for educational, business, or sales promotional use. For information, please
write: Special Markets Department HarperCollins Publishers Inc. 10 East 53rd Street, New York, NY 10022

Editor
Nacho Asensio

Coordination and texts
Marta Serrats

Translation
Michael Brunelle

Graphic design and layout
Núria Sordé

Editorial project:
Bookslab, S.L.
editorial@bookslab.net

Library of Congress Cataloging-in-Publication Data

Serrats, Marta.
 New shops and boutiques / by Marta Serrats.
 p. cm.
 ISBN 0-06-074796-X (hardcover)
 1. Specialty stores--Designs and plans. 2. Store decoration--Psychological aspects.. I. Title.
 NA6227.S64S47 2005
 725'.21--dc22
 2004016498

Printed by:
Indústrias Gráficas Mármol, Sant Andreu de la Barca, Spain

D.L: B-47.317-2004

First Printing, 2004

Contents

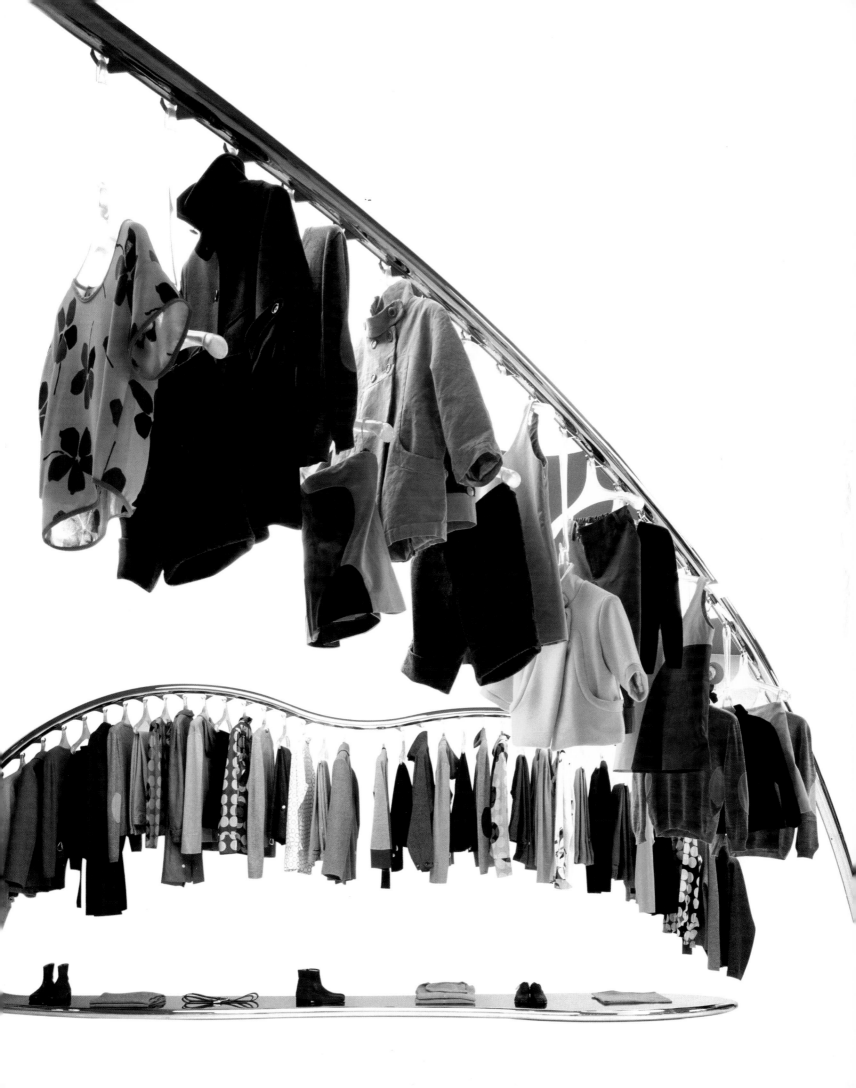

Introduction

In recent years, shops and boutiques have assumed an urban and cultural role that would have been unimaginable in earlier times. Consumers today find that brand names furnish quality goods. As a result, they will visit their favorite brand-name stores all over the world in search of an identity that brand-name loyalty provides.

Recent work, such as the Guggenheim Museum in Bilbao, proves that marketing and culture can go hand in hand, that intellectuality and consumerism can sell. With this unification of what were long thought to be opposites, a redefinition of the temples of consumerism began to take place and new fashion spaces appeared, converted into spectacular containers where a person could shop while contemplating a work of art.

New ways of interpreting such spaces have been appearing since the 1980s. Commercial strategists saw in current Minimalism a language that invited the treatment of objects as the true stars of a space. Interiors were stripped and the products were exalted inside a neutral, often nearly invisible, shell.

In a competitive retail environment, the need to provide new experiences that differ from simple consumerism has encouraged the resurgence of spaces like those shown in this book. *New Shops and Boutiques* takes us into the most recent projects that best illustrate the flexibility of today's spaces. Arranged in five chapters (Clothes, Accessories, Home Design, Showrooms, and Healthcare), *New Shops and Boutiques* presents a selection of the most outstanding commercial spaces that have been designed by architects to offer extraordinary shopping experiences. The spaces are multifunctional, hybrids, incorporeal, imaginative ventures to make neo-romantic and customizable shells that can be renewed at the same time as the collections.

The competitive era that we are living in continues to provoke a revolution in timeless, indefinite, and flexible spaces. The architect Rem Koolhaas captured this spirit of change most clearly when he said, "I have lived through four ideological periods in my lifetime, and I have no reason to believe that the changes will ever end."

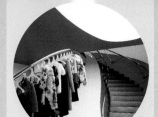
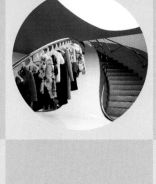

CLOTHES

CLOTHES

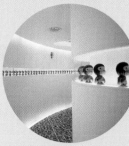

CLOTHES

CLOTHES

CLOTHES

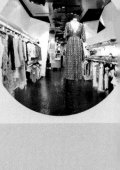

CLOTHES

CLOTHES

CLOTHES

CLOTHES

CLOTHES

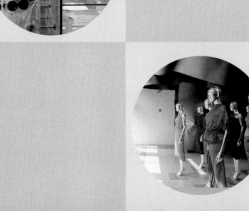

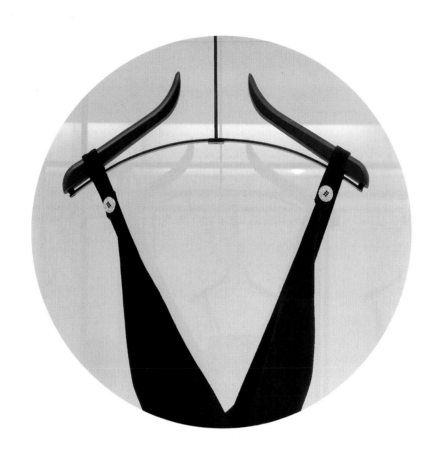

CLOTHES

EMPORIO ARMANI

Designer: **Massimiliano and Doriana Fuksas**
Photographer: **Ramon Prat**
Location: **Hong Kong, China**
Opening date: **2002**

The Emporio Armani store located in the city of Hong Kong has become an innovative space for showcasing the fashions of the new century. The space rejects architectural Formalism, opting for the Minimalist logic that has dominated the design of fashion stores in recent years.

With their new ideas, Massimiliano and Doriana Fuksas explore an experimental territory where the real inspiration is not the decoration itself, but the cultural trends reflected in the clothes exhibited in the store. The two agree that architecture is a permanent element that contrasts with fashion, which is ephemeral and varies with the tastes of each decade. Furthermore, the accelerated pace of contemporary society puts these two values in constant tension.

A curving design divides the establishment into three areas: interior, exterior, and inter-spacial. The floor and the ceiling frame a space in which images seem infinite, neutral, and immaterial. Inside, the store contains displays of Emporio Armani clothes, a cafeteria, a florist, a bookstore, and a cosmetics shop. The walls separating the spaces are luminous objects that define the interior.

This new Emporio Armani store was based on the premise that the customer should feel he is the protagonist in a space designed by himself—changing, variable, and hybridized like the city of Hong Kong itself, with flashing signs hanging from the urban architecture. As most elements of the setting, such as the floor, the ceiling, or the curving walls, recede from view, the visitor becomes the real star.

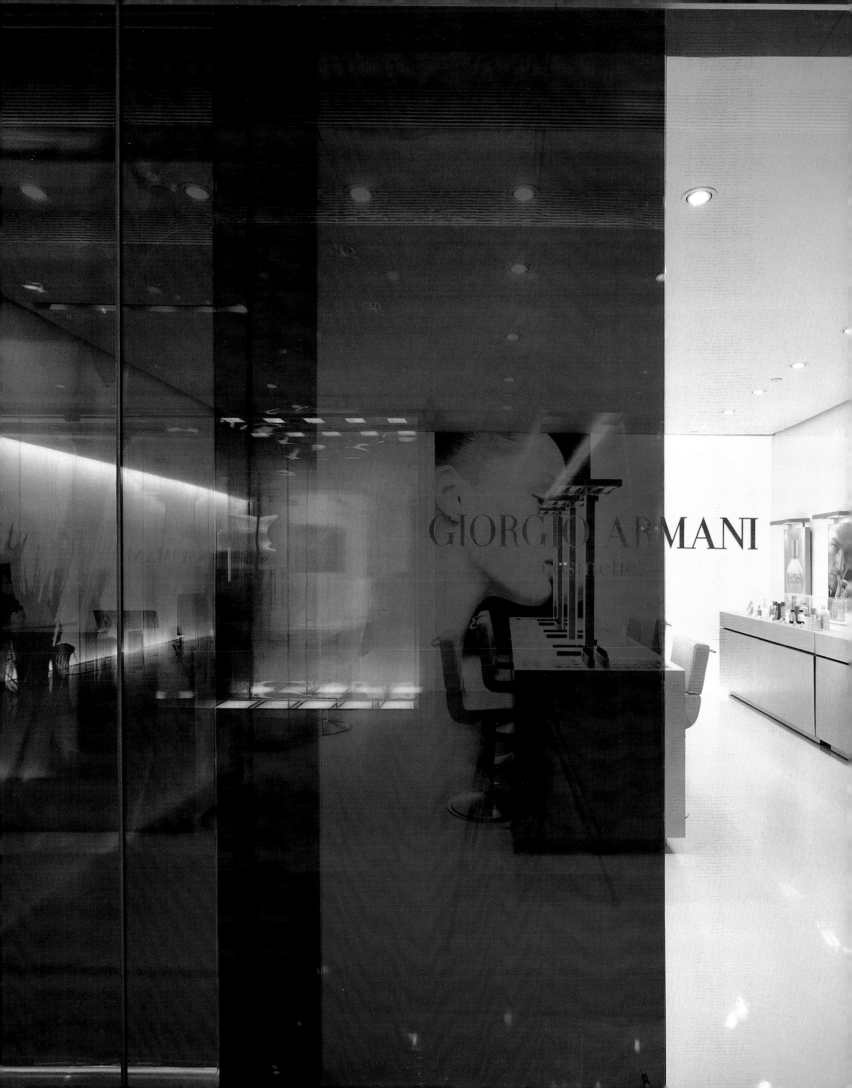

EMPORIO ARMANI

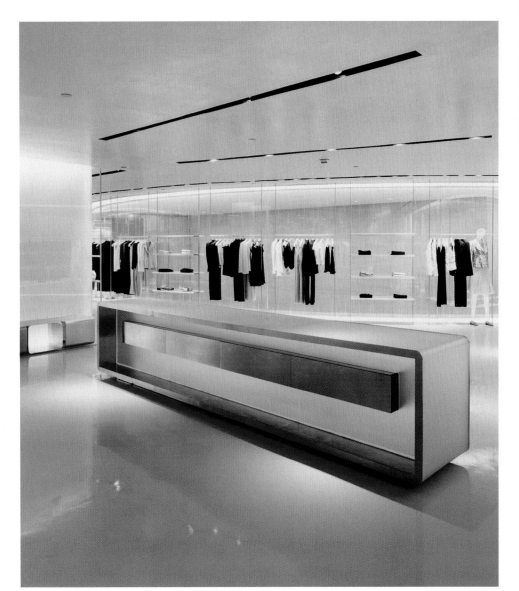

The quality of the Emporio Armani collection is obvious when seen against a neutral background with the perfect amount of light, highlighting the beauty and elegance of each piece.

Floor plan

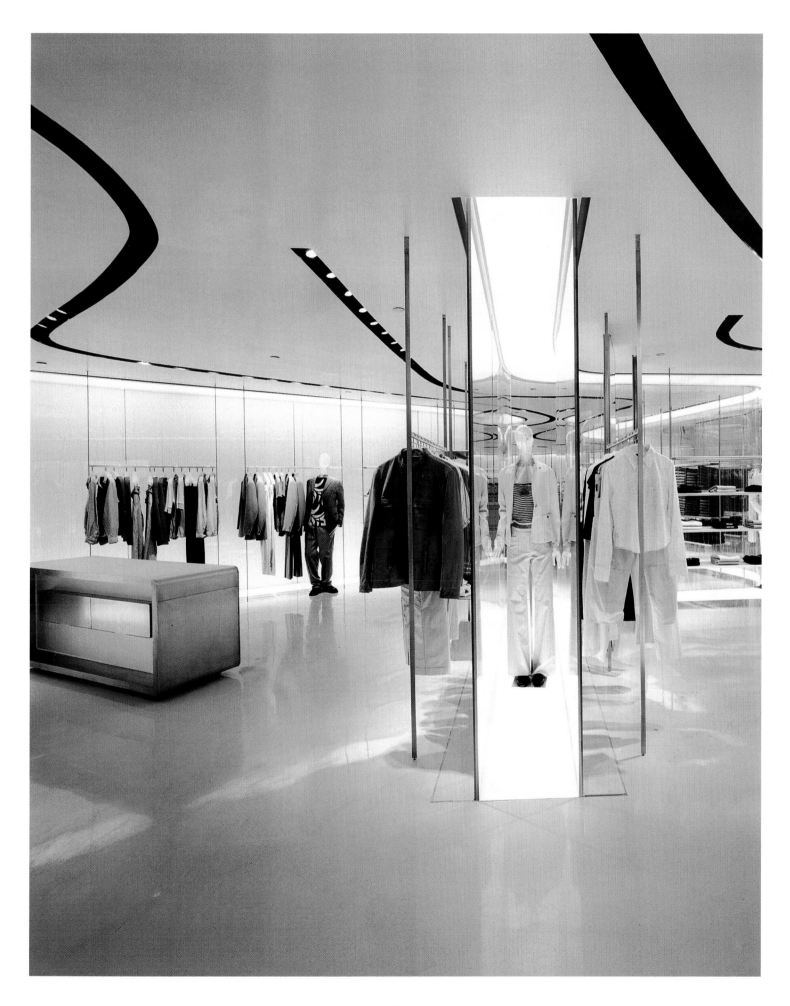

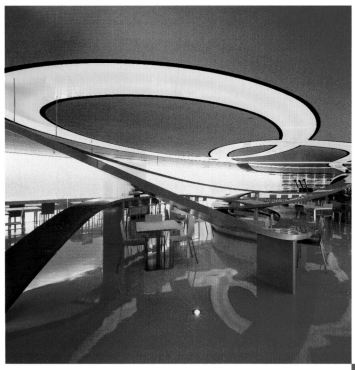

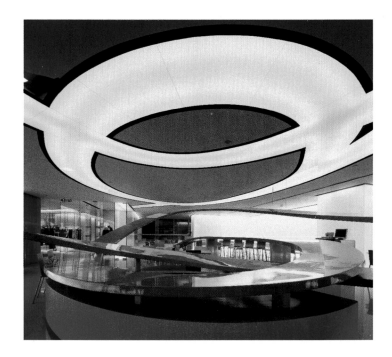

Inside the restaurant, the explosion of color and the geometry of the forms truly stimulate the senses.

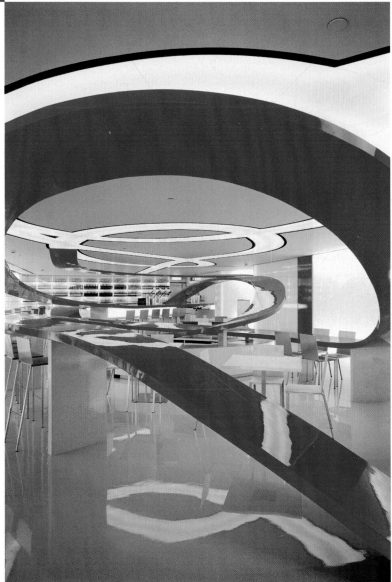

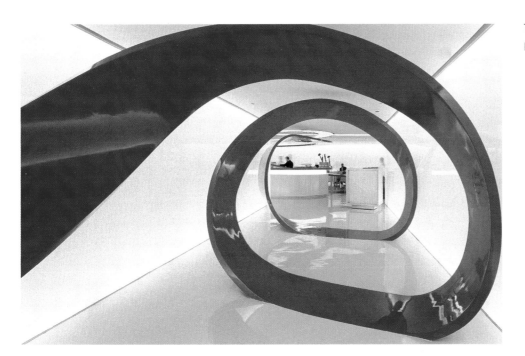

The encompassing spiral welcomes the visitor, a prelude to the sensory spectacle that awaits inside.

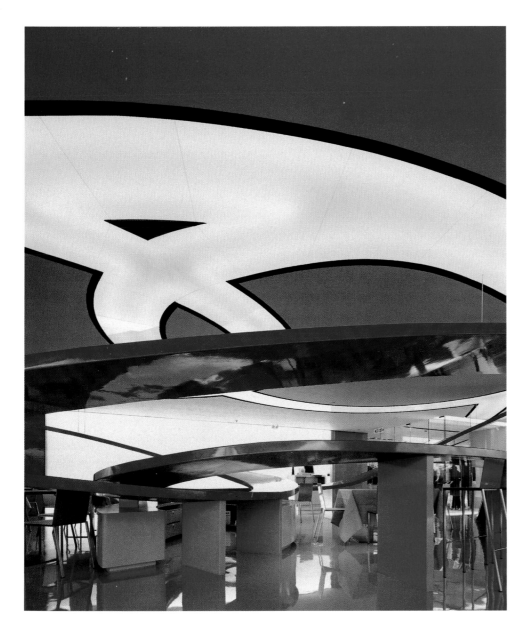

In addition to the clothing store and the restaurant, the building contains other spaces, such as a bookstore, a cosmetics store, and a flower shop.

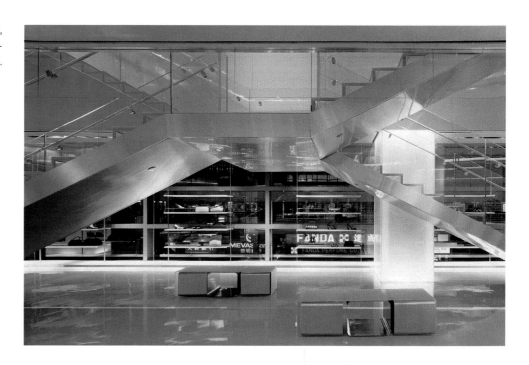

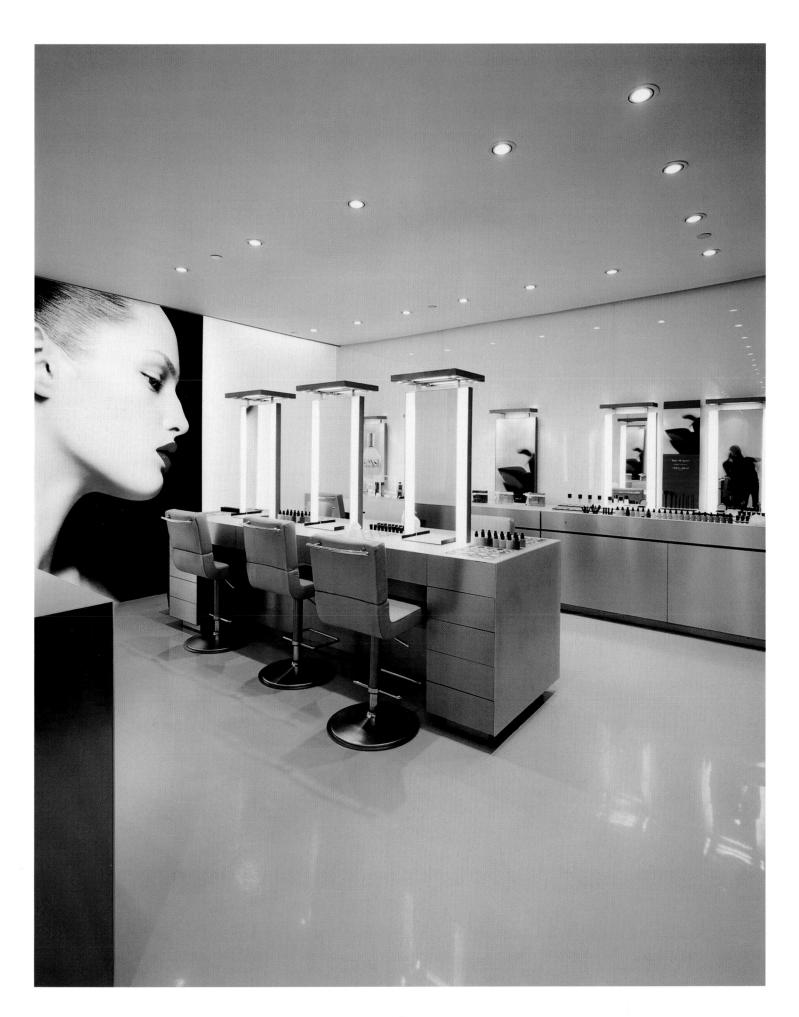

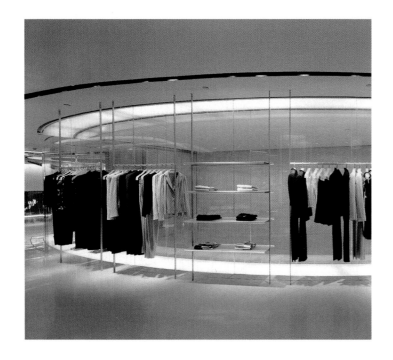

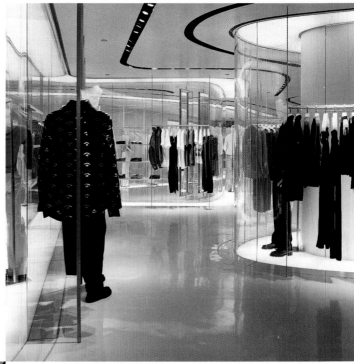

The main source of light comes from the undulating design on the ceiling and is filtered through a white panel. The interior also has various independent fixtures that act as auxiliary sources of light.

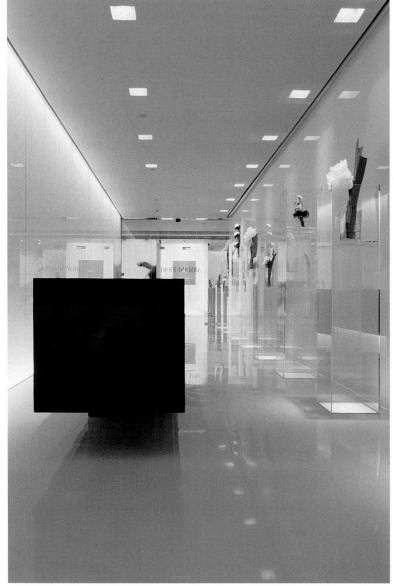

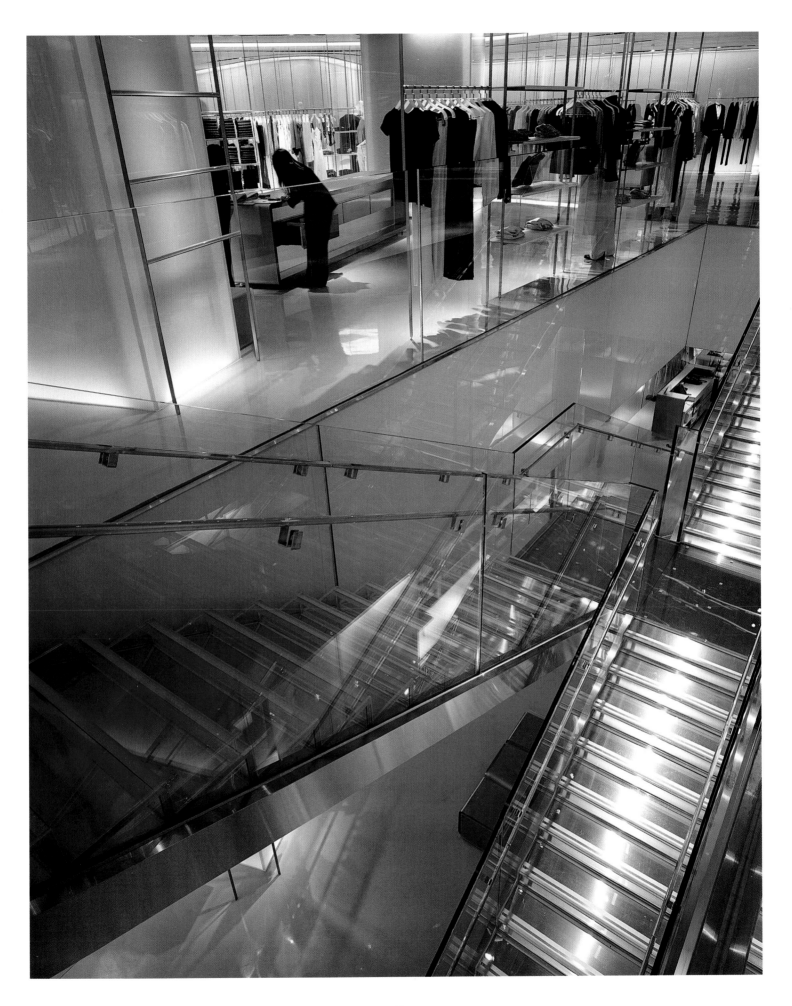

CARLOS MIELE

Designer: **Asymptote**
Photographer: **Paul Warchol Photography**
Location: **New York, USA**
Opening date: **2003**

The flagship store that Brazilian designer Carlos Miele opened in Manhattan can be added to the list of spaces that have a sense of urban and cultural responsibility. Located in a jungle of industrial buildings, art galleries, and shops, the store is a place in which art installations transform themselves into architectural elements.

Hani Rashid and Lise Anne Couture created a spare, almost malleable interior. The result is a space that adapts the exuberant vibrancy of Brazilian culture to the architecture of the setting, and to the very collections that are exhibited inside.

The project has an open feeling, thanks to a neutral palette based on white with light green and blue green tones mixed with gray. A customer in the interior is surrounded by a sculptural structure in which the solidity of the walls is negated by sinuous and curved forms. The flexible, high gloss PVC paint has a very watery appearance, reflecting the flashes of color and the movement in the street. The mannequins hang from the ceiling in the middle of the setting, surrounded by a halo of neon and halogen light that is aimed towards the floor.

With the clear intention of bringing art to the people, Asymptote integrated two artistic video installations, which were presented at Documenta XI at the Venice Biennale, into the interior of the shop. Through its union of art, architecture, and fashion, the new Carlos Miele store in New York becomes a hybrid of gallery and store.

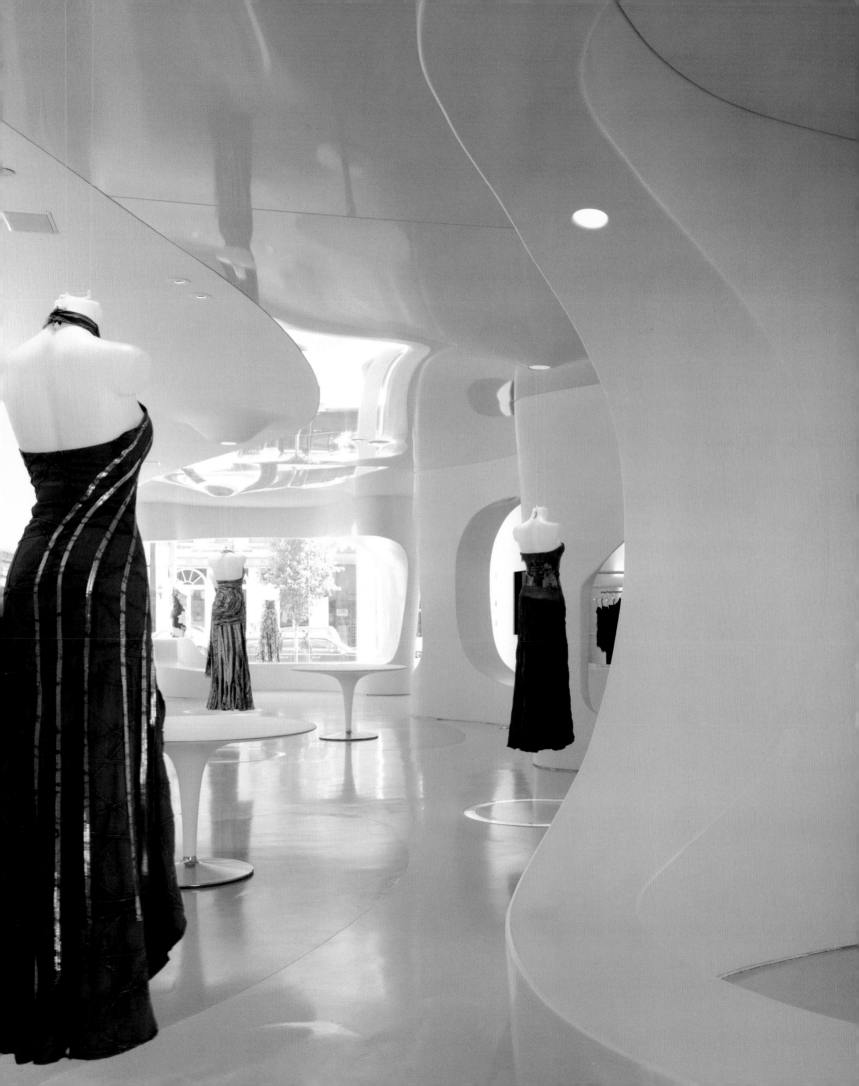

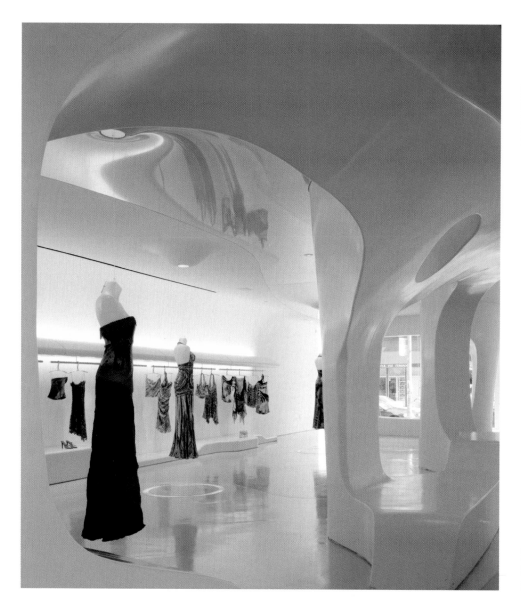

CARLOS MIELE

The mannequins, with no obvious support, seem to be floating in the center of the space. A single, barely visible wire supports the figures.

Elevations

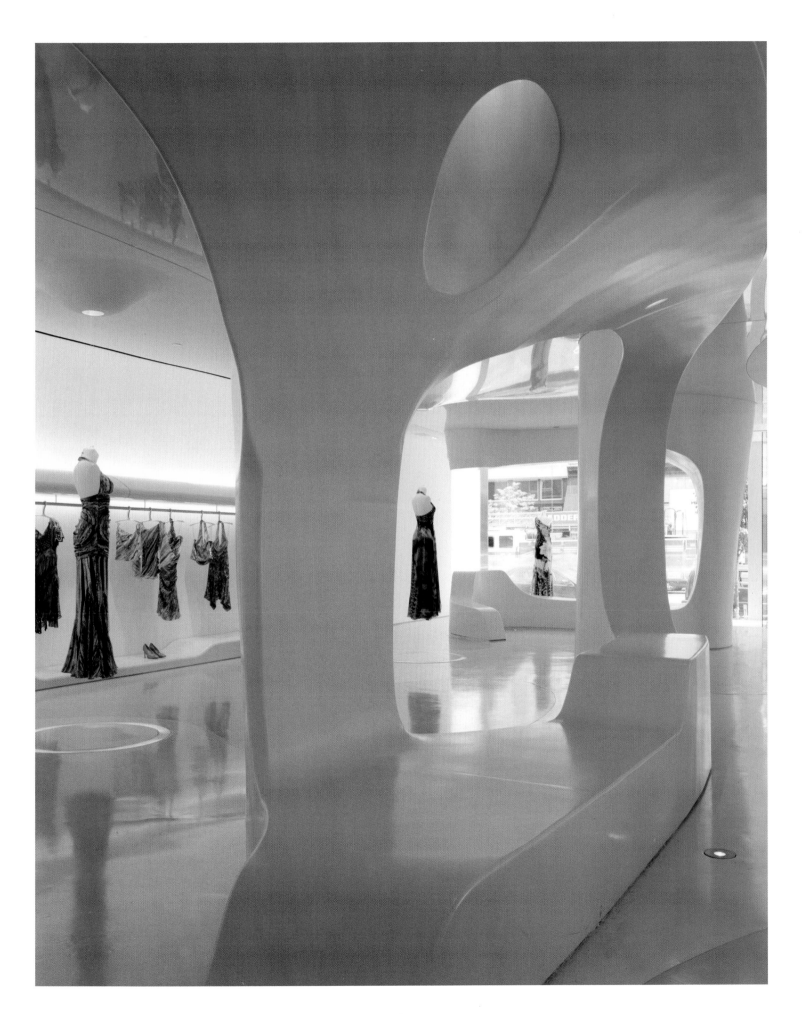

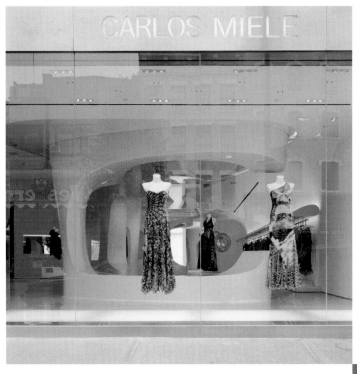

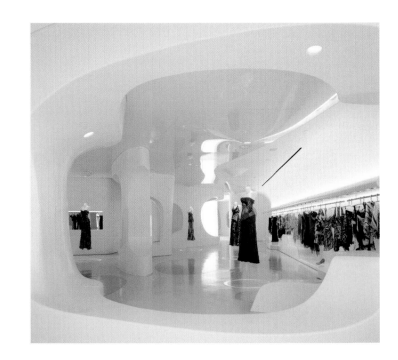

The public is exposed to art inside the space in the form of video installations that were presented at Documenta XI, during the Venice Biennale.

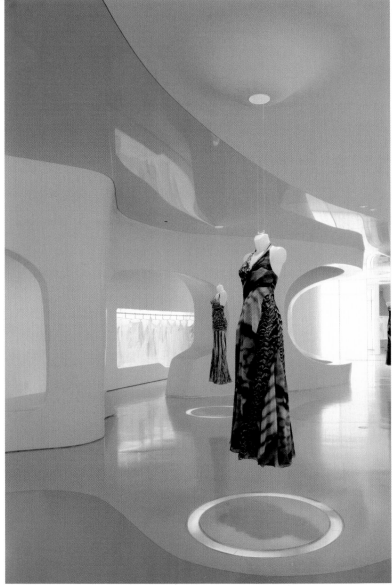

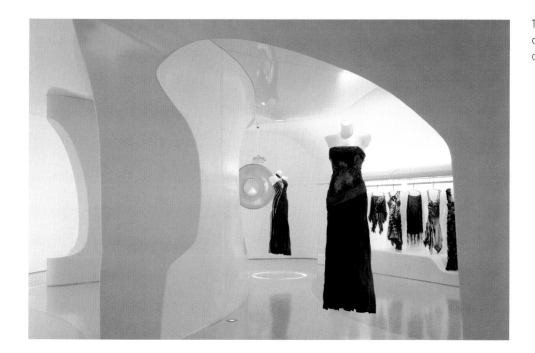

The bright colors of the Brazilian designer's collections create a strong contrast with the palette of whites and neutrals used in the interior.

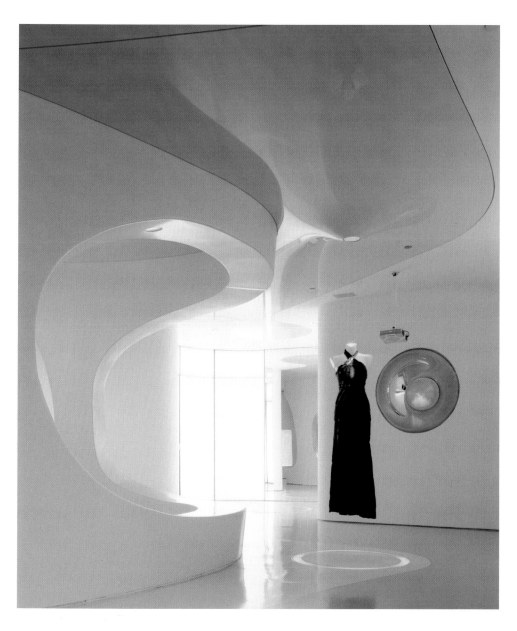

MARNI

Designer: **Sybarite**
Photographer: **Richard Davies**
Location: **London, UK**
Opening date: **2003**

 If the concept of this team of architects was to stimulate the senses, there is no doubt that they fulfilled their goal with this new store that Marni recently opened in London. Ever since Simon Mitchell and Torquil McIntosh created Sybarite in 2002, they have become one of the leaders of modern design in London. The first store that Sybarite designed for Marni was in Aoyama, Tokyo, which the trade press described as one of the best commercial spaces in the city.

This new location for the Italian company sums up the concepts that inspired the architects in the previous stores: volume, movement, colors, and attractive textures— a jolt for the senses. The sinuous lines create an organic space inspired by natural forms (the inspiration came from a medusa and a volcano). One example is the pair of stainless steel rails that extends through the middle of the space like the legs of a futuristic insect and is used for displaying the collections. To increase the sense of movement, the designers used a shining white resin floor that surrounds the stairway with a wavelike effect. In the red ceiling, fixtures with irregular elliptical shapes light the different areas of the store.

Sybarite preceded this project for Marni with stores in Dubai, Paris, South Korea, Taiwan, and recently, a space in London's Selfridge department store, with an enclosed and transmutable design that is typical of the work of Mitchell and McIntosh.

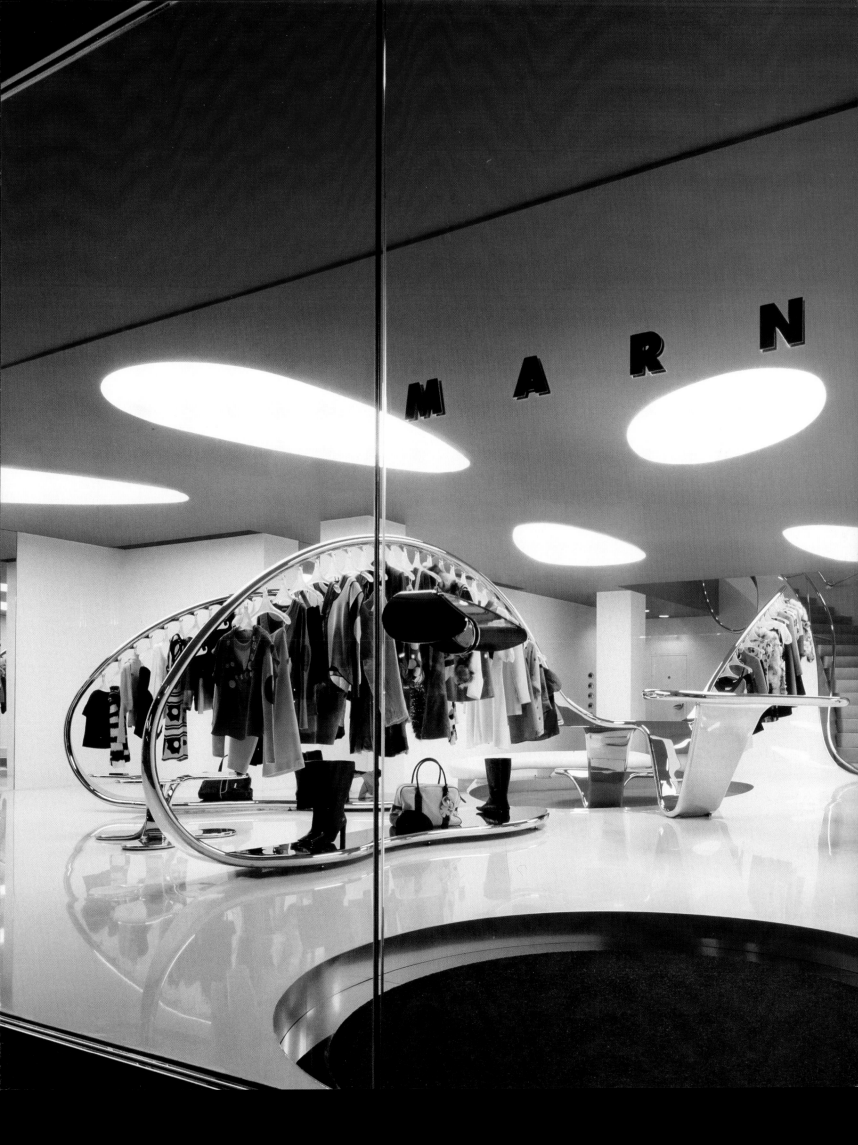

clothes

M A R N I

The shapes, movement, and colors of this interior are a jolt to the senses.

Floor plans

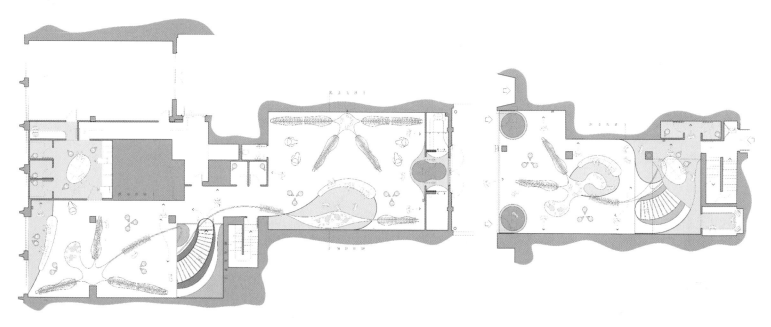

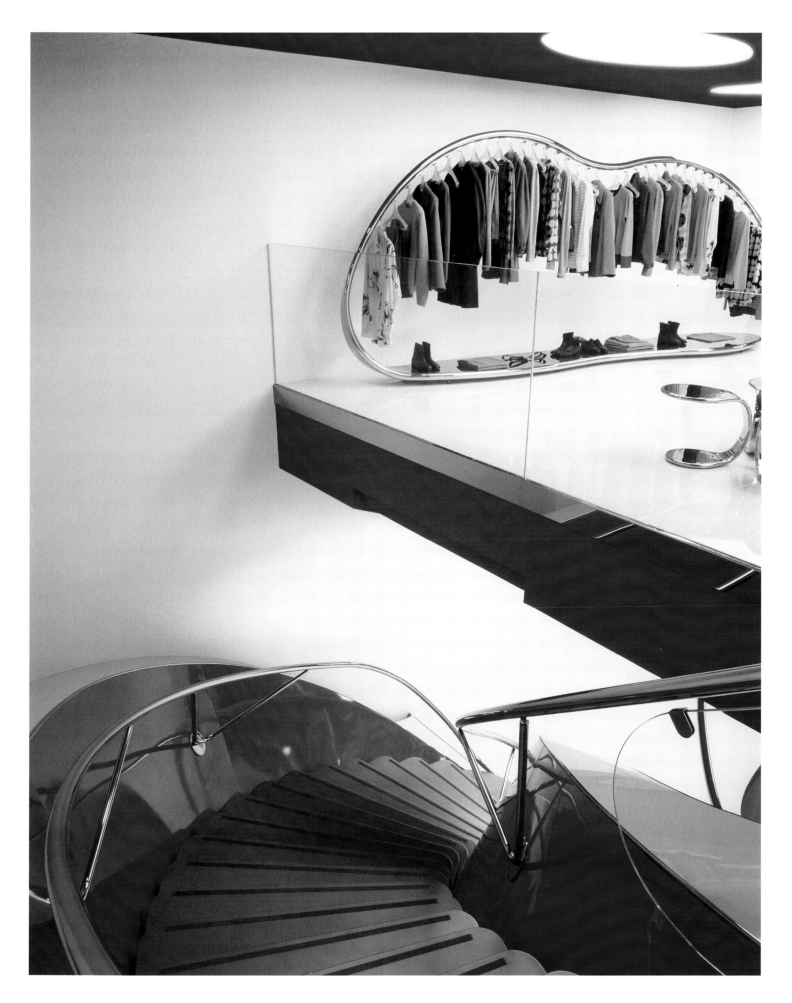

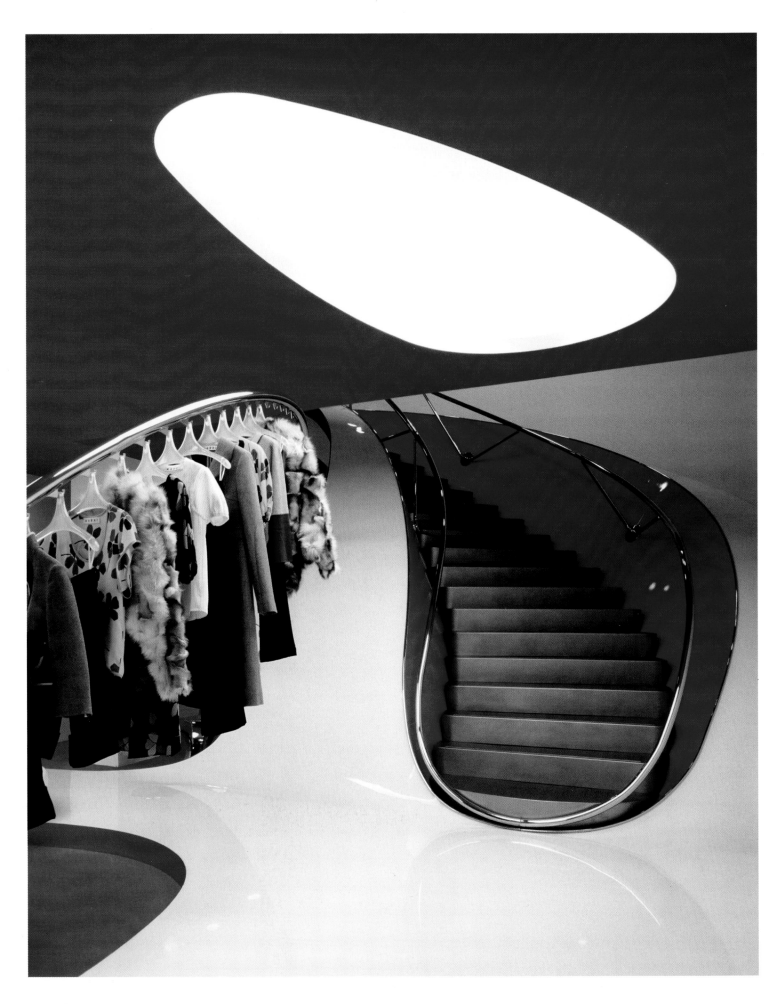

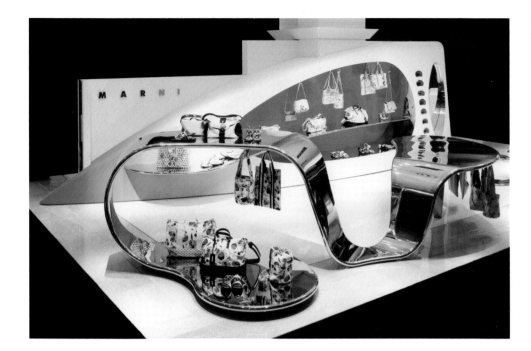

The collections are displayed on stainless steel racks, inspired by natural forms that flow through the organic space.

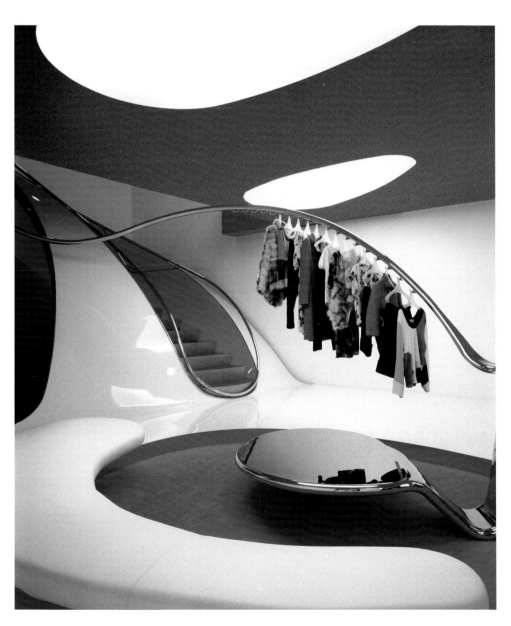

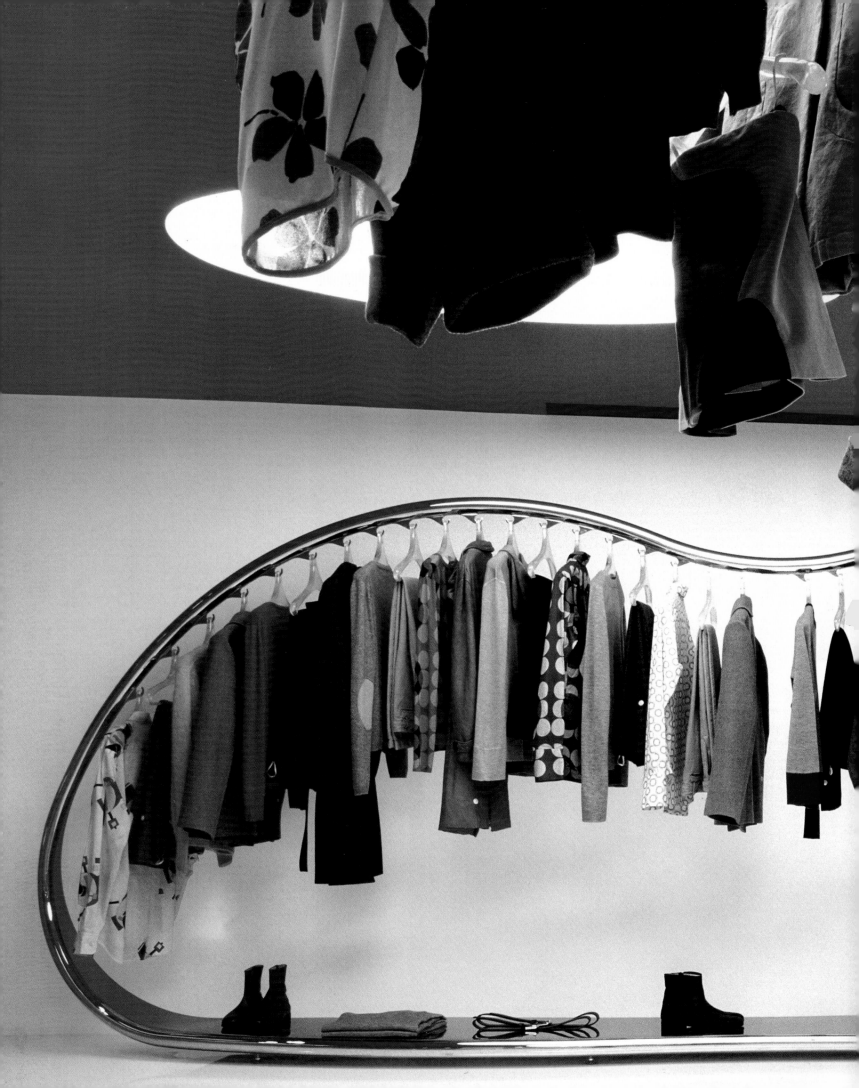

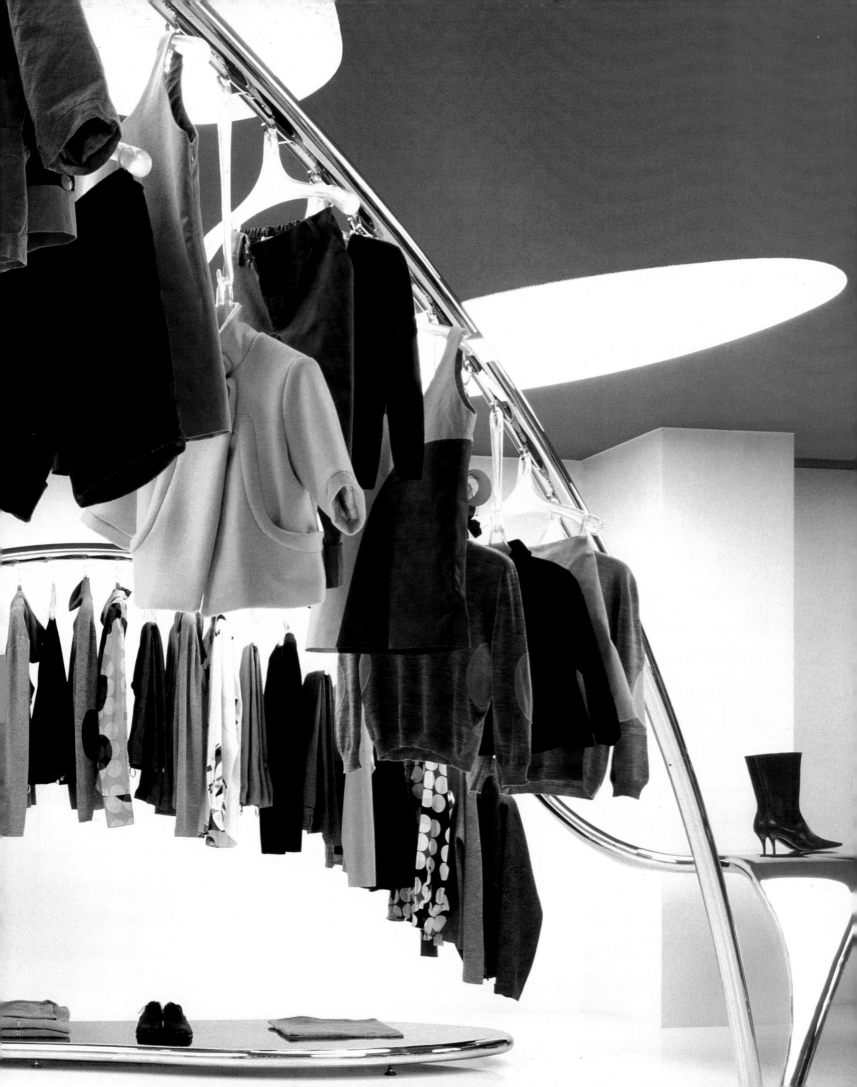

BABY MILO STORE

Designer: **WonderWall Inc.**
Photographer: **Kozo Takayama**
Location: **Jingumae Shibuya-Ku, Japan**
Opening date: **2002**

The design of the Baby Milo store in Tokyo is the result of an attack of creativity suffered by Masamichi Katayama, founder of WonderWall Inc. This designer is capable of turning the act of shopping into an attractive and surprising experience. The Baby Milo space is an impressive play of two-dimensional graphics that come alive when a customer crosses through the entrance—the effect is spectacular. Once inside the store, the customer enters a world full of thousands of tiny Milos, the monkey that is the symbol of the brand. One behind the other, like a binary sequence, the diminutive figures direct the client to the center of the store. Once there, a carousel of "Baby Milos" welcomes visitors, who are astonished by the number of monkeys.

The floor covering, chosen specifically for the figures in its design, could be right out of an animated cartoon. Visitors walk through the store on a floor that seems to be made of fictional bricks. On the ceiling is a mirror of irregular design that reflects this dazzling image while contrasting with the white walls.

Design becomes entertainment in the hands of Masamichi Katayama. Always looking to the future, he designs spaces that hide surprising elements with little tricks that provoke the senses of anyone who contemplates his work.

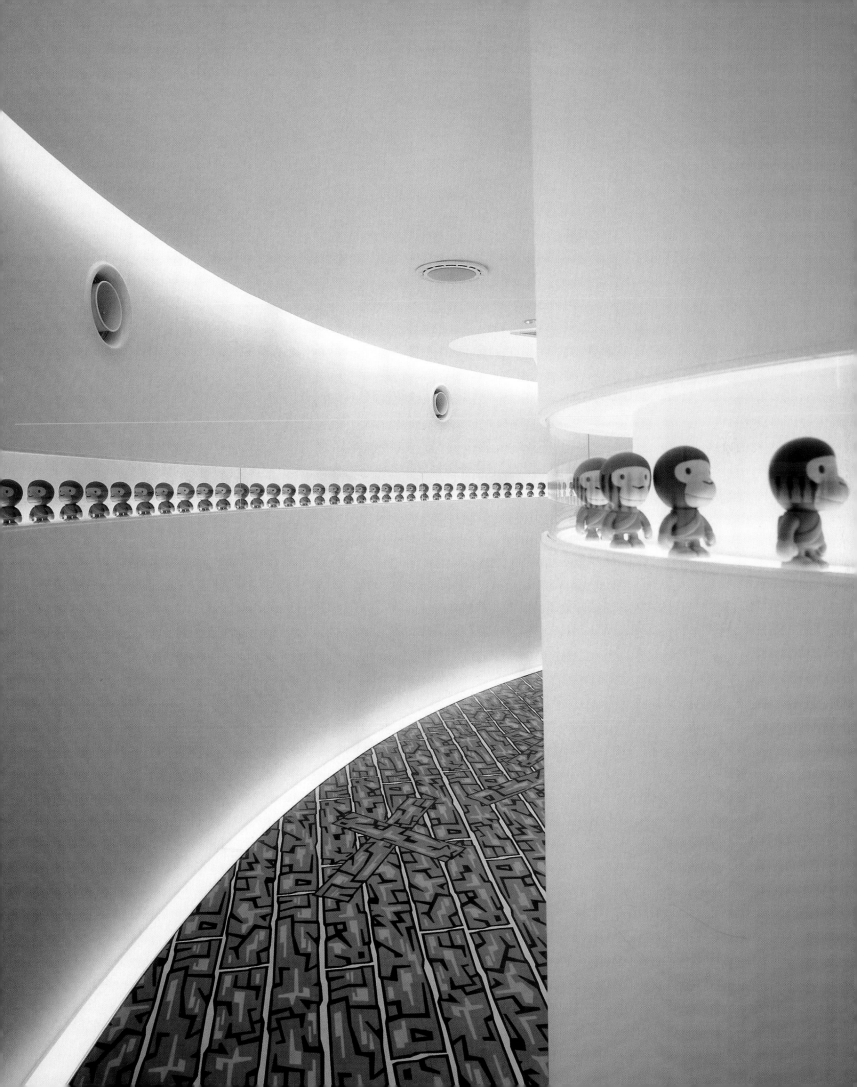

clothes

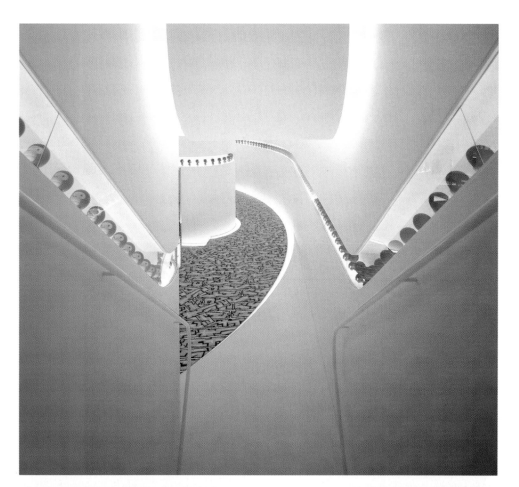

*milo
store.

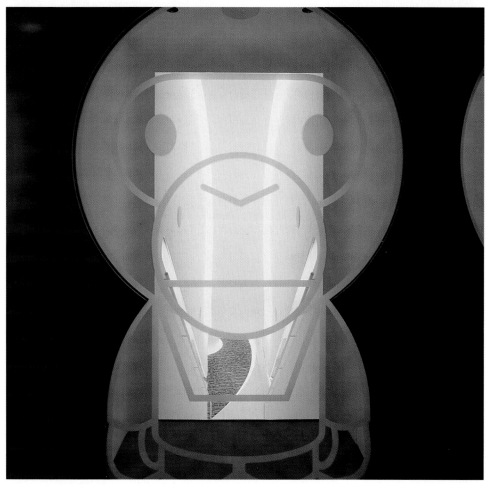

The store is located in the basement of the building. A door with the company logo welcomes customers as they enter the world of Baby Milo.

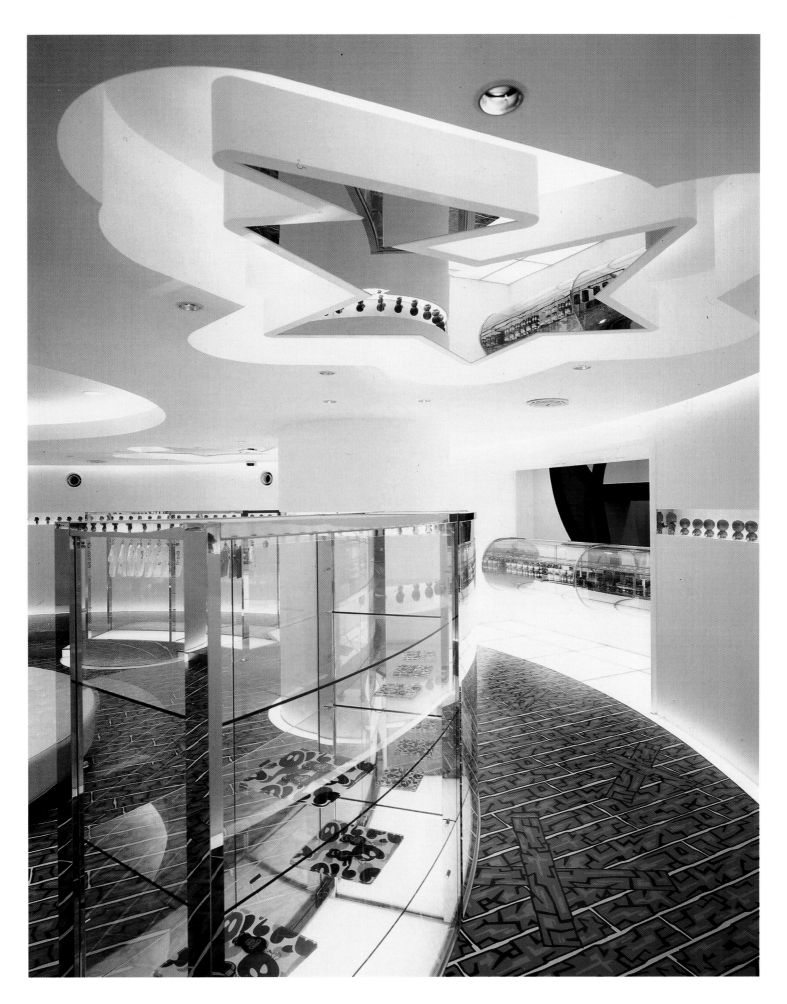

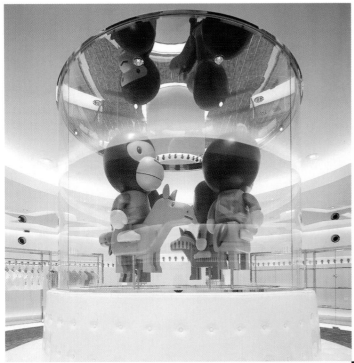

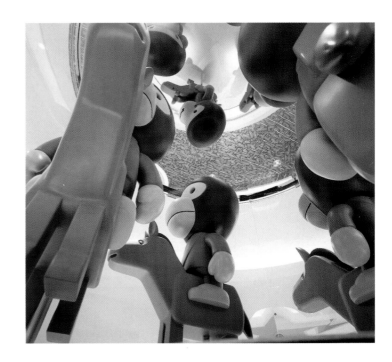

A Milo carousel welcomes visitors. Faced with this scene, it is impossible to leave without further exploring the store.

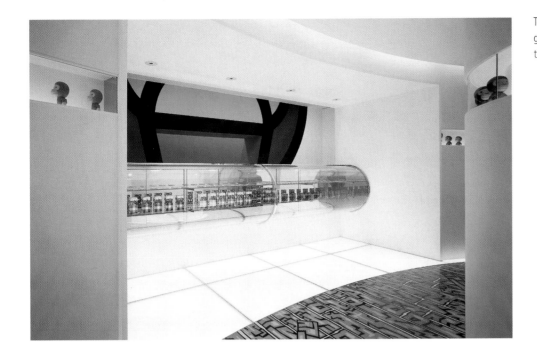

The merchandise is exhibited in futuristic-looking glass tubes that become essential parts of the structure itself.

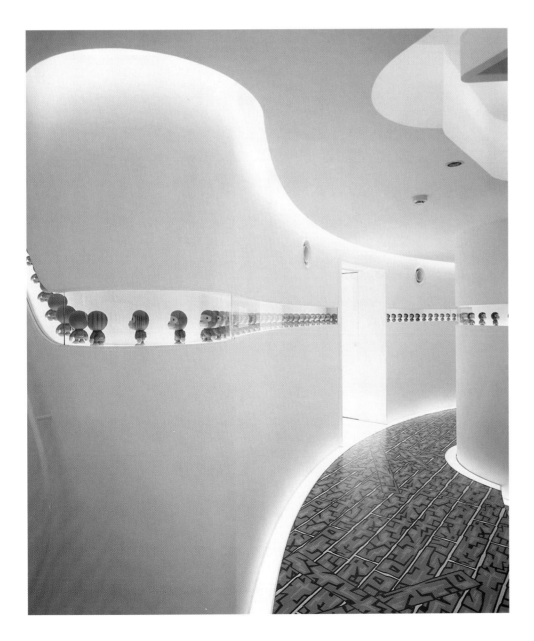

MISS SIXTY/ENERGIE

Designer: **Studio 63 Associati**
Photographer: **Yael Pincus**
Location: **Barcelona, Spain**
Opening date: **2003**

The Italian team Studio 63 Associati created a design that has been applied in Miss Sixty stores around the world.

The recent opening of this store in Barcelona was the latest of a generation of very successful Miss Sixty locations, among them stores in New York, Florence, Catania, Tokyo, Berlin, and Los Angeles. The Miss Sixty world, as defined by the architects, is nothing less than enchanting. The interior walls are curved, the counters are notable for their sculptural design, and the surfaces are finished with soft and attractive materials—all to create a fictitious, almost unachievable reality. According to Studio 63, the customer should be free to be whomever he or she wishes to be in this space.

The designer's reference to the 1960s is an identifying element for the interiors of the shops. The furniture has organic forms; the color range is based on bright, shiny hues; the curtains are velvet; and even the subtle lighting sweetens the interior. The designs on the wallpaper and fabrics are also applied to the furniture designs, and there is music by David Bowie. The details are reminiscent of a time that had a very distinctive style, and in some locations, they translate into spaces that are very feminine and glamorous.

Although each establishment has its own identity that is always related to the structure of the space and the location, Studio 63 Associati has created a new store design that will cause more than one person to dream.

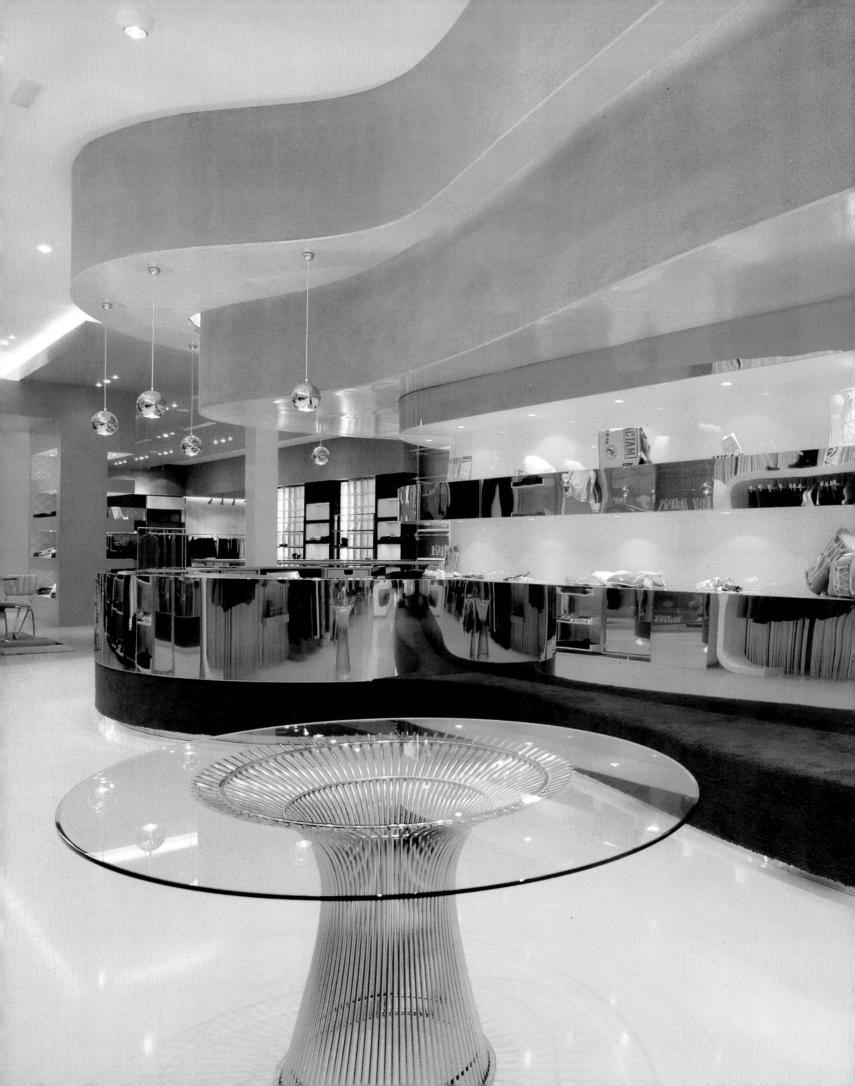

clothes

In Barcelona, intense colors dominate the background of the setting, the brightest of which are different shades of yellow and orange.

Ground-floor plan

Section

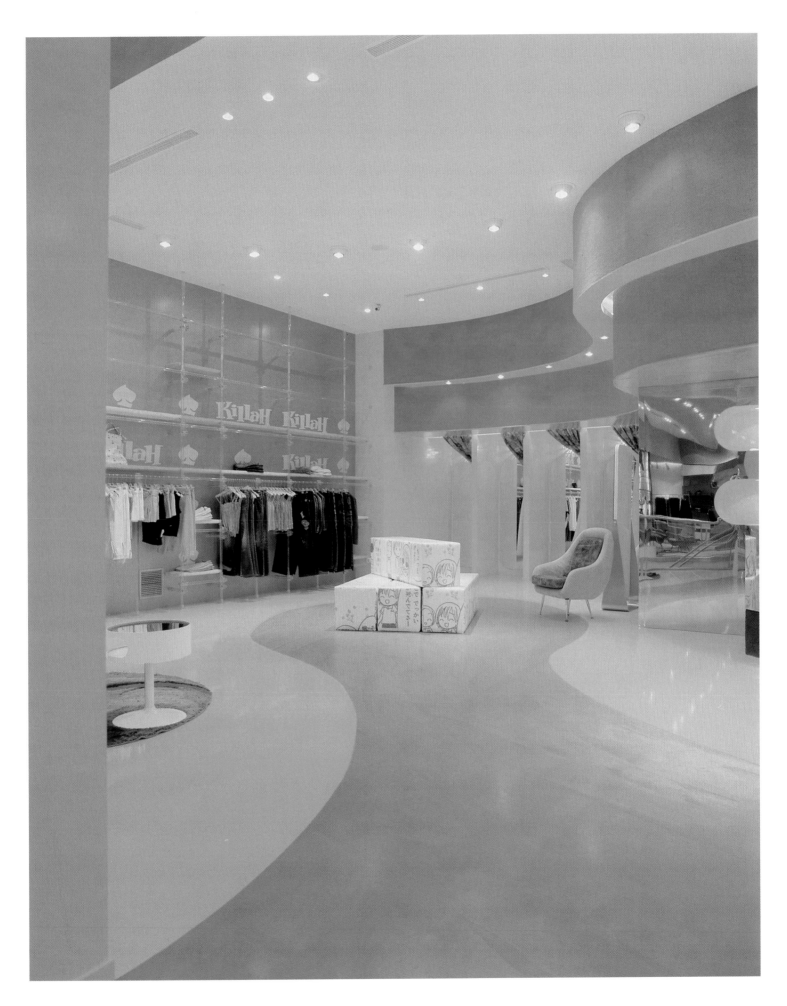

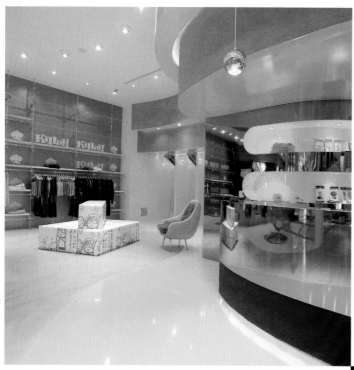

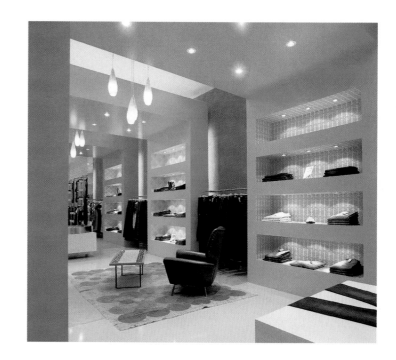

Comfortable areas with sofas, chairs, and tables were created for resting at various points throughout the store.

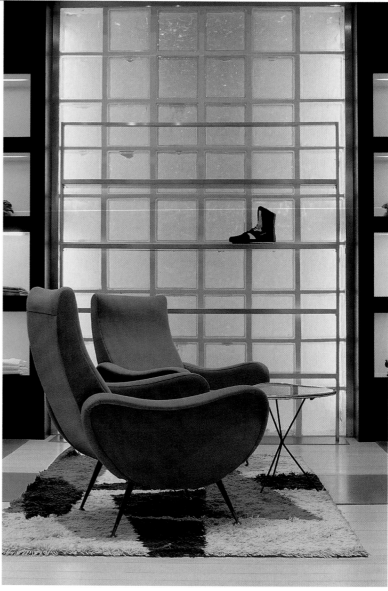

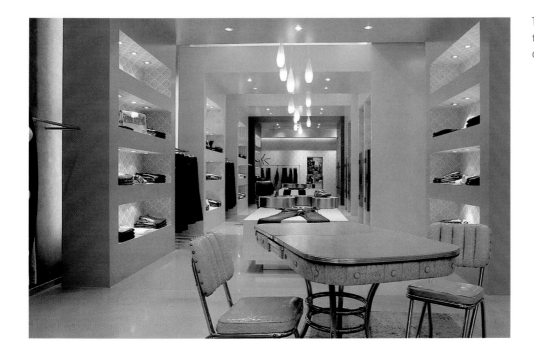

The gradation of colors leads the customer through the areas where the new clothing collection is displayed.

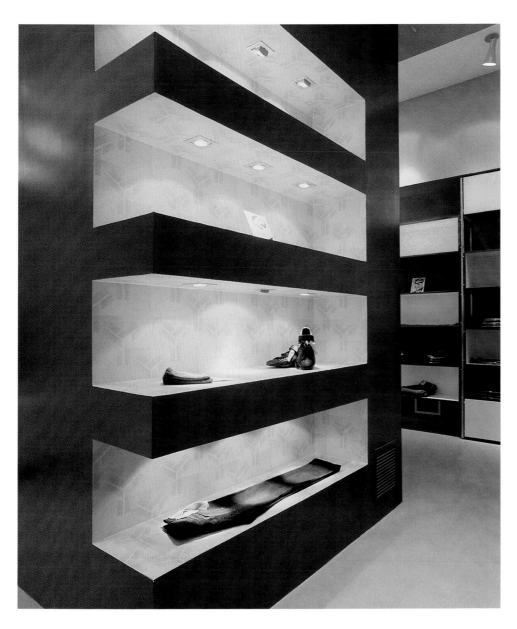

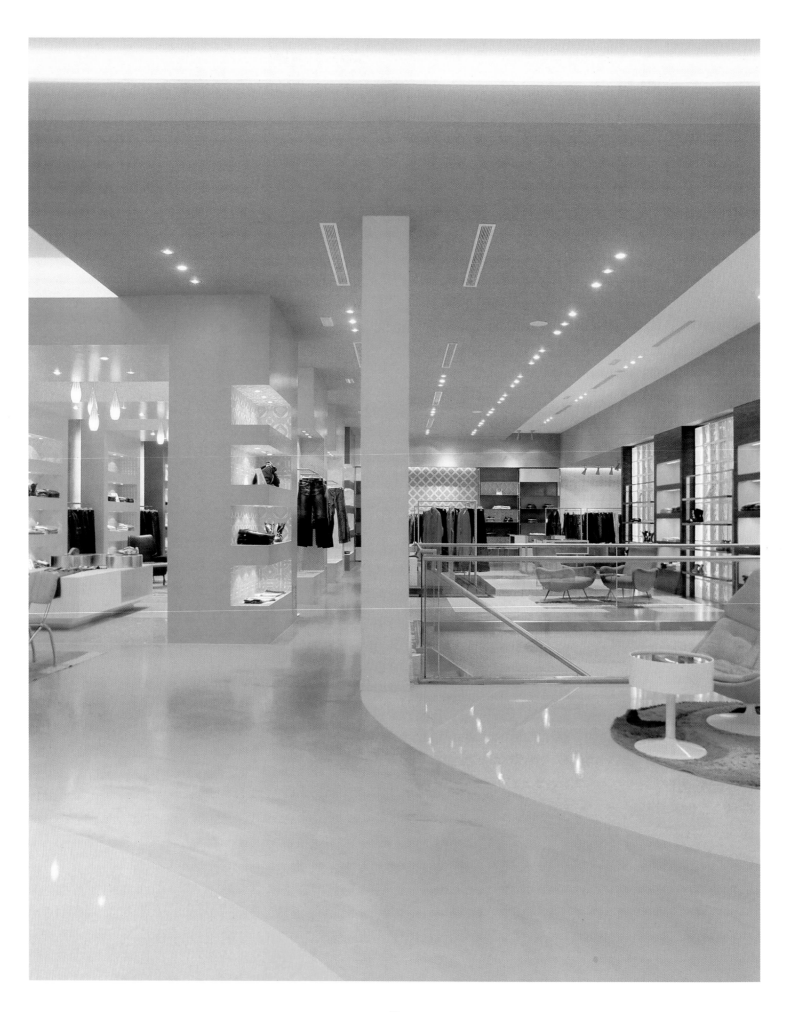

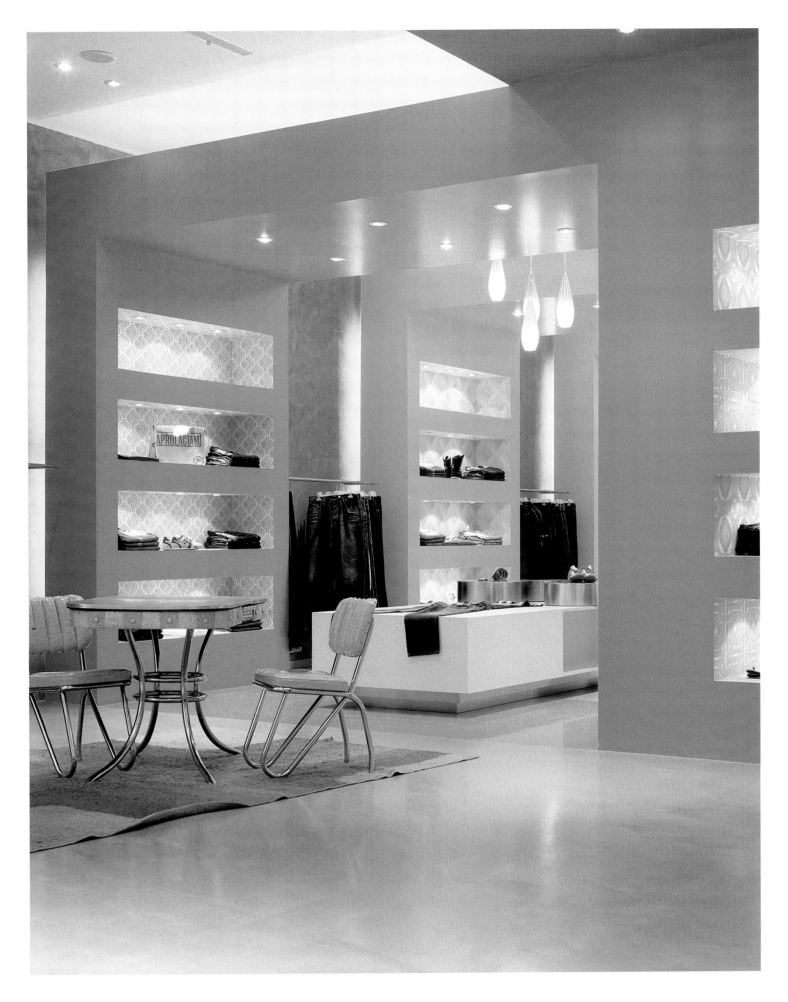

MISS SIXTY/ENERGIE

CATANIA

Designer: **Studio 63 Associati**
Photographer: **Yael Pincus**
Location: **Catania, Italy**
Opening date: **2003**

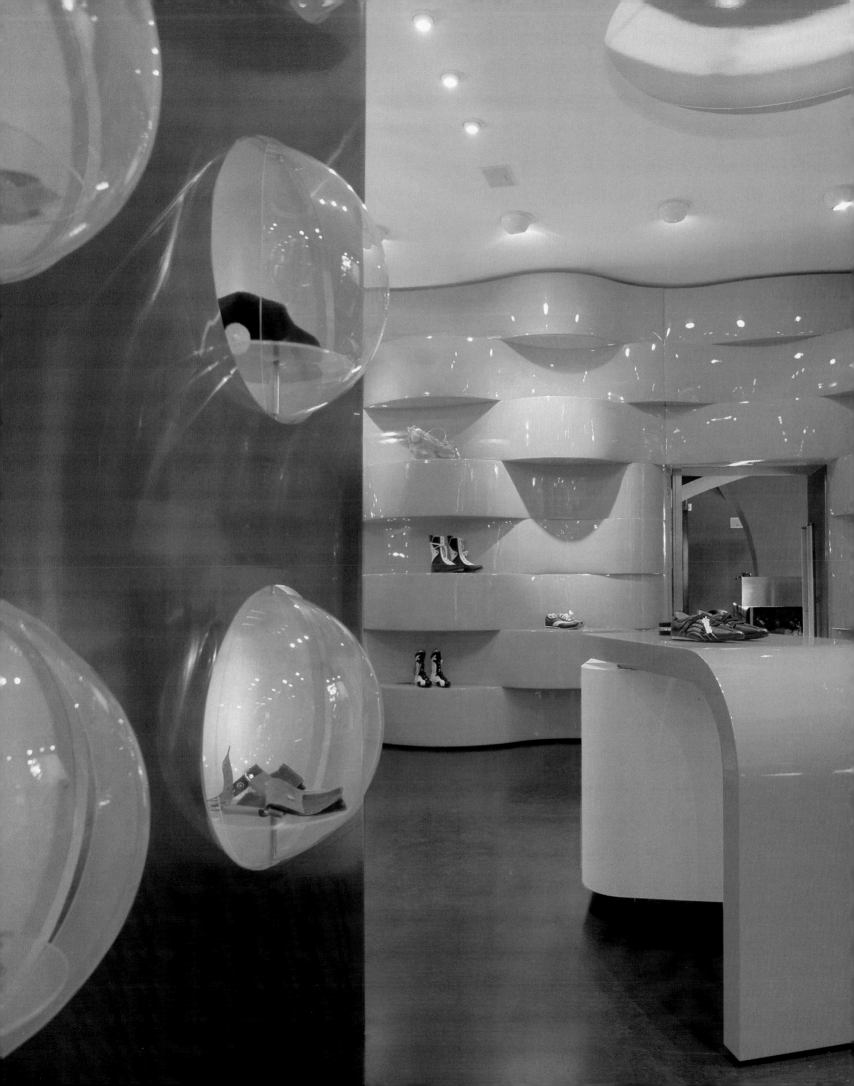

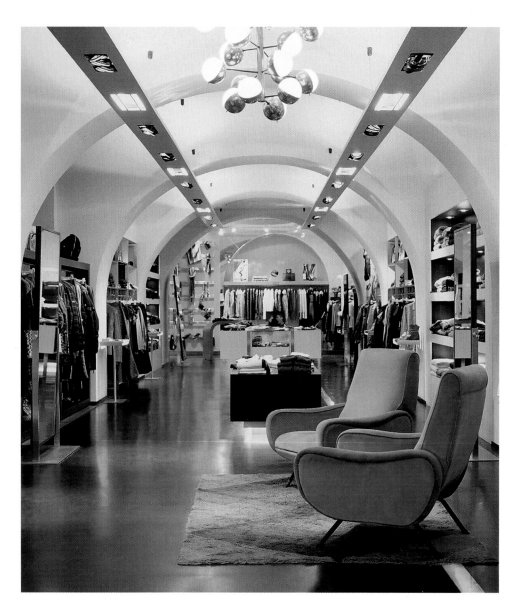

Squared angles are nonexistent in this space, as seen by the curved structure of the ceiling.

Floor plan

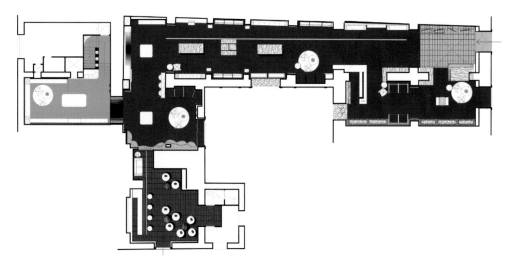

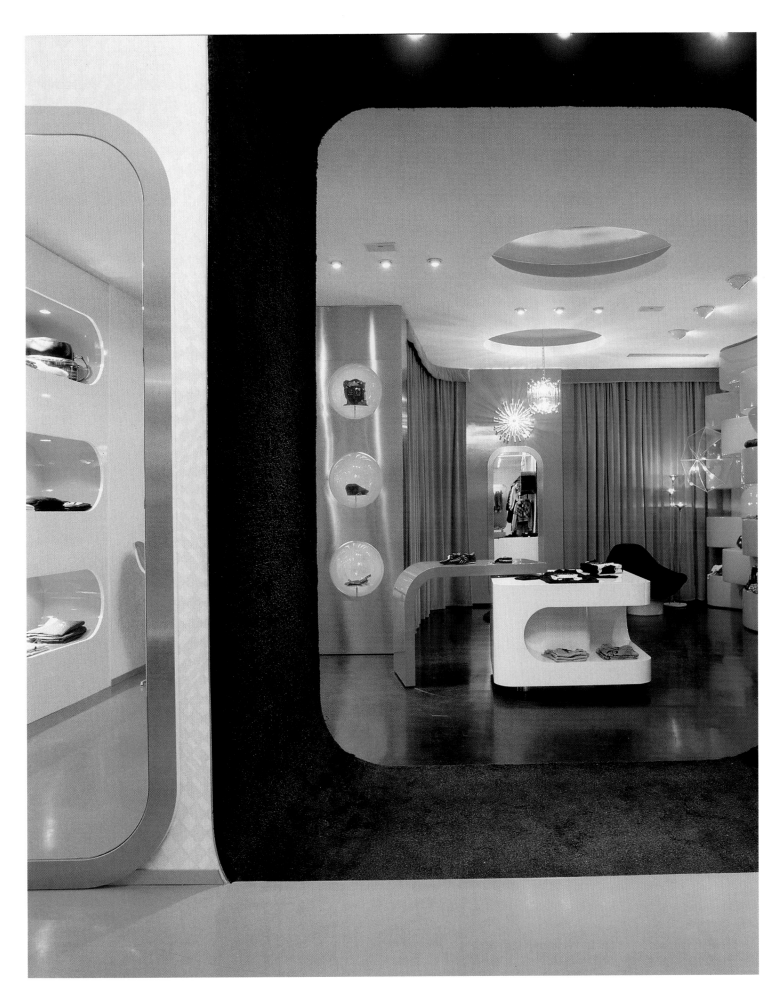

54

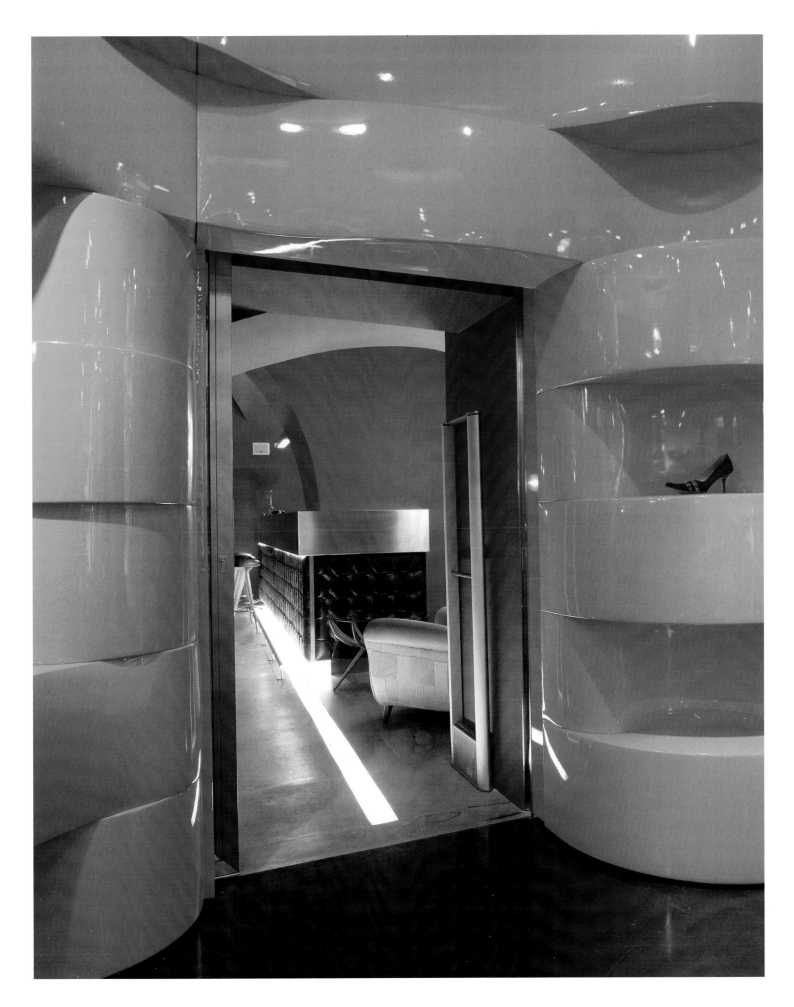

ENERGIE / LONDON

Designer: **Studio 63 Associati**
Photographer: **Yael Pincus**
Location: **London, UK**
Opening date: **2002**

A stairway climbs above the interior garden to the display area on the second level of the store.

Floor plan 1

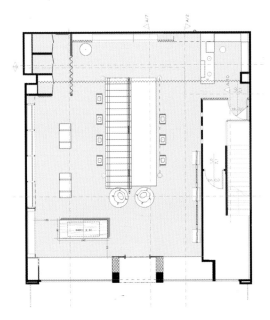

Floor plan 2

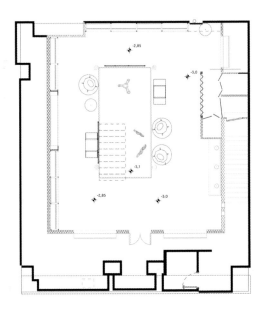

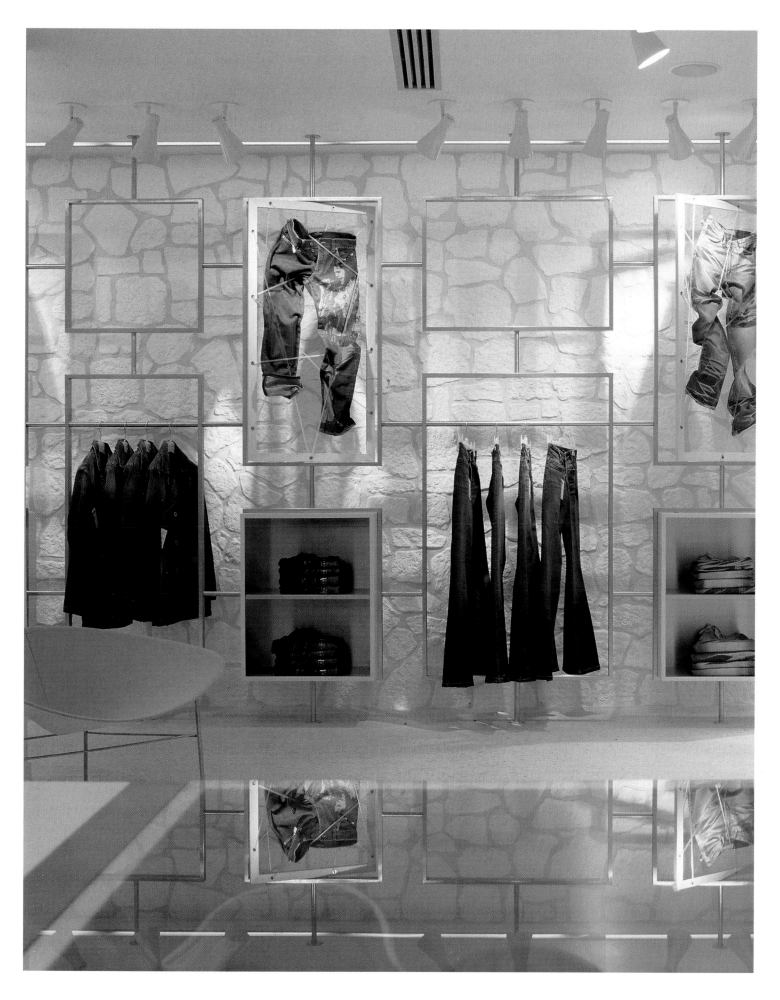

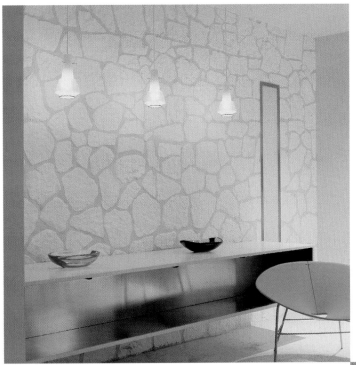

Perfect interior lighting creates a seemingly
transparent space, with simple lines that complement
the geometry of the details.

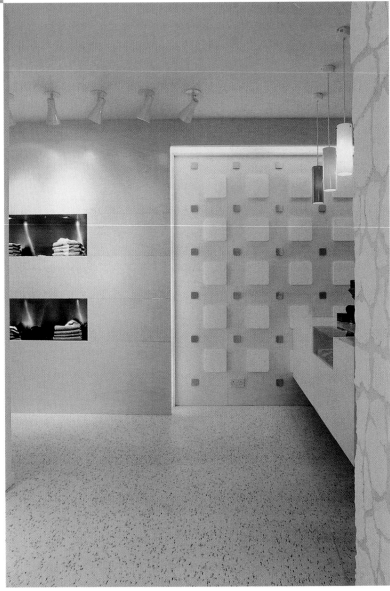

Details like the lamps, the armchairs, and the display fixtures are all in the style of the 1960s.

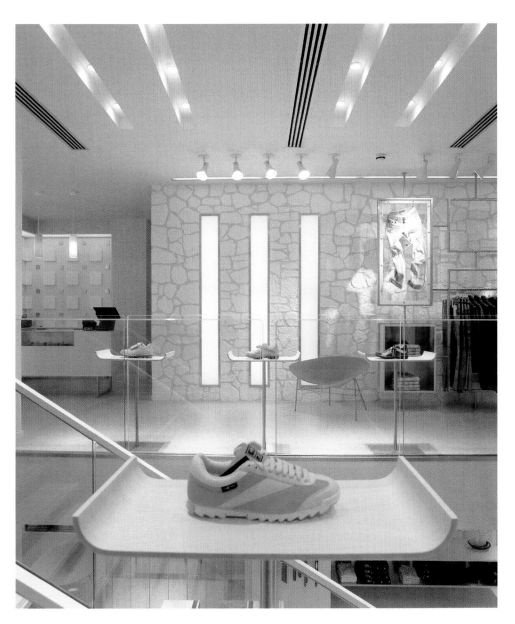

ENERGIE / BOLOGNA

Designer: **Studio 63 Associati**
Photographer: **Yael Pincus**
Location: **Bologna, Italy**
Opening date: **2002**

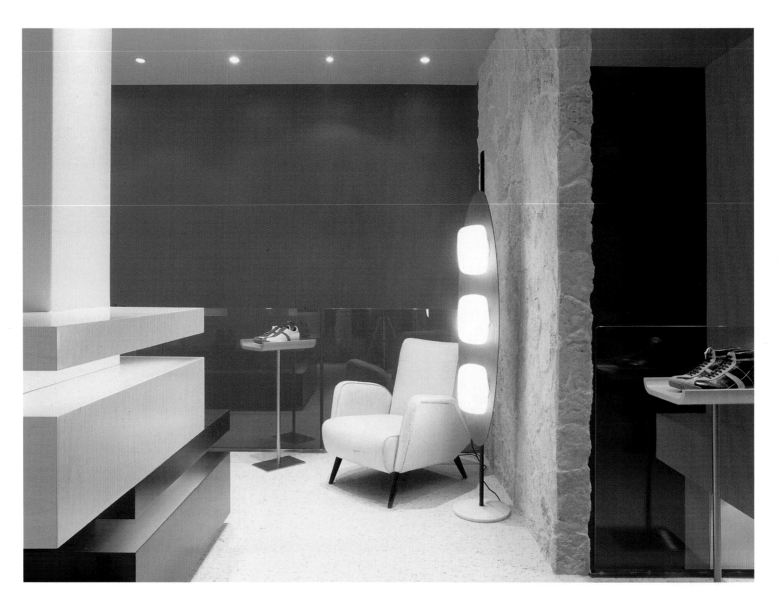

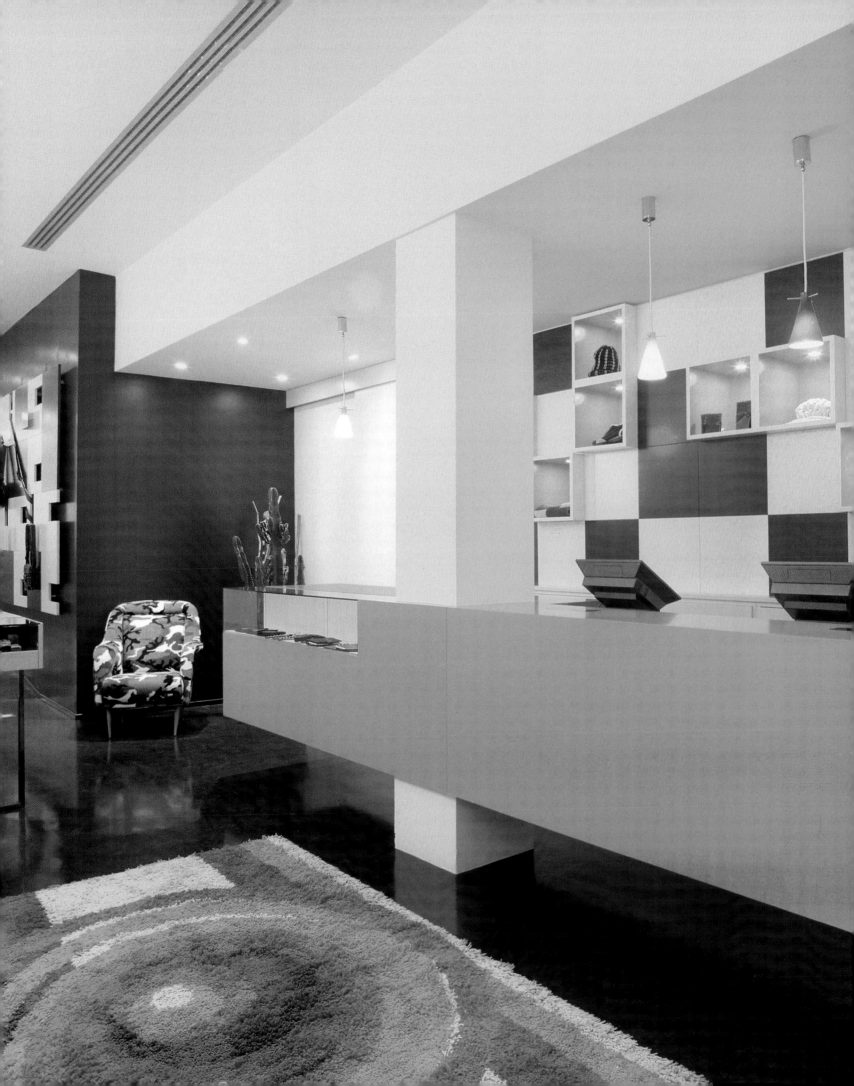

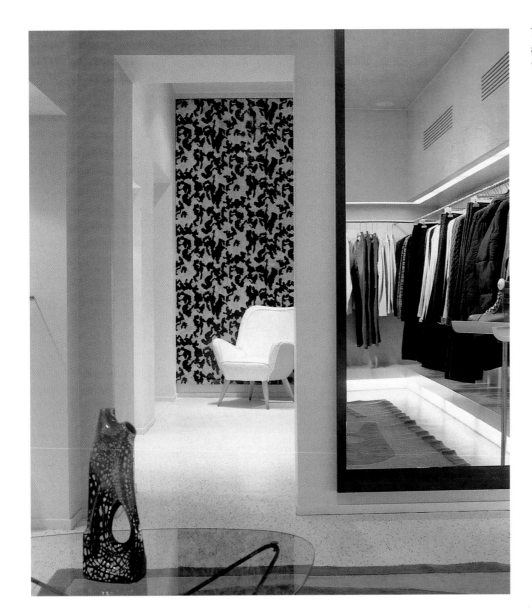

The fitting rooms, which adhere to the same design aesthetic as the rest of the space, are located behind the area where the Energie clothing is displayed.

Ground-floor plan

First-floor plan

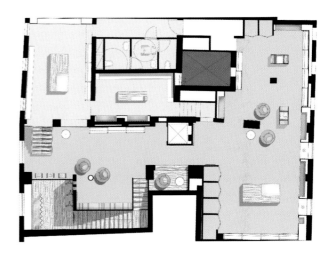

Section

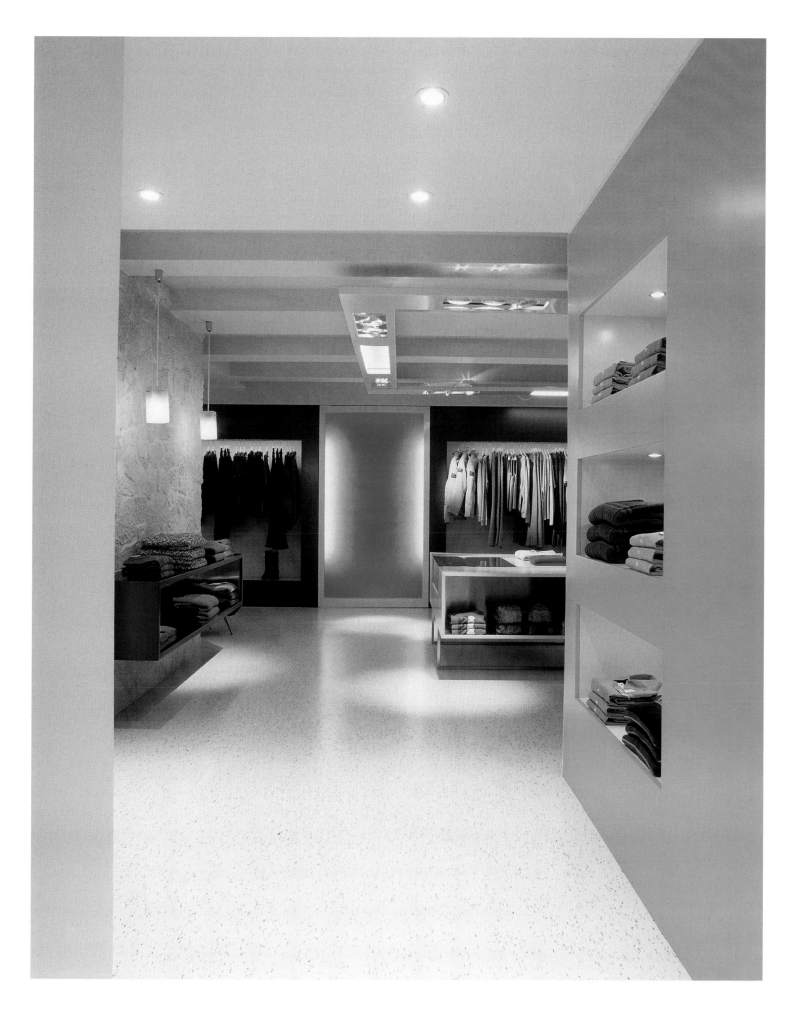

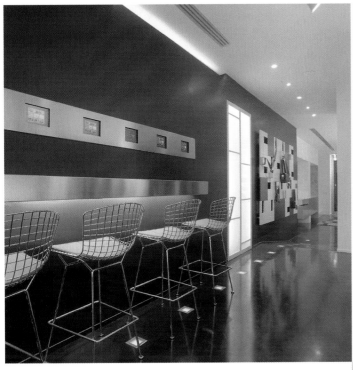

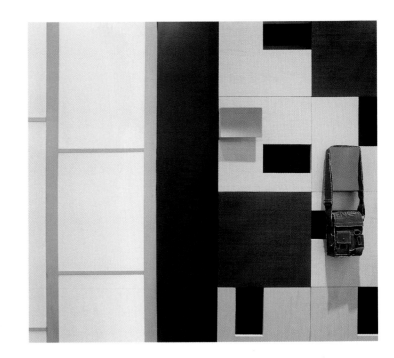

The store has its own bar, where a drink
can be enjoyed after shopping.

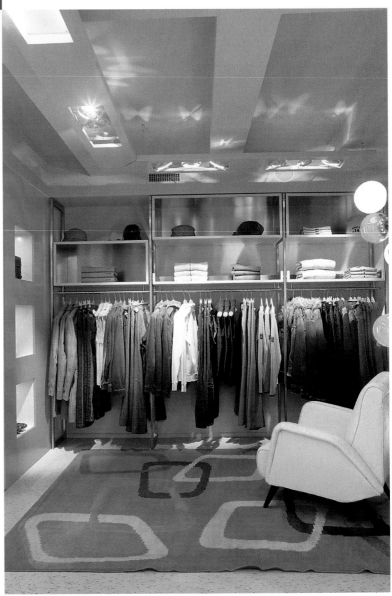

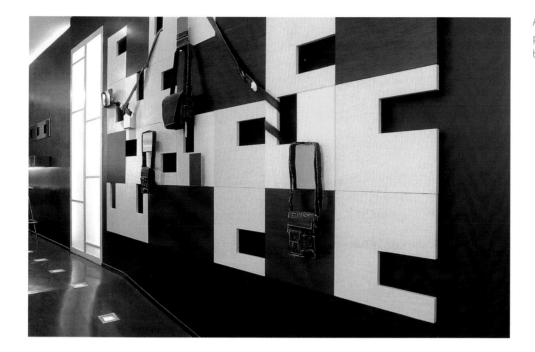

A geometric design, created with different colored panels, allows some of the company's accessories to be hung on the wall.

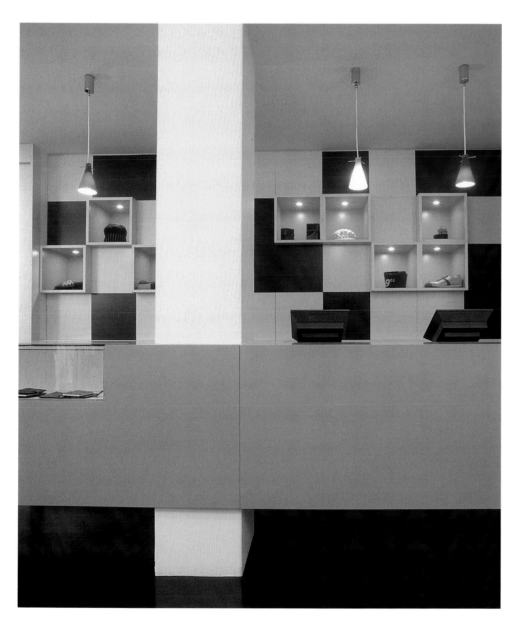

ADAM ET ROPÉ FEMME/HOMME

Designer: **OUT.DeSIGN**
Photographer: **Kozo Takayama**
Location: **Kyoto, Japan**
Opening date: **2002**

The OUT.DeSIGN team, headed by Tsutomu Kurokawa, was commissioned to design the interiors of the Adam et Ropé stores for both men and women in different Japanese cities.

The carefully planned corporate identity of the store is based on the concept of multifunctional spaces in which combinations of different materials and textures personalize each establishment.

The Kyoto space has an industrial character: the beams and utility ductwork of the unique ceiling are visible at the top of the structure. OUT.DeSIGN designed a multi-use space, with open display areas of different sizes. The design uses polyhedral and circular elements to diminish the uniformity of the space. The same approach was used in Sendai. Cylinders suspended from the ceiling for use as display fixtures accentuate the geometry of the objects and soften the horizontal feeling of the interior. None of the counters are the same—some were designed as simple metal pieces for displaying the collections, others are avant-garde glass cases that extend toward the middle of the space, supported by the exposed brick walls.

Added to the juxtaposed forms that define the different stores are their contrasting warm and cool textures. Rough materials share the space with transparent, polished materials. Some of them include mosaic surfaces mixed with natural woods. This results in spaces where the perceptions and story lines continually confront each other, making each interior distinctive.

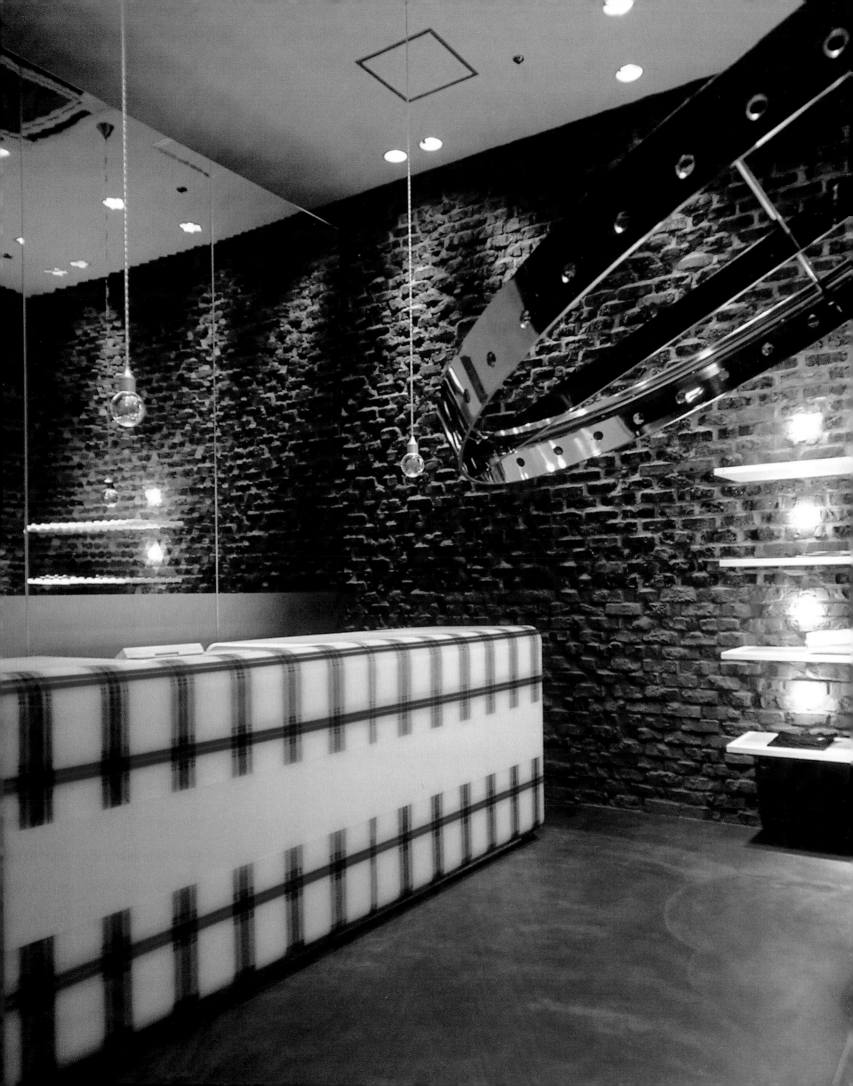

Adam et Ropé

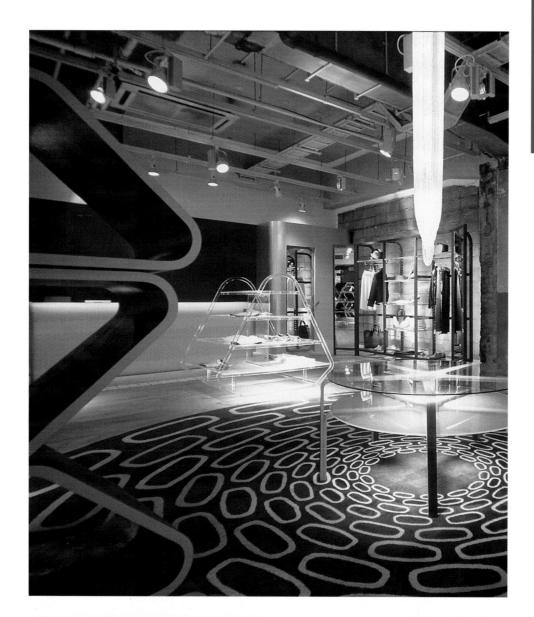

The space is designed with an industrial theme that makes use of different materials and textures.

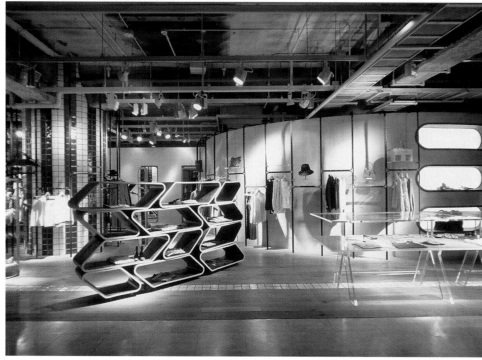

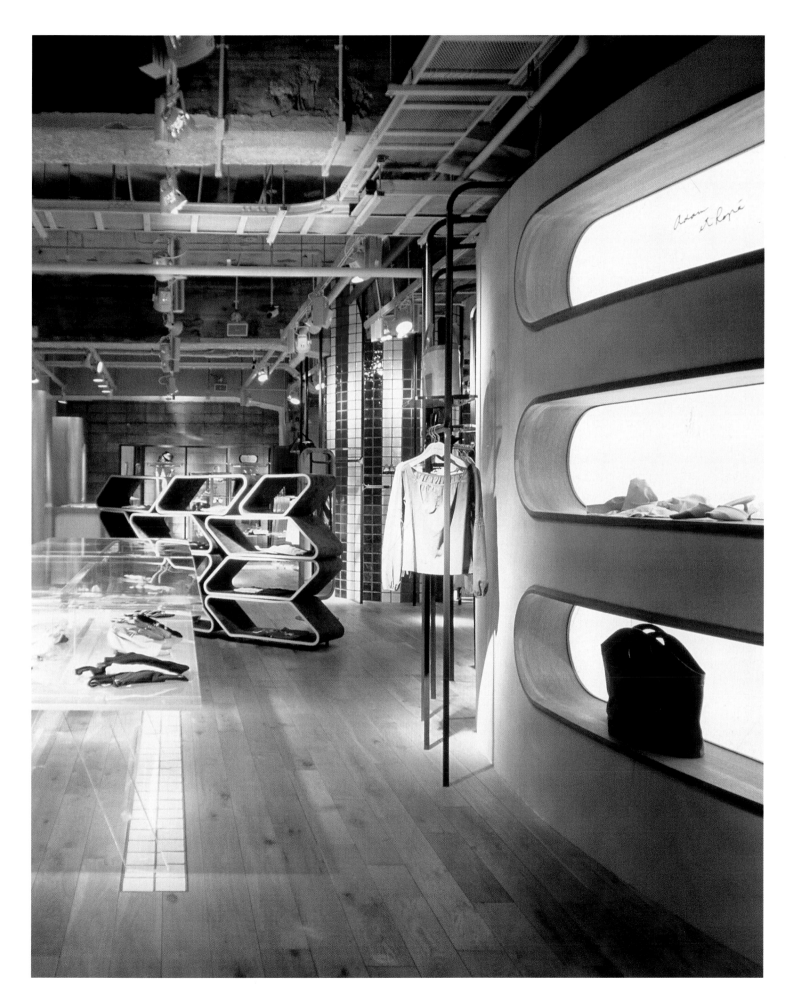

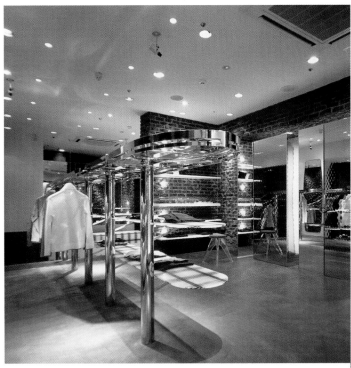

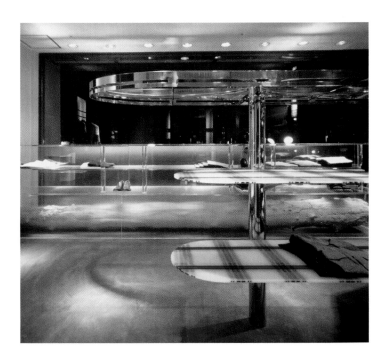

The shelves are created from cool, transparent
materials that contrast with the brick walls
surrounding the space.

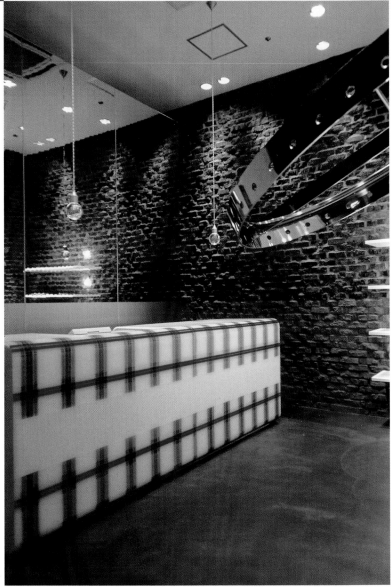

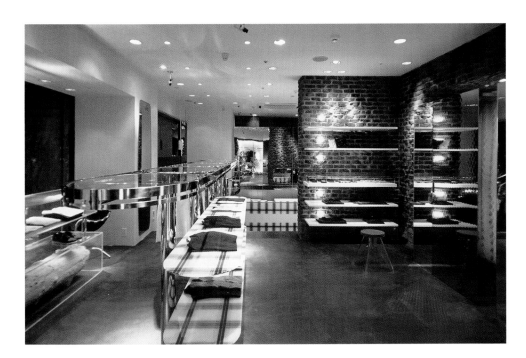

The customer can browse through different areas that display everything from sweaters to shoes.

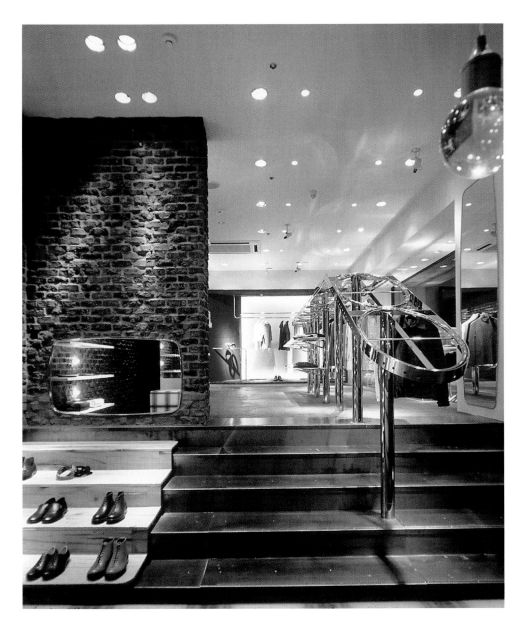

ADAM ET ROPÉ FEMME/HOMME

SENDAI

Designer: OUT.DeSIGN
Photographer: Kozo Takayama
Location: Sendai, Japan
Opening date: 2002

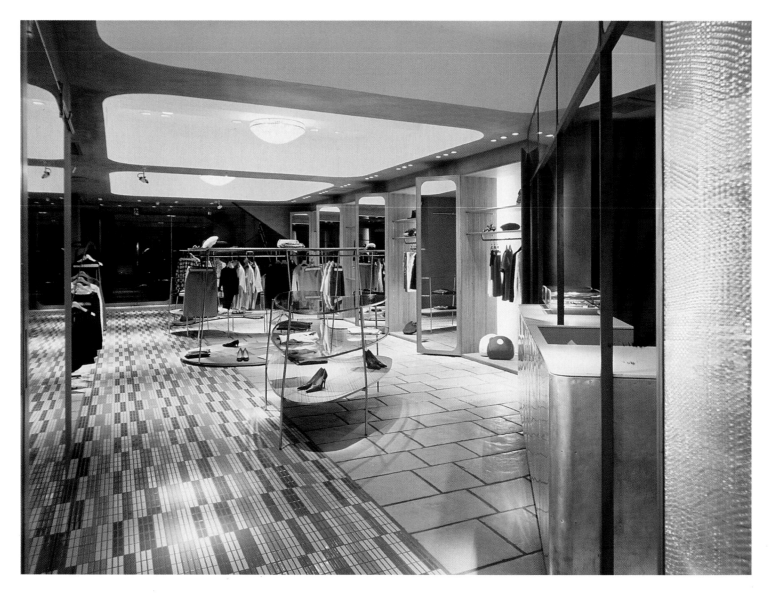

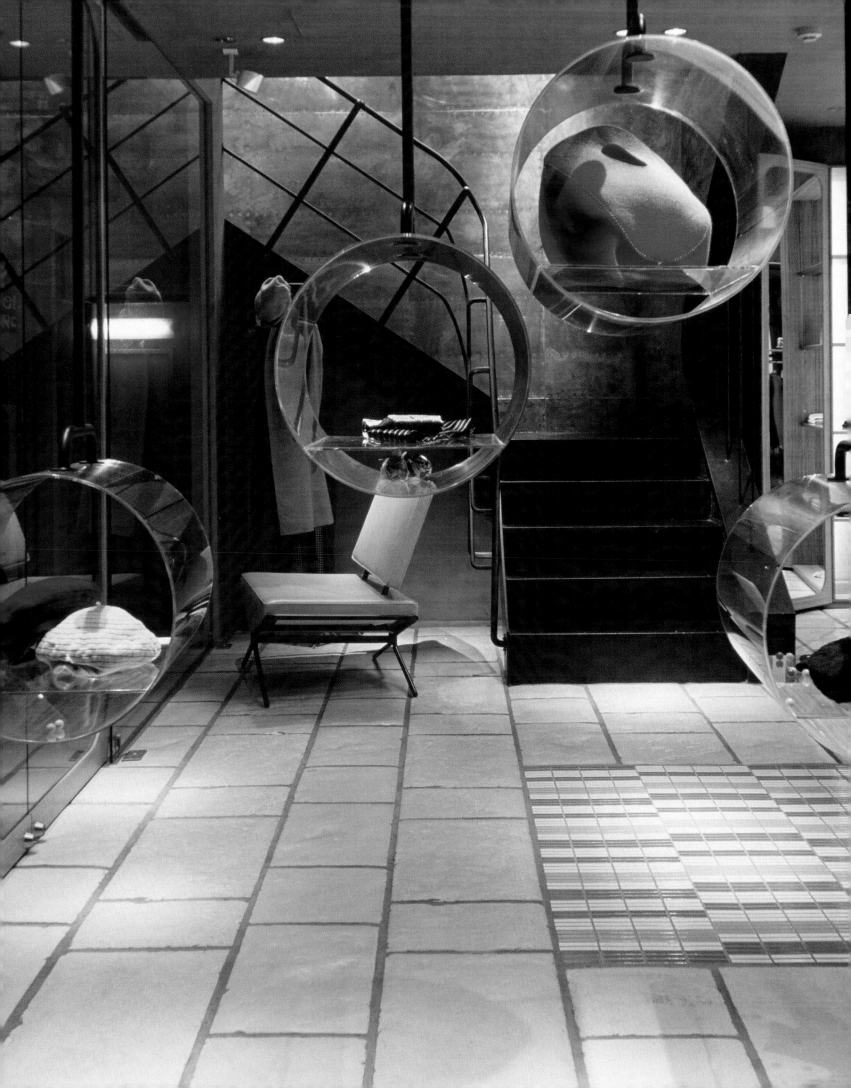

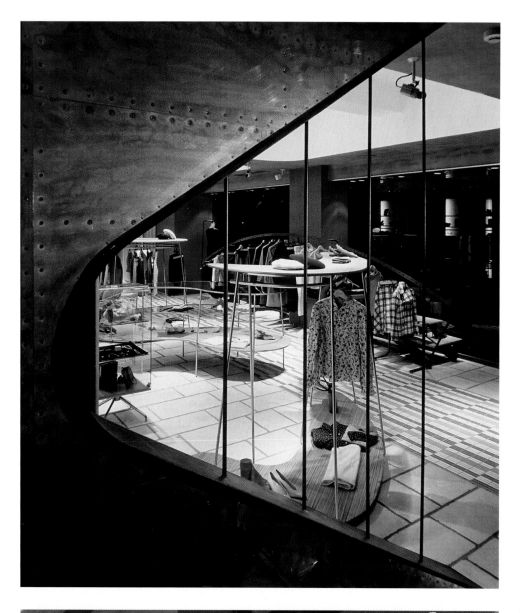

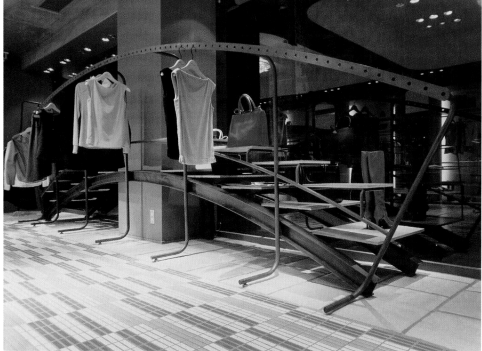

This space is characterized by several industrial-style details, such as the metal panels that surround the interior.

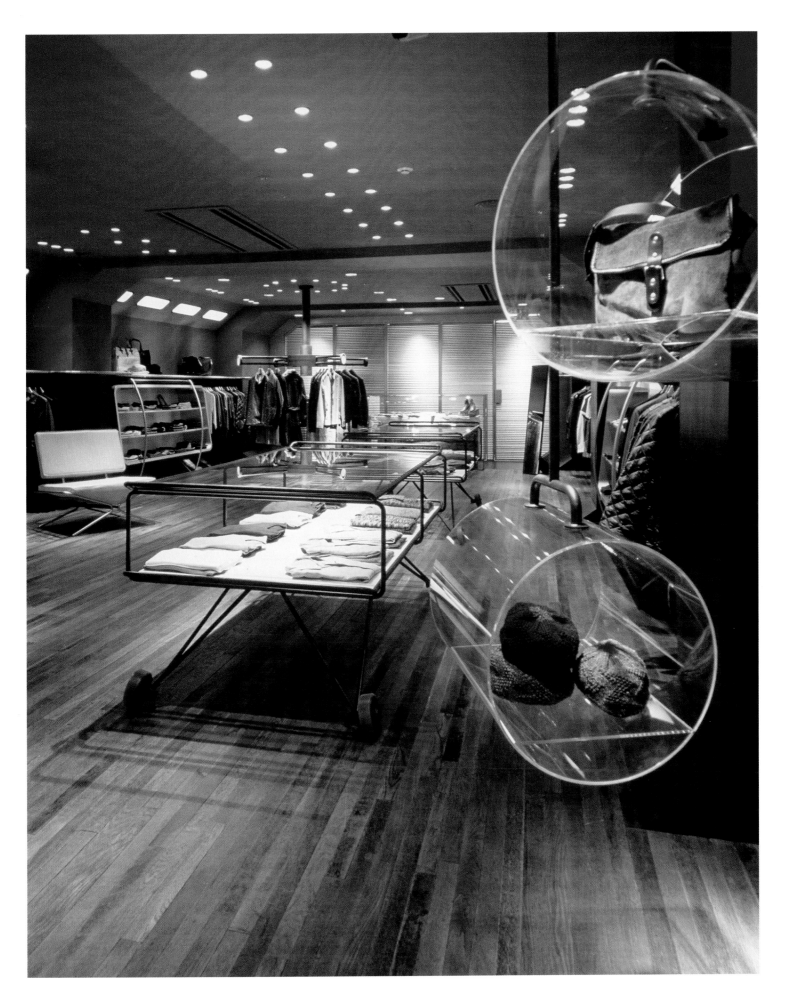

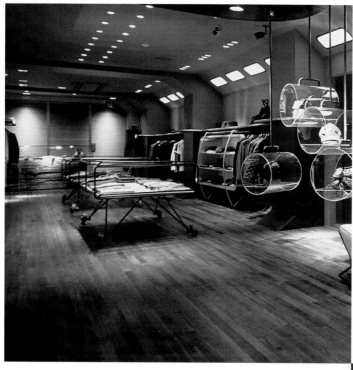

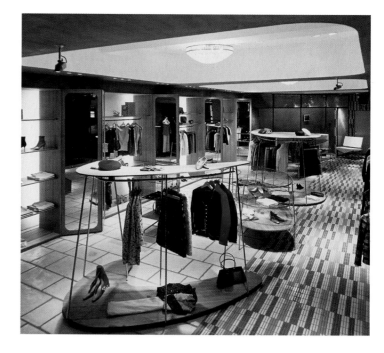

Transparent cylinders, which hang from the ceiling
by a metal bar, display some of the accessories.

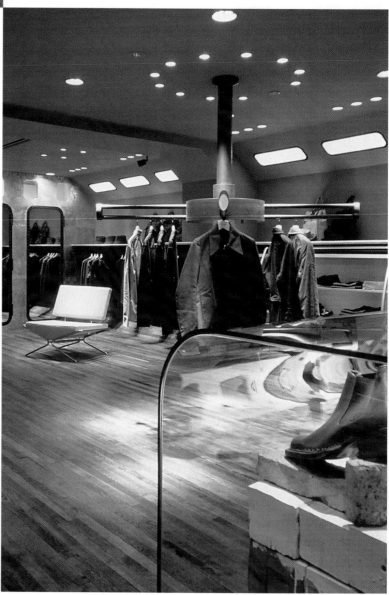

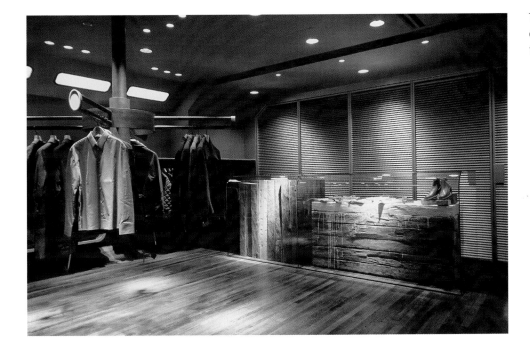

The different colored tiles covering the floor contrast with the natural wood that is used throughout the space.

CALVIN KLEIN

Designer: **John Pawson**
Photographer: **Vincent Knapp**
Location: **Paris, France**
Opening date: **2002**

Architect John Pawson's first project for Calvin Klein was in 1995, when the company chose the architect to design its flagship store in New York. The Minimalist aesthetic was at its peak then, and Pawson was at the head of a generation of architects who knew how to celebrate space in its most essential expression.

This new Paris store, located on the Avenue de Montaigne, is perhaps a more mature continuation of that first project, the result of the brand's natural evolution.

In Paris, Pawson achieves an interior that reflects the distinguished and modern luxury of Calvin Klein. The key is the quality of the space. The interior of the new store is based on the distribution of sensual white spaces in which the proportion of light is perfect. According to John Pawson's concept, if the atmosphere is good, the clothing will look good, and the customer will feel good. In this way, the architect converts the product into a work of art exhibited in a neutral and aseptic space. To achieve such results the architect worked with different materials and textures to create perfect lines and surfaces. For the architect, it was important that the perfect detailing of the Calvin Klein clothing be highlighted, and that the interior not overpower the intrinsic qualities of the product.

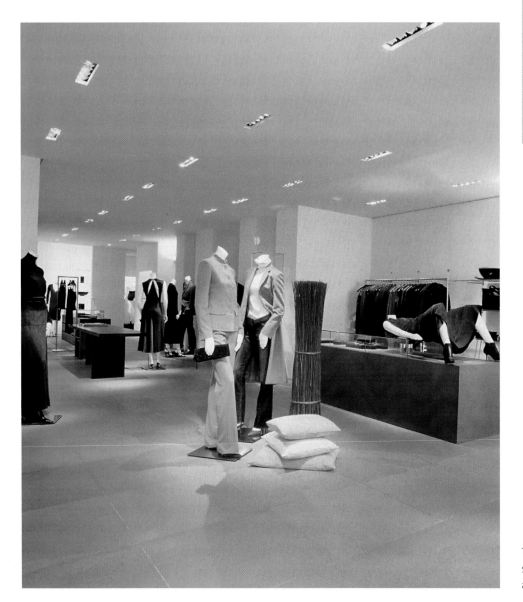

Calvin Klein

The store is laid out on two levels where white, sensual spaces are characterized by perfect proportions and lighting.

Ground-floor plans

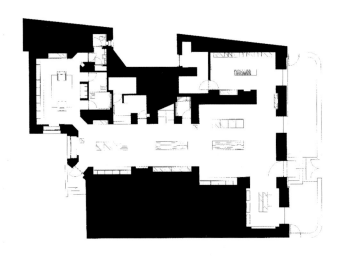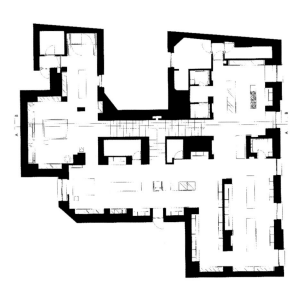

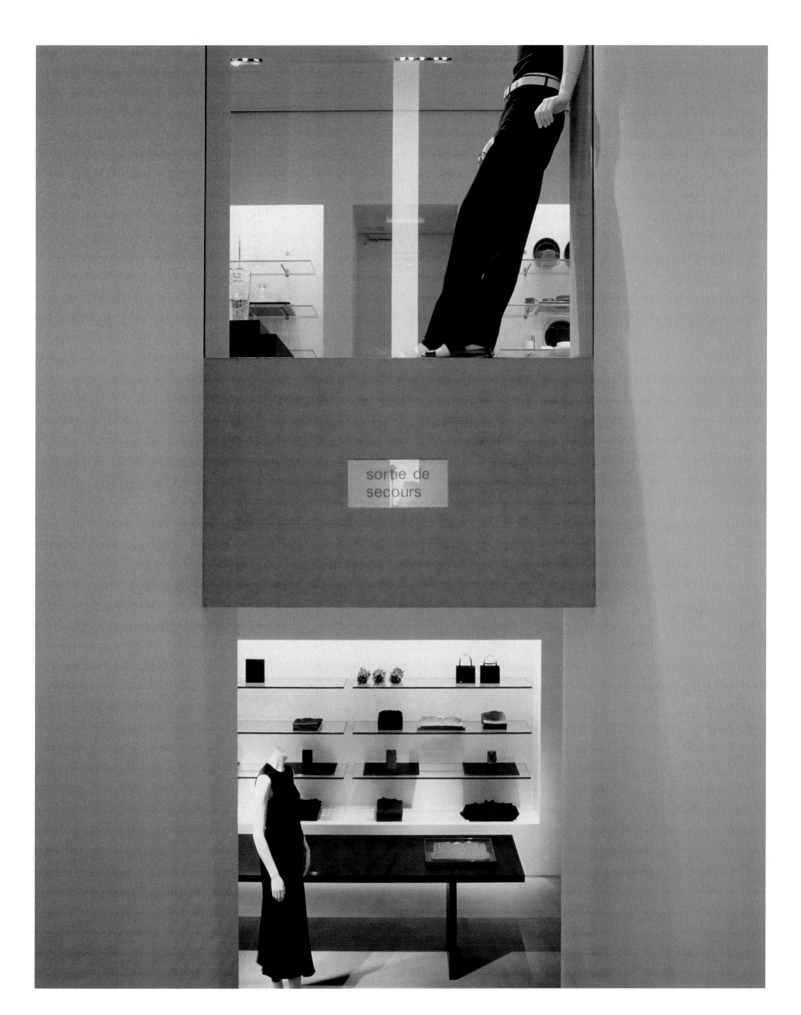

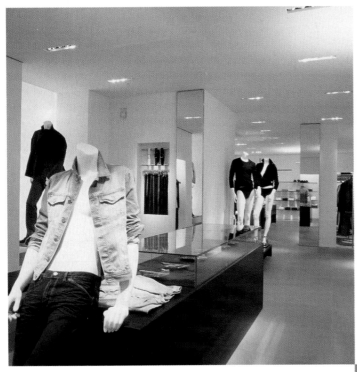

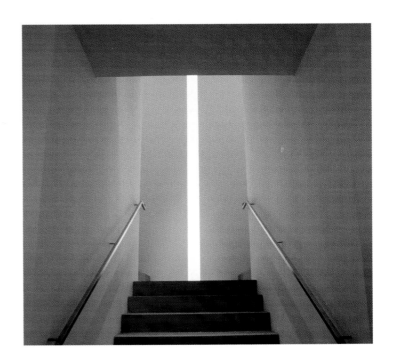

Pawson fully exploits the tactile and visual aspects of the interior, working with a limited palette of materials and colors.

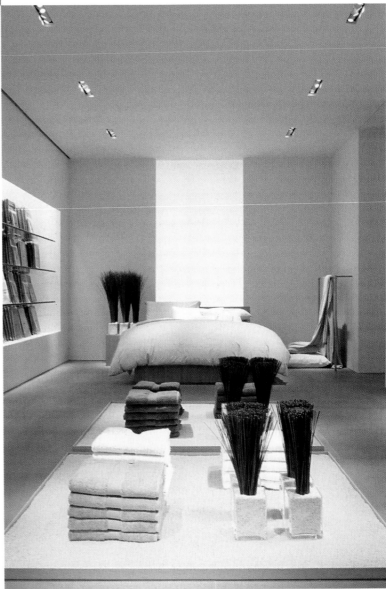

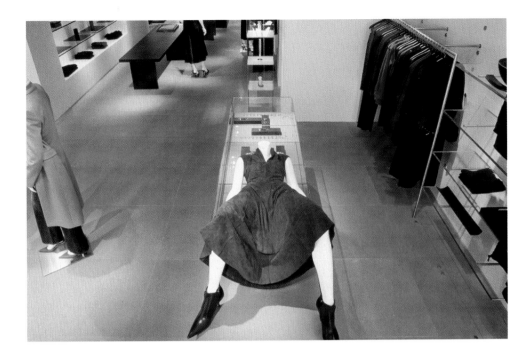

The classic combination of light and dark woods contrasts with the theatrical mannequins.

CUSTO BARCELONA

Designer: **Air-Projects**
Photographer: **Jordi Miralles**
Location: **Seville, Spain**
Opening date: **2003**

Custo Barcelona is a clear example of how a brand can become a cult object. To maintain such success, the architecture must help sell it; and to do this, a shop must be transformed into a spectacular interior, as seen in the stores that exhibit Custo Barcelona collections worldwide.

The Air-Projects studio, consisting of architect Inés Rodríguez Mansilla and the interior designer Raúl Campderrich, designed the new store in Seville. Having already received good reviews for their work on the stores in Barcelona, Paris, Milan, and Rome, they again demonstrated in Seville that architecture plays a very important role in the corporate identity of a firm. The new space in Seville is open, without furnishings that would clutter the central setting. The designers purposefully created an interior that exhibits a minimum of expression and gives priority to the forms and details of the structure. Transparent surfaces frame the shell of a neutral, almost imperceptible space, where the movement and the color of the clothing becomes the main focus.

For the store that was recently opened in Tokyo, the Japanese firm OUT.DeSIGN used a concept very similar to that of Air-Projects. The designs of Custo Dalmau hang from attractive, illuminated fluorescent lights that show off the uniqueness of each item. The space is totally open, and its repeating curves echo the sensuality of the structure. From the outside, a totally transparent, undulating surface distorts the visual continuity of the interior, altering the perceptions of the customers drawn to the products. With this store, OUT.DeSIGN achieves a space that raises each piece to the level of an exclusive work of art.

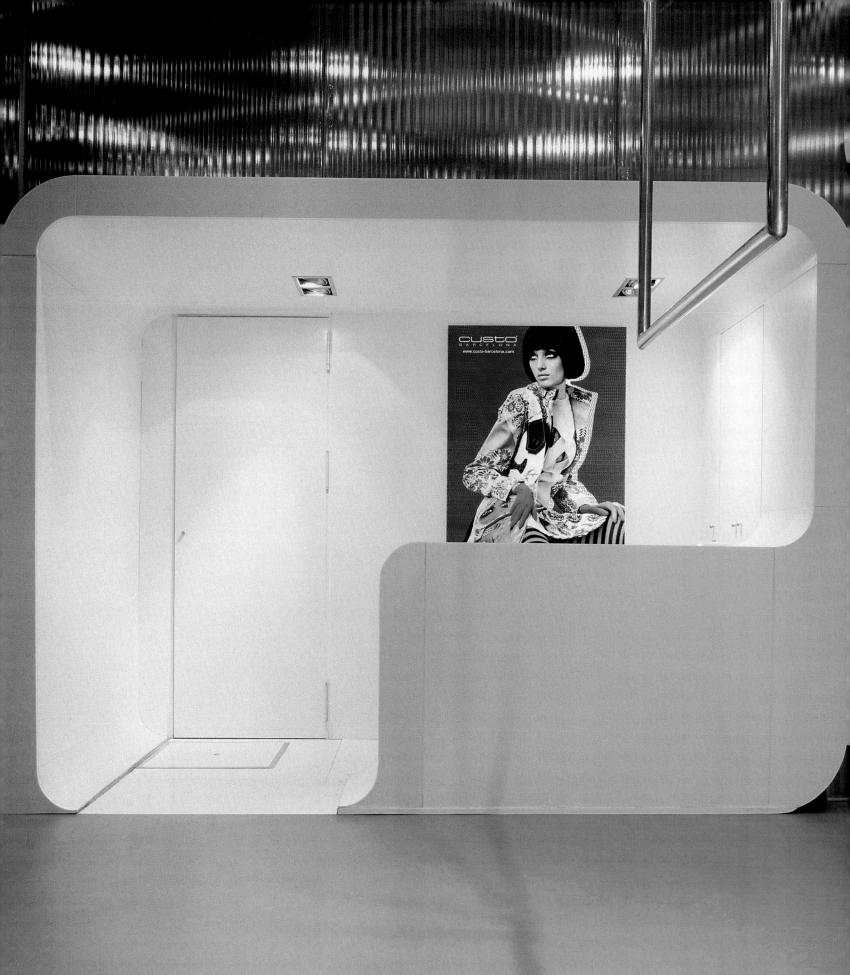

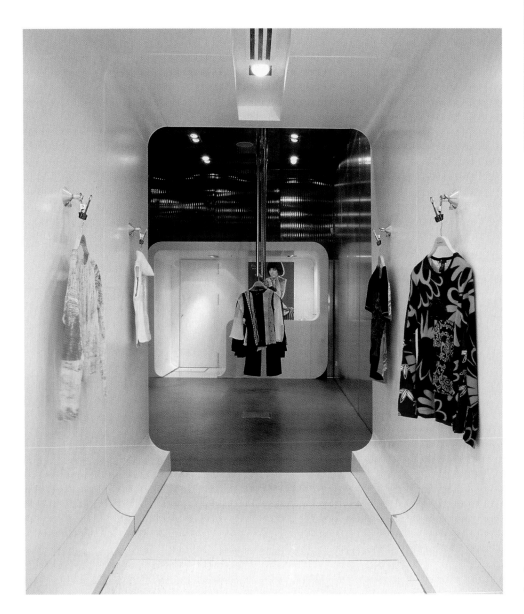

This store was planned as a modular space in which open capsules are distributed throughout the interior.

Floor plan

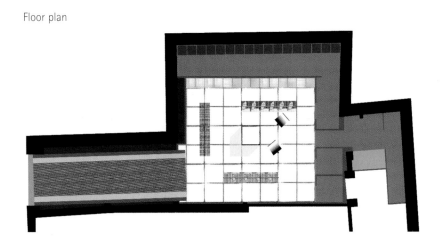

Section

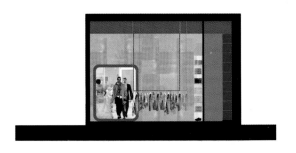

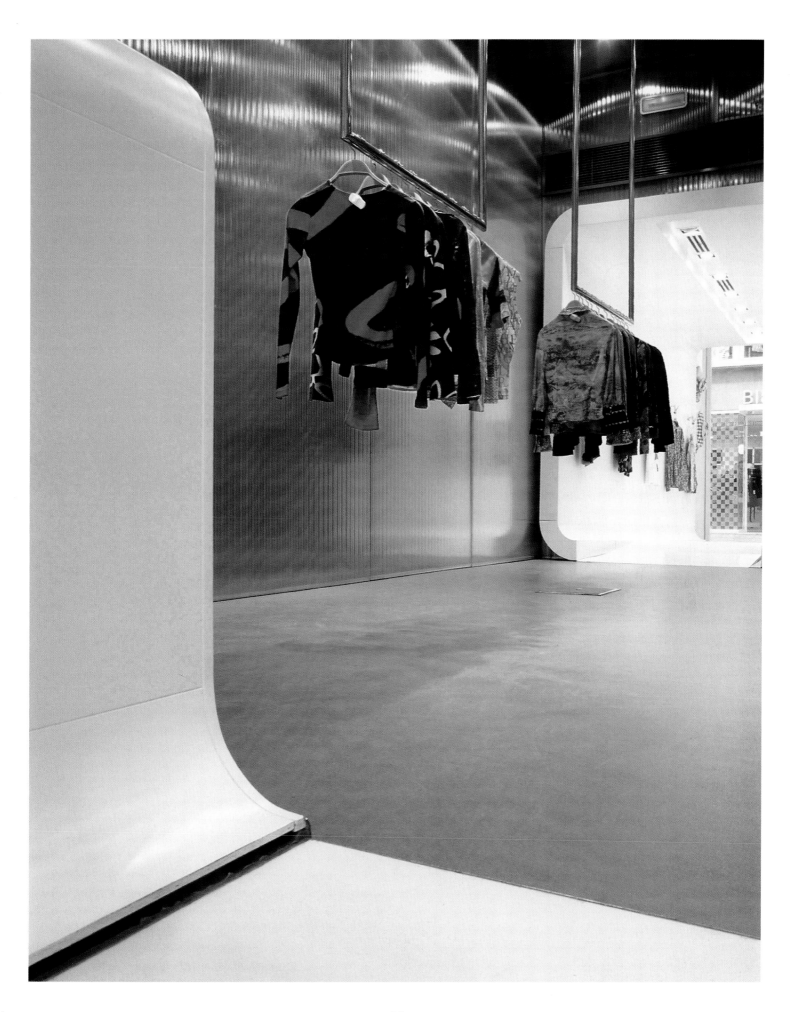

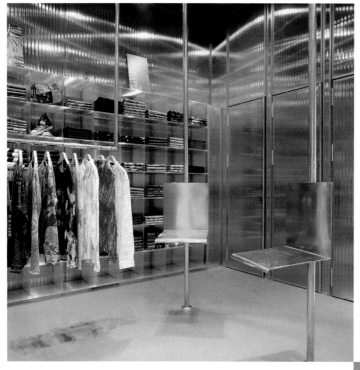

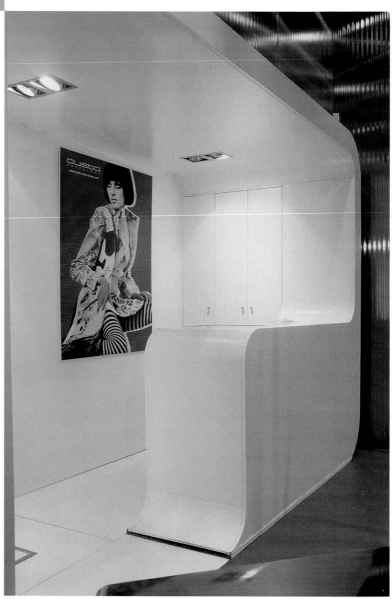

A daring, avant-garde look is created by using materials such as plastic and cool, transparent textures.

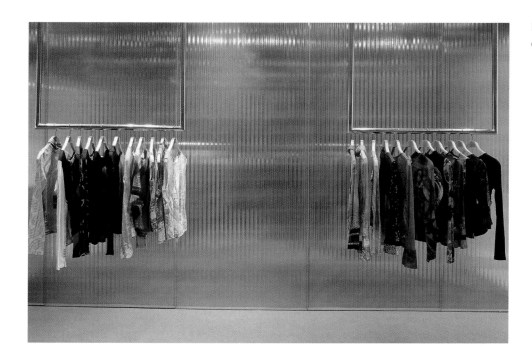

Metal bars, extending from the ceiling in the shape of trapezes, are used for displaying T-shirts.

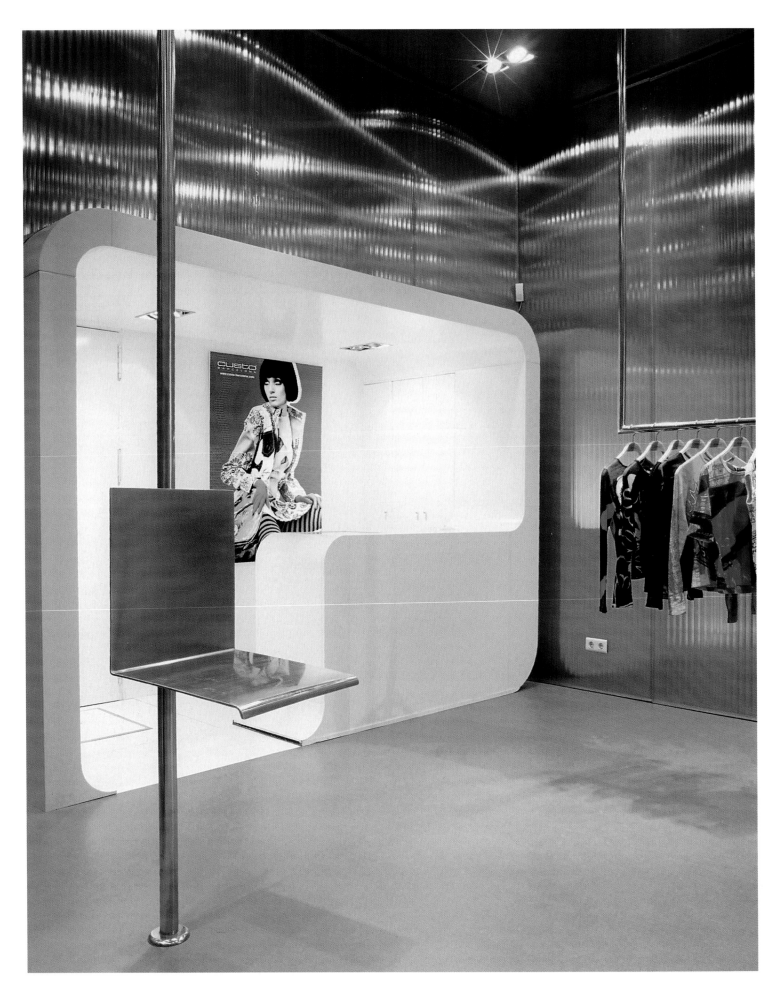

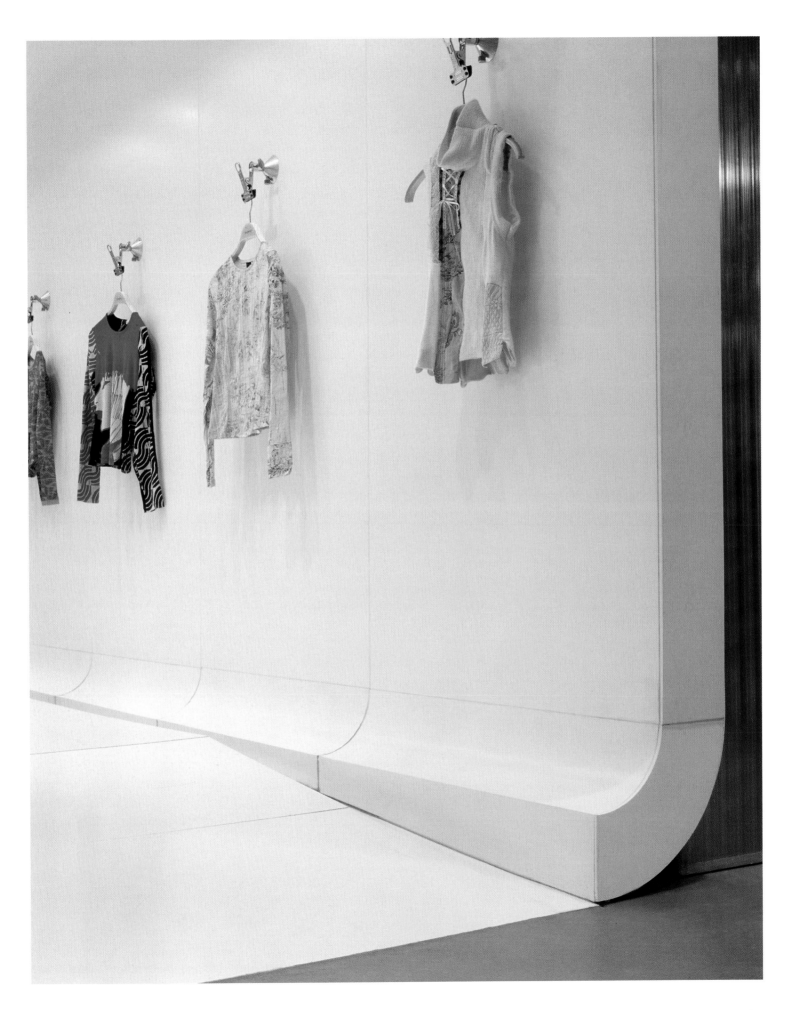

CUSTO BARCELONA / TOKYO

Designer: **OUT.DeSIGN**
Photographer: **Kozo Takayama**
Location: **Aoyama, Japan**
Opening date: **2002**

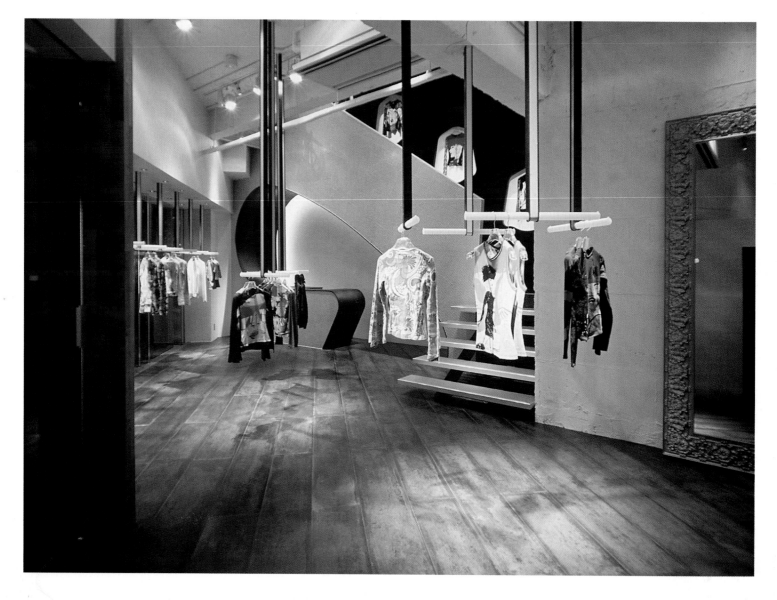

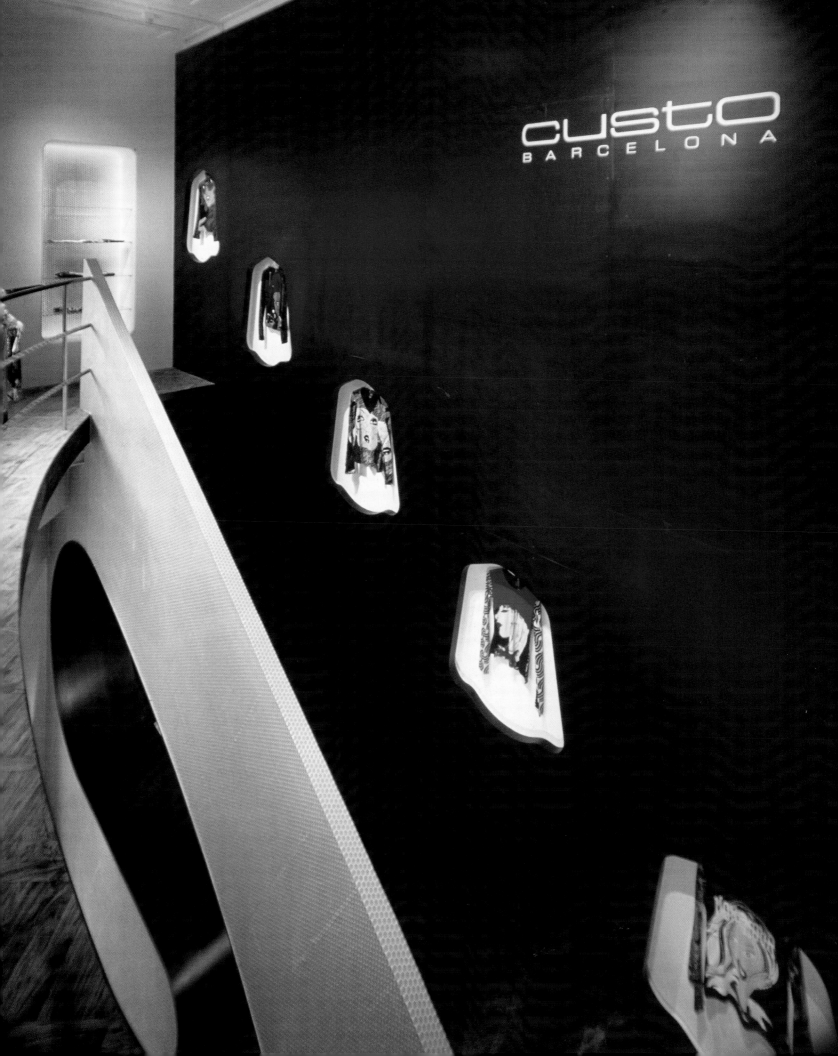

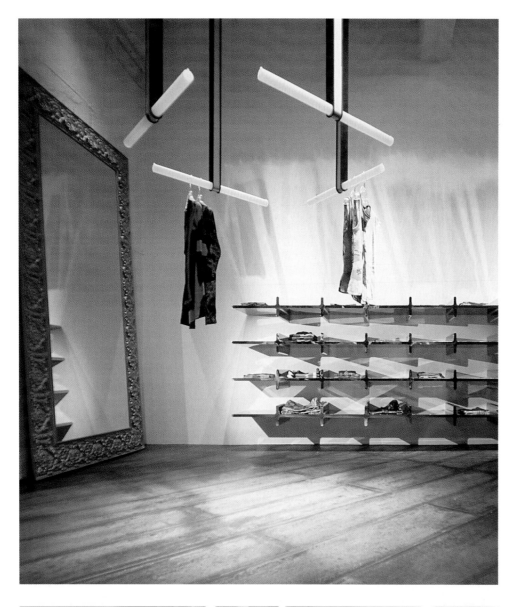

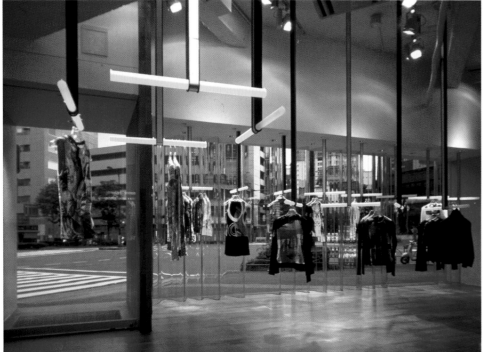

Metal straps with a fluorescent light at the end allow T-shirts to be hung in an attractive, psychedelic way.

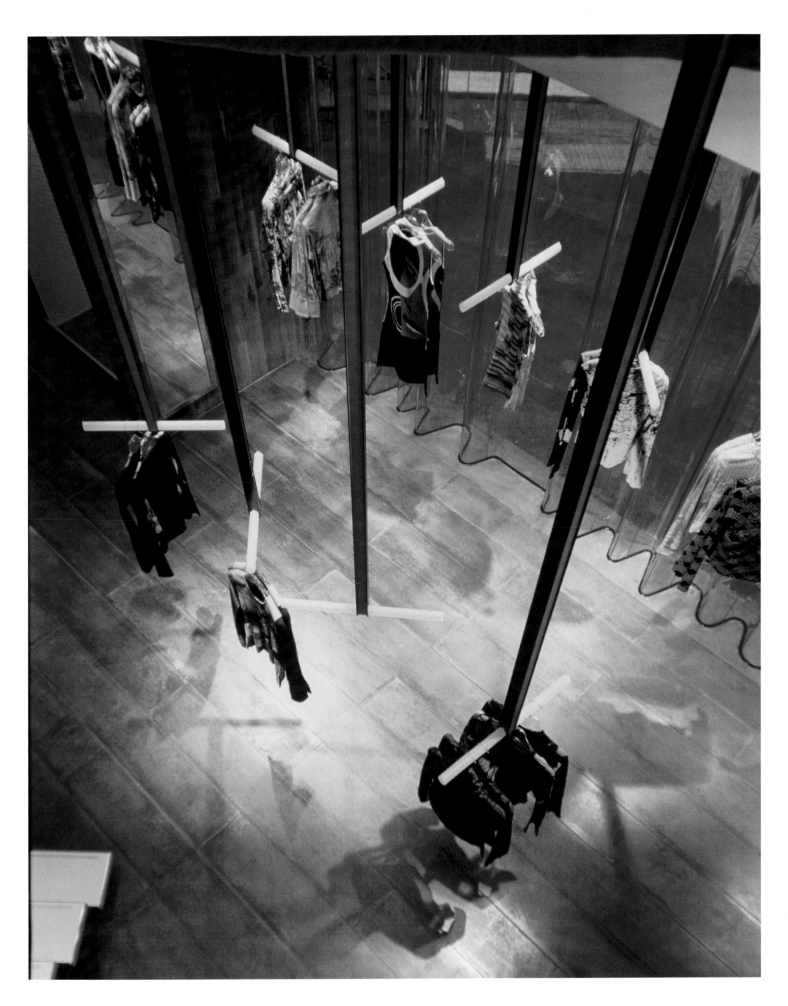

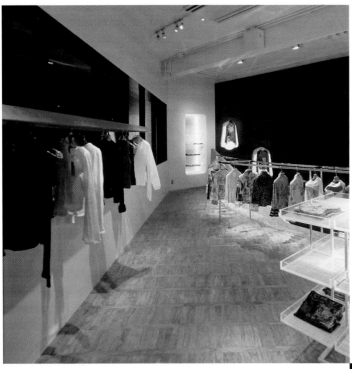

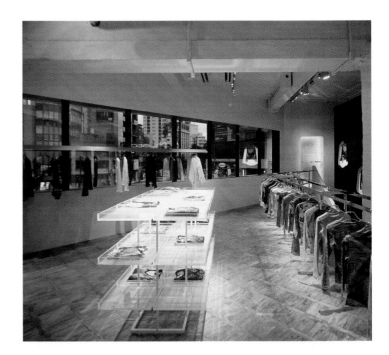

An undulating surface covers the front display window in a way that visually attracts visitors.

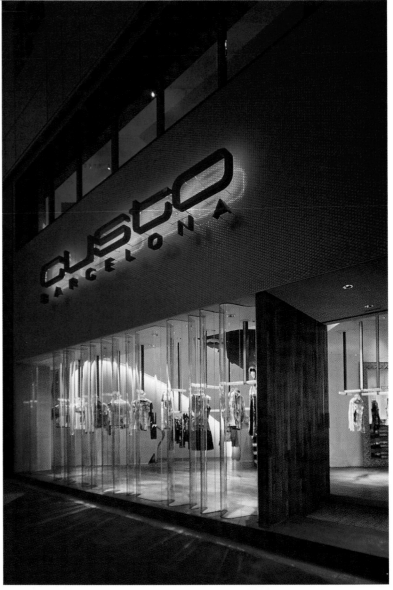

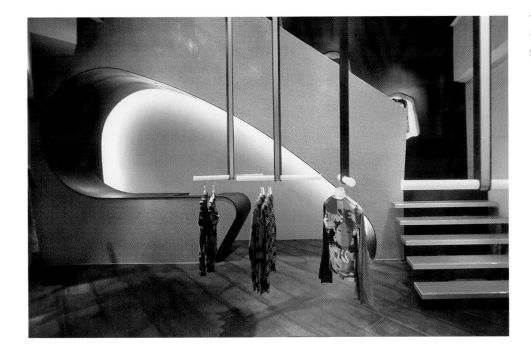

The shape of the staircase continues to curve to the floor, creating a display area within its own structure.

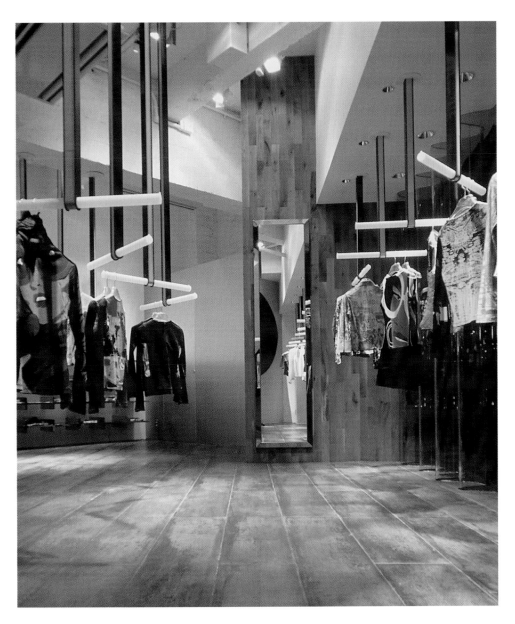

,248

Designer: **José Luis Portillo**
Photographer: **Galilea Nin**
Location: **Barcelona, Spain**
Opening date: **2003**

,248 is a space where children can have their say. The Barcelona children's store, the work of José Luis Portillo, is located on the same block as the iconic Pedrera by Gaudí, and recreates an elementary school setting in its interior. According to the architect, the intention was to create a space for a generation of children's product consumers that has grown up with an innovative design culture.

Thanks to some imaginative elements, José Luis Portillo created an interior concept in which children can feel comfortable with the unexpected. In tune with this idea, a blackboard lets children turn the simple purchase of a sweater into a fun experience of drawing and recording their impressions.

Above the shelves in the display area, the large fluorescent orange numbers on a ruler indicate the location of clothing by age. Although dark gray was chosen as a background color for the setting, orange is also used in the store's logo and graphic design.

The children's clothing is displayed in the center of a brightly-lit space, while the rest of the interior is bathed in soft light. A doodle in three-dimensional fiber optic light accentuates the straight lines of the changing area.

Also designed for the tastes of adult consumers, this store is one of many modern establishments in which the architecture and design can have their say when it comes to selling.

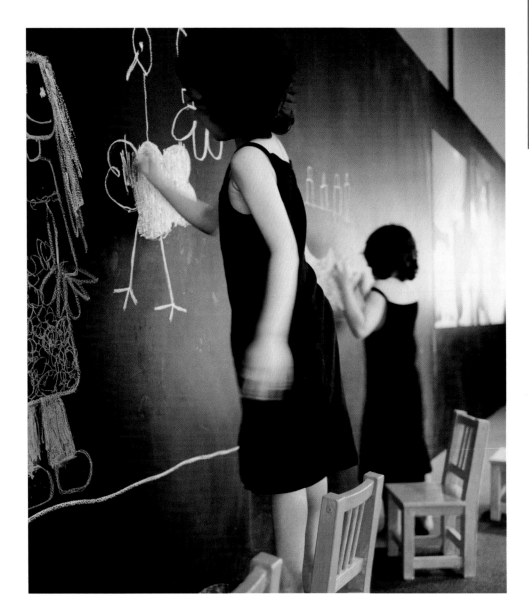

,248

One of the walls of this establishment has a chalkboard where children can have fun drawing.

Floor plan

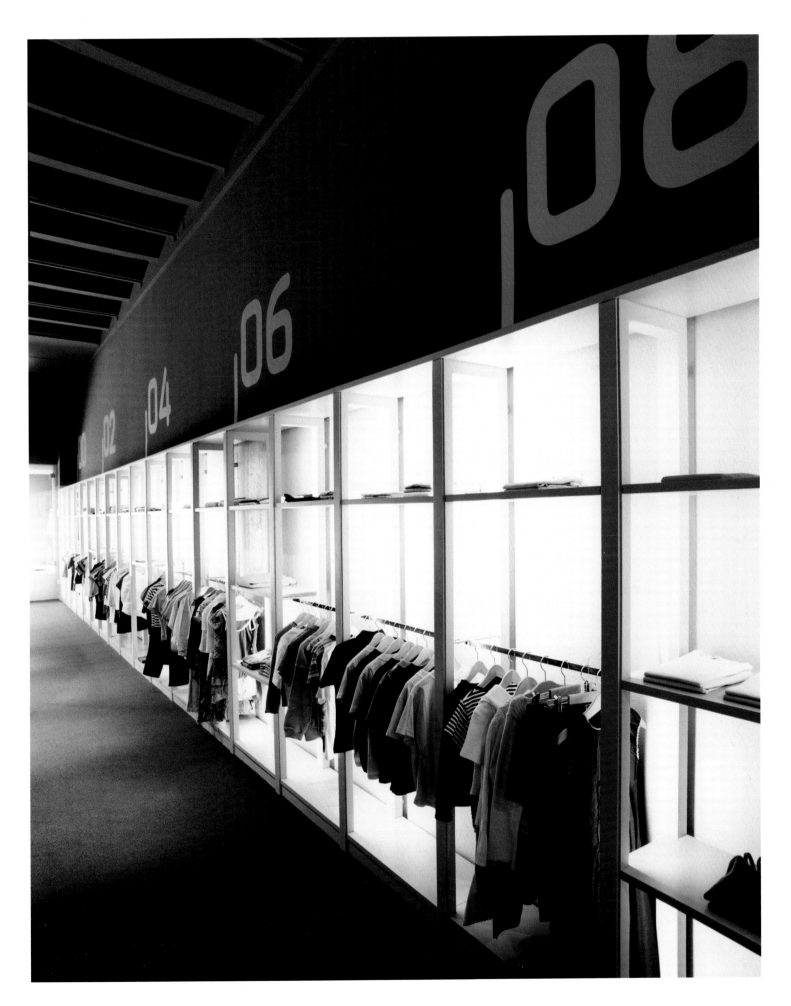

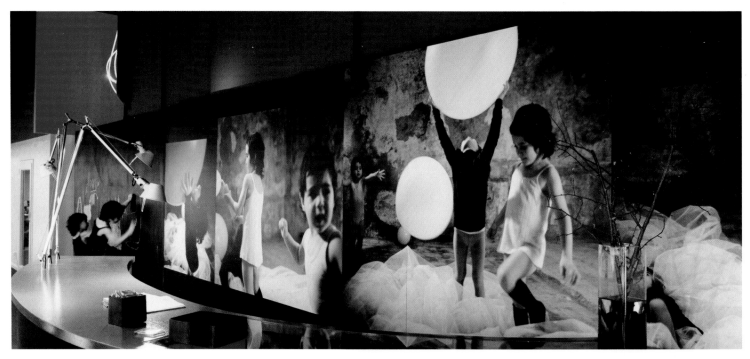

Surprising details create a new interior that adapts
to the needs of the smallest children.

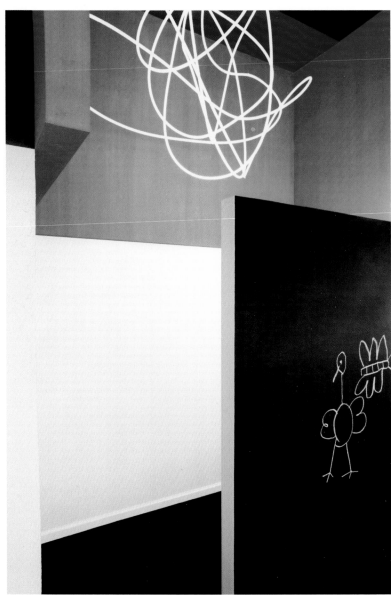

This space has imaginative details, such as the illuminated doodles that hang near the ceiling of the store.

DESIGUAL

Designer: **Martí Guixé**
Photographer: **Imagekontainer**
Location: **Barcelona, Spain**
Opening date: **2002**

Desigual is a commercial establishment located in the mythic Zeleste building in Barcelona, one of the most well-known concert halls in the city from the moment it opened its doors in the mid-1970s. After experiencing several problems with space and ambient noise, the concert hall left the Born neighborhood and opened in a new space in the Barcelona neighborhood of Poble Nou, where it closed forever in 2001. Desigual is in one of the buildings of greatest historical value in Barcelona, so the remodeling had to be done very carefully.

The intention, according to Guixé, was to relocate the old staircase because it blocked the entrance. The double wall that acted as an acoustic barrier was also eliminated, gaining five feet (one-and-one-half meters) on the inside perimeter.

The resulting space is divided into two distinct areas, a white area for showing the collections and a dark blue perimeter composed of lattice windows. This is where the changing rooms are located, and also where part of the original structure of Zeleste is preserved. Recurring elements such as press clippings about the most famous moments of the music hall put the clothing in the context of the building's celebrated past.

In the hall that leads to the interior of the store is an assortment of clothing that is visibly nailed to the wall, an approach that will definitely capture the attention of visitors. At the end of the hall, in a separate room, Martí Guixé provides a camera so that customers can record a video up to a minute-and-a-half long with their views on the temporary installation.

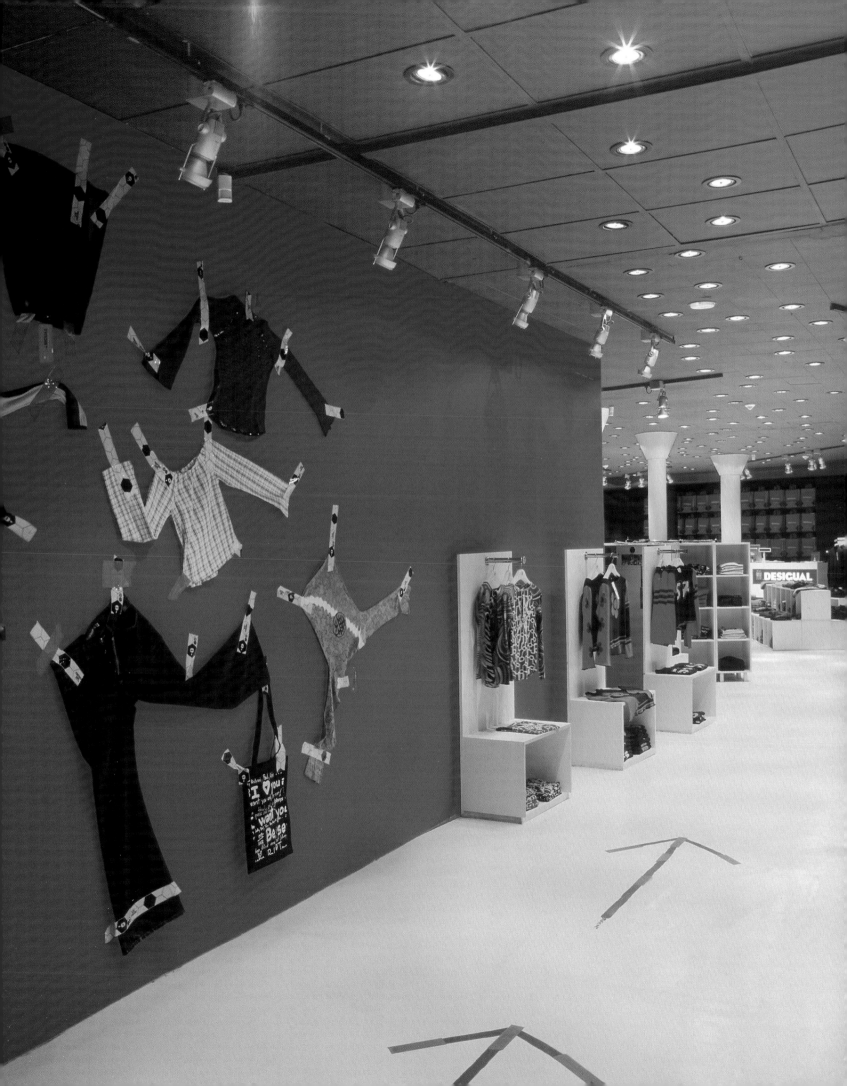

clothes

DESIGUAL
BARCELONA

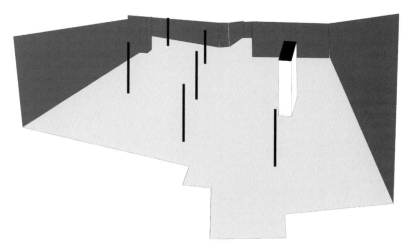

The space is divided into two different areas: a white one for displaying the clothing and a dark blue one for the fitting rooms.

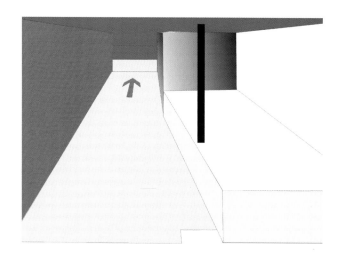

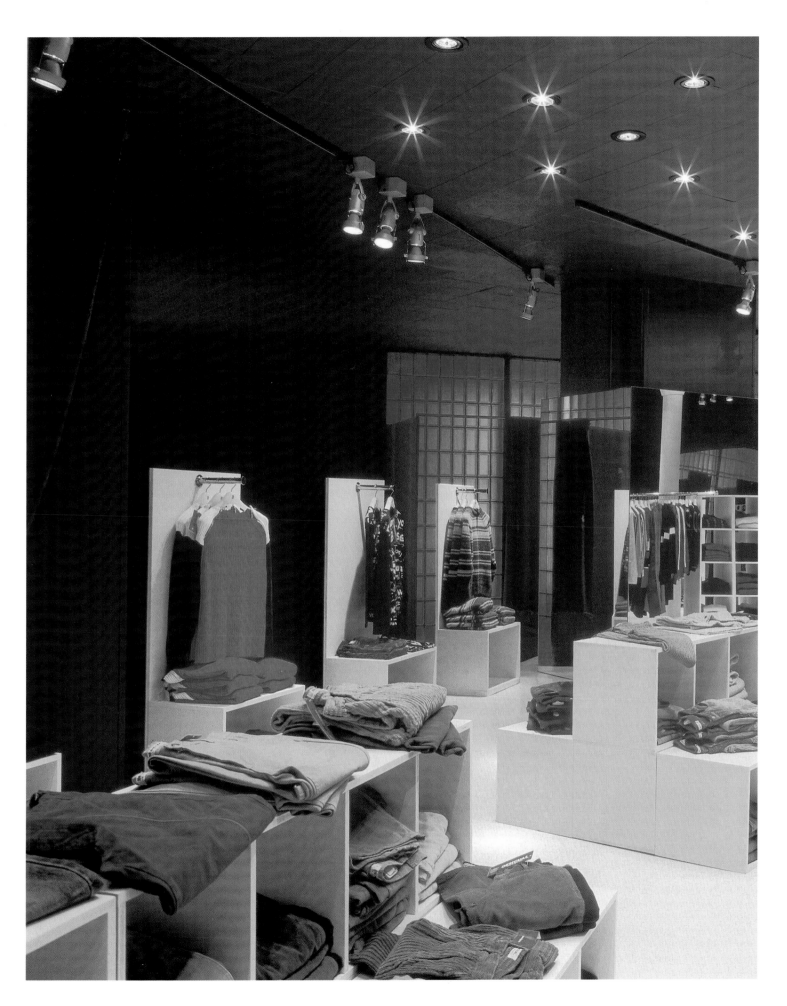

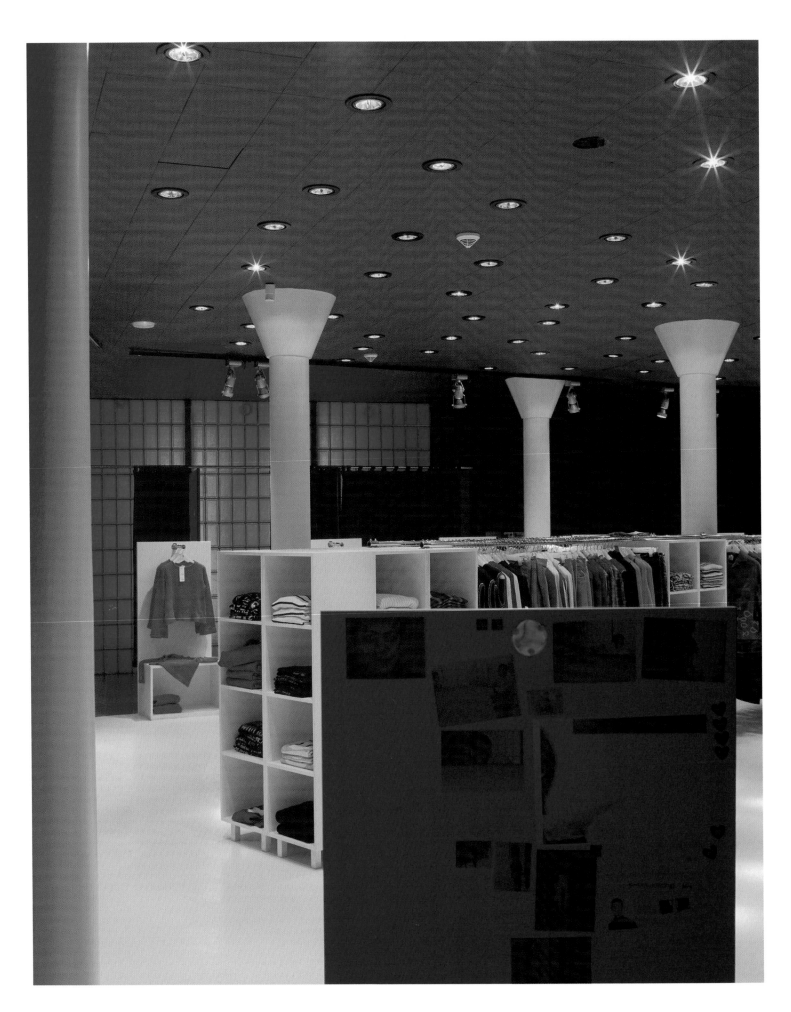

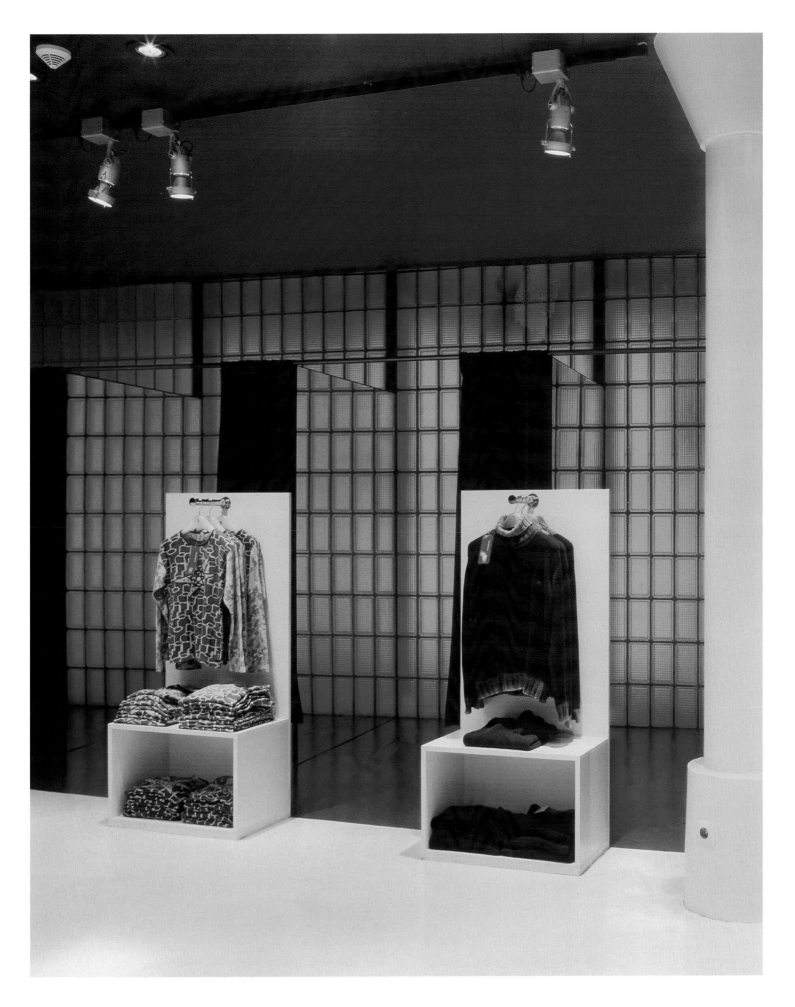

GIORGIO ARMANI

Designer: **Claudio Silvestrin Architects**
Photographer: **James Morris**
Location: **London, UK**
Opening date: **2003**

It has become the norm in recent years for the big names in fashion to entrust the design of their commercial spaces to prestigious architects. For a new store recently opened in London, Giorgio Armani selected Claudio Silvestrin Architects, who were also responsible for Armani stores in Milan, Paris, Sao Paulo, Costa Mesa, Moscow, Hong Kong, and Vienna.

The international image of the Armani stores is a transcendent Minimalism, which achieves great elegance by using natural materials such as limestone from St. Maximin and Macassar ebony. The design of the entrance and the stairway follow the basic concept of the design of the store itself. Claudio Silvestrin created a pristine space, with linear and proportioned surfaces. The interior makes use of the natural light that flows in through openings in the quiet architecture. According to the architect, the entrance becomes a poetic pause between the exterior and the display area for Armani's collections. In some of the stores, Claudio Silvestrin uses water as a symbolic element to create a magic space. In London, however, the architect preferred a more spiritual feeling, inspired by archaic and sacred sources.

Inside the store, each piece is displayed on a pristine canvas painted with a color palette of neutral tones. The result is a space where the majesty of the Armani collections blends with the elegance of the architecture.

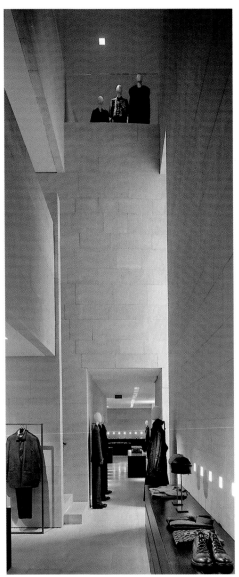

clothes

The monumental space allows the collections to be exhibited as if they were actual works of art in a museum.

Basement plan

Longitudinal Section

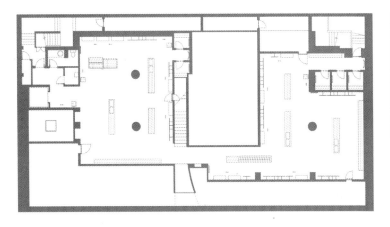

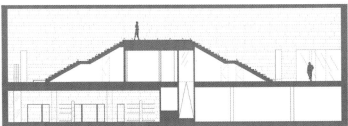

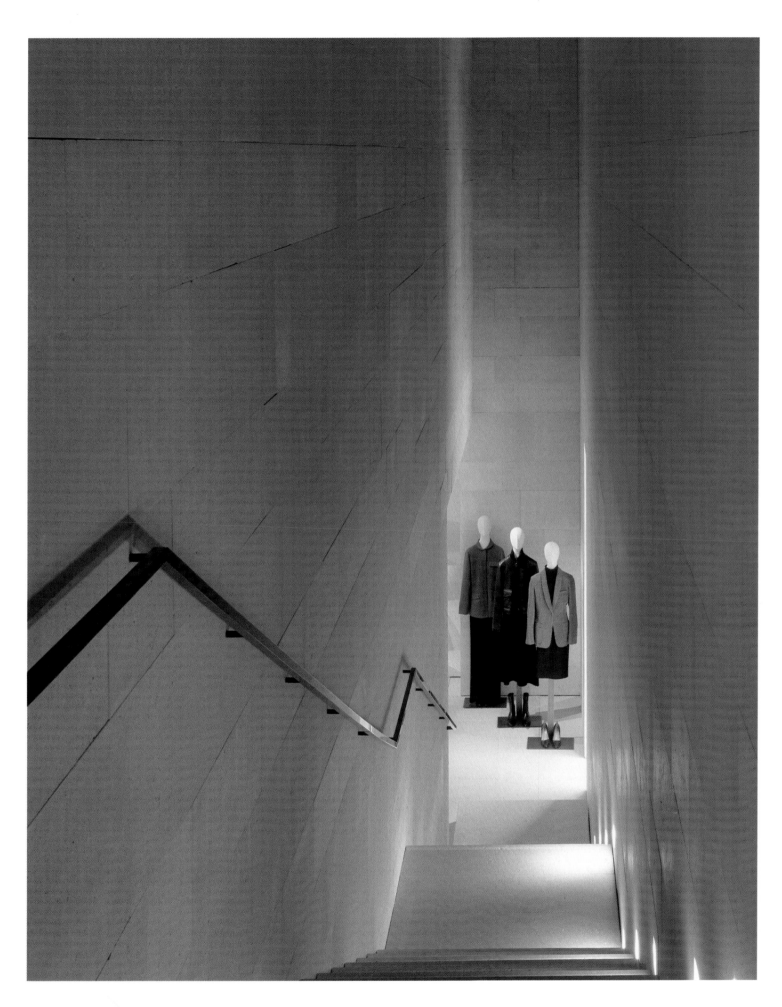

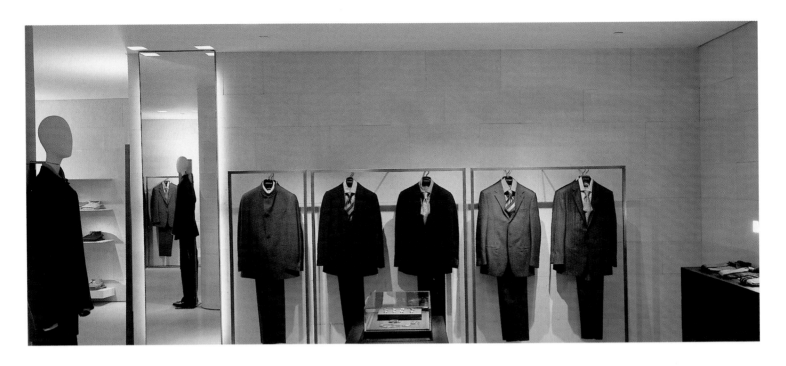

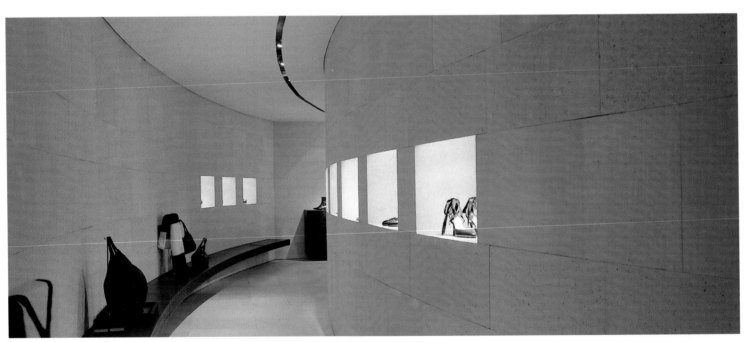

Each space in the store is the result of the perfect fusion of Armani elegance and rational architecture.

The architectural space takes full advantage of natural light, although there are light fixtures and an occasional piece lighted from behind.

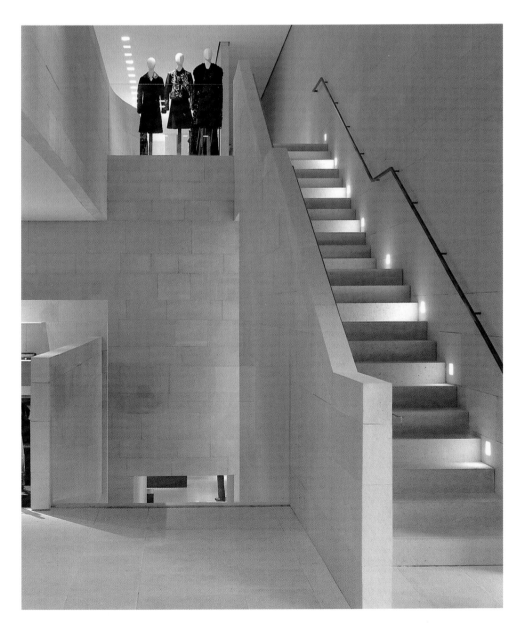

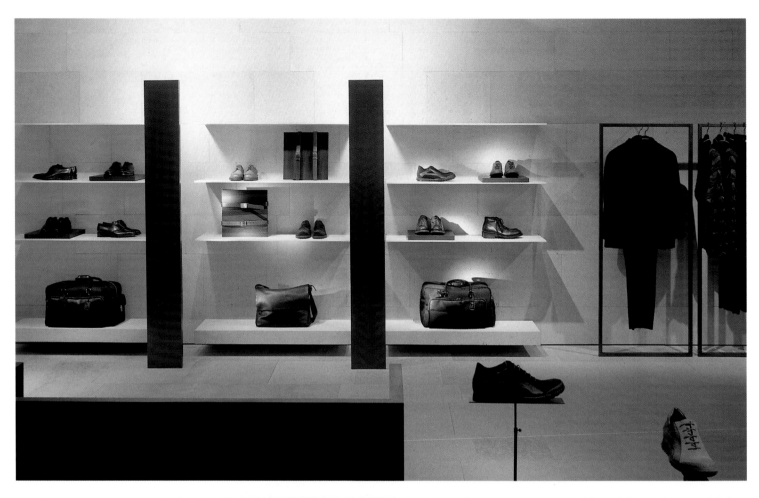

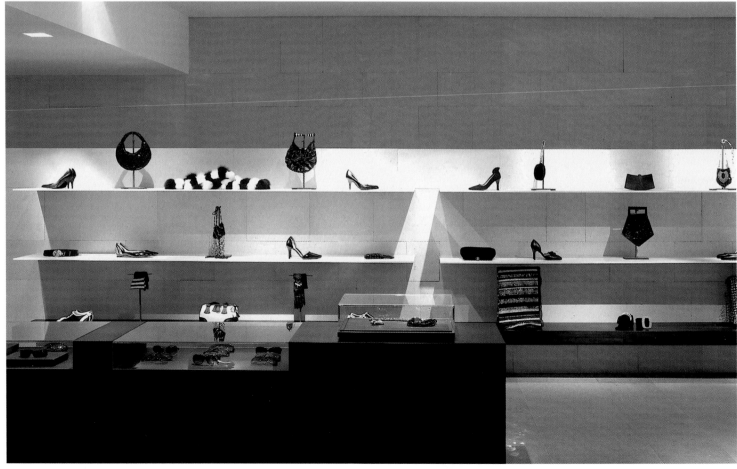

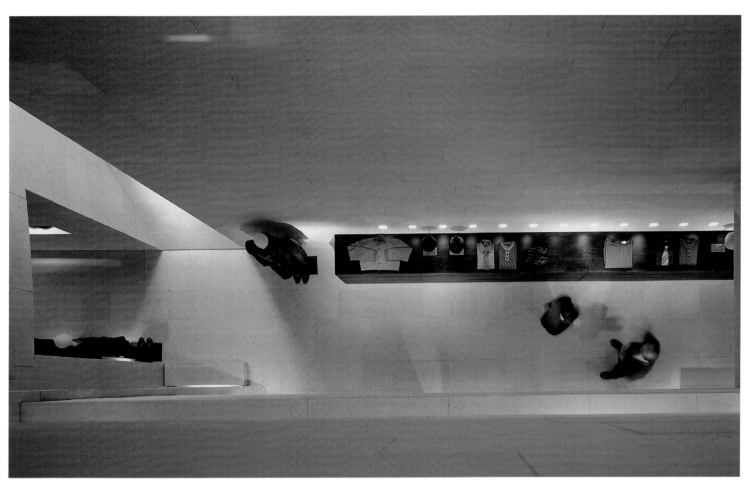

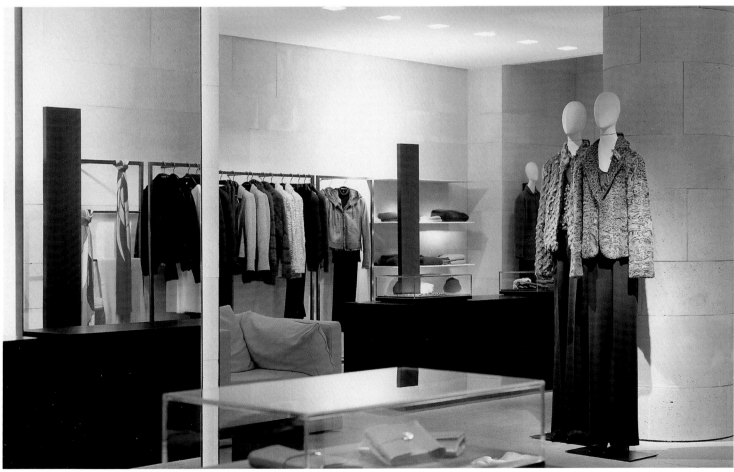

BELLUCCI

Designer: **Studio 63 Associati**
Photographer: **Yael Pincus**
Location: **Grosseto, Italy**
Opening date: **2003**

Bellucci, located in the historic center of the Italian city of Grosseto, is certainly one example of the new interiors that stand out for their conceptual diversity. With this project, Studio 63 Associati reveals its fascination with the flexibility of the interior.

In the design of this space, Studio 63 experimented with geometric forms and volumes with the intention of creating a daring and feminine space. Examples of this are the red and white spheres sunk into the floor that enliven the color of the shirts exhibited in the displays.

Using a Futurist aesthetic similar to that of the 1970s, Studio 63 attempts to challenge viewers and avoids a cold, neutral interior.

Creating a feminine atmosphere with the clothing displayed means that attention must be paid to the materials and colors of the store. Sensual materials with transparent qualities were chosen in the three colors that are mixed in the interior: red, black, and white. In the changing area, the baroque details of the curtains and lamps suggest a new romantic style that has reemerged in recent years.

In the central area, where the counter is located, an enormous red circular rug echoes the elements embedded in the floor. However, the detail that invites visitors to enter the store is the illuminated staircase. It allows a customer to enter and shop at Bellucci while feeling like the star of a glamorous and beautiful movie.

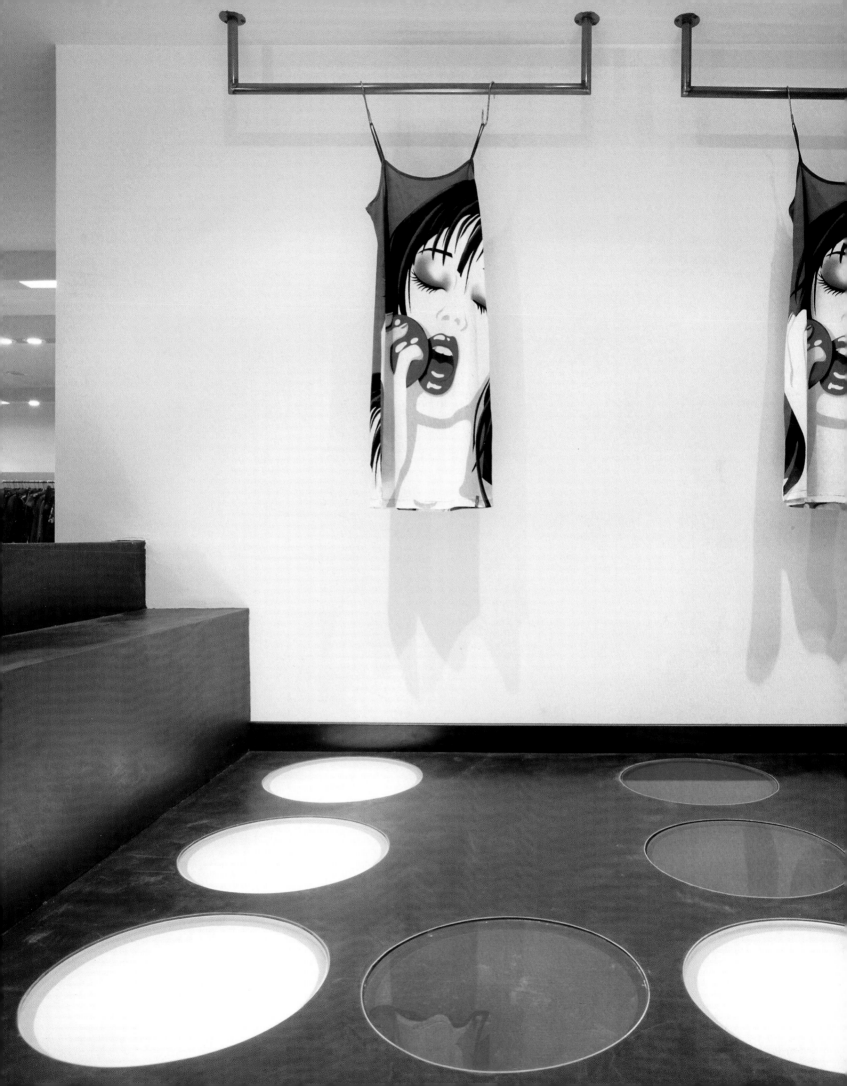

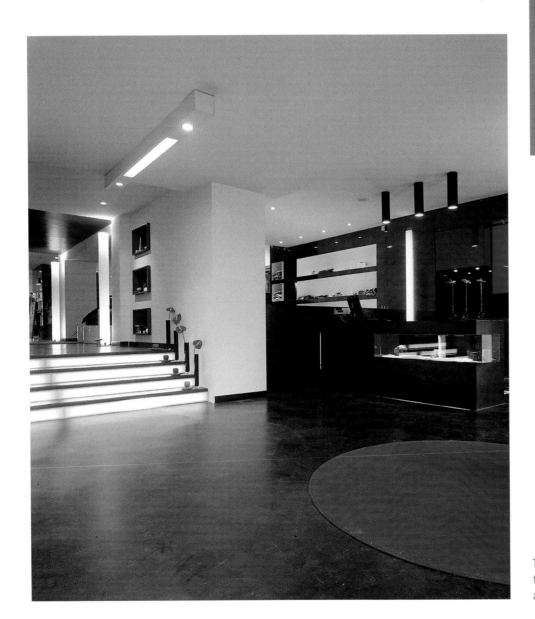

clothes

The architectural characteristics of the space allow for a generous distribution of the different display areas.

Floor plan

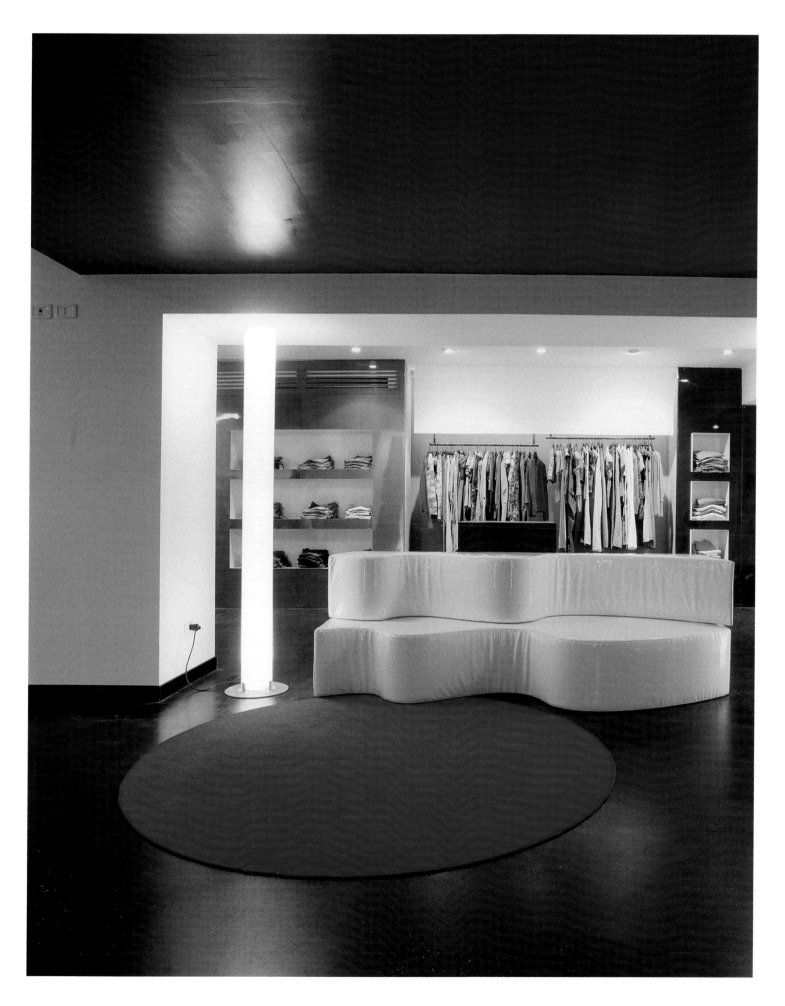

The linearity and geometry of the display elements contrast with the romantic style of the fitting rooms.

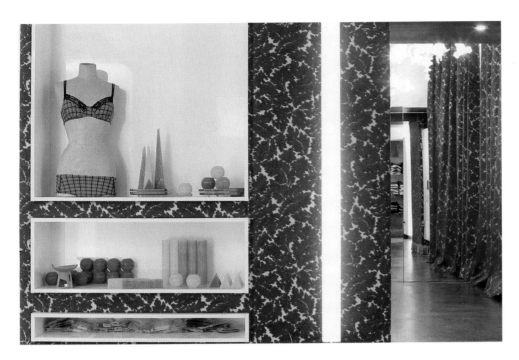

Renaissance-style curtains lend a completely different look to the fitting room area.

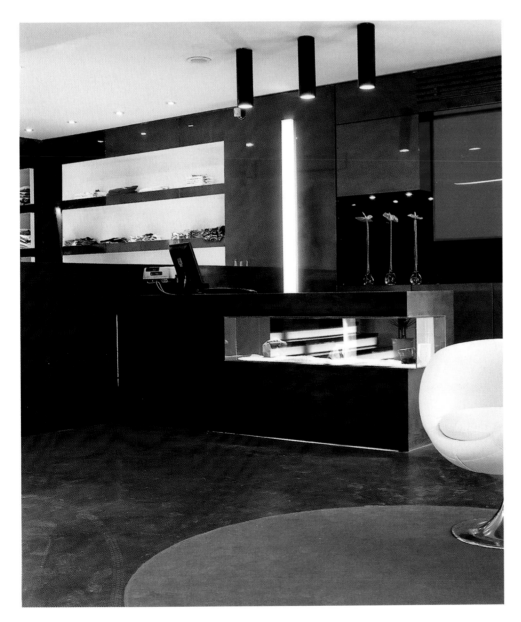

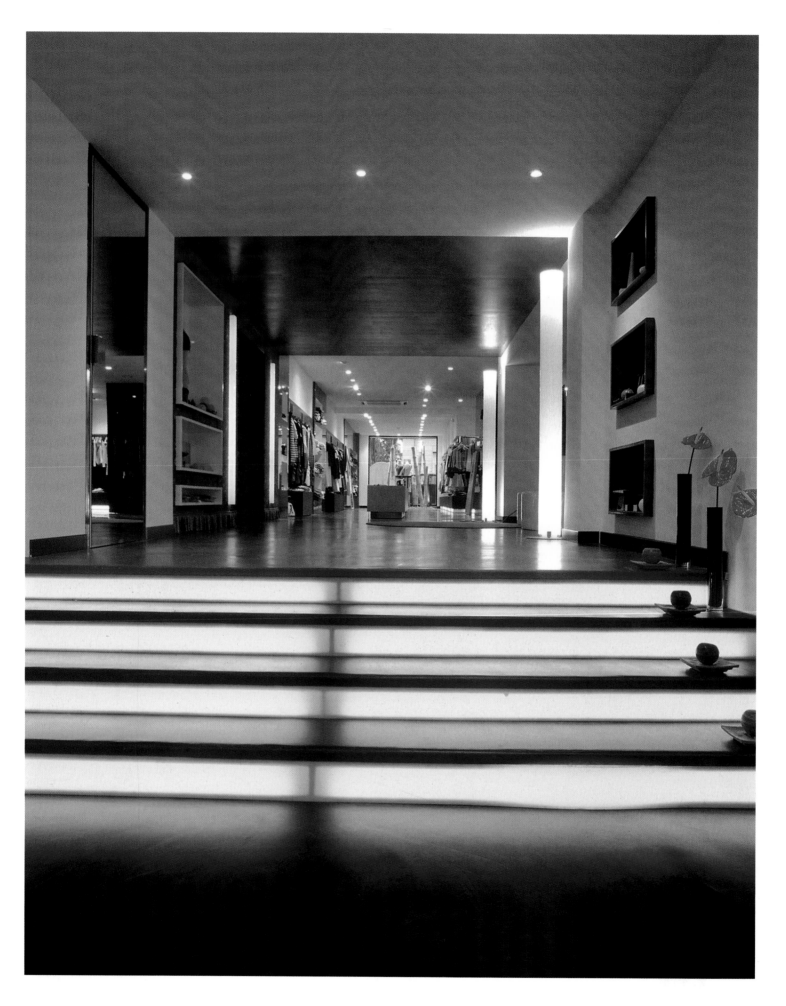

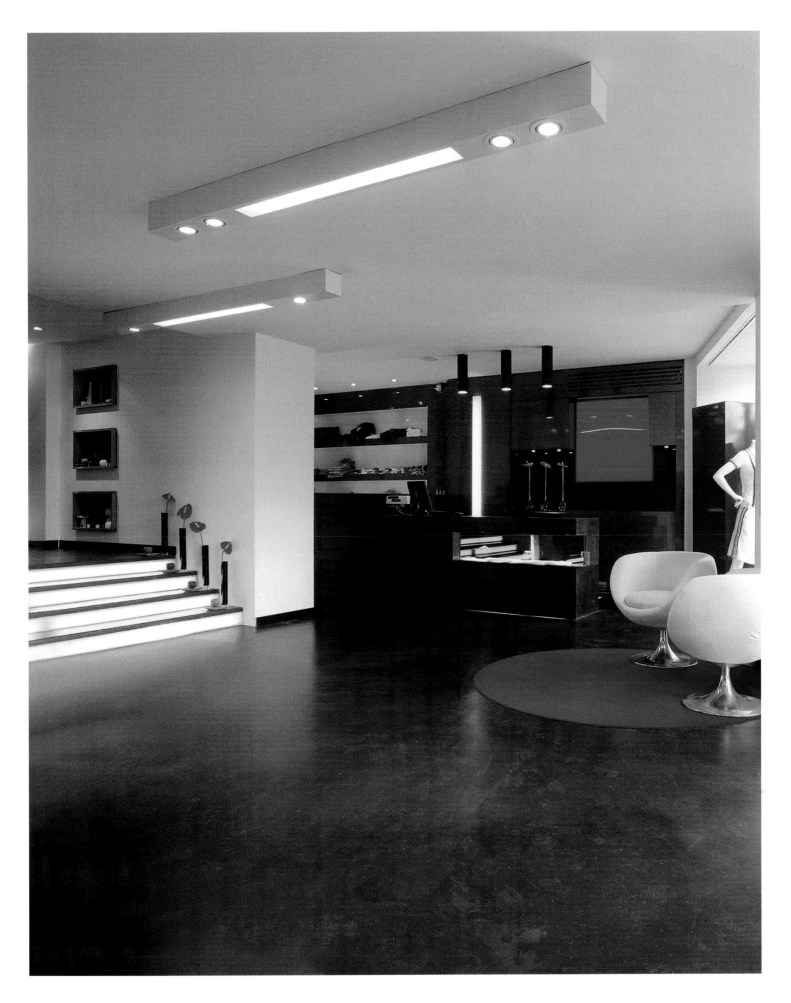

M-PREMIER

Designer: **Fumita Design Office**
Photographer: **Nacása & Partners Inc.**
Location: **Kyoto, Japan**
Opening date: **2003**

The world has changed with the new century, and with it the tastes of a demanding society that clamors for new approaches. After the Minimalist phenomenon at the end of the 1980s there was still a taste for openness, for space with simple ornamentation. The architects of Fumita Design Office made use of this concept in M-Premier, a store located in the Japanese city of Kyoto.

Following the guidelines of the Minimalist aesthetic, Fumita Design Office created an interior based on simplicity, the elegance of pure lines, and transparent materials, where each piece plays its part within the whole. Dominated by a collection of white jackets, the soft-colored clothing that is displayed becomes an element that visually ties the structure to the fixtures.

Building upon the simplicity of Minimalism, the commercial strategy of this space consists of attracting customers to an interior that is elegant and subdued, where each piece stands out for its own distinctive design. Fumita Design Office suspended from the ceiling several luminous panels, which double as hangers to show the latest seasonal collections. Complementing the display area are glass fixtures exhibiting some of M-Premier's pieces.

The architects considered the lighting to be one of the key aspects of the project. From the outside, a lucid interior can be seen through the all-glass façade, the transparent light coming from strategically placed light fixtures. The use of cool materials such as stainless steel, mixed with transparent surfaces, achieves an effect of brightness and great visual lightness in the space.

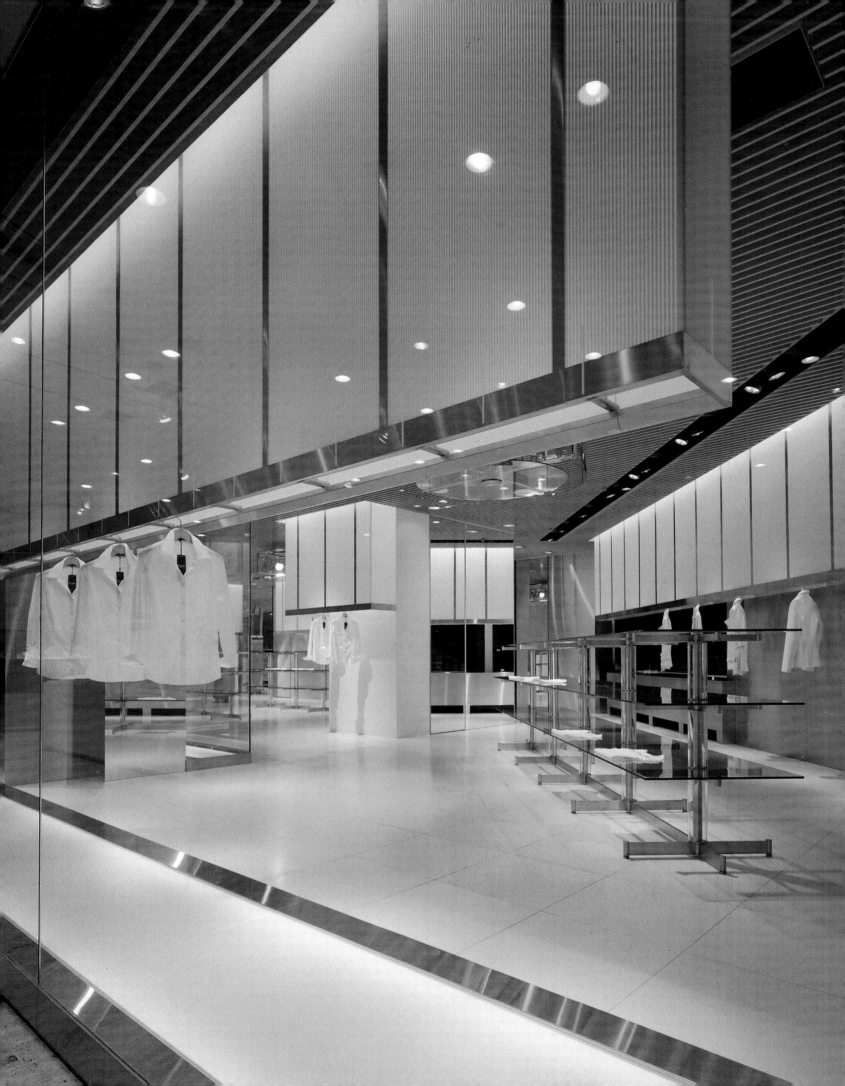

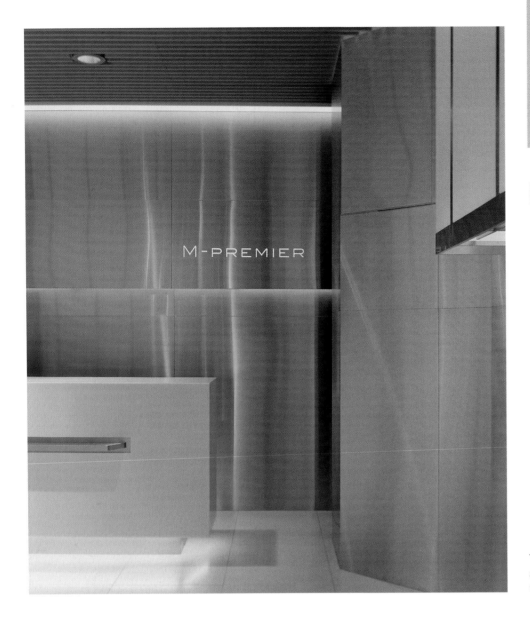

M-PREMIER

The stainless steel wall with the store's logo attached to it reflects the coolness and austerity of the pieces on display.

Floor plan

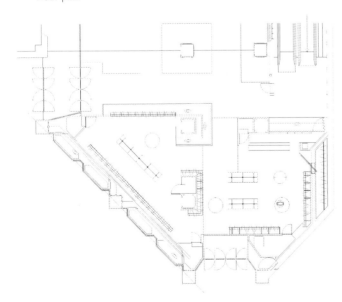

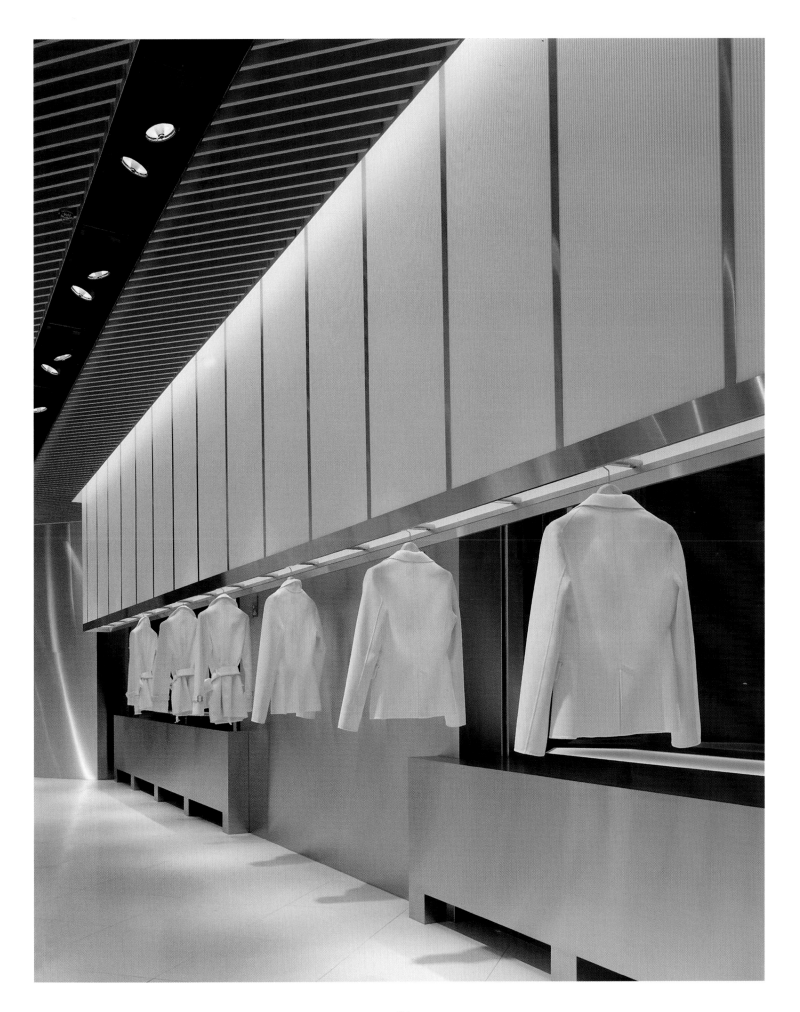

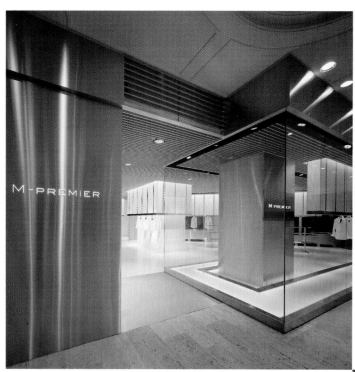

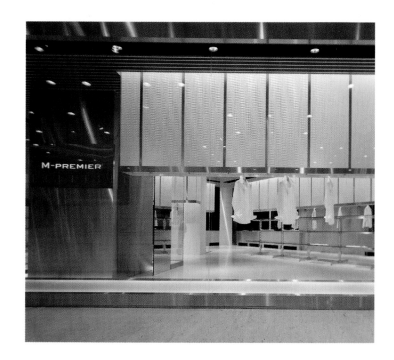

Because of the well-designed lighting, the seemingly transparent interior can be seen through the front glass window.

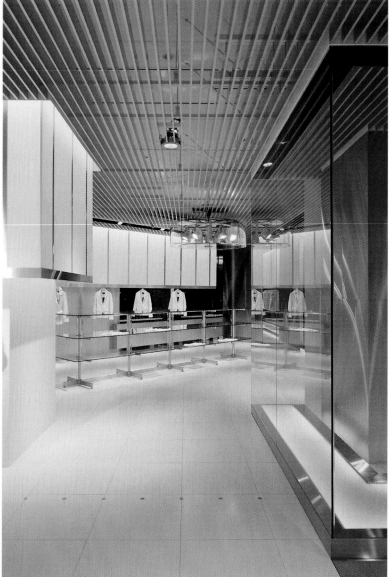

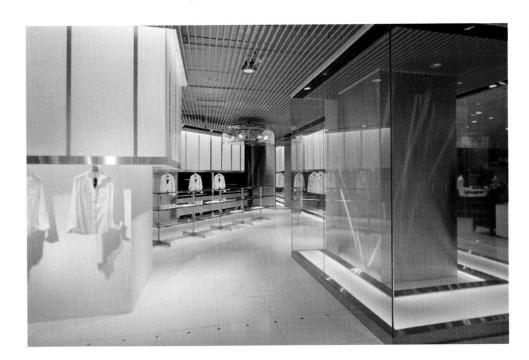

Luminous panels suspended from the ceiling act as
hangers while also lighting the displayed clothing.

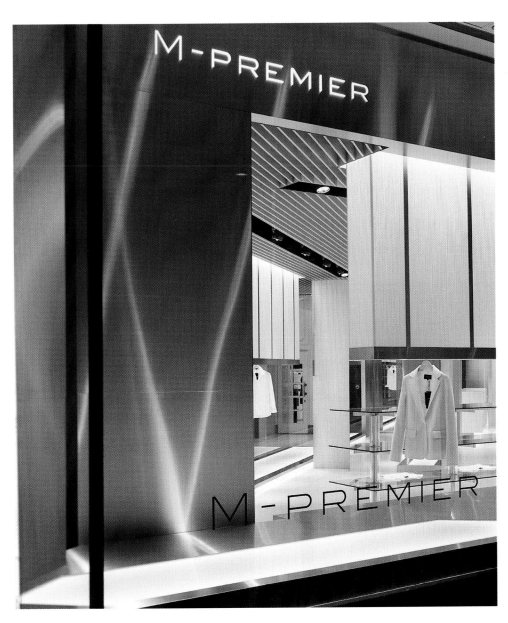

ISSEY MIYAKE / NEW YORK

Designer: **G Tects LLC and Frank O. Gehry**
Photographer: **Roger Casas**
Location: **New York, USA**
Opening date: **2001**

A redefinition of commercial spaces took place in the new Issey Miyake store in Manhattan, where Gordon Kipping, from the studio G Tects LLC, and Frank O. Gehry, revolutionized the concept as it had been developed up to that moment.

Conceived as the flagship store of Issey Miyake, the designer's entire collection is on display in the interior. Canadian Gordon Kipping was charged with carrying out the project and Gehry was responsible for the spectacular sculpture, "Tornado," that dominates the scene.

The intervention consisted of renovating an old warehouse from the late nineteenth century. The challenge was to develop a neutral space in which the clothing could "dance" with Gehry's sculpture. "Tornado" rises from the basement floor and flows through the entire store, following the lines of the staircase to the ground floor in a manner that links the two display areas. Gehry created the piece with 1/64-inch-thick (0.4 mm) titanium panels that are attached to the frame with Velcro, and to each other with adhesive tape.

Besides the selling space, Kipping designed the interior offices, workshops, art gallery, and storeroom that occupy 5,760 square feet (535 m^2) and are distributed throughout three floors. The first showroom is located in the central space, the area outlined in the floor with laminated glass. The art gallery, on the ground floor, is reserved for temporary exhibits of work by young artists, and it has a mural by Alejandro Gehry with daring drawings that emphasize the expressionism of the setting.

In the hands of Kipping and Gehry, the Issey Miyake store has become the standard-bearer of a new generation of interiors. The visitor can buy, as well as contemplate all of the work as if it were in a museum.

clothes

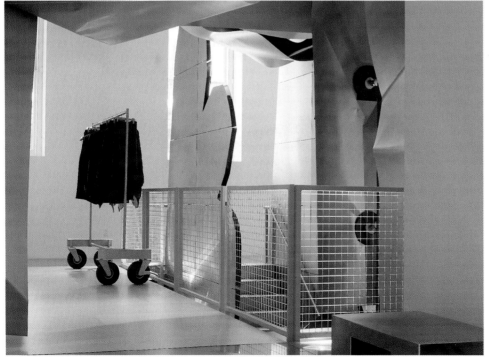

Mobile racks, which were designed for displaying the clothing, can be used to vary the layout of the space for seasonal changes.

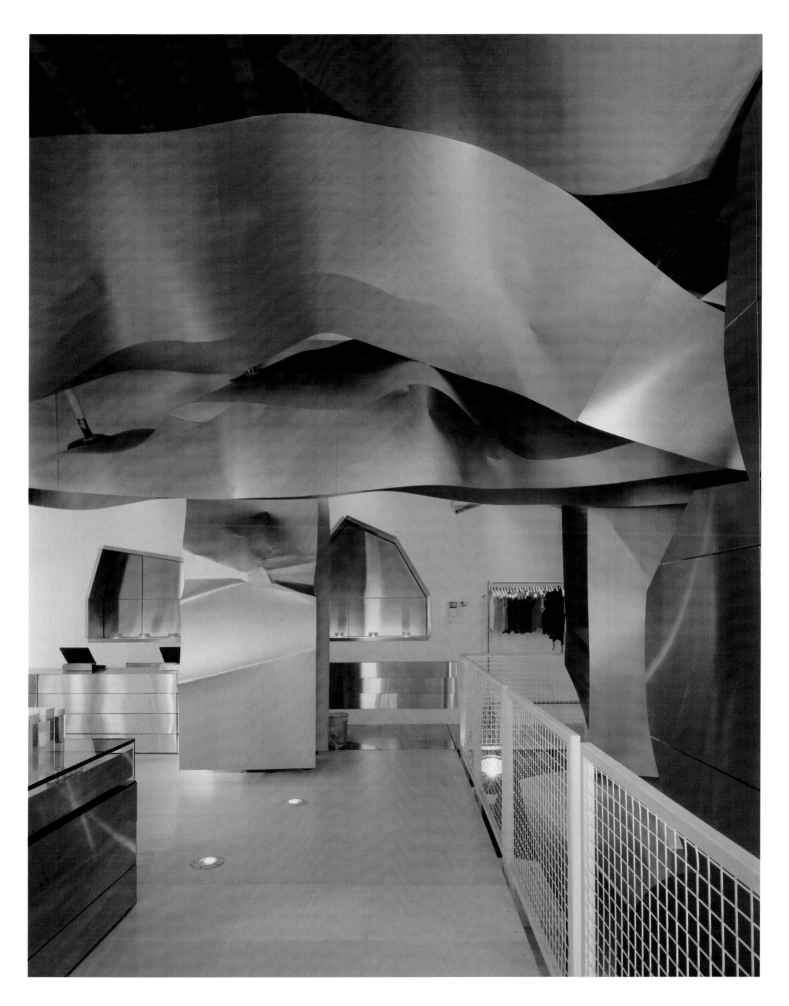

Gehry's sculpture is made of 1/64-inch-thick (0.4 mm) titanium panels that are attached to the structure with Velcro.

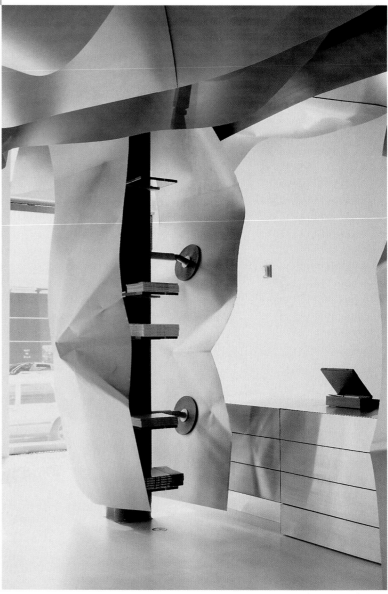

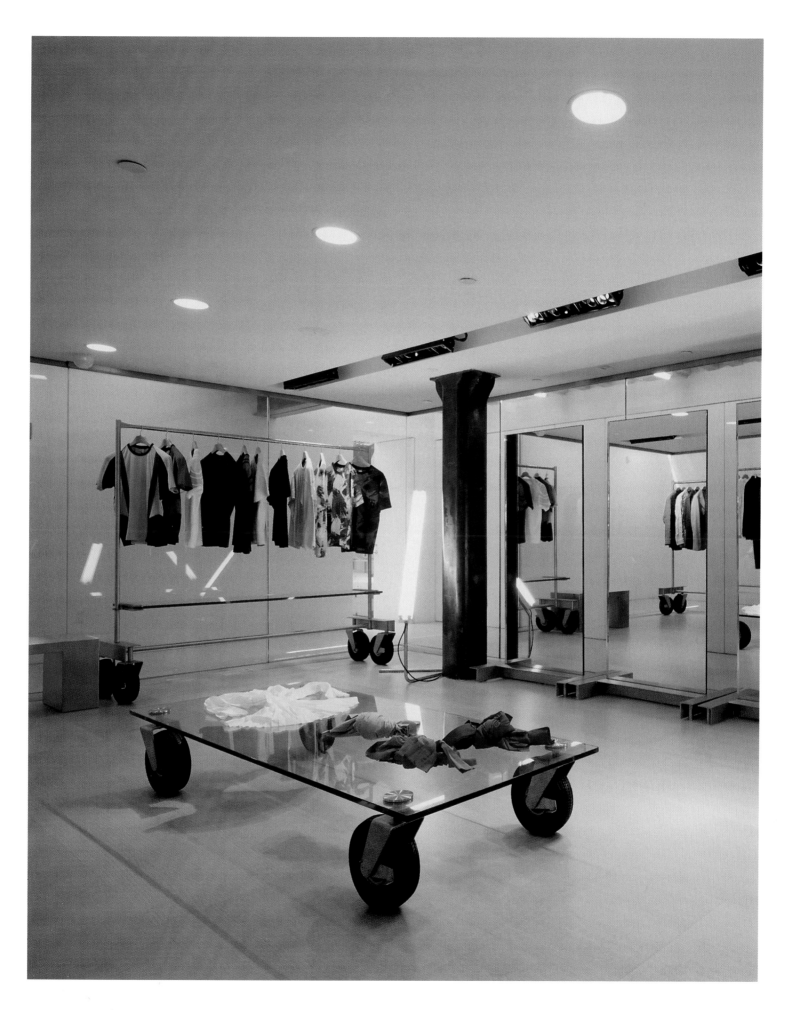

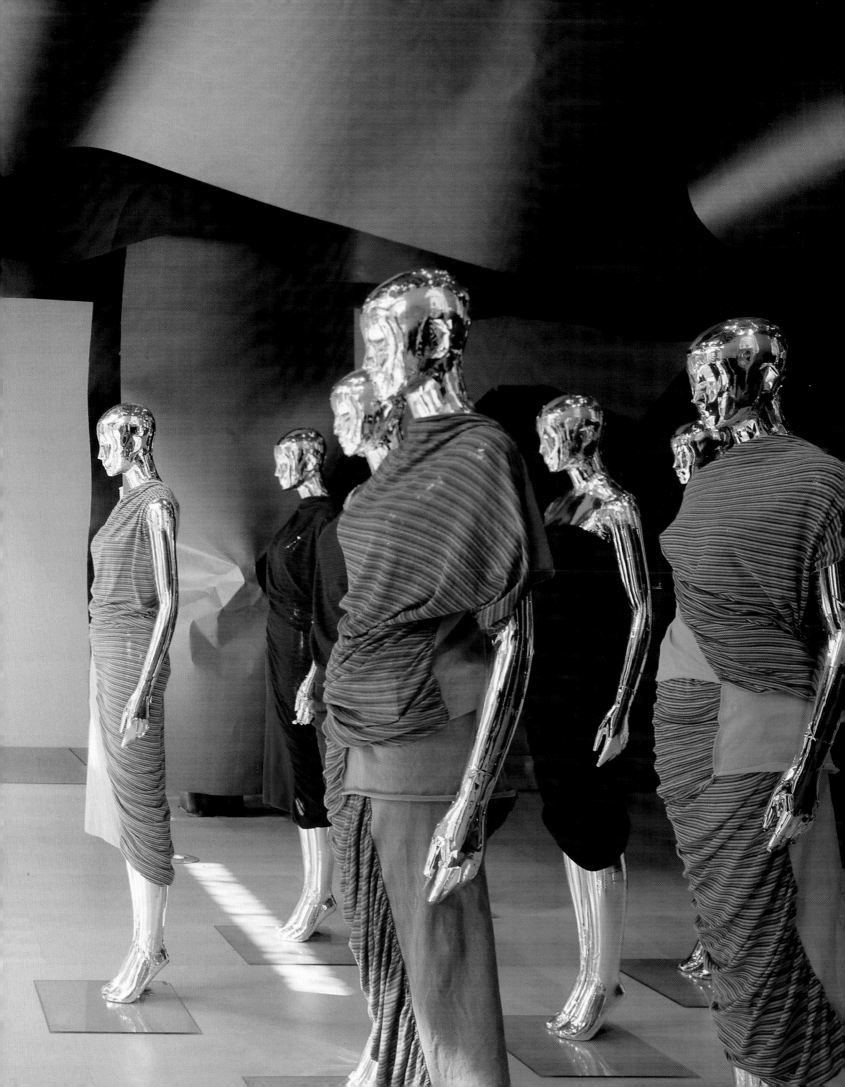

ME, ISSEY MIYAKE / TOKYO

Designer: **Curiosity**
Photographer: **Yasuaki Yoshinaga**
Location: **Tokyo, Japan**
Opening date: **2001**

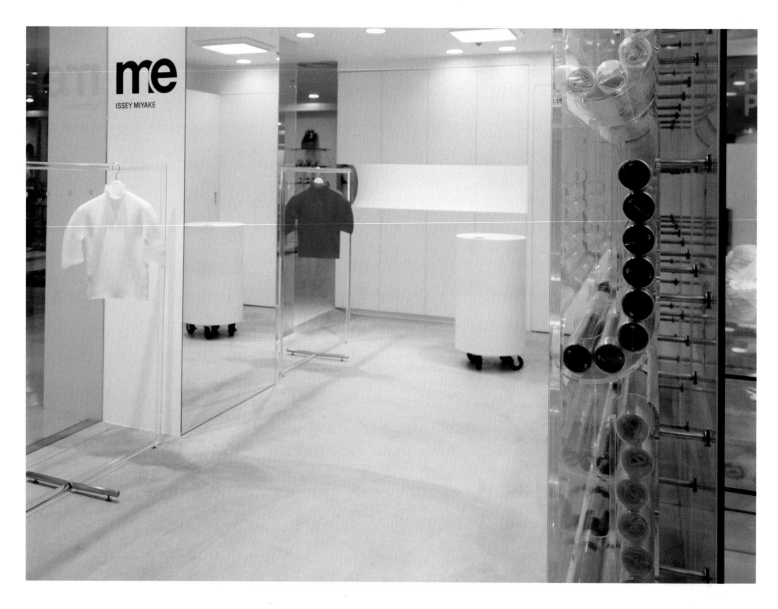

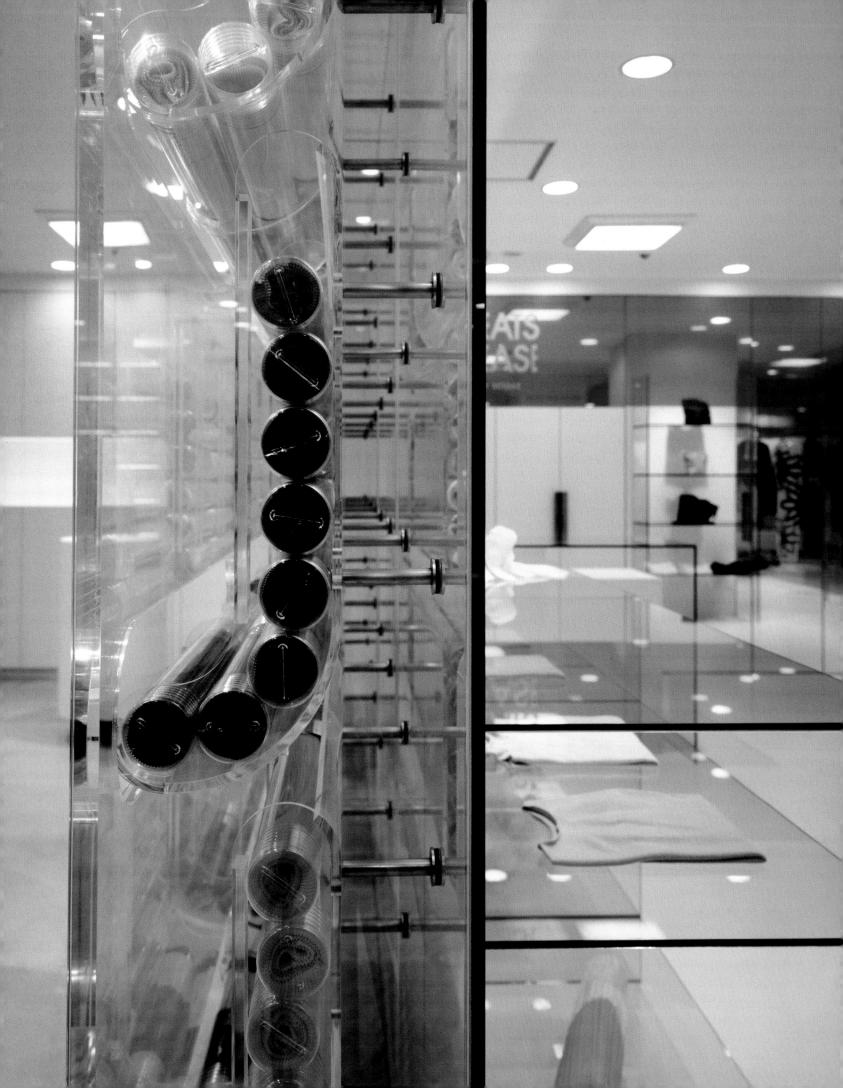

clothes

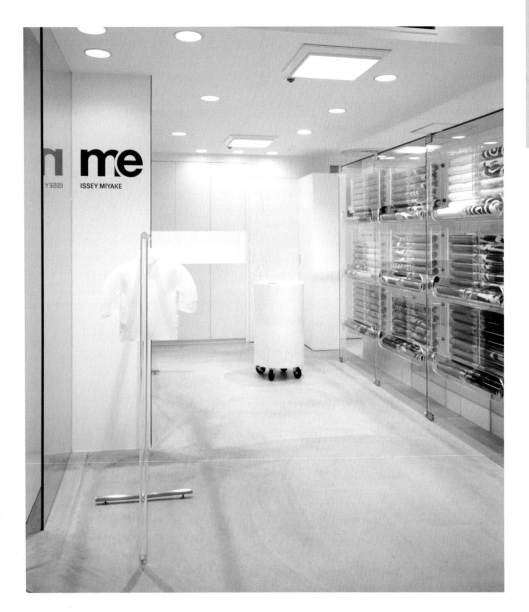

me

ISSEY MIYAKE

The interior is completely filled with light. Interior details, such as the shelves, were created from clear, transparent materials that appear weightless.

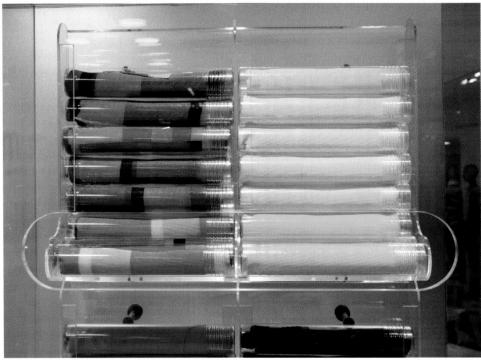

CHRISTIAN LACROIX

Designer: **Caps Architects**
Photographer: **Nacása and Partners Inc.**
Location: **Tokyo, Japan**
Opening date: **2001**

After doing several projects together, Christian Lacroix and architect Christophe Carpente of Caps Architects recently developed a new concept for the Christian Lacroix store in Tokyo.

The French fashion designer's store is a creative labyrinth, the fruit of an intense exchange of ideas with the architect. It is like a gallery, and the Lacroix collections are the main works of art in the setting, surrounded by different elements that emphasize their beauty. Paintings, photographs, and videos by contemporary artists (such as Delphine Kreuter, Nils Udo, Bernard Quesniaux, and Joel Bartolomeo), are liberally arranged among the multicolored glass prisms, summing up Lacroix's sensibility.

The guiding principle of this labyrinth is seen in the freely arranged furnishings, which differentiate it from other important brands that equate luxury with architecture that is often overloaded with cold details. The multicolored glass displays create a sensual labyrinth, which can be modified between collections by changing their dimensions and layout.

The various displays do not block the sight lines of the space; but rather, they create a play of colors that is synonymous with the work of Christian Lacroix. The transparent colors, the colorful bases, and the graphic freedom of the display fixtures can be seen from the outside through a 32-foot-high (10 m) façade decorated with Christian Lacroix's calligraphy.

The space is completed with ethnic references like rattan structures on the floor and Southeast Asian lobster pots. Baroque details alluding to the era of Napoleon III add a finishing touch.

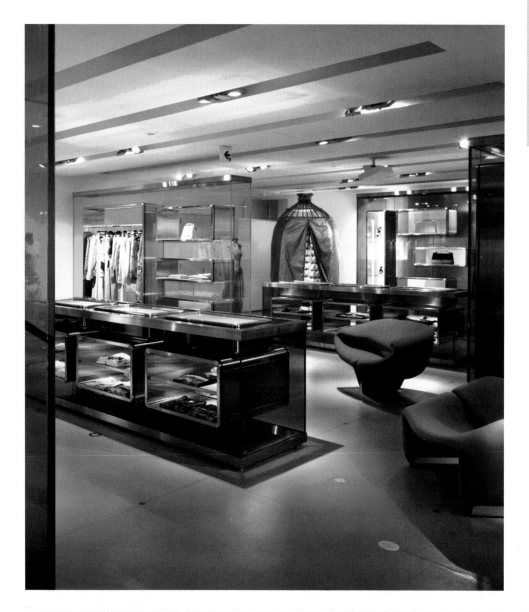

CHRISTIAN
LACROIX

Calligraphy designed by Christian Lacroix himself
covers the store's 32-foot-high (10 m) façade.

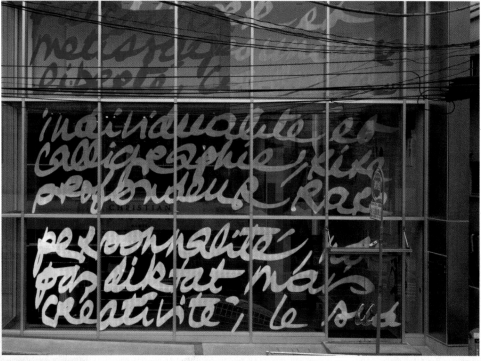

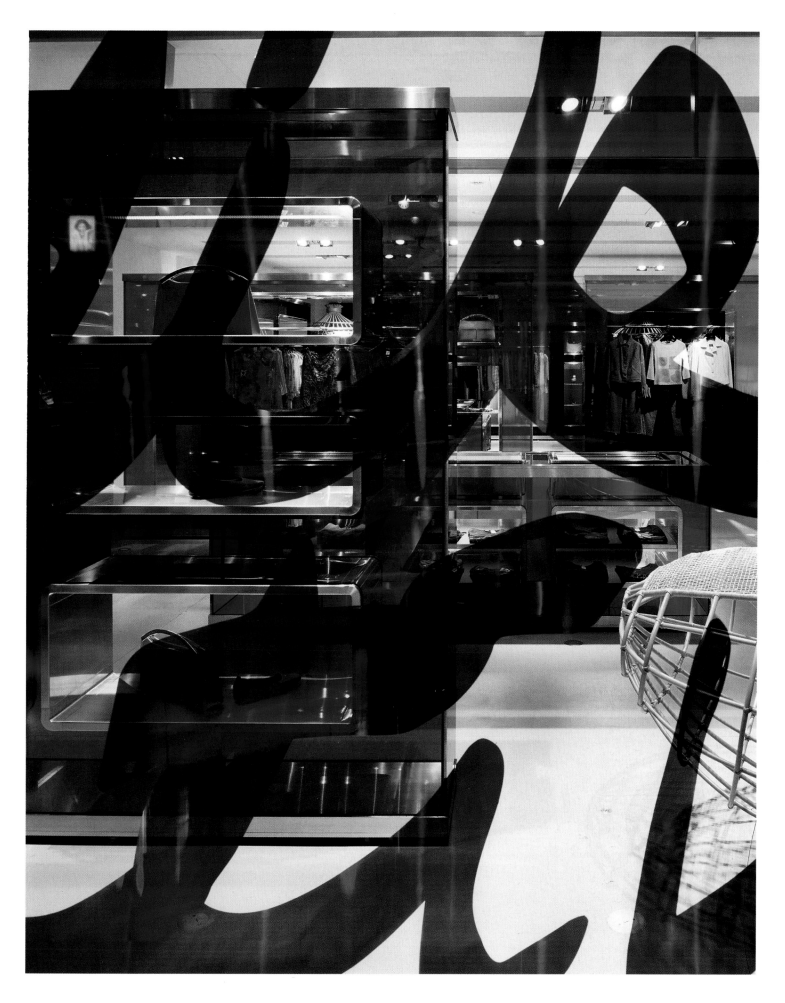

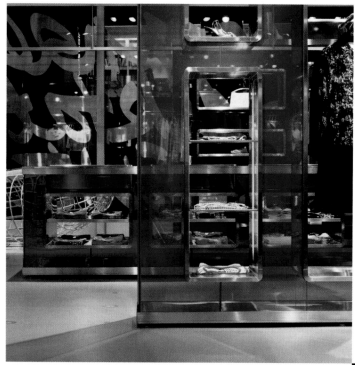

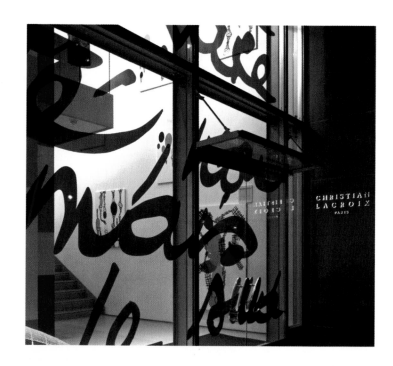

The glass displays that divide the space are mobile pieces that can be modified from one season to the next.

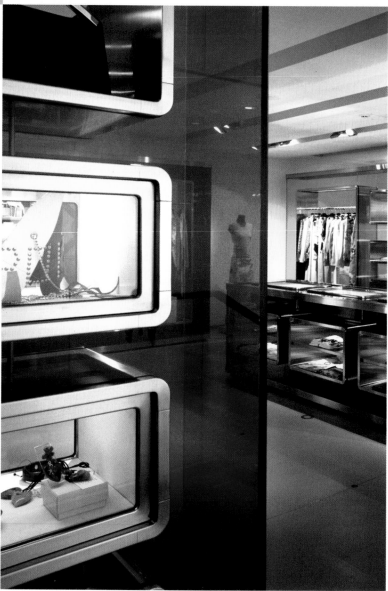

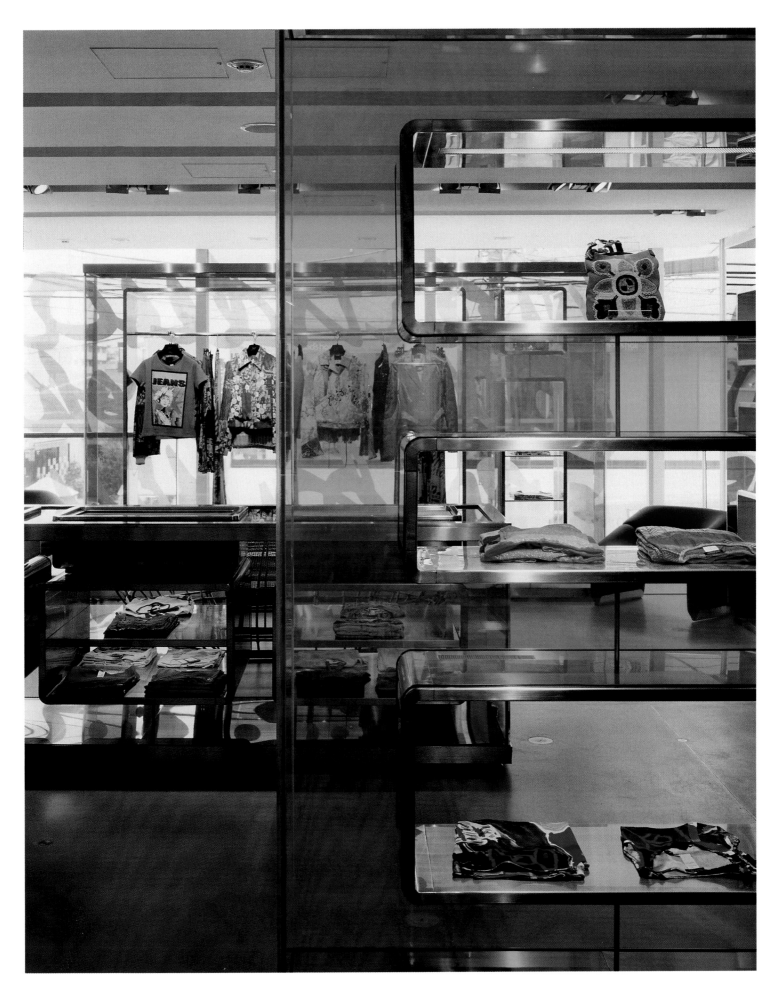

MARITHÉ + FRANÇOIS GIRBAUD

Designer: **1100 Architect**
Photographer: **Eric Laignel**
Location: **New York, USA**
Opening date: **2003**

 Spaces like the Marithé + François Girbaud store in New York often appear in times of change.

1100 architect, with the collaboration of Kristian Gavoille of Agence Mobile, designed Marithé and François Girbaud's flagship store in New York's Soho neighborhood. The store is located in a building with a metal structure, and the interior interacts with the purity and dynamism of Girbaud's designs. 1100 Architect chose to use transparent and fragile materials to emphasize the delicacy of each one of the displayed pieces. The walls rise to an angular, luminous ceiling that is reflected in the shiny resin floor. A ramp leads customers to the men's department, where the designs are displayed on translucent shelves, also made of resin. In contrast, the collections in the women's department are shown on stainless steel displays.

The interior of Marithé and François Girbaud is characterized by a sense of weightlessness. In the center of this floating and changing scene is a 270-square-foot (25 m²) garden designed by the French researcher Patrick Blanc. This landscape is uniquely composed of more than 250 species of tropical plants.

The simplicity of the lines and the transparency of this project adapt to each season, to each era, and to the tastes of whoever contemplates them. The result is a space that stimulates the individual sensations of each customer.

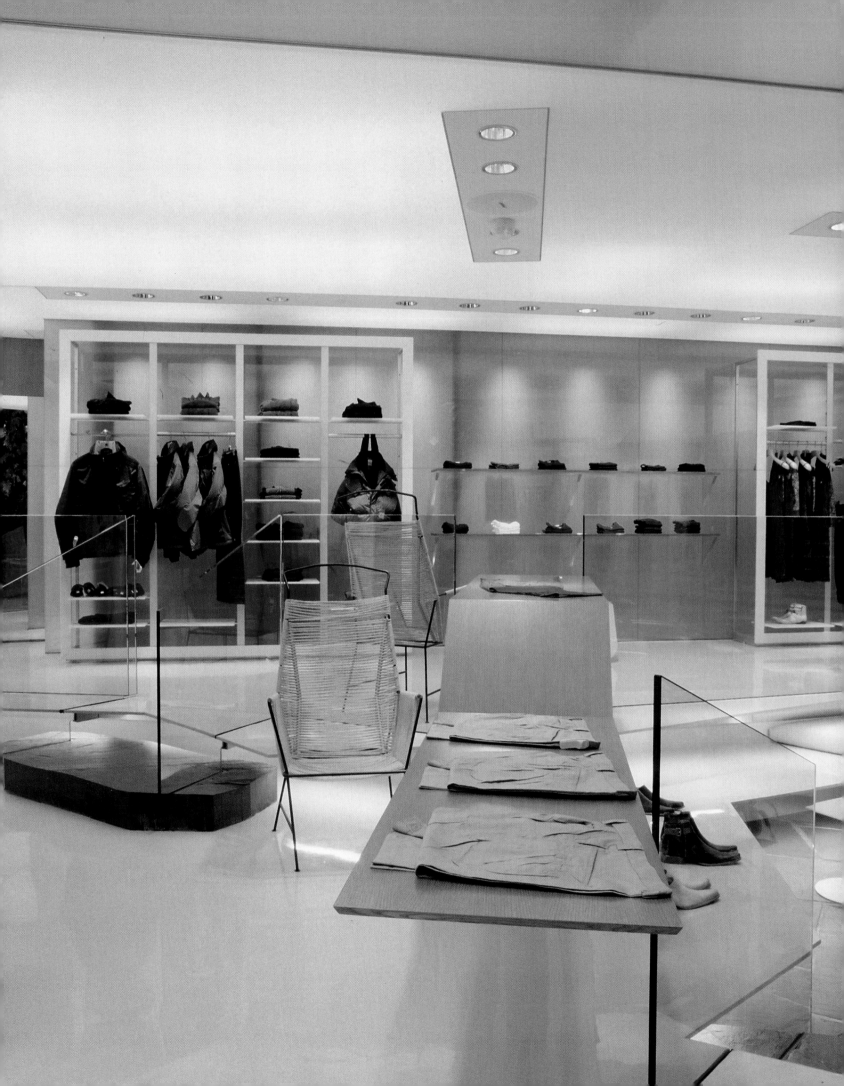

clothes

LE JEAN DE **MARITHÉ
FRANÇOIS
GIRBAUD**

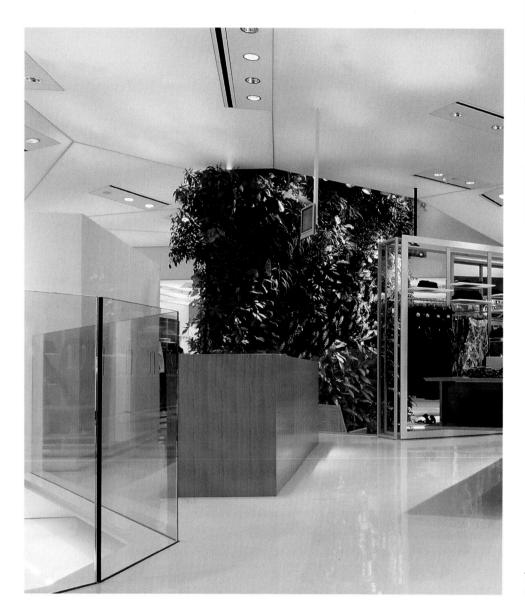

The bright resin floor, with a watery-like texture, reflects the ceiling and the surrounding walls.

Floor plan

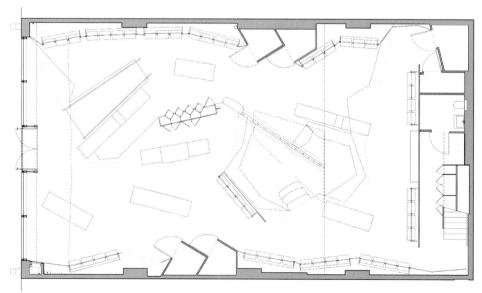

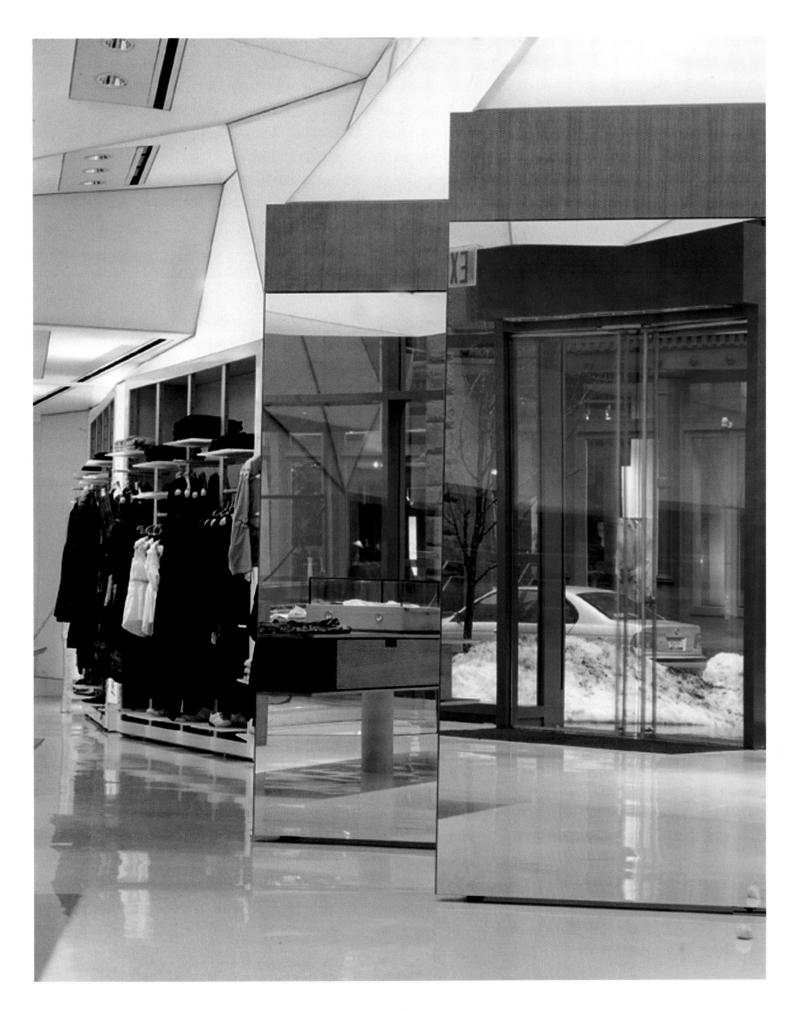

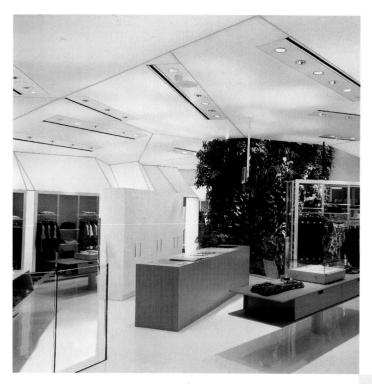

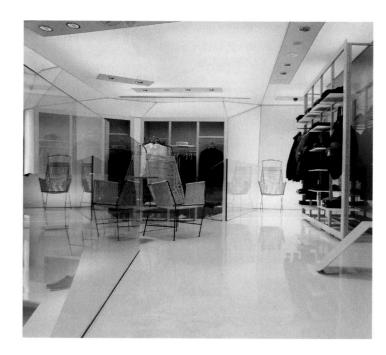

The linearity of the interior and the delicacy of the materials create a space that showcases each of the pieces on display.

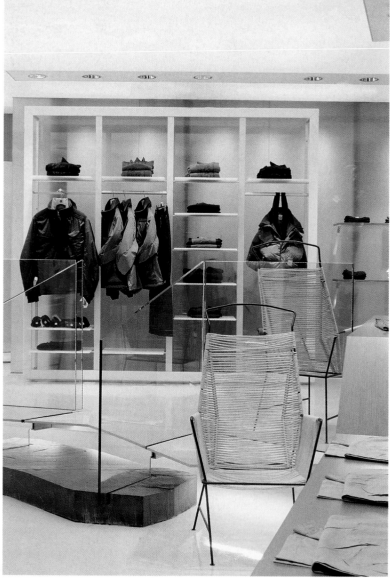

An interior garden, designed by the French landscape architect Patrick Blanc, has more than 250 different species of tropical plants.

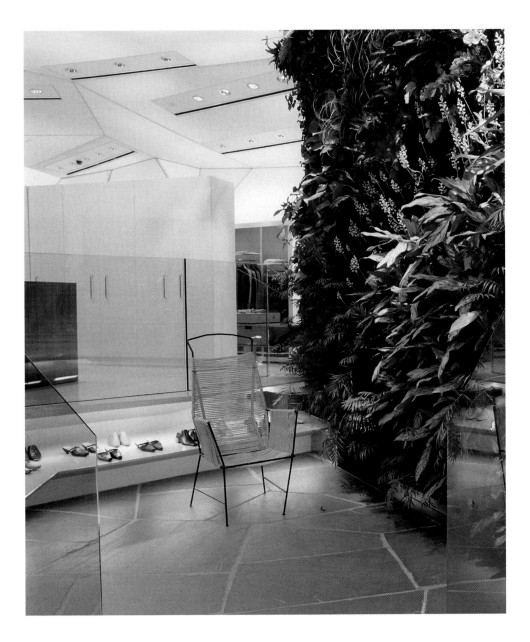

HARE

Designer: **OUT.DeSIGN**
Photographer: **Kozo Takayama**
Location: **Osaka, Japan**
Opening date: **2003**

Ill-defined architectural spaces often produce banal and insignificant design. This is not the case with Hare, a store designed by the Japanese team OUT.DeSIGN. The architects were conscious of how great an opportunity it was to work with a space of such dimensions, and they knew how to make full use of the structural details to develop a unique design. The structure of the store enhances the identity of each piece so that Hare's clothing stands out against an excellent background like a work of art on a canvas. OUT.DeSIGN proved its artfulness in choosing materials and their ability to combine different textures in the interior.

Taking advantage of the network of beams that crisscross the ceiling, OUT.DeSIGN designed an interior that contrasts the pure white of the walls with the roughness of the flooring and part of the ceiling. Among the beams that support the upper level of the store are lamps that hang from the ceiling like drops of water, illuminating the central area.

In the middle of the space, the combination of white and wood elements is even more evident. The design of the transparent white counters stands out against the natural wood parquet. Along the sides, the simple lines of the stainless steel clothes racks display part of the store's seasonal collection. The space appears nude to visitors, revealing to them its most natural state. However, warm materials such as the natural wood coverings, combined with the coolness of the white and the transparency of some materials add the feeling of well-being that is necessary for any commercial space.

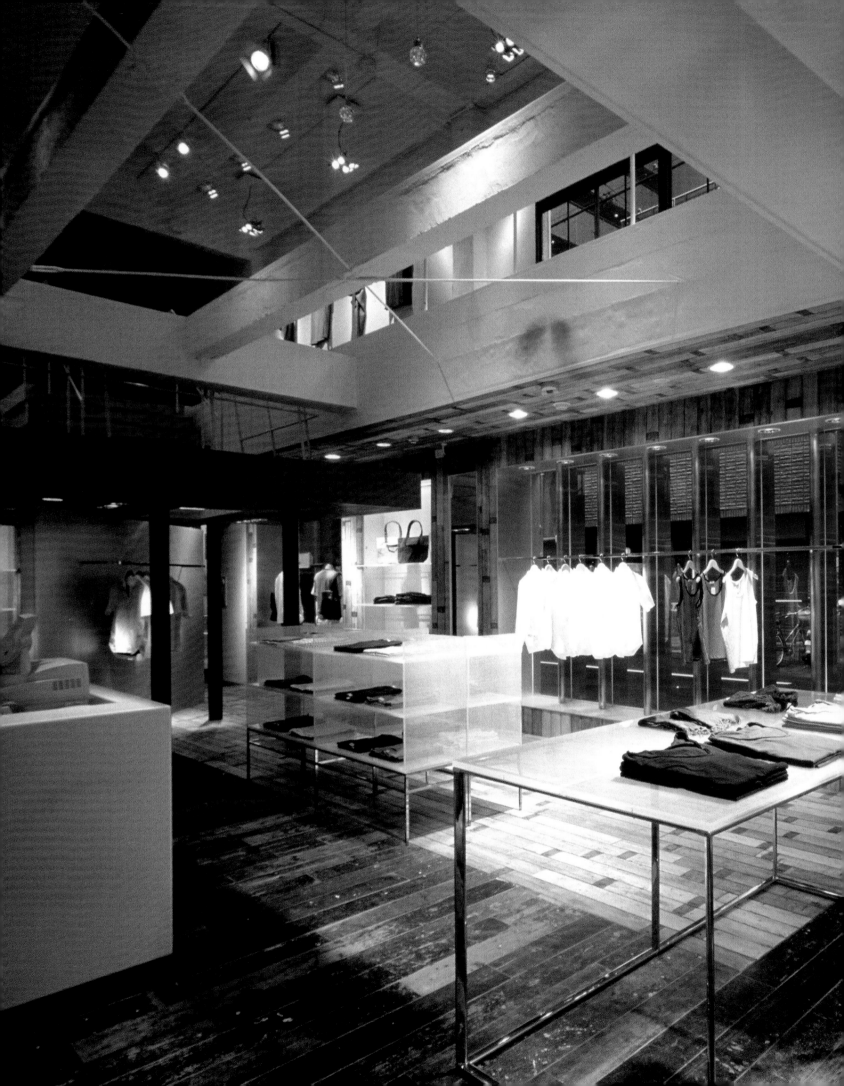

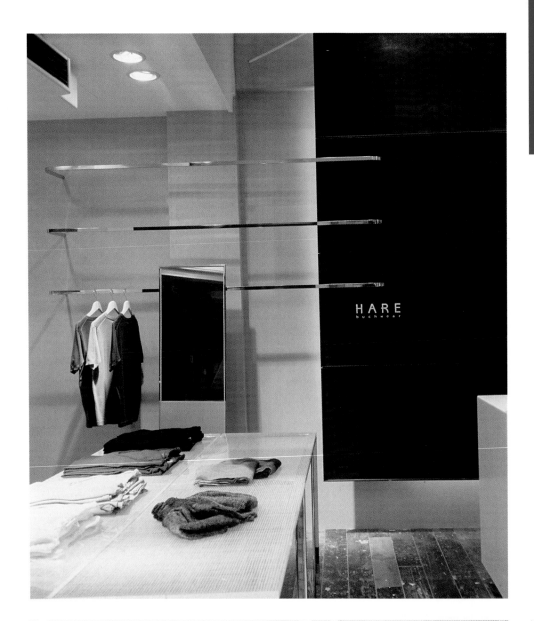

clothes

H A R E
b u c h w e a r

Warm materials such as the natural wood contrast with the purity of the glass surfaces.

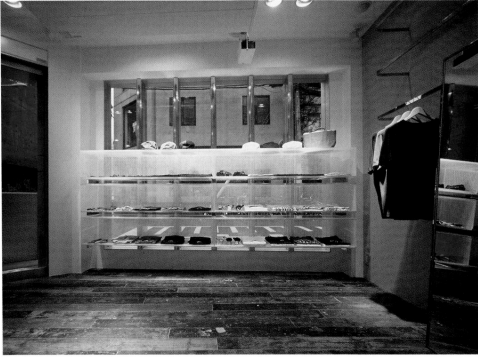

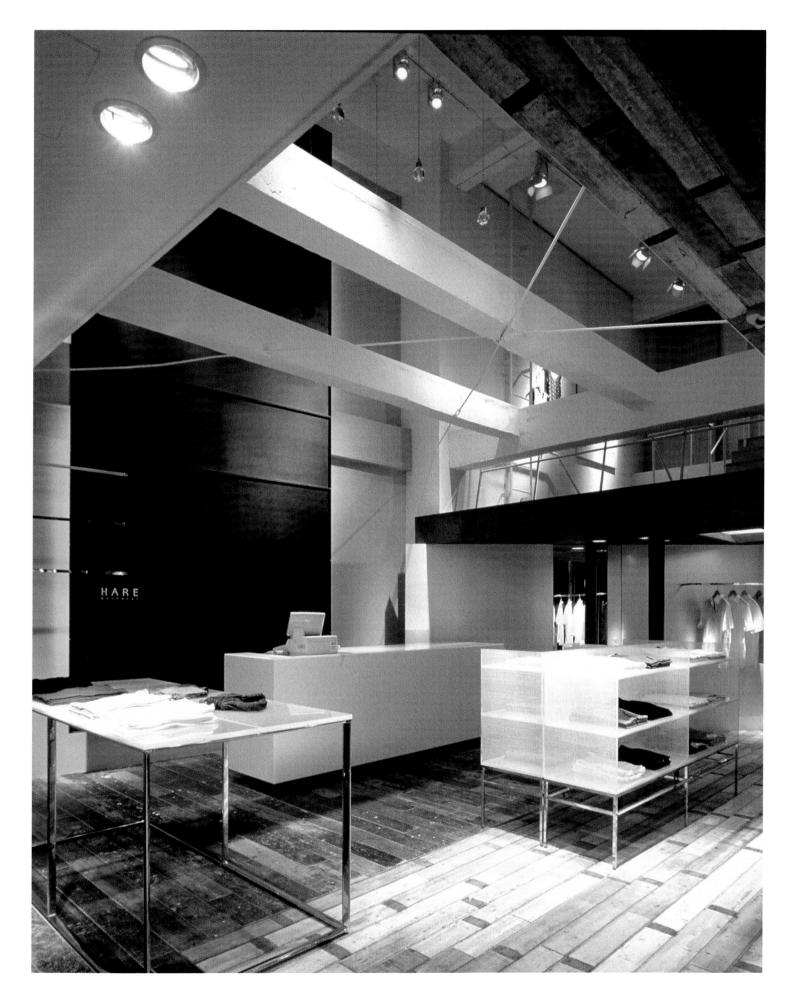

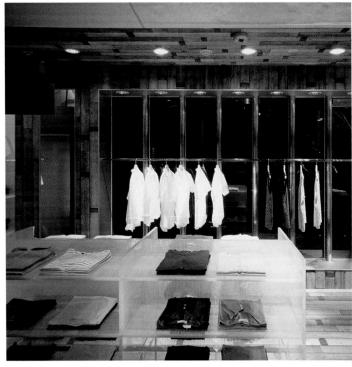

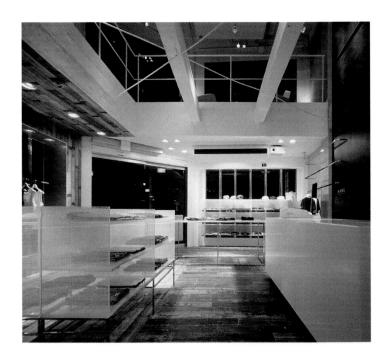

The architects made full use of the architectural advantages of the space, such as the crossed beams in the roof.

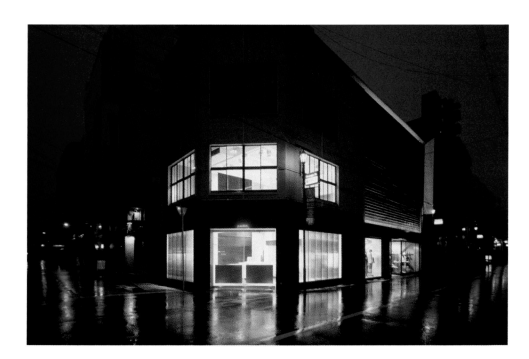

The store occupies both levels of the building and still maintains some of the original structural details.

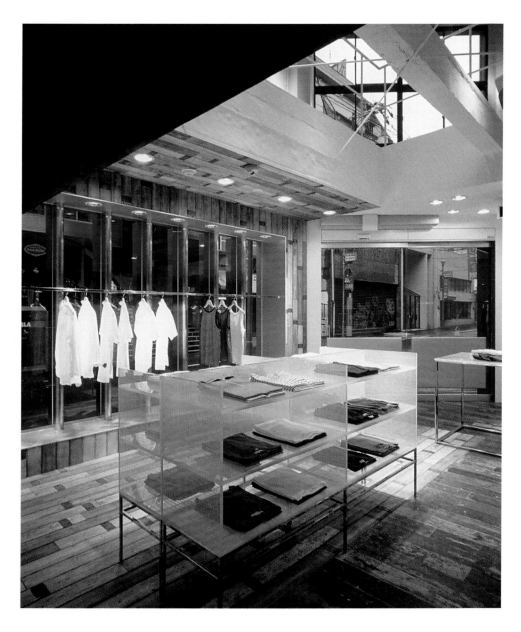

FASHIONHAUS

Designer: **1100 Architect**
Photographer: **Michael Moran**
Location: **New York, USA**
Opening date: **2001**

Fashionhaus, located in an old factory warehouse in midtown Manhattan, is an impeccable showroom that displays different collections from European companies. 1100 Architect was the New York firm responsible for renovating the interior. The characteristics of the space were helpful in the initial development of the concept. Faced with a very large space with a high ceiling and open feeling, the architects decided to design a neutral, well-lit shell with simple lines to highlight the color and the subtlety of the collections being exhibited. The architects organized the space into different display areas to create a variety of environments, each designed with slightly curved structures made of vertical wood rods. These screens separate the various product lines on exhibit and create simple traffic patterns while adding visual fluidity.

To highlight the space even more, the clothing is arranged along the sides, leaving an open central area with a table. All of the furniture in the store was designed by 1100 Architect, from the display fixtures for the collections and accessories to the stainless steel racks, the tables, and the wood shelves that hold the books. To create an organic feeling in the space, the architects placed several adjustable light fixtures in groups of three to supply the white, ethereal light in the interior of the store. The resin floor and the white ceiling and walls enclose an interior that is free of superfluous details, an interior where the organic, rational space itself is the star.

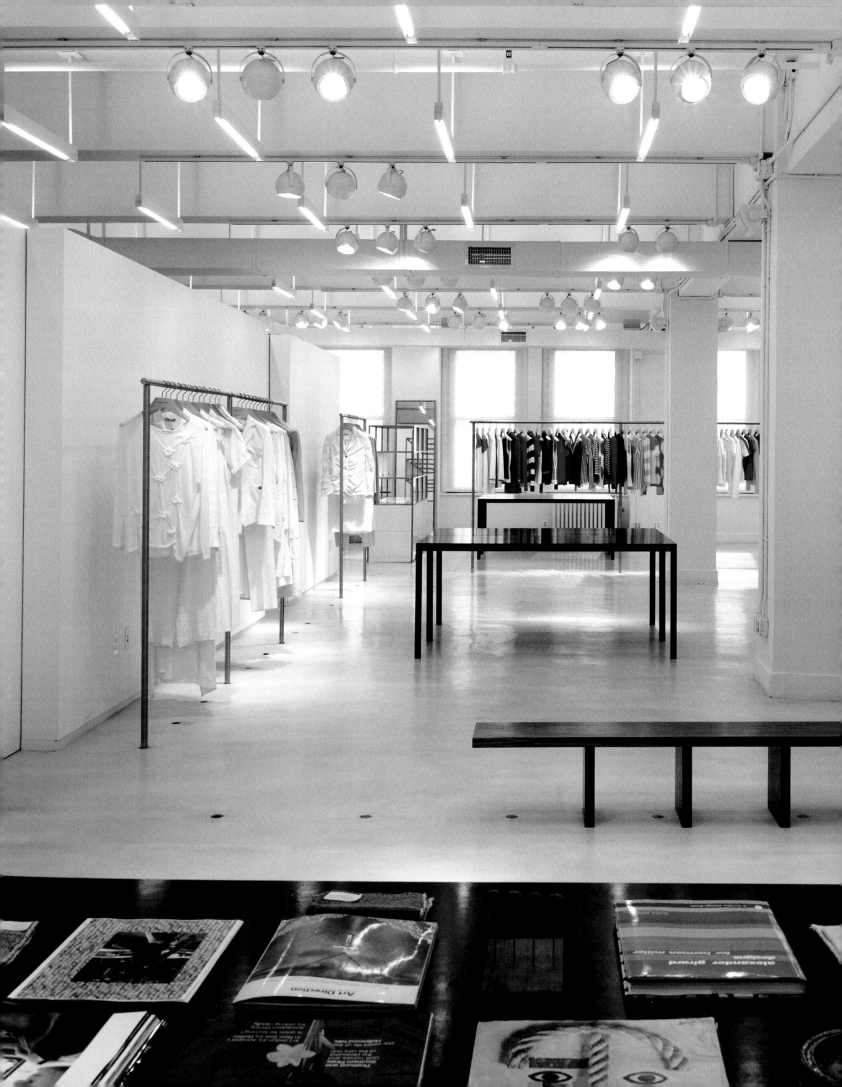

clothes

The clothing is displayed along the sides to leave the center open, increasing the neutrality of the interior.

Floor plan

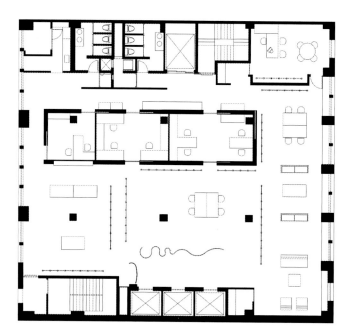

VALENTINO

Designer: **Antonio Citterio and Partners**
Photographer: **Gabriele Basilico**
Location: **Milan, Italy**
Opening date: **2001**

The Italian company Valentino chose to locate one of their stores on the Via Montenapoleone in Milan. On the lower floor of the two level, 7,040-square-foot (654 m²) space, the store offers ready-to-wear collections for men and women and the Roma Collection. The upper level accommodates women's ready-to-wear, the Roma, and Valentino Sera collections.

Valentino entrusted Antonio Citterio and Partners to design the interior of the space—the results could not have been better. The Valentino store in Milan has become one of the most outstanding examples of the integration of an architectural space with the products on exhibition, which greatly enhances the value of the brand.

The concept of this new store was to focus on accentuating the spectacular designs of Valentino. To do this, Antonio Citterio and Partners created an interior that emphasizes the experience of Valentino's fashion designs. The idea was to present an enclosed area, with a certain timeless feeling that would evoke a walk through a luxurious space. Exhibit areas for the collections on both levels were integrated within the architectural spaces, and they are framed by thin bronze rods that suggest that the clothes are inside glass displays.

On the upper level, where the men's clothing is exhibited, the linearity and elegance of the structure, with its outstanding, perfectly square skylight, lends a sumptuous air to the clothing hanging there, very appropriate for this prestigious company.

VALENTINO

The space is presented as a neutral shell; inside, the perfection of the forms and the linearity of the structure emphasize the value of the brand.

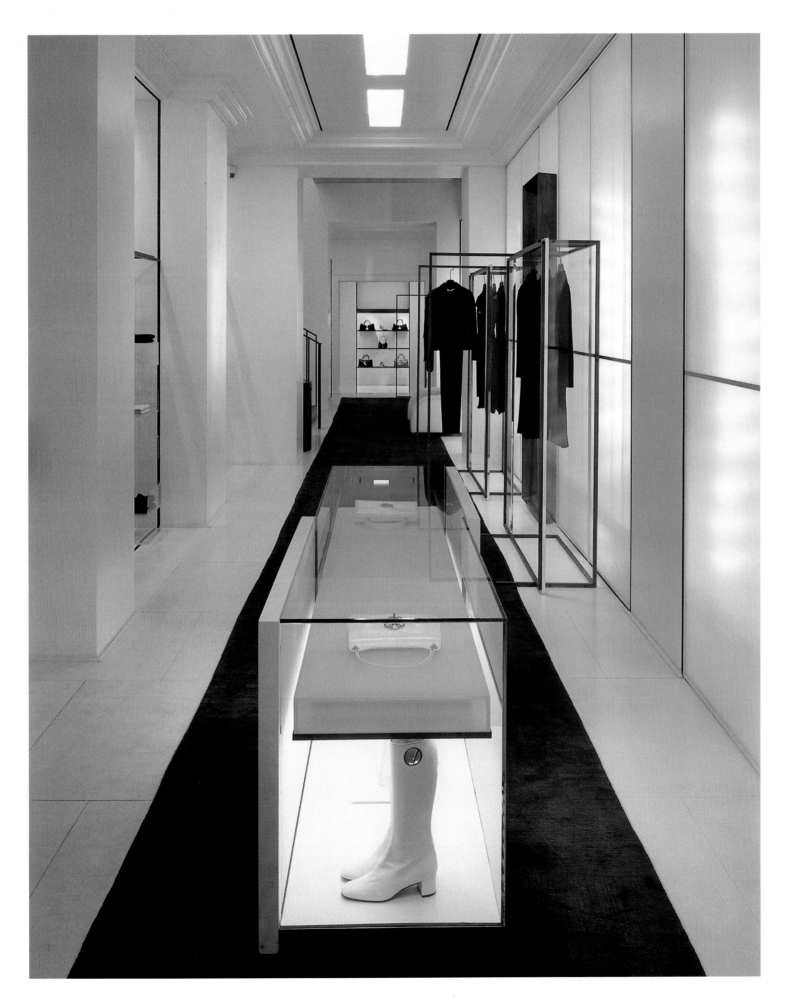

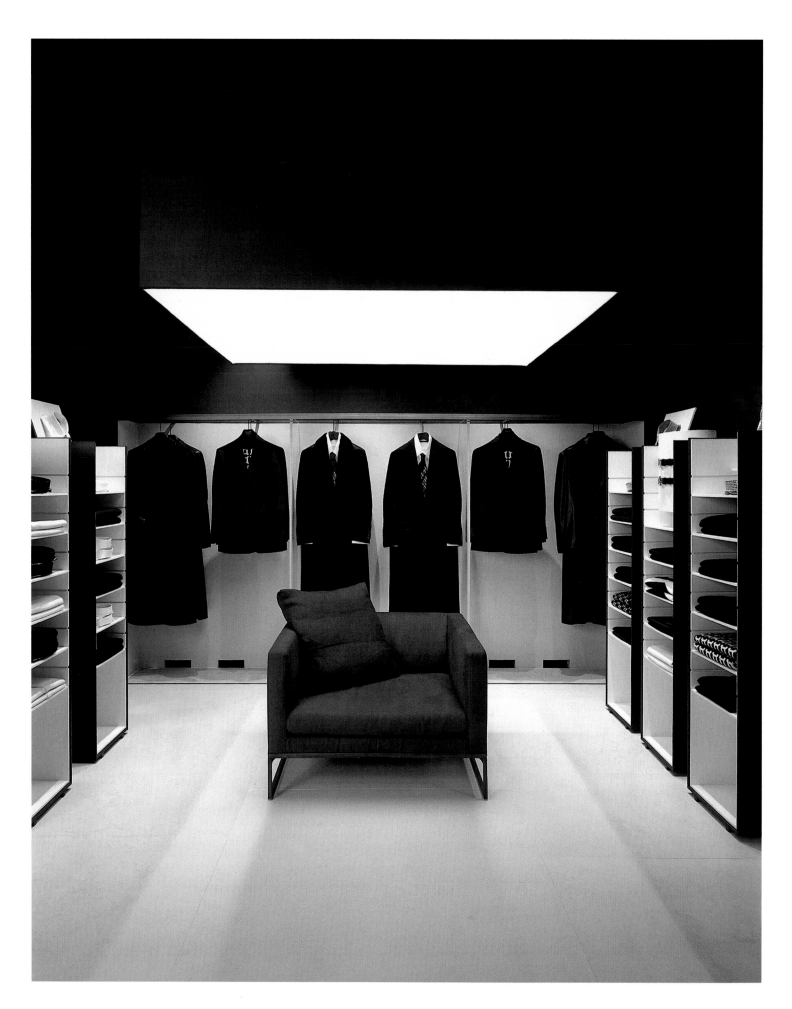

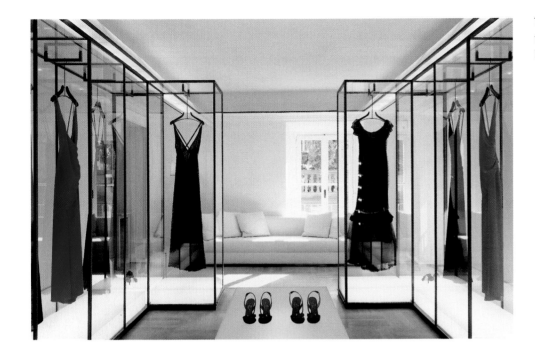

The clothing is shown inside fixtures created with thin bronze rods that organize the space and subtly imitate display windows.

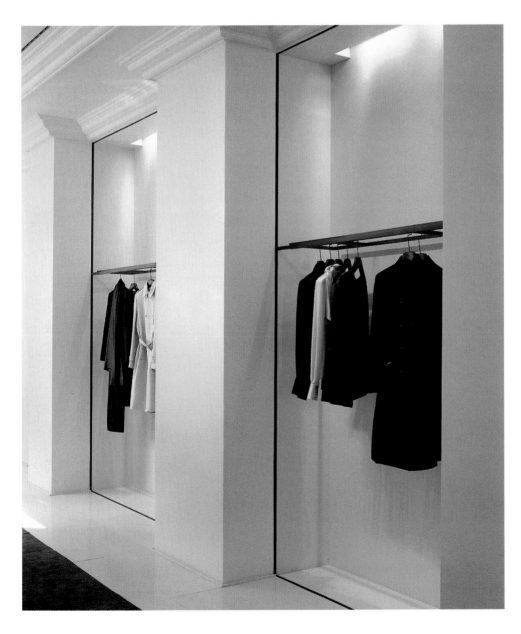

PINCEAU

Designer: **OUT.DeSIGN**
Photographer: **Kozo Takayama**
Location: **Tokyo, Japan**
Opening date: **2002**

 One of OUT.DeSIGN's latest projects for the Pinceau store is located in the Marunouchi Building in Tokyo. The new store follows the same aesthetic guidelines as the rest of the firm's establishments, which are characterized by simple detailing and a serene atmosphere. The composition of the elements is based on a modular design that is lit from the ceiling. This formula allows flexibility and adaptability when lighting the different zones in the interior. On the floor, the displays mix very different materials. The counters combine natural wood with transparent surfaces, curved hangers in blue, and simple modular designs in white. In this store, the variety of materials and forms break away from the aesthetic of commercial spaces that limit themselves to a single prevailing look.

The structure that surrounds the space is devoid of square corners and seems to embrace the sinuosity of the elements that compose the interior. The ceiling seems to float as if the walls were not supporting it, an effect achieved by not running the wall covering all the way to the ceiling.

Different kinds of materials are combined on the floor as well, including a combination of rough, matte-textured natural wood with reflective materials like ceramic tile.

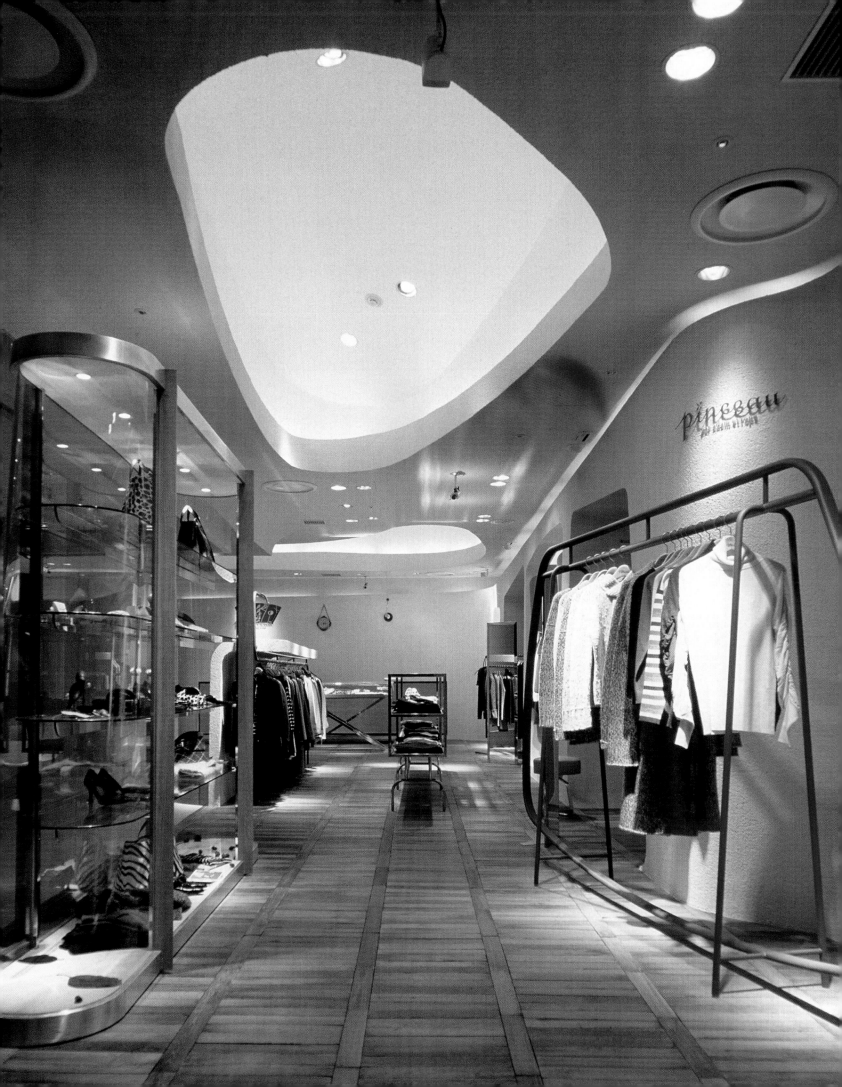

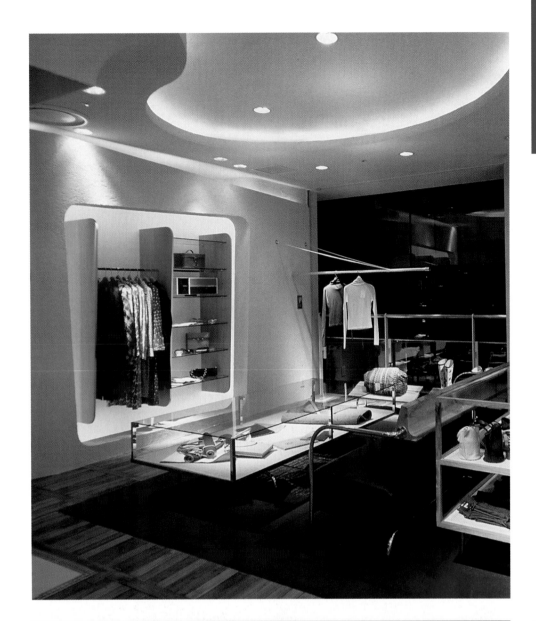

pïnceau
par adam et ropé

Polished and transparent surfaces are combined
with warm, opaque materials such as natural wood.

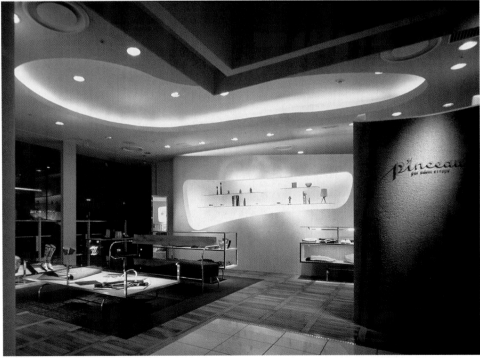

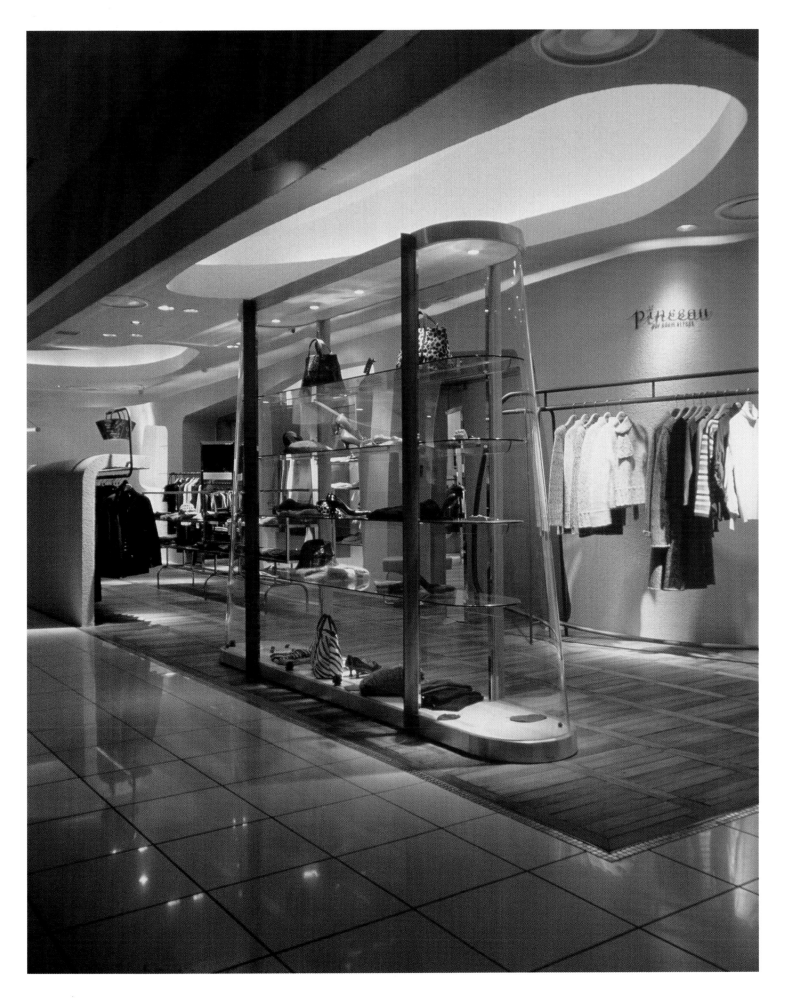

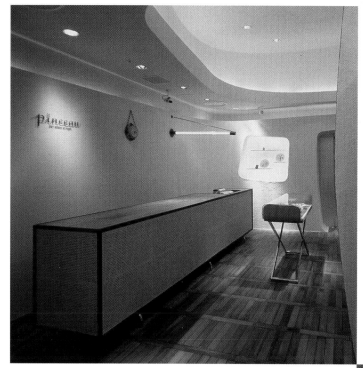

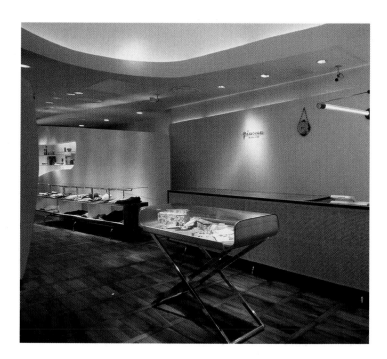

Combining a variety of materials creates a flexible interior that breaks away from the relentless uniformity of most retail spaces.

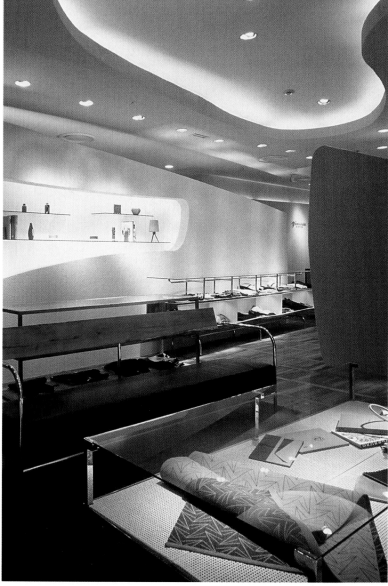

The designs of the display cases do not conform to one single aesthetic. Some mix wood with transparent surfaces, while others are simple metal structures.

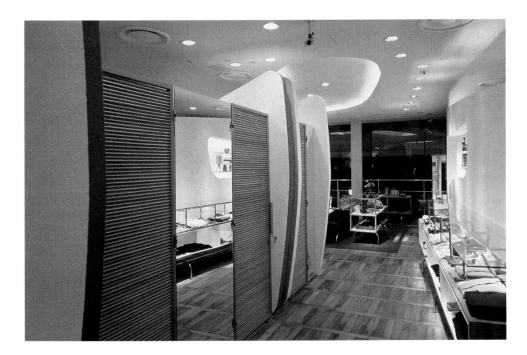

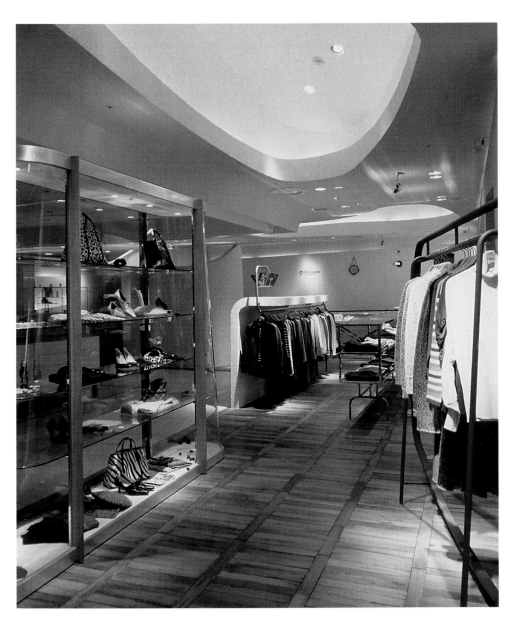

SITA MURT / MANRESA

Designer: **Rosa Rull/Manuel Bailo**
Photographer: **Jordi Miralles**
Location: **Manresa, Spain**
Opening date: **2003**

By applying the same aesthetic principles they followed in their previous projects, the Catalan designers Manuel Bailo and Rosa Rull chalk up another success with their new store for Sita Murt in Manresa. After the much-deserved notoriety of the Sita Murt store on Calle Avinyó in the historic center of Barcelona, Bailo and Rull created an interior in Manresa along the same lines. For them, the stores they have finished up until now for the family of weavers that owns the company have become a reflection of the world of fabric. In Barcelona, they were able to renovate a very small space in a surprising and functional way by incorporating the basement, while in Manresa they remodeled an interior in the opposite manner—by going up. The characteristics of the space allowed the architects to design a second level near the ceiling to increase the useable space.

The designers used the same color guidelines as in the projects carried out before Sita Murt: red covers the interior. Bailo and Rull turned the space into a perfect combination of elements, some are innovative while others maintain their original character.

In the entrance to the main level, a metal screen separates the display window from the rest of the store. This same object functions as the front wall of the upper level. Its open texture allows the setting on the opposite side to show through, creating a perfect interrelation between the two environments.

The central counter and the displays themselves are suspended from the ceiling and seem to be an extension of the structure, perfect examples of how structural elements can become furniture. Once again, Bailo and Rull have demonstrated their mastery of the art of working with geometric surfaces.

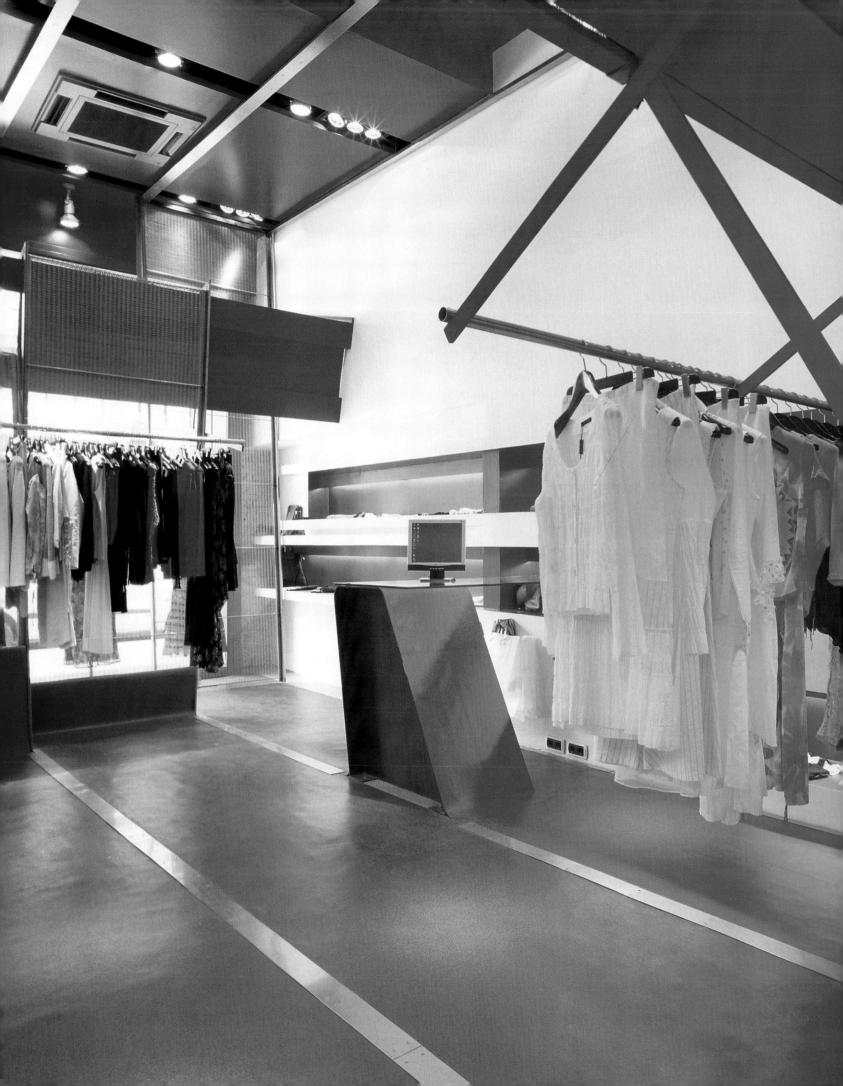

clothes

sita murt

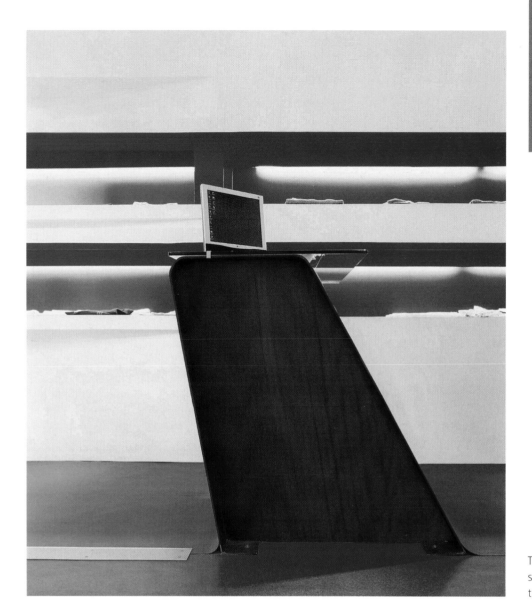

The counter top is parallel to the floor, while the sides were designed with a slant that contrasts with the surrounding perpendicular lines.

Floor plan

Section

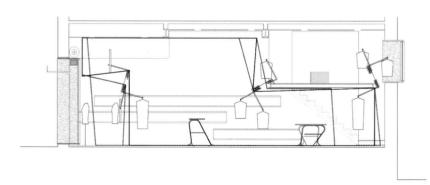

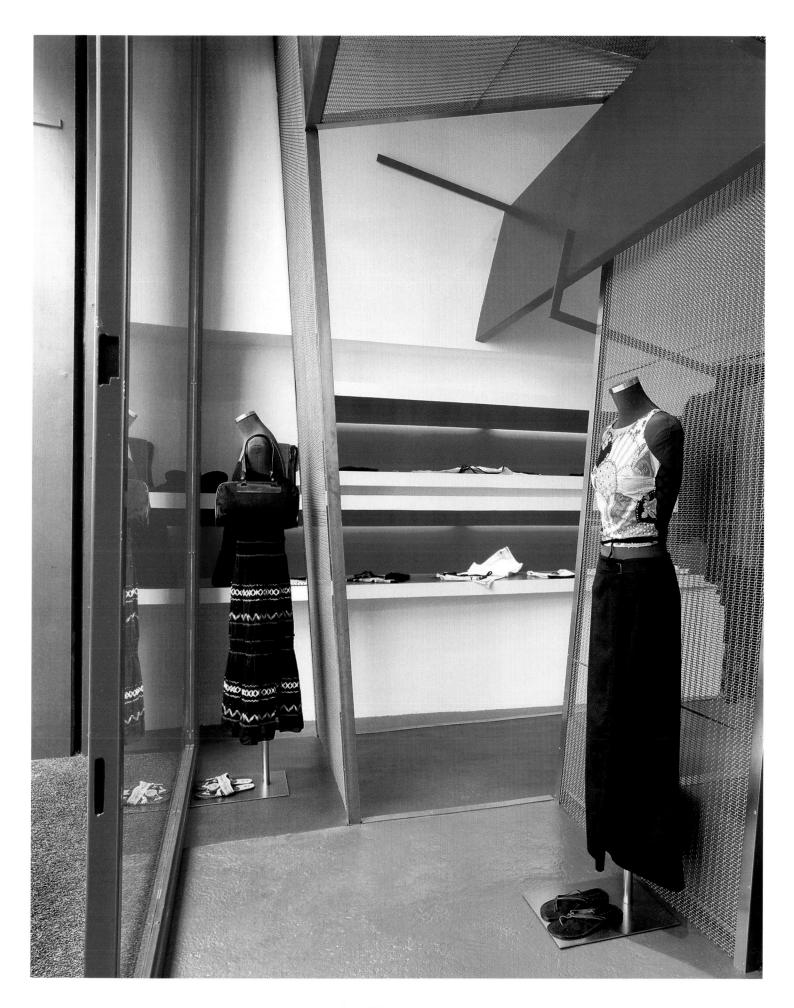

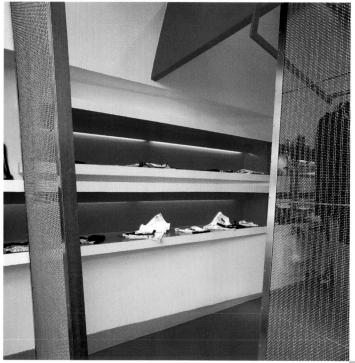

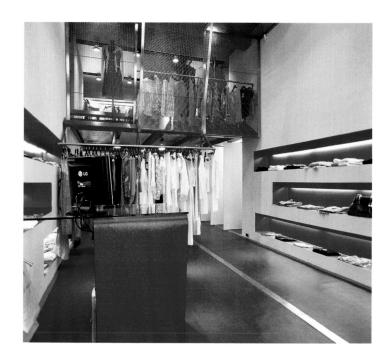

Some structural elements become display fixtures, such as the racks suspended from the ceiling.

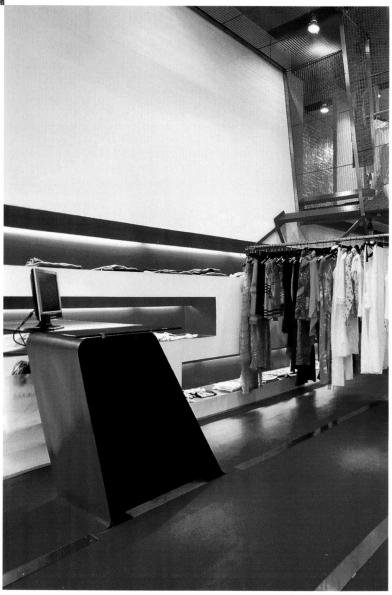

The metal screen on the top level allows natural light to flow into the space and establishes a better relationship between the two levels.

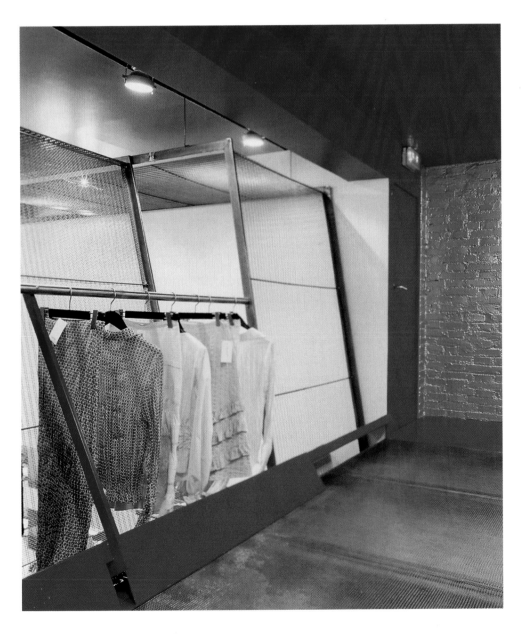

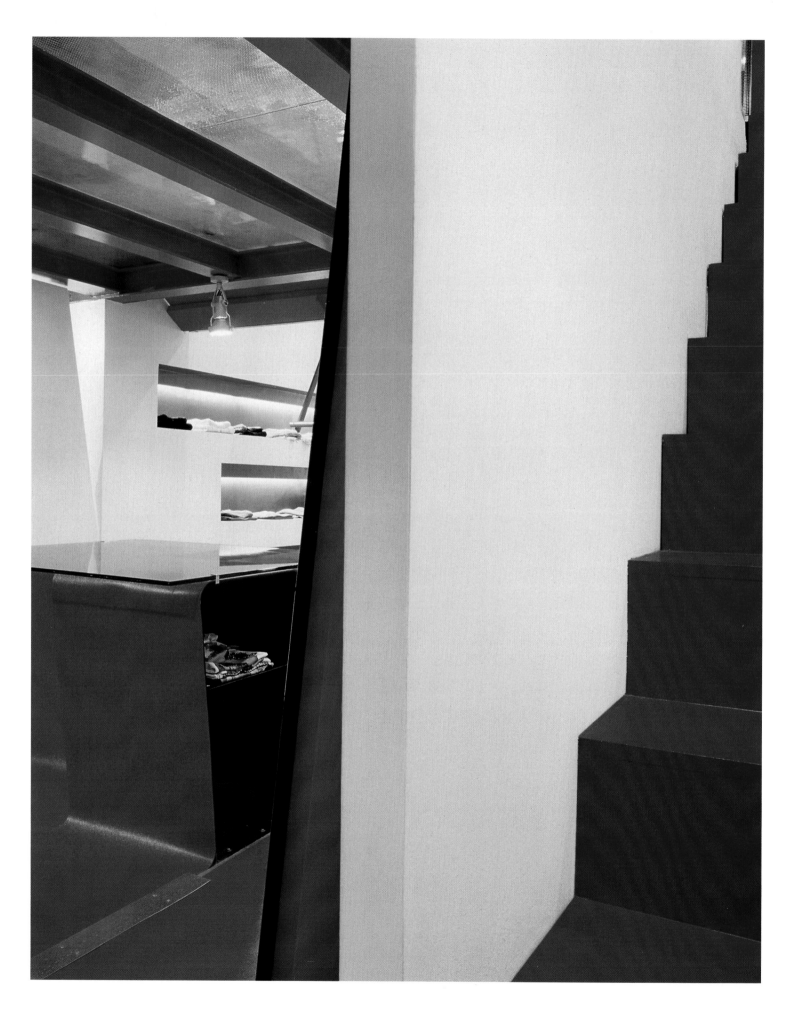

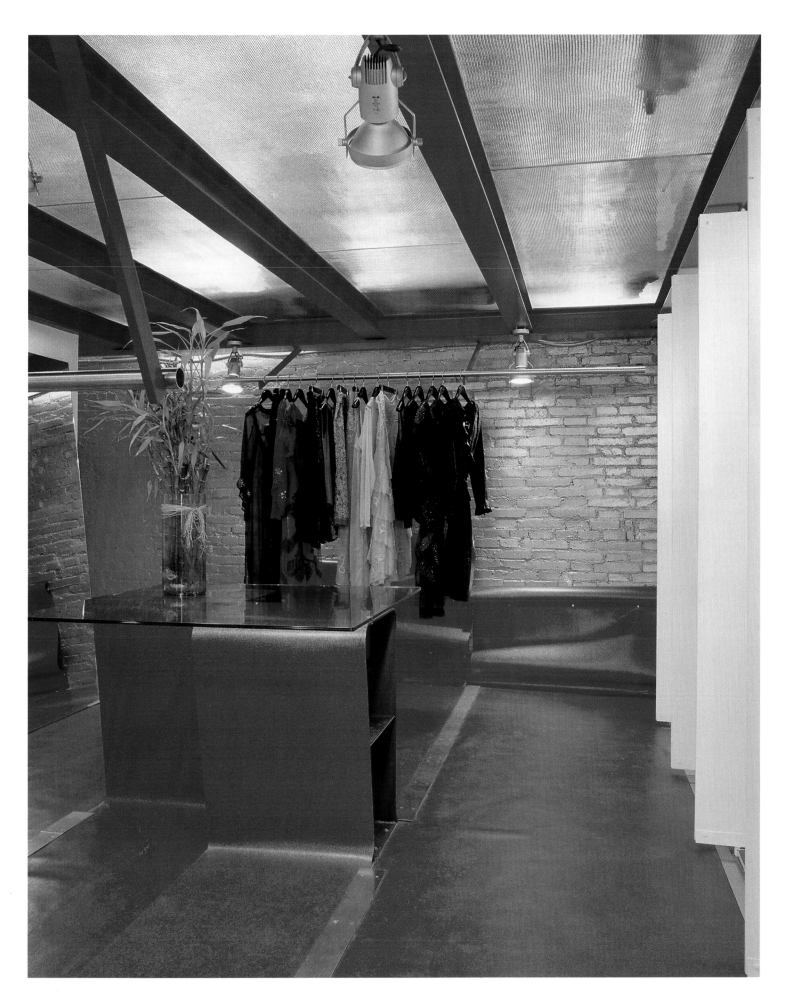

SITA MURT / BARCELONA

Designer: **Rosa Rull/Manuel Bailo**
Photographer: **Jordi Miralles**
Location: **Barcelona, Spain**
Opening date: **2004**

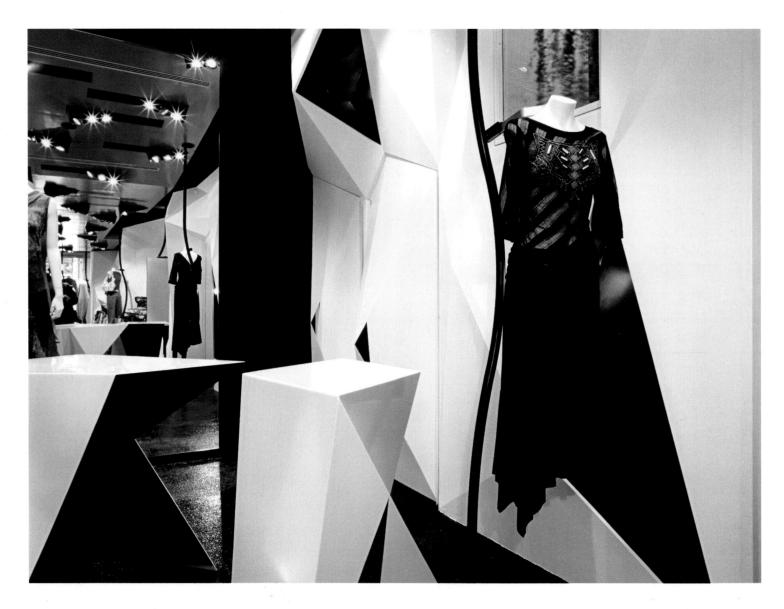

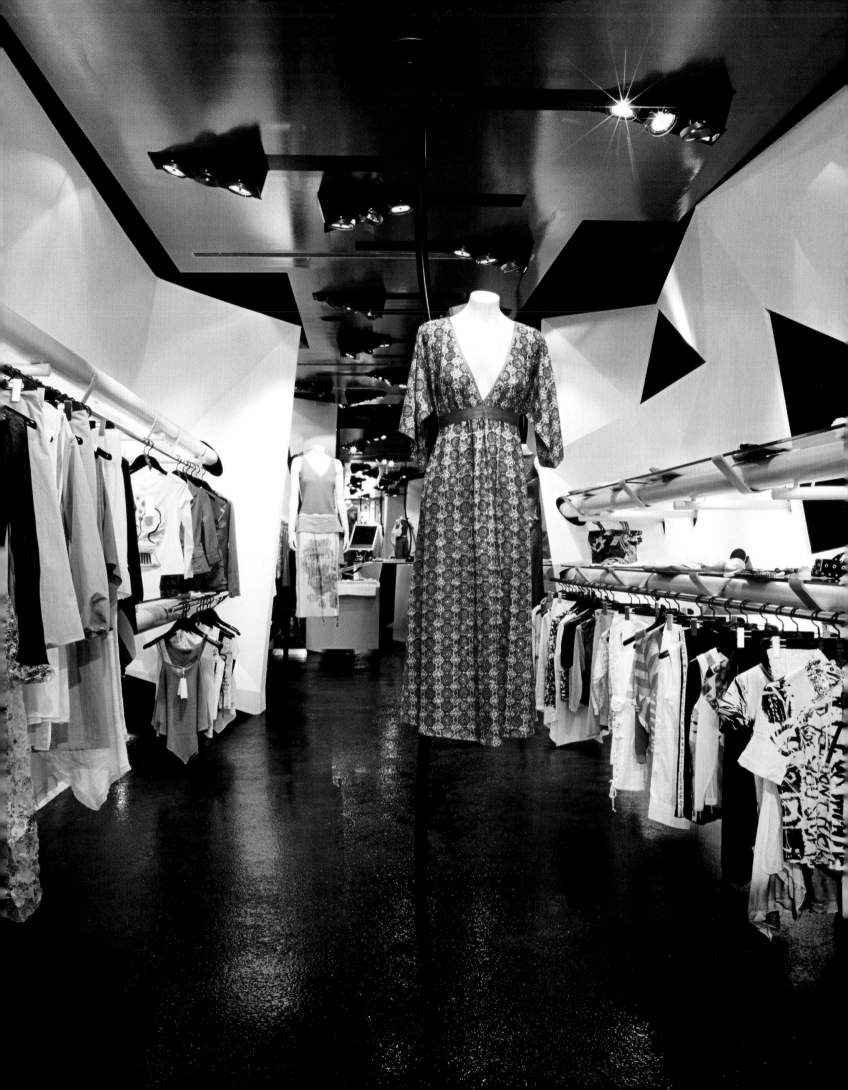

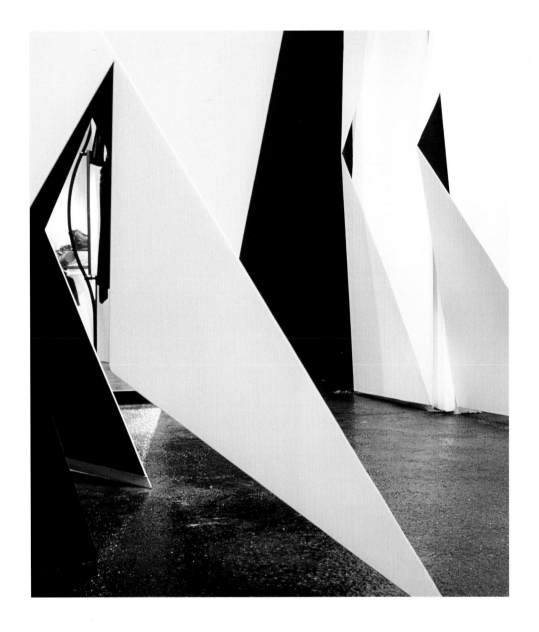

The visitor's perception of the physical space is influenced by the quality of the structural forms, which were inspired by origami techniques.

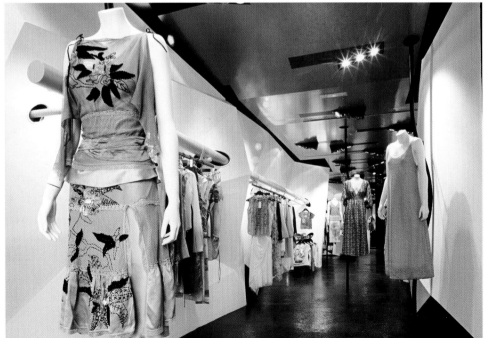

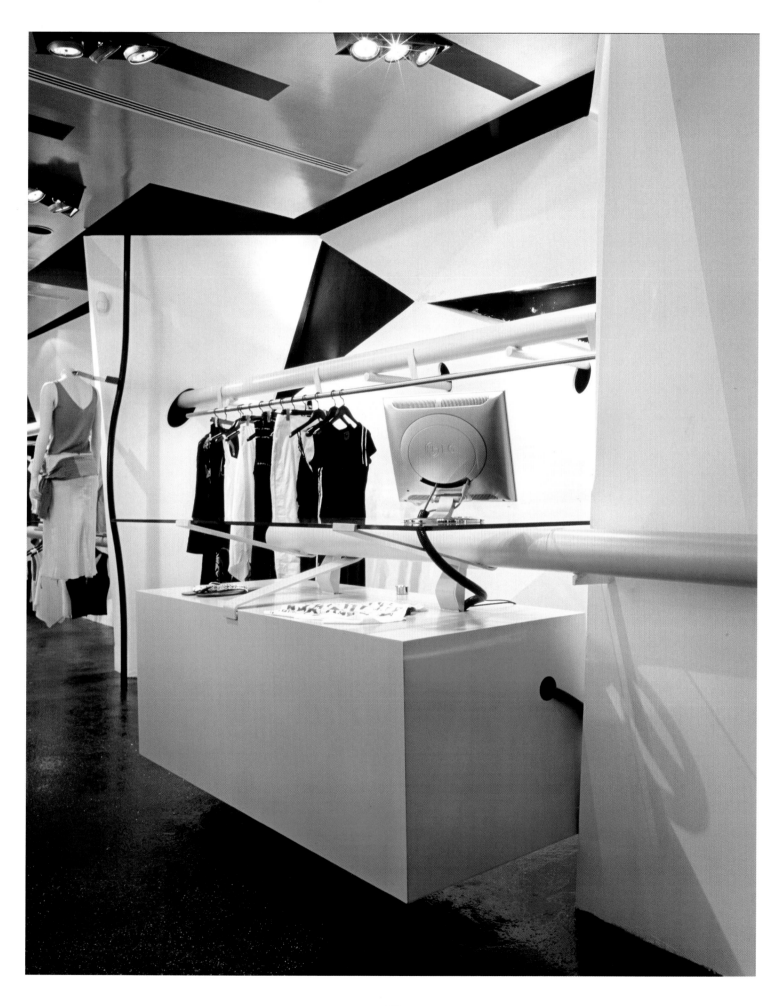

The precise lines of the structures create an interior that has rigorous and detailed proportions.

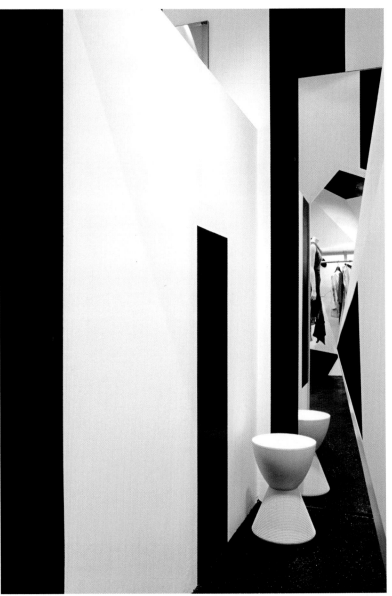

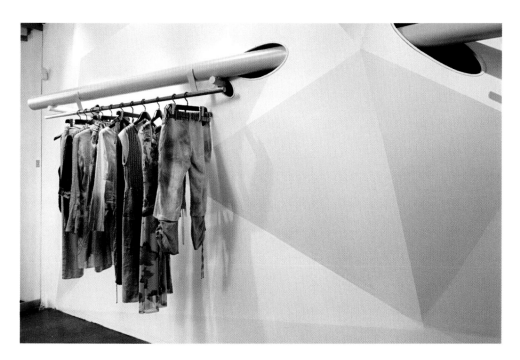

The clothing is displayed on metal tubes that are part of the angular structures.

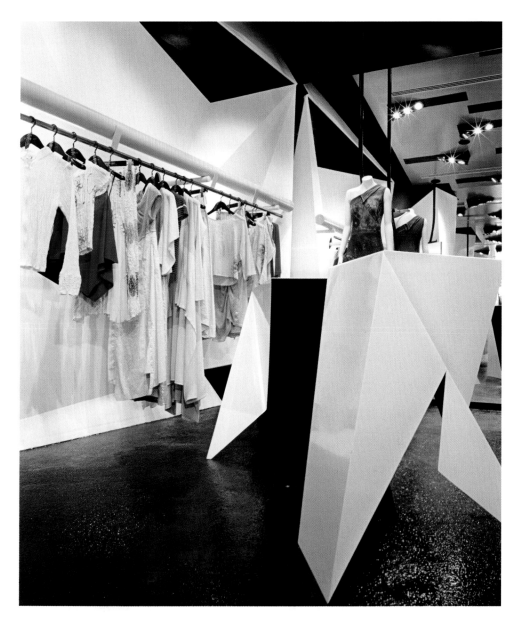

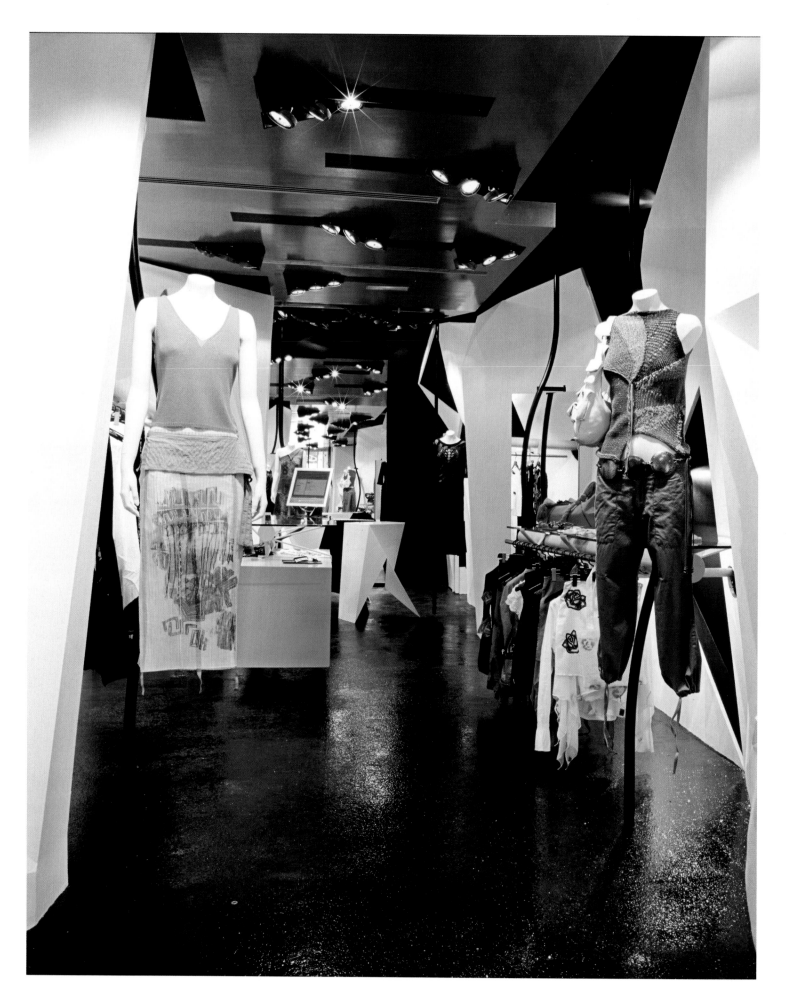

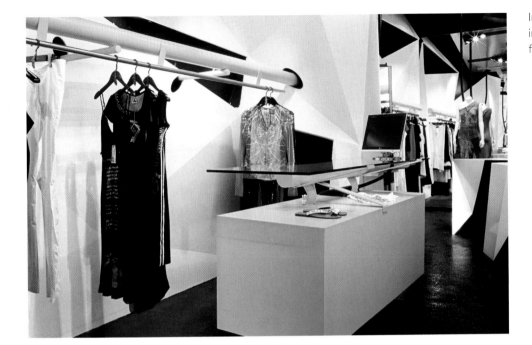

Innovative steel bars hold up the mannequins from inside the neck as if they were floating above the floor.

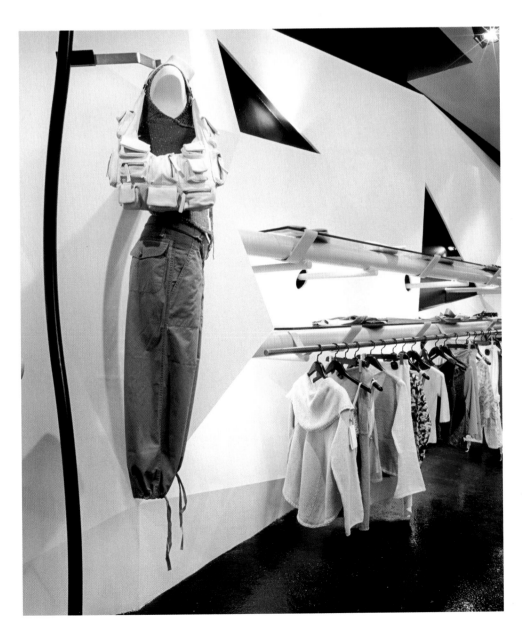

COSTUME NATIONAL

Designer: **Marmol Radziner and Associates**
Photographer: **Benny Chan**
Location: **Los Angeles, USA**
Opening date: **2000**

This store, the first of the Italian company Costume National's West Coast stores, opened in Los Angeles and was designed by Marmol Radziner and Associates. The space, an old restaurant, underwent an exhaustive renovation that began with the gutting of the entire interior, except for the high windows of the façade. The front windows were enlarged from the floor to the ceiling to take advantage of natural light and maximize the altitude of the space. The resulting exterior of the building was painted a warm gray to contrast with the light shade of the interior.

Costume National projects an international image with its collections, which are based on an impeccable and elegant minimalism. These qualities are reflected in an interior that mixes a simple palette of whites with touches of stainless steel. A few white lacquered panels define the different display areas of the collection. Aided by a screened light that projects from two sides, the panels seem to float away from the structure of the walls while the light emphasizes the clothing on display. Marmol Radziner placed Lucite shelves next to the windows, illuminating the accessories with fiber optics that extend from the floor to the ceiling. The pearl gray floor and the seats upholstered in suede and leather complete the clean and neutral background.

All of the furniture, glass displays, panels, and shelves in the interior were specially designed for the Los Angeles store. This new space on Melrose Avenue is the most recent of the Costume National stores opened in New York, Milan, and Tokyo.

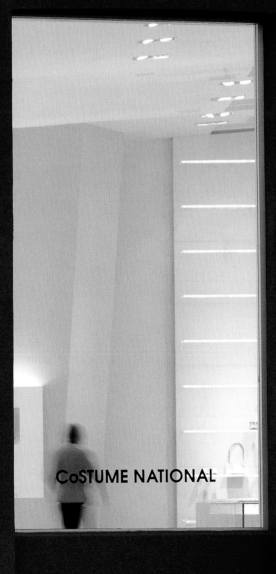

CoSTUME NATIONAL

CoSTUME NATIONAL

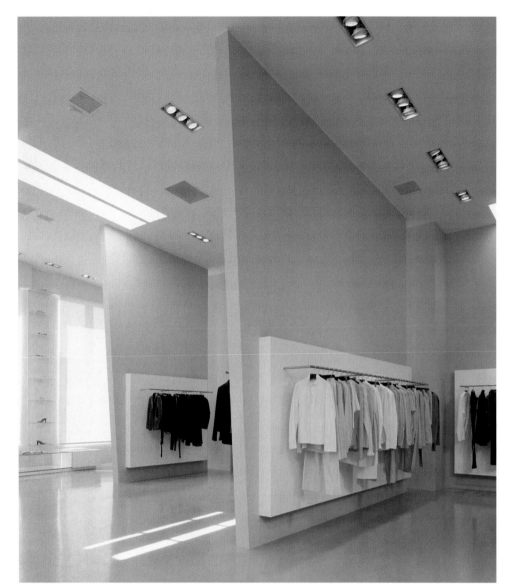

The windows of the façade were extended from the ground to the ceiling to take advantage of natural light and maximize the height of the space.

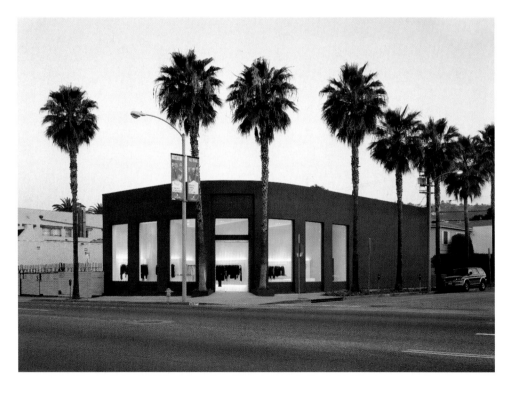

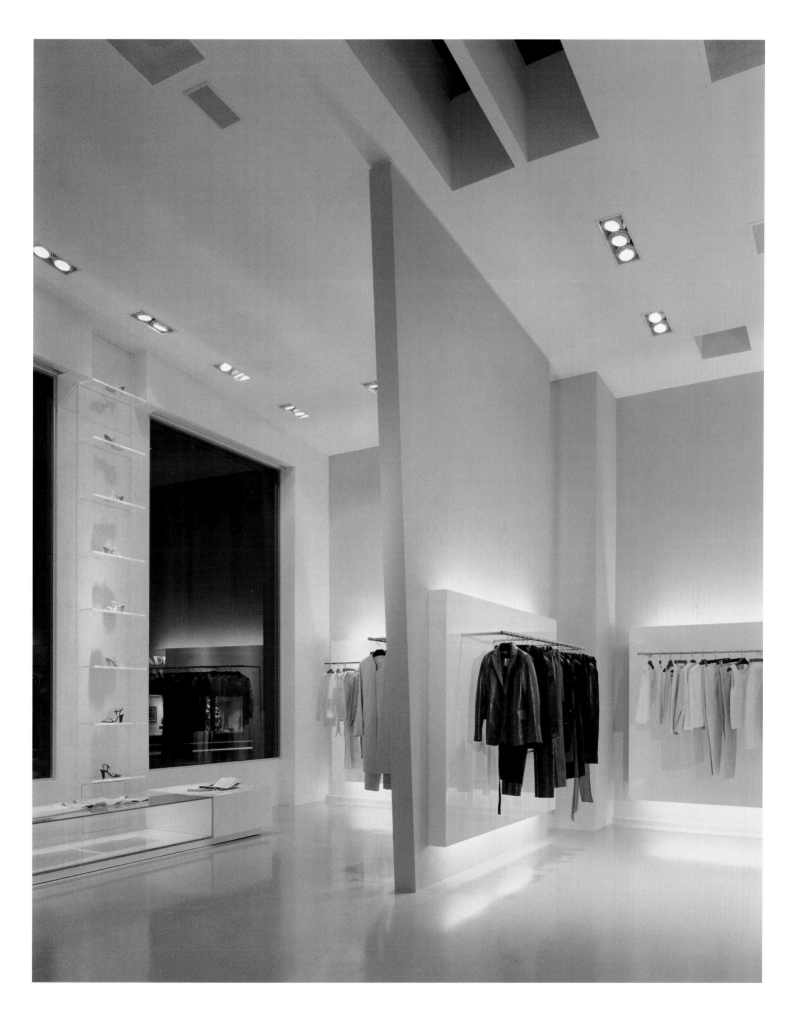

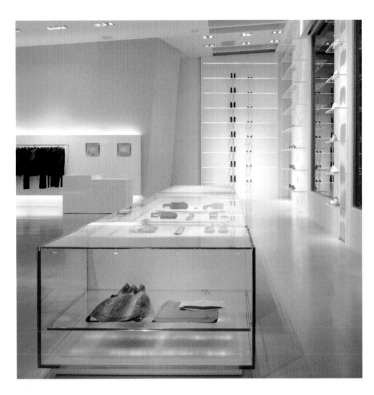

The furniture, displays, panels, and Lucite shelves are illuminated with fiber optics that were specially designed for the Los Angeles store.

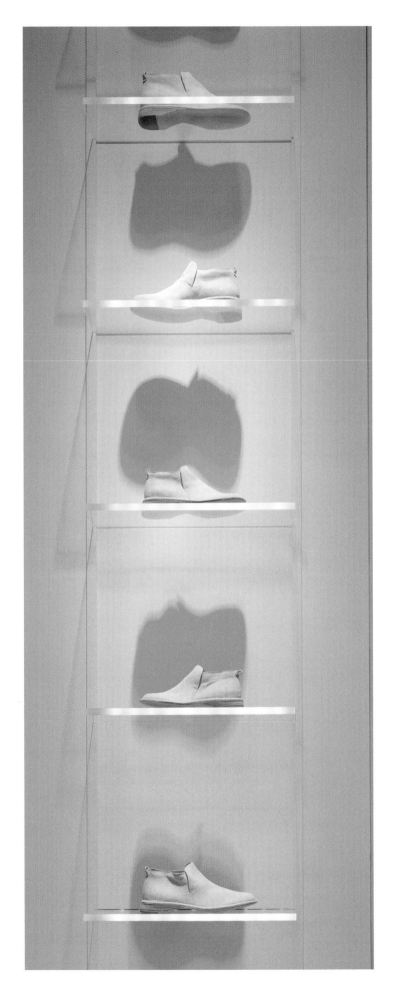

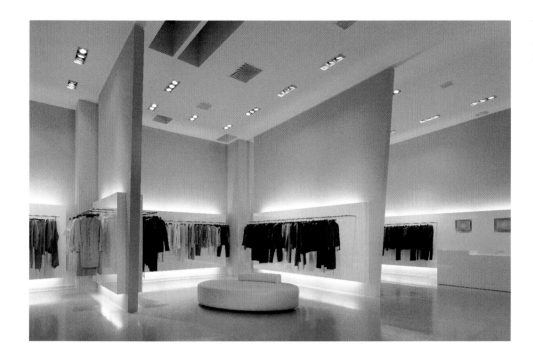

The interior has an elegant Minimalist character that uses white panels to create the different display areas of the store.

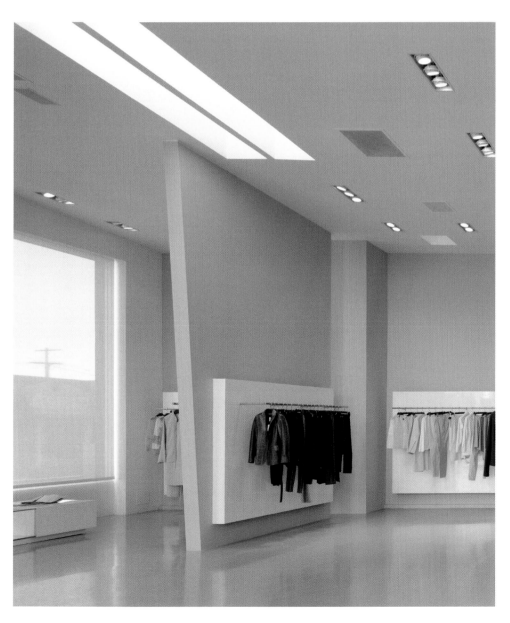

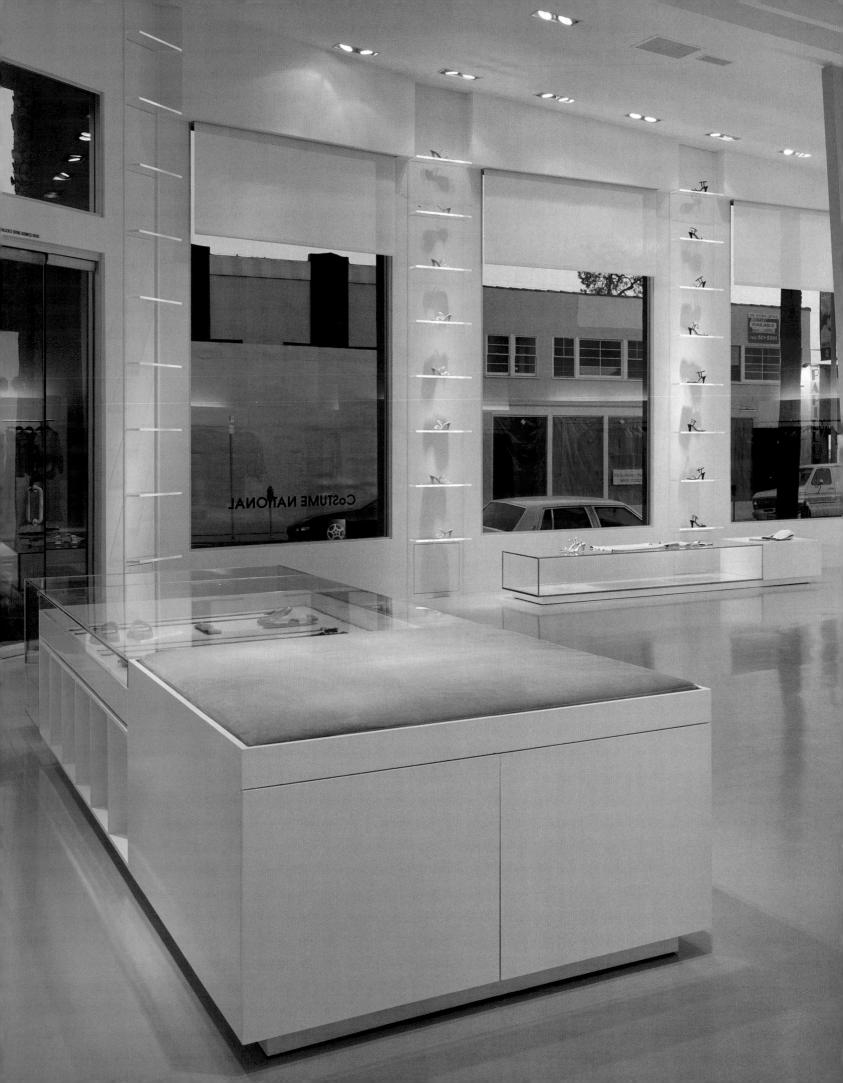

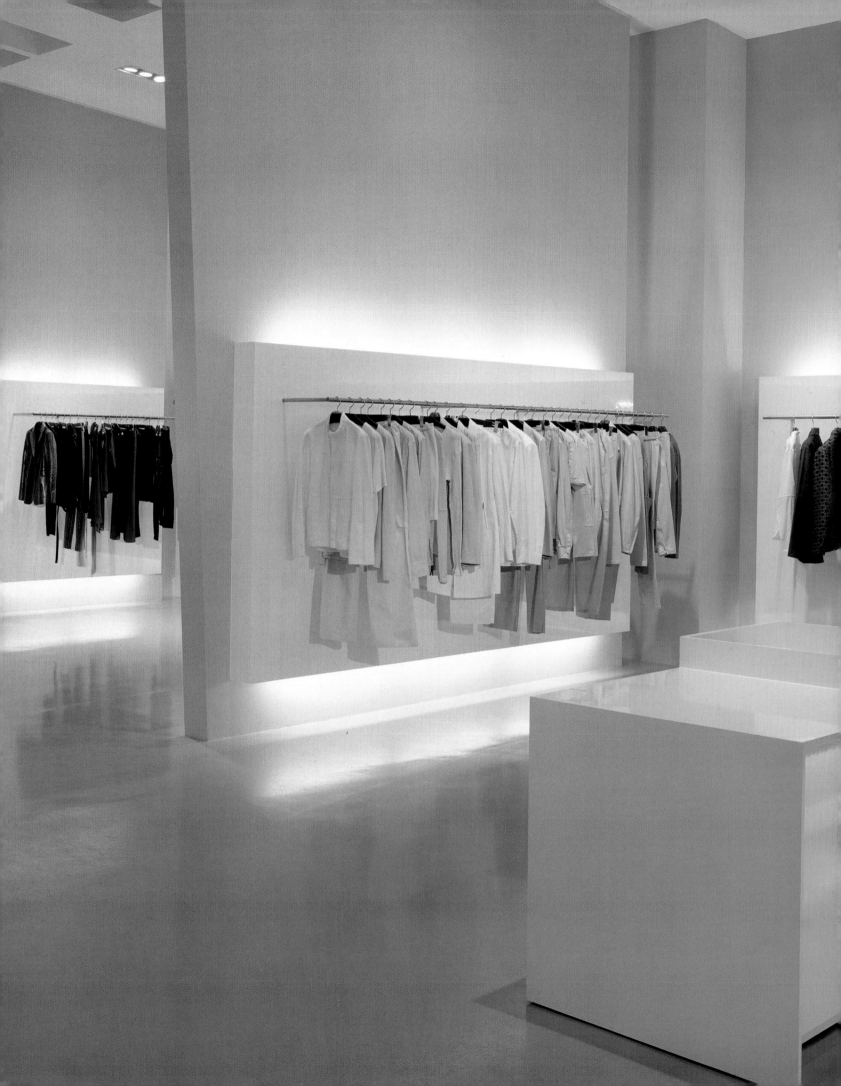

m, i, d, shop

Designer: **Fumita Design Office**
Photographer: **Nacása & Partners Inc.**
Location: **Tokyo, Japan**
Opening date: **2003**

New spaces for fashion have turned into interiors that clamor for the attention of the customer. The inducement to go shopping, in many cases, is characterized by good stage design in the interior. Fumita Design Office converted the m, i, d, shop located in Tokyo into a neutral shell that invites us to explore the elegance and the sobriety of its latest collection.

M, i, d, shop was developed as a plane of perfect lines. Following a Minimalist aesthetic repeated in other designs by the Fumita Design Office, the interior opens up into a fluid space in which the absence of details gives the setting the simplicity that is necessary to catch the customer's atten-tion. Inside the store, the elements seem to disappear into the structure. The fixtures are so well integrated into the space that each piece disappears in the emptiness. In the center of the space, only the glass display that runs from end to end stands out. The material's transparency causes the fixture to go unnoticed when viewing the space as a whole. On the sides is a back-lit system for hanging clothing, which looks as if it is floating in space. Behind the fix-tures, walls created with transparent blue surfaces make the space feel lighter. The transparency and coolness of the materials give it a watery texture that visually light-ens the atmosphere. This strategy results in a seemingly empty interior in which each detail finds its own space.

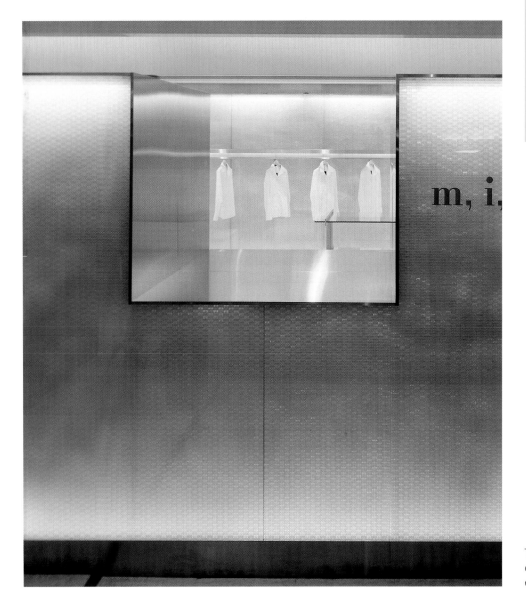

m, i, d, shop

The transparency and coolness of the materials chosen for the interior give it a simple and elegant look.

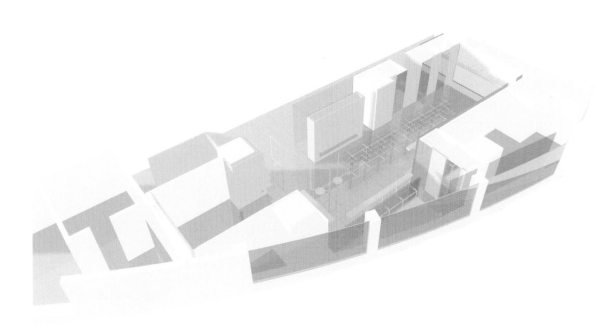

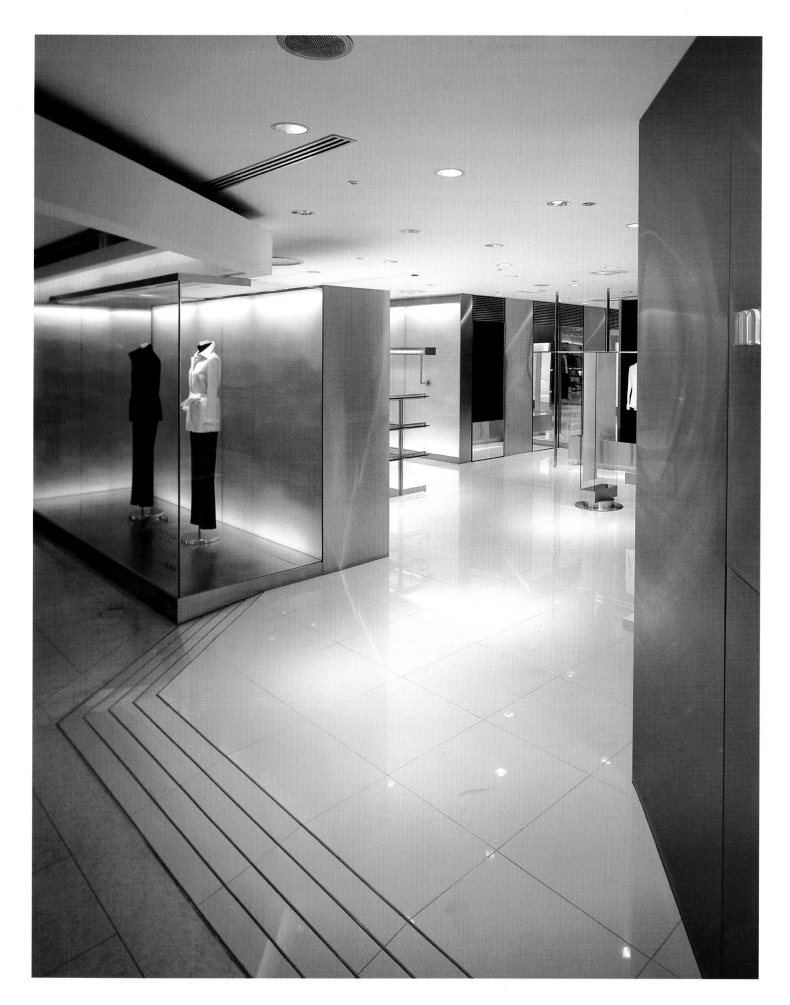

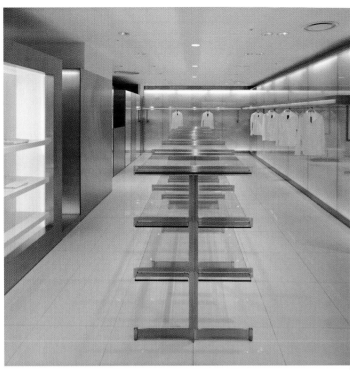

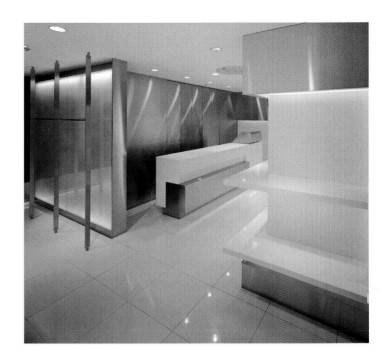

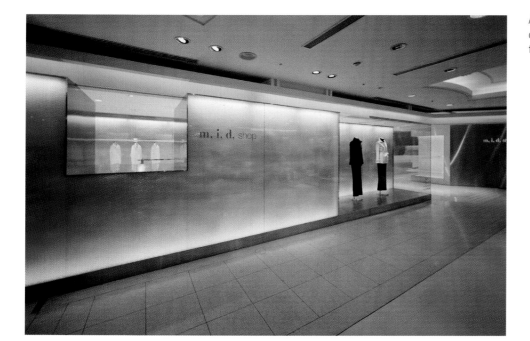

A transparent counter extends through the middle of the space without changing the sense of a light-filled interior.

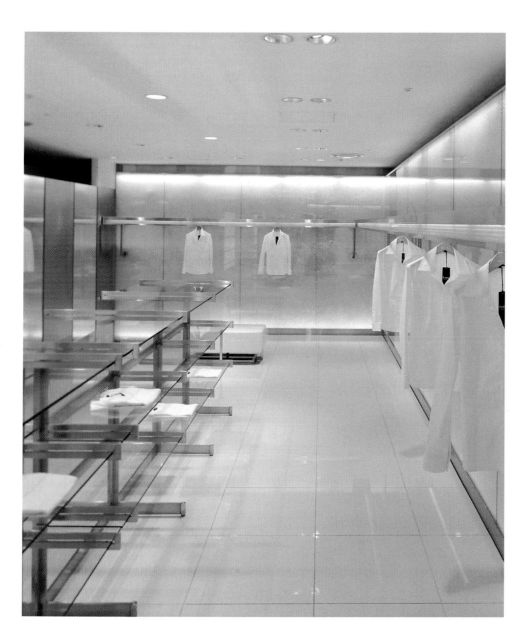

ACCESSORIES

ACCESSORIE

CCESSORIES

ACCESSORIES

ACCESSORIES

CAMPER

ACCESSORIES

ACCESSORIES

ACCESSORIE

CCESSORIES

ACCESSORIES

ACCESSORIE

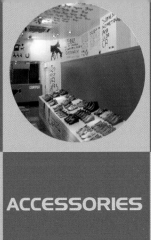
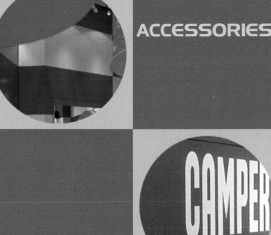
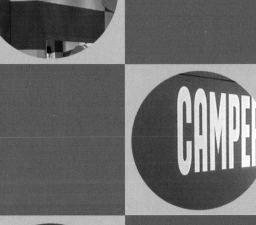

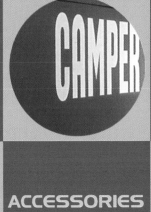

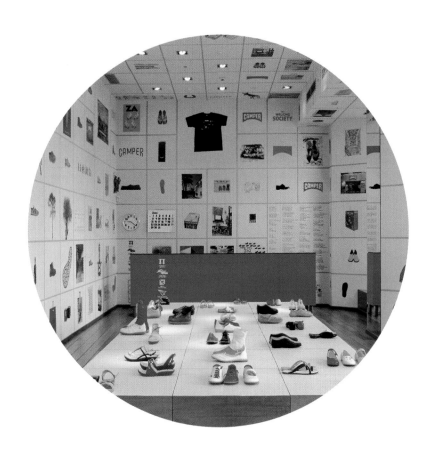

ACCESSORIES

MANDARINA DUCK

Designer: **Studio x Design Group**
Photographer: **Oscar Brito/Lara Rottondini (Studio x Design Group)**
Location: **Paris, France**
Opening date: **2003**

The new Mandarina Duck space, designed by the architectural team of Studio x Design Group (STX), is based on the new identity planned for the so-called agent stores (the most spread-out and traditional point-of-sale stores of the Mandarina Duck brand).

The STX project should be seen as a manifesto against superficial design; STX avoids the fragmentation so widespread in commercial spaces today, where furnishings seem scattered throughout the interiors. The coherent structure of the project, meant to focus on the Mandarina Duck product, provokes a sensation of surprise and curiosity in consumers.

As a response to these conditions, Lara Rettondini and Oscar Brito created the new concept of "Mandaring": a modular furniture system that allows the store and landscape to fuse together in the Italian firm's stores. The "Mandaring" concept divides the available space into a precise modular grid of 48 x 24 inches (120 x 60 cm). Curving compositional lines become tables, pedestals, vertical displays, illuminated wall shelf systems, and unexpected elements that hang from the ceiling like stalactites. The colors, such as the yellow that refers to the brand's duck icon, as well as the materials and the forms, are designed to capture the attention of the consumer.

The exterior filters into the interior through a translucent screen that separates it from the display window area and only permits direct views through a cutout in the shape of the duck icon, which functions as a corporate logo on the urban plane.

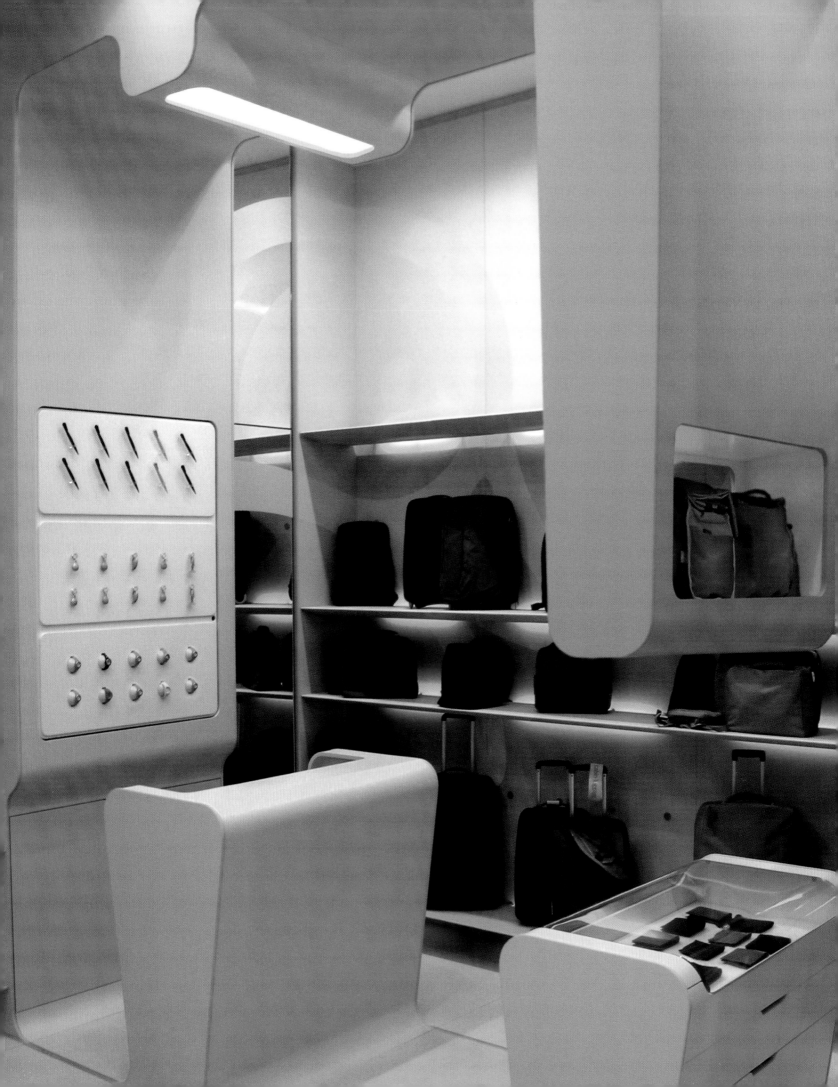

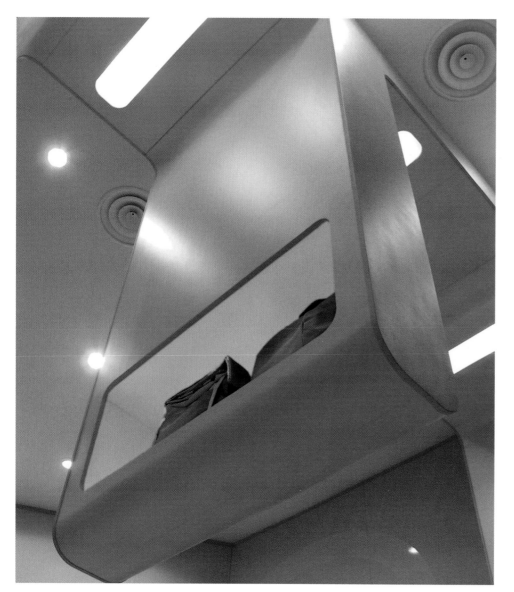

accesories

MANDARINA DUCK

Structural elements hang from above like stalactites, serving as displays for the Mandarina Duck designs.

Sections

 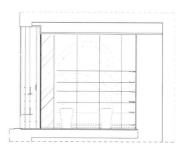 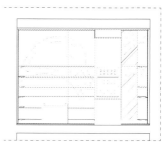

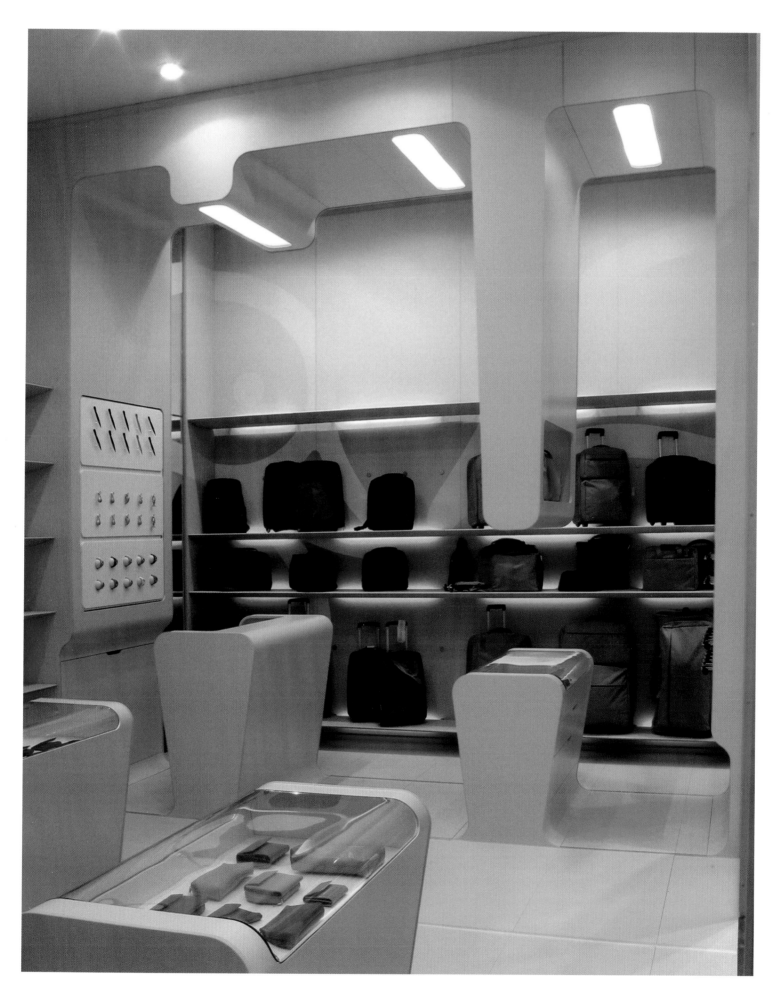

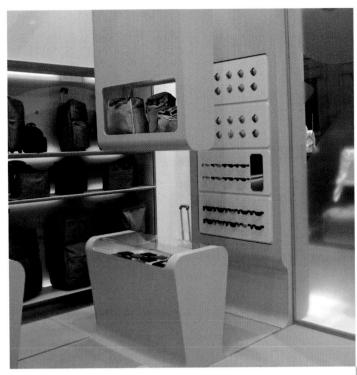

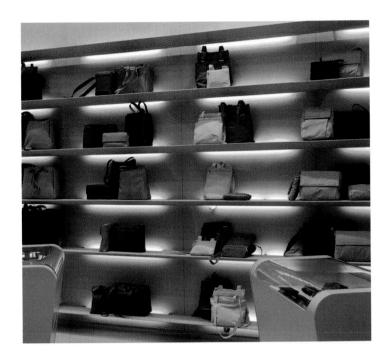

The plasticity of the bright yellow material, a reference to the brand's duck icon is used to create a fantastic interior full of sinuous forms.

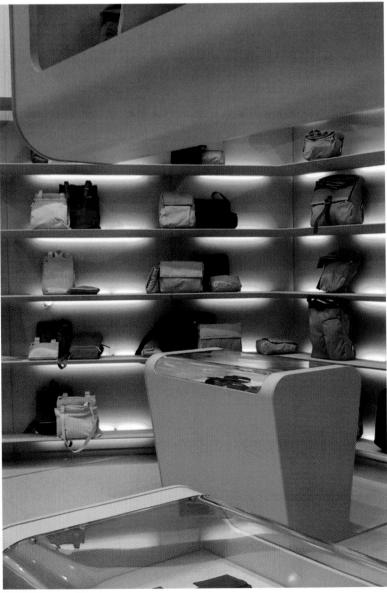

The modules that rise from the floor are equipped with drawers for storing products.

CAMPER / MADRID

Designer: **Martí Guixé**
Photographer: **Imagekontainer**
Location: **Madrid, Spain**
Opening date: **2003**

Camper's new space in Madrid is based on the "info-shop" guidelines proposed by Martí Guixé. After the successful results in London and Munich, Madrid was added to the new wave of camper establishments that are implementing this new concept in their interiors.

The design for this store consists of an encompassing three-dimensional program that recreates the Camper world. More than 700 samples of shoes are placed in the middle of the space, surrounded by drawings, collages, and press clippings that refer to the brand, as well as other elements neatly arranged in the setting, to create an encyclopedia of the Majorcan company. Evident among the many details is a drawing by Javier Mariscal and words of advice such as, "True beauty is on the inside".

Martí Guixé had already used this information as a decorative element in the Barcelona stores, where the walls morph into gigantic photographs. The store in New York's Soho neighborhood has handwritten text and drawings, and other stores, such as "walk in progress," contain a board for leaving messages.

The "info-shop" concept replaces expensive materials, complicated construction details, and exclusive elements with information. Guixé insists that this method allows the budget originally meant for unnecessary elements to end up in the hands of the authors, who create intellectual content, whether written or visual.

The functional aspect of the commercial space does not disappear; rather, it is layered over the information. Texts by different collaborators are spread across all of the surfaces, even the floor. On the ceiling, for example, can be seen 137 icons that represent the varied trends of today's society. In the case of the London store, the theme chosen as the subject of the exhibition is the history of the Majorcan donkey, icon of the brand's publicity campaigns.

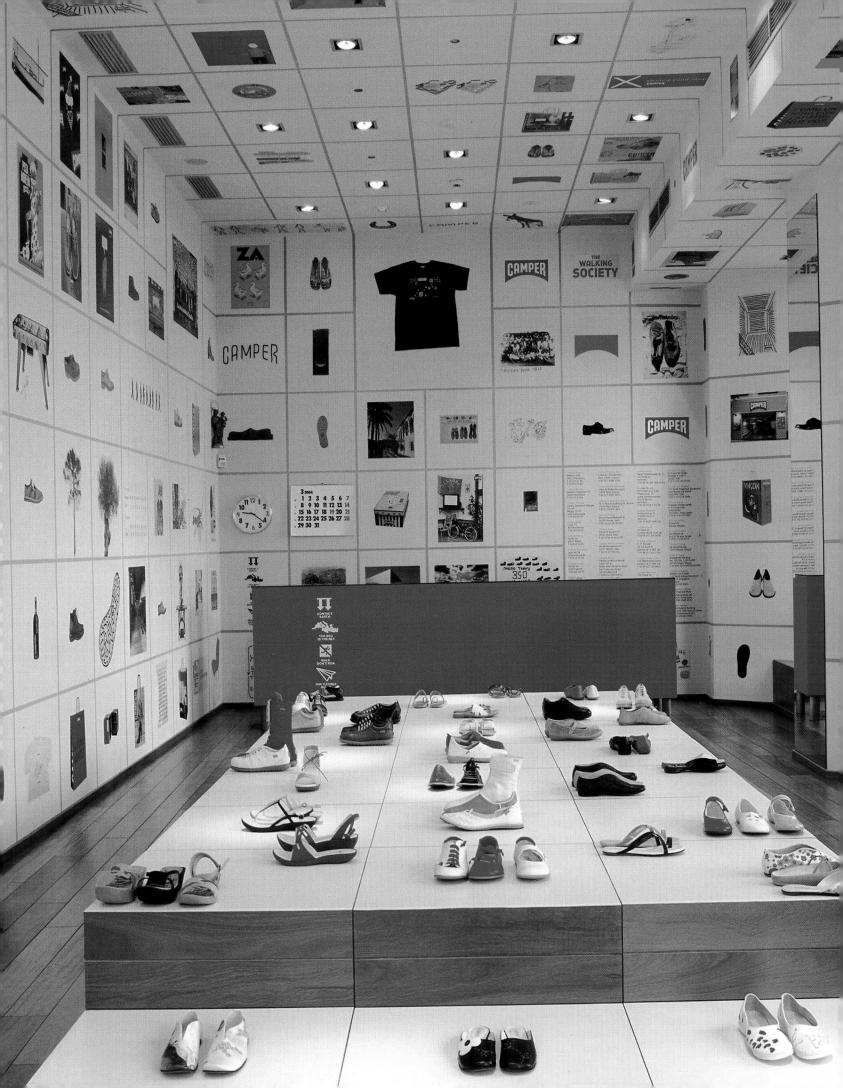

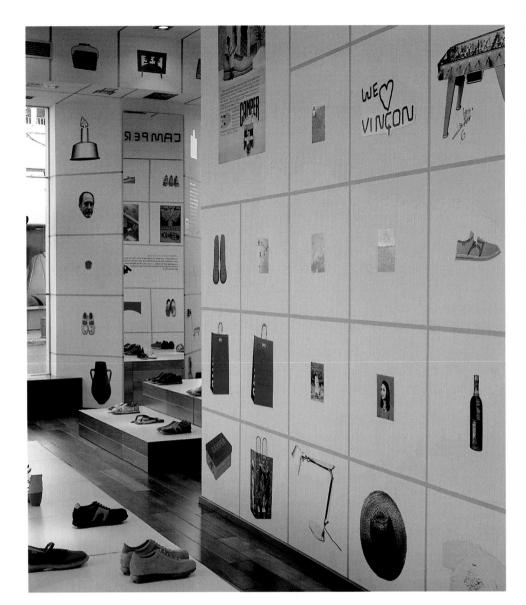

The structure becomes a visual enclosure that displays more than 900 references to the Camper world.

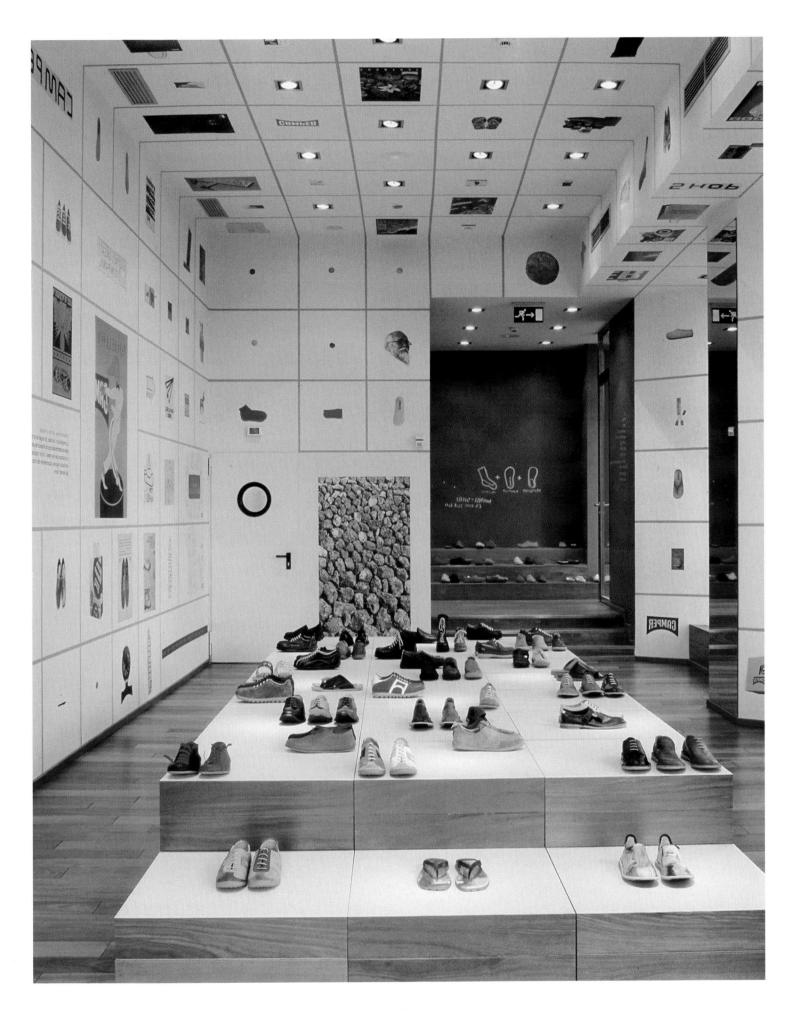

CAMPER / LONDON

Designer: **Martí Guixé**
Photographer: **Imagekontainer**
Location: **London, UK**
Opening date: **2003**

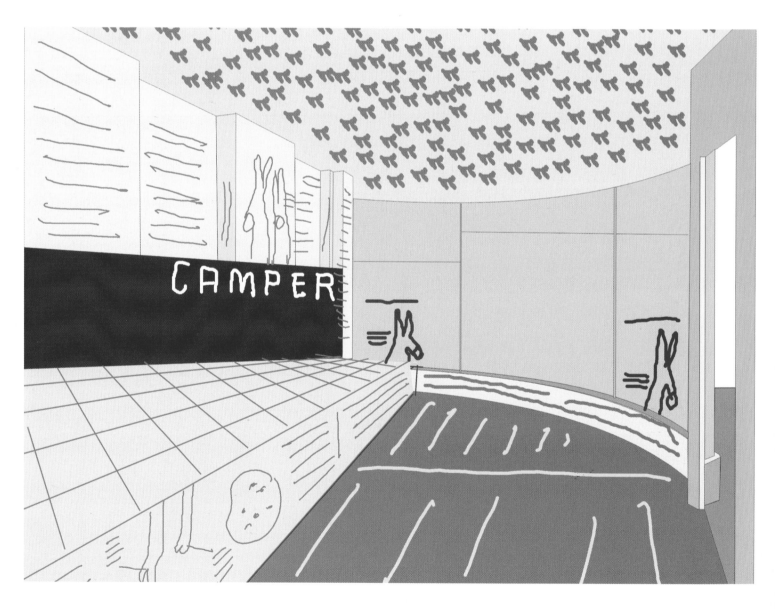

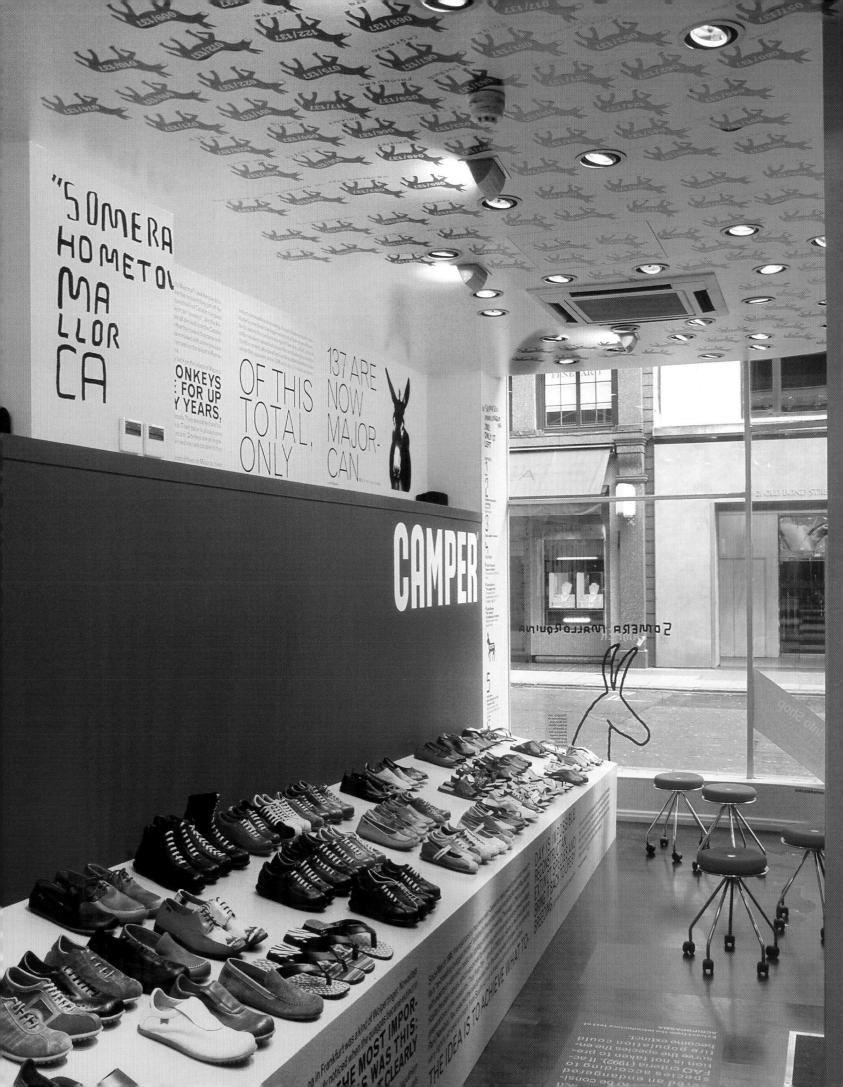

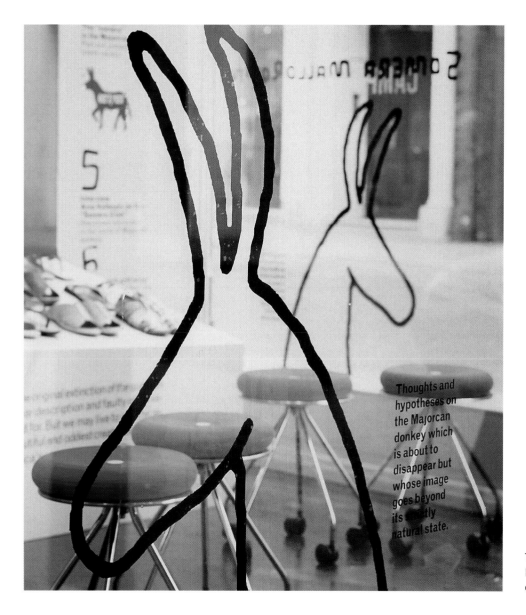

The history of the *somera*, a donkey indigenous to Majorca and icon of the brand, is the subject of an exhibition in the store.

Ceiling

Ground floor plan

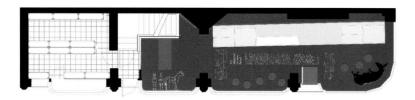

Elevations

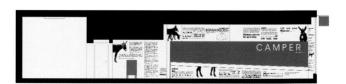

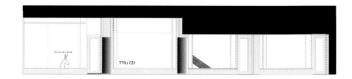

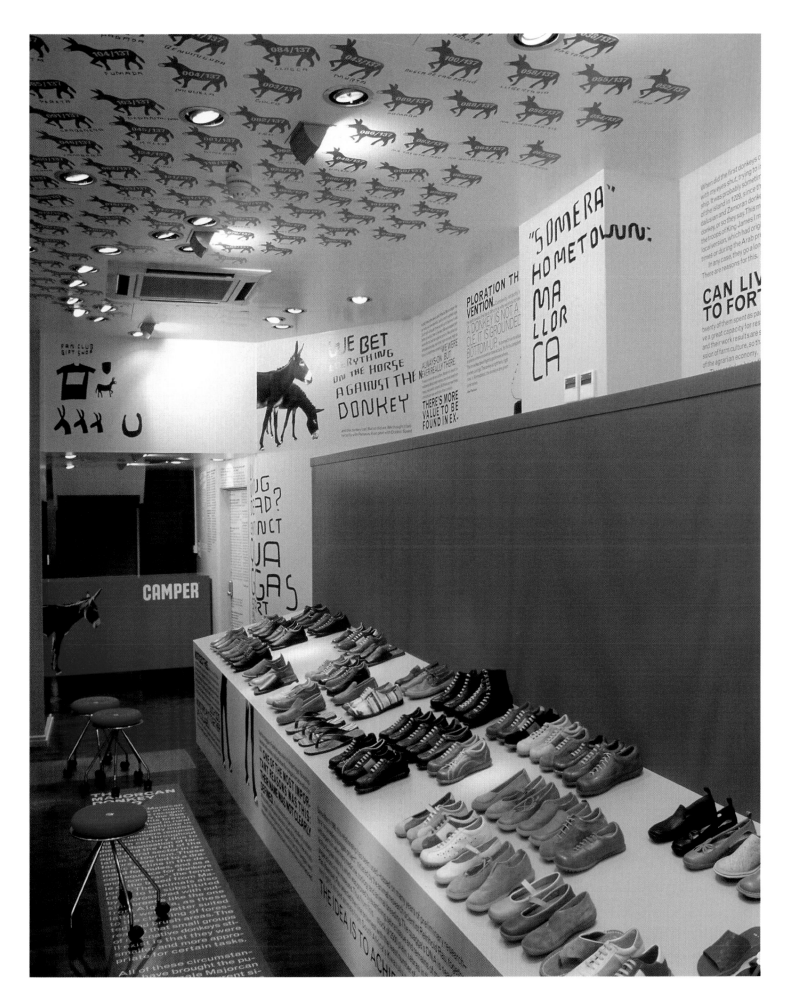

CAMPER / MUNICH

Designer: **Martí Guixé**
Photographer: **Imagekontainer**
Location: **Munich, Germany**
Opening date: **2003**

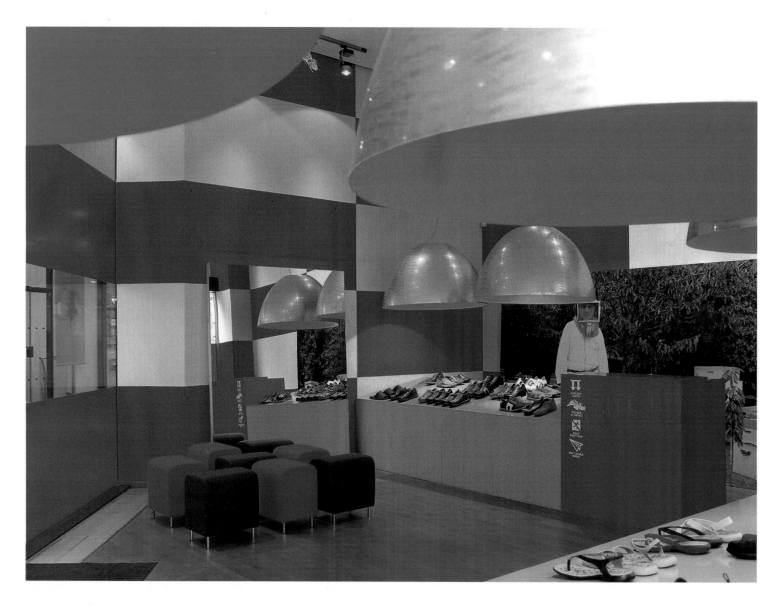

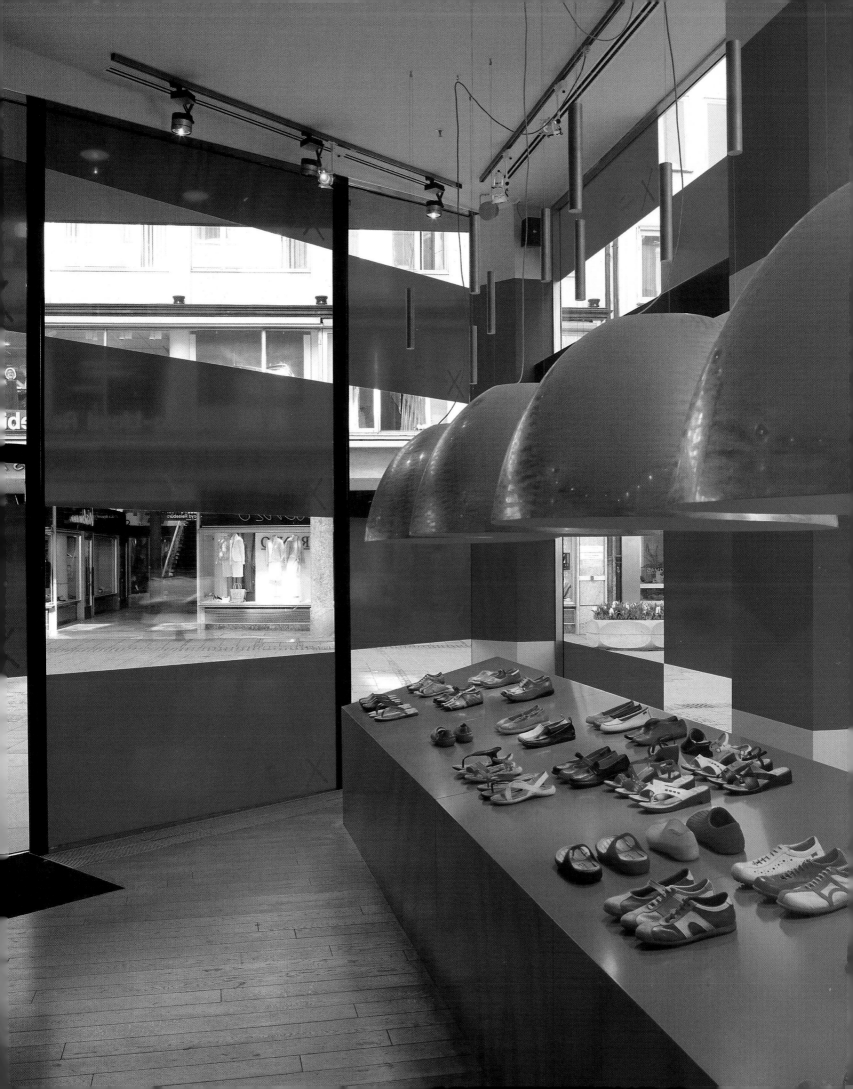

ANIMA

Designer: **Air-Projects**
Photographer: **Jordi Miralles**
Location: **Barcelona, Spain**
Opening date: **2004**

The Anima jewelry store is the paradigm of an interior that is pure, transparent, and scrupulous in its details. Air-Projects, the architects in charge of the project, began with a very small space. They had to create a design that would take full advantage of the floor plan so that the pieces on display would have breathing room.

Seen from the outside, the façade was totally covered with glass so that the interior would seem translucent to the customers. In the entrance, three pillars hold a selection of the designs sold inside. The shell of the store is a neutral box. The four surfaces that enclose the box—the floor, the two walls, and the ceiling—become four totally white planes that isolate the space. The tables where the jewelry is shown, the chairs, and the central counter all blend together in the same scrupulously white color. On both walls, transparent glass boxes act as displays for a selection of the best jewels. The rationality of the composition can also be seen in the distribution of these glass boxes, which are arranged in a rigorously studied order.

The interior takes full advantage of the natural light that flows through the clear window during the daytime. Nevertheless, a channel for lighting was designed to run along the tops of both walls, which increases the sense of three-dimensional space.

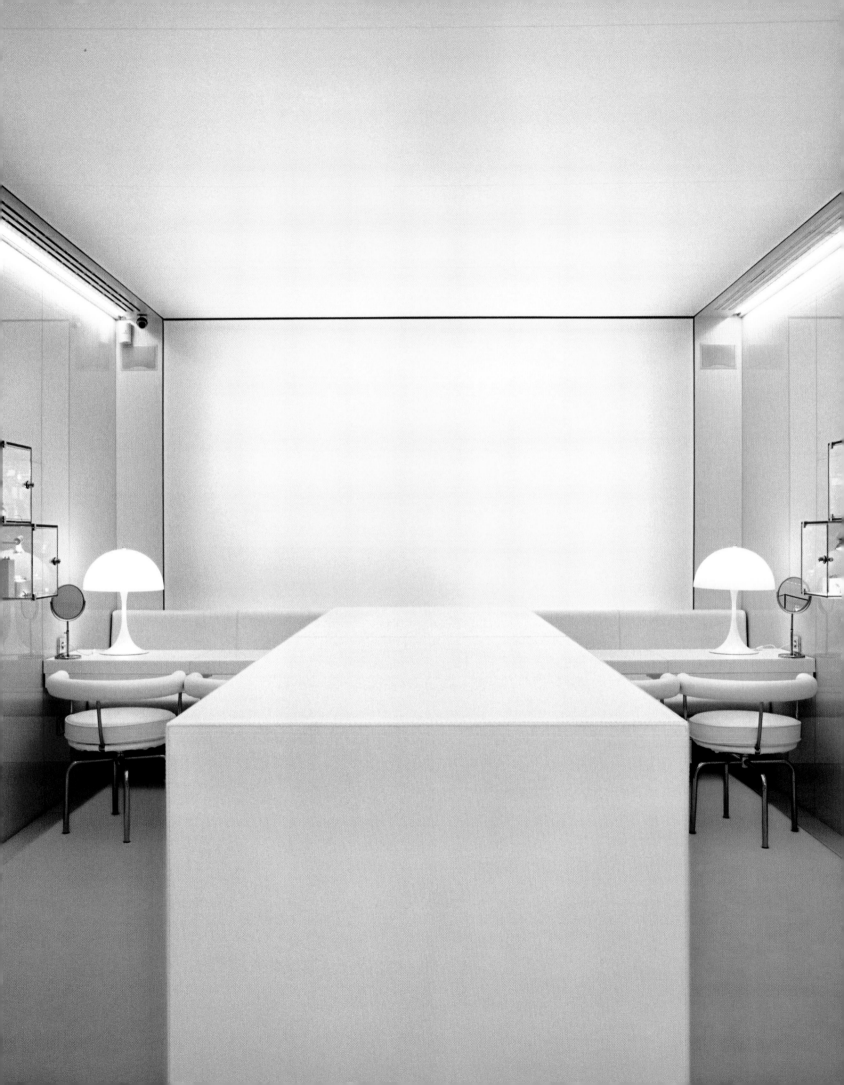

ÅNIMA

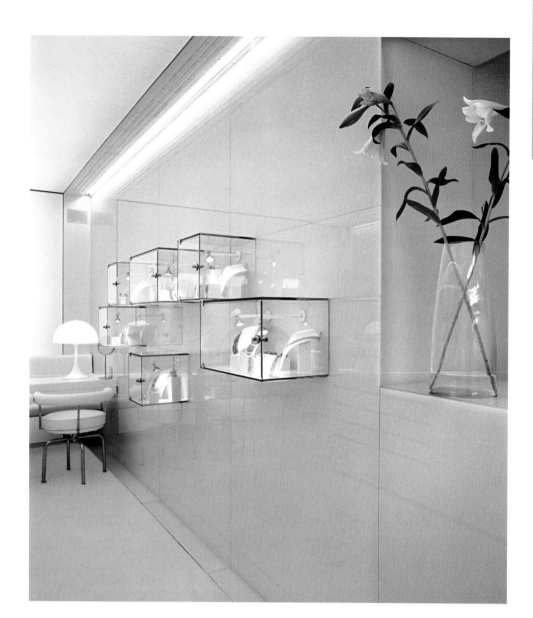

A selection of jewels are exhibited inside the glass boxes.

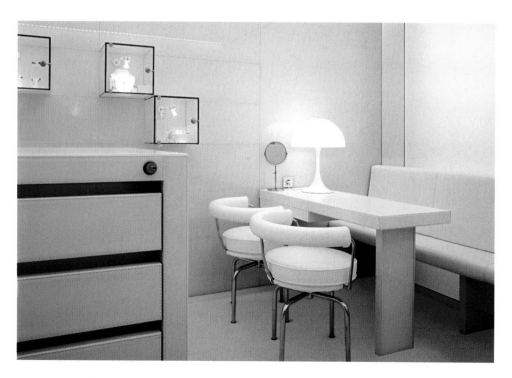

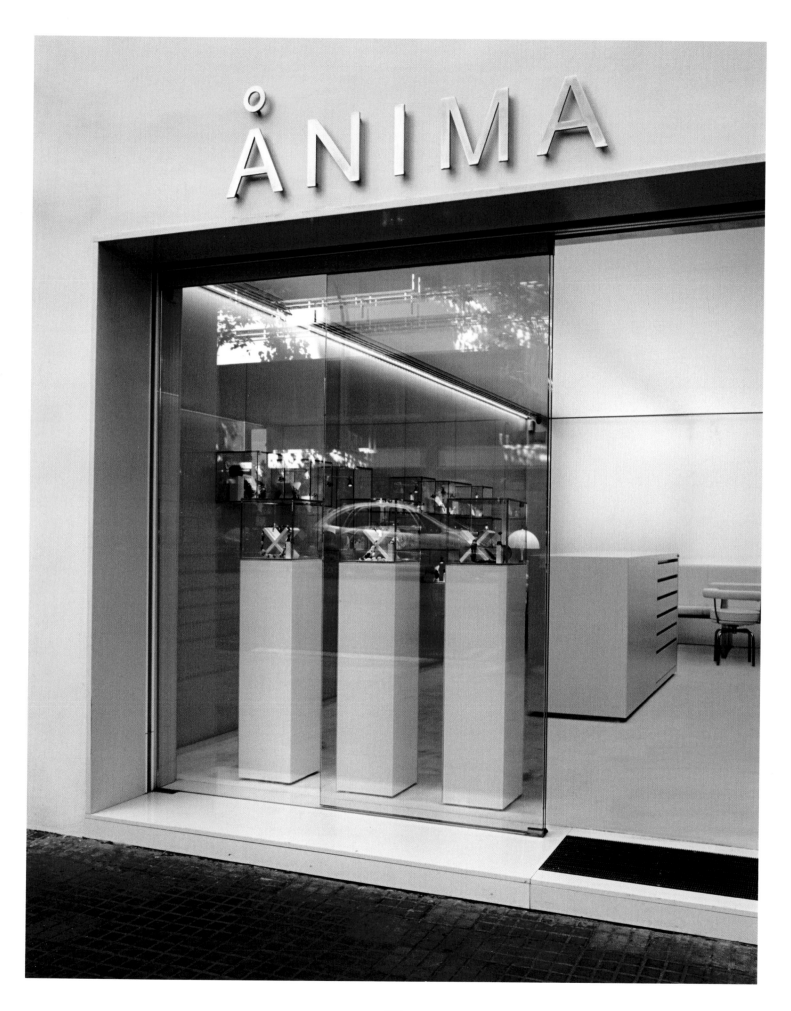

A minimal, all-white decoration allows the small space
of the shop a certain amount of breathing room.

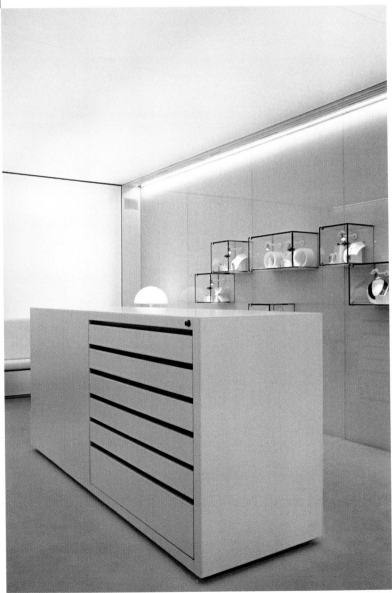

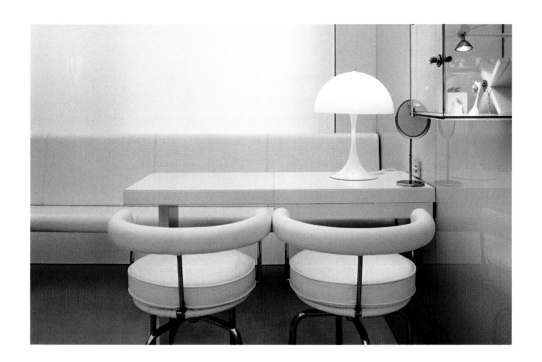

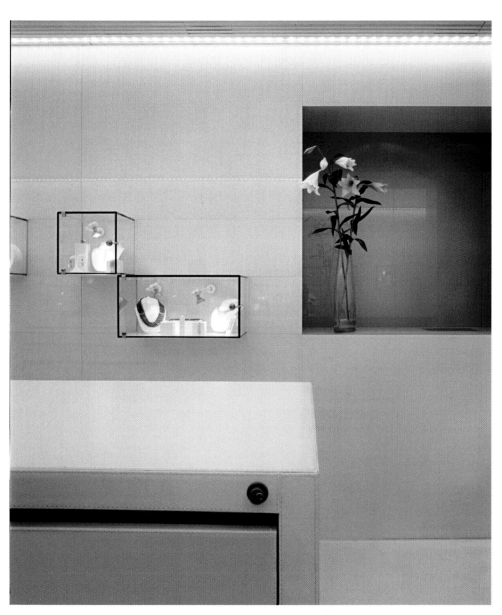

B-JIRUSHI YOSHIDA

Designer: **WonderWall Inc.**
Photographer: **Kozo Takayama**
Location: **Daikanyama, Japan**
Opening date: **2003**

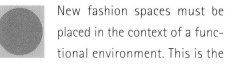

New fashion spaces must be placed in the context of a functional environment. This is the idea that WonderWall has brought to fruition in some of its latest projects, which include two totally different stores in the same building. On the first level is B-Jirushi Yoshida, a well-known handbag company; on the second is Beams T, an avant-garde T-shirt gallery and shop.

WonderWall had help from the famous handbag designer Yoshida Kaban with the concept of the store's interior (his name has a double meaning since Kaban means bag in Japanese). The space had to fulfill one requirement: reflect the deeply rooted tradition of the handbag brand. To do this, WonderWall experimented with materials, mixing different textures and playing with the details of the interior. Seen from the outside, the building has two completely different levels that are perfectly integrated in a single structural skeleton.

One of WonderWall's objectives was to design a calm and peaceful interior. This comfortable space was achieved by juxtaposing the textures of warm materials against the coolness of transparent surfaces. The floor and several counters make use of dark wood. The contrast between this material and the polished surfaces of the display tables and the glass displays create a perfectly balanced and neutral exhibition space. A transparent, glass-covered structure can be seen overhead, perforated by several taut metal cables that suspend it from the ceiling, illuminating the space.

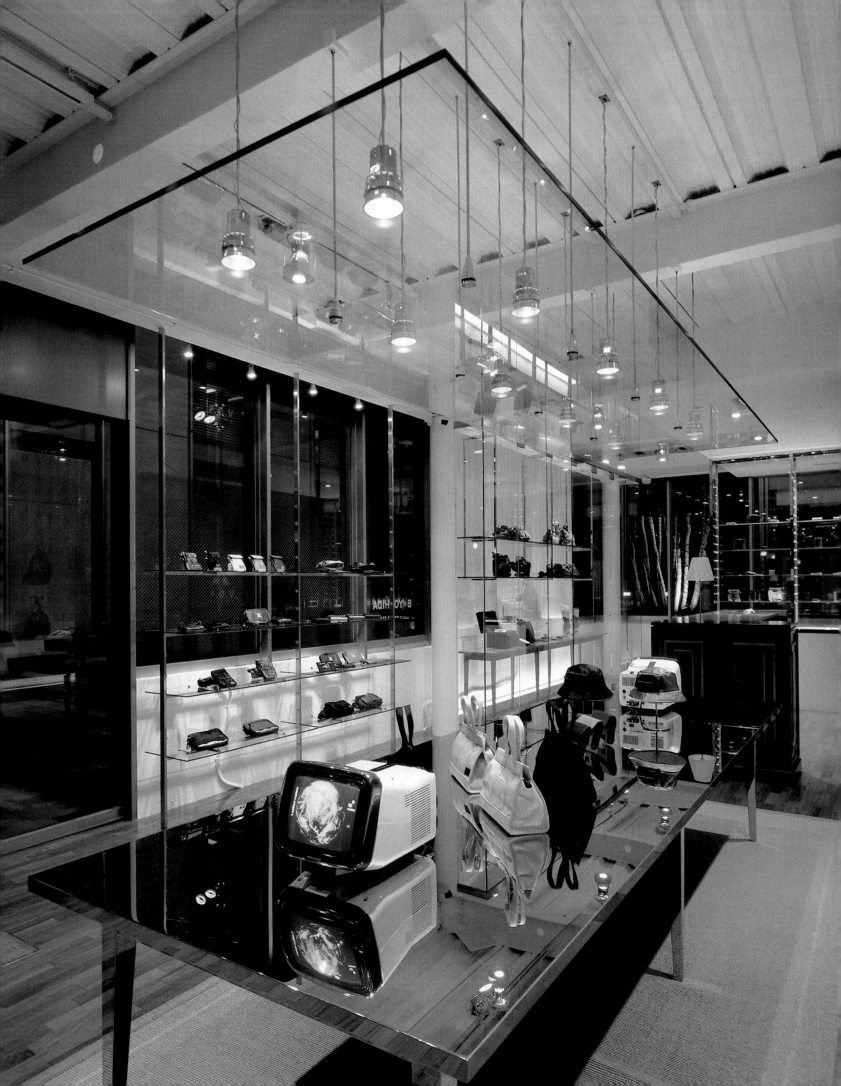

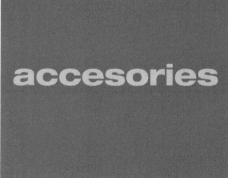

B⊞YOSHIDA

The light cast by lamps that hang from the ceiling filters through a transparent surface that softens the intensity of the light in the center of the space.

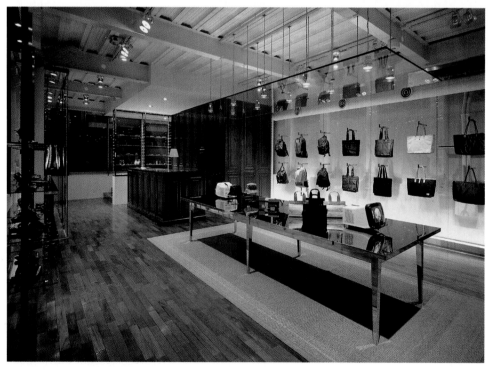

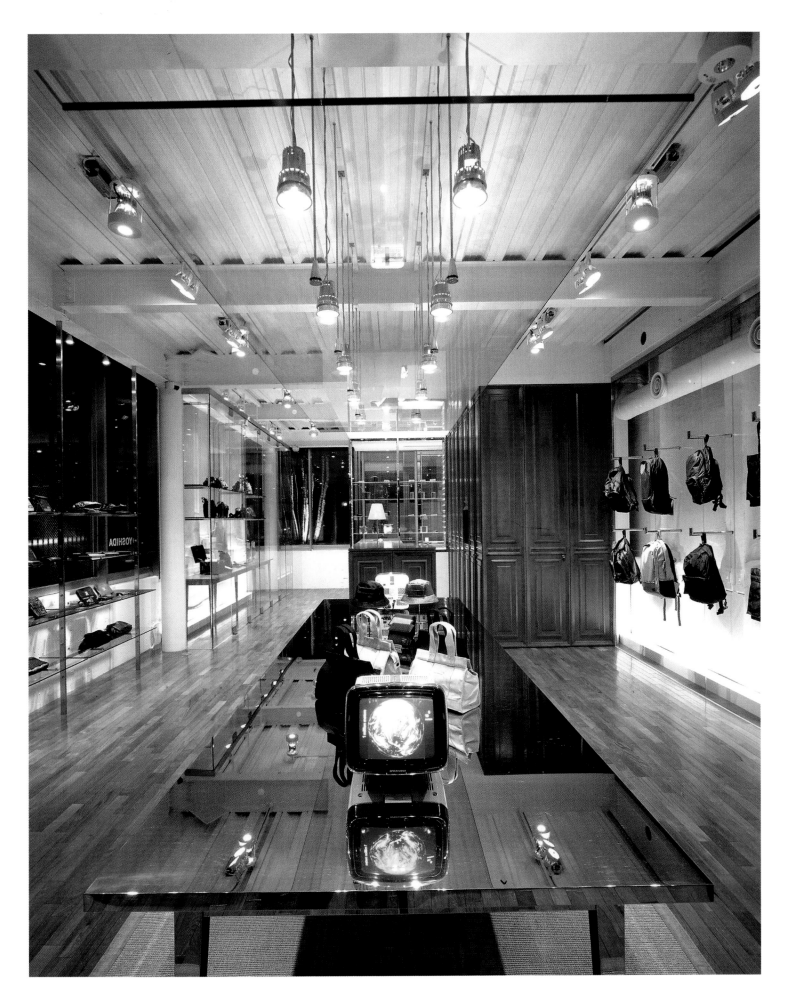

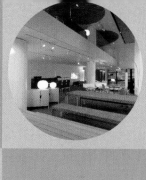

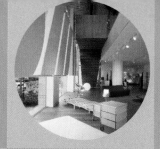

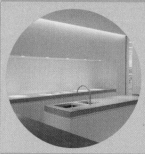

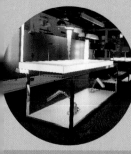

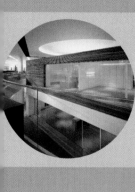

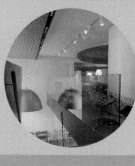

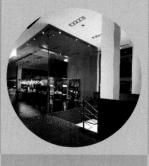

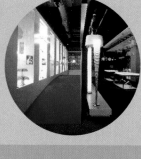

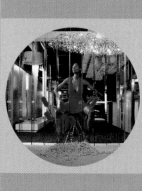

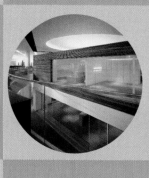

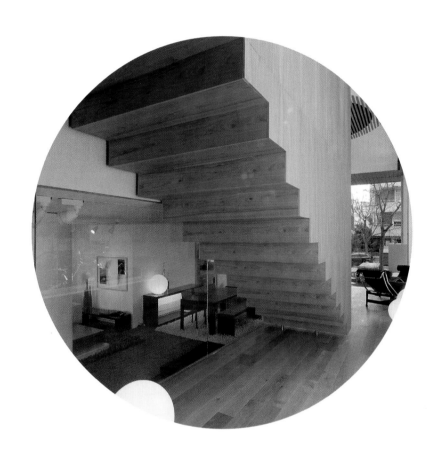

HOME
DESIGN

PILMA

Designer: **Eduard Samsó**
Photographer: **Jordi Miralles**
Location: **Barcelona, Spain**
Opening date: **2003**

The eclecticism of the materials used in this project was inspired by that of the best furniture and accessory designs sold in Pilma, a prestigious store located in Barcelona.

The architect, Eduard Samsó, used a mix of warm materials such as wood to contrast with the cool coloring of the white structure. The space is distributed on two levels that are connected by a spectacular transitional passage—a wood staircase whose exterior follows the outline of each one of the steps.

The play of geometry is repeated in the layered treatment of the wood in the ceiling. A surface reminiscent of a wood trellis runs across the entire ceiling with a sinuous and curving line. This technique not only layers the spaces, but creates contrast and dynamism in the interior. The central counter and the rest of the auxiliary counters were also built with wood. The center counter makes a half circle near the entrance. The counter and the wall that extends behind it were finished with the same material: this helps customers locate the cashier area, which is a compact unit.

The shelves that hang from the ceiling on thin wires are an example of consistency in the architect's use of materials. Paralleling the unifying effect of the wood used throughout both levels of the store is the cool, hermetic feel of the stainless steel shelves and the impressive interior lighting.

The lighting is what contributes the most to the project. Natural light filters through the magnificent front glass window to the interior. Various light fixtures, some similar to those that are available for sale, illuminate the areas that receive less natural light.

Overall, the project reflects a commanding use of the large space, with impressive white columns and many opportunities for mixing different techniques and styles.

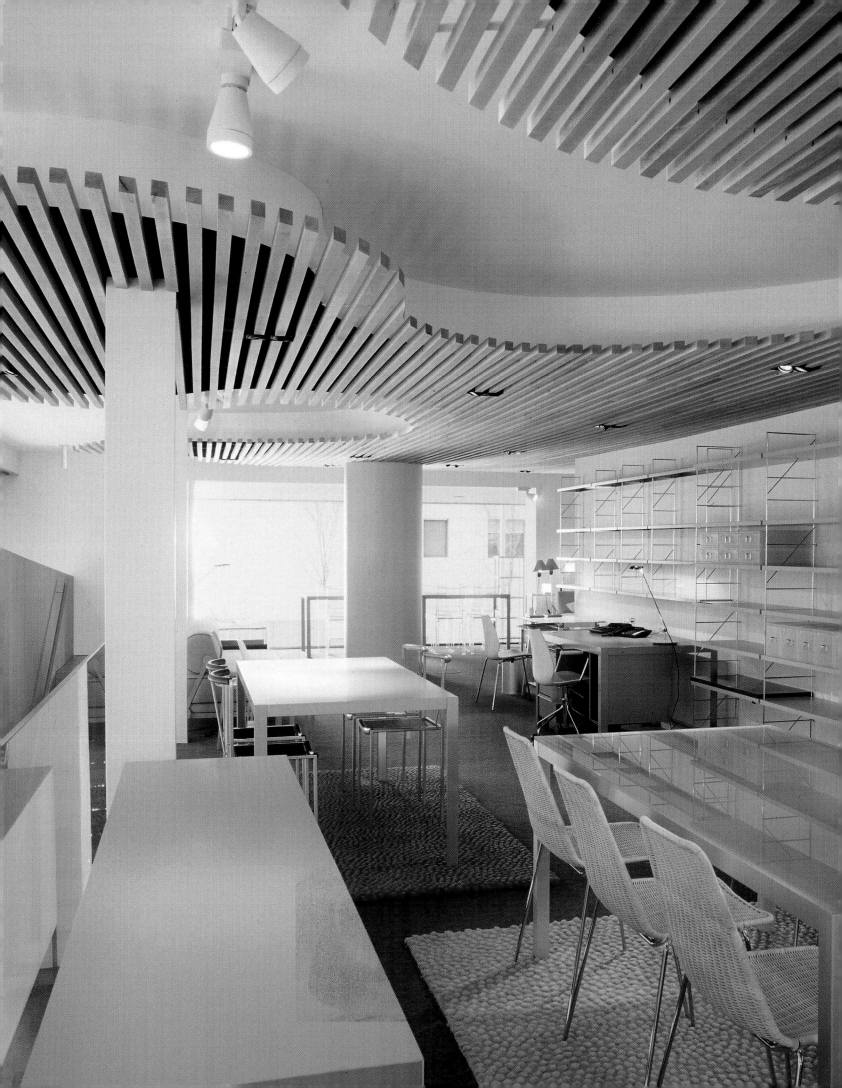

home design

pilma

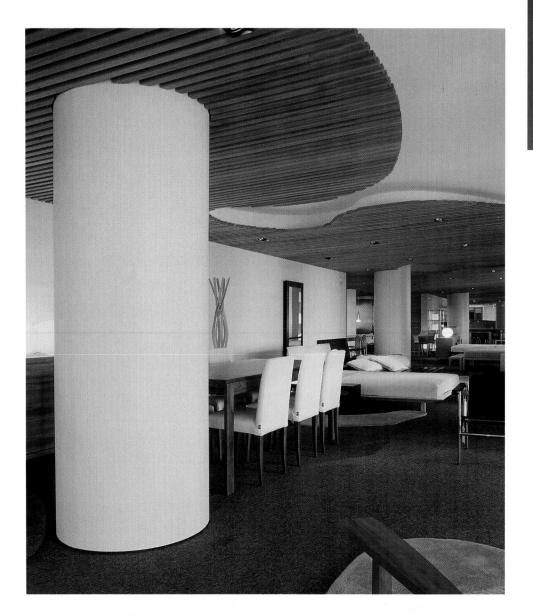

Warm materials such as wood contrast with the cool textures of stainless steel.

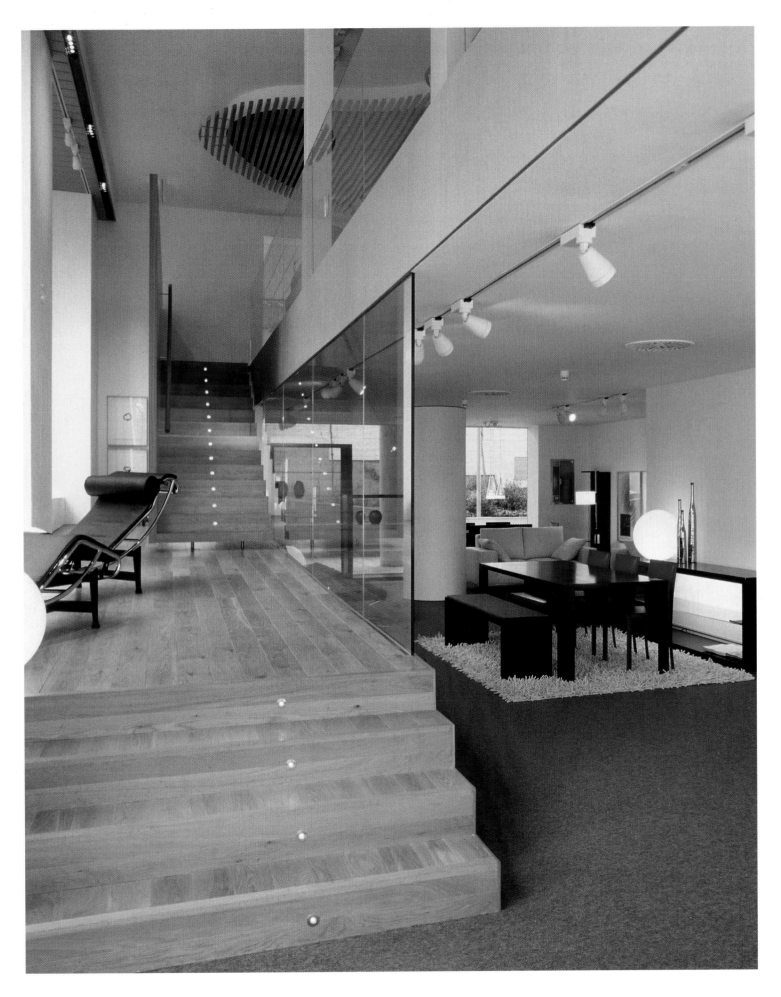

A lattice made of thin wood sticks covers part of the ceiling with an engaging geometric shape.

A wood stairway, whose exterior structure echoes each one of the steps, leads to the second level of the floor.

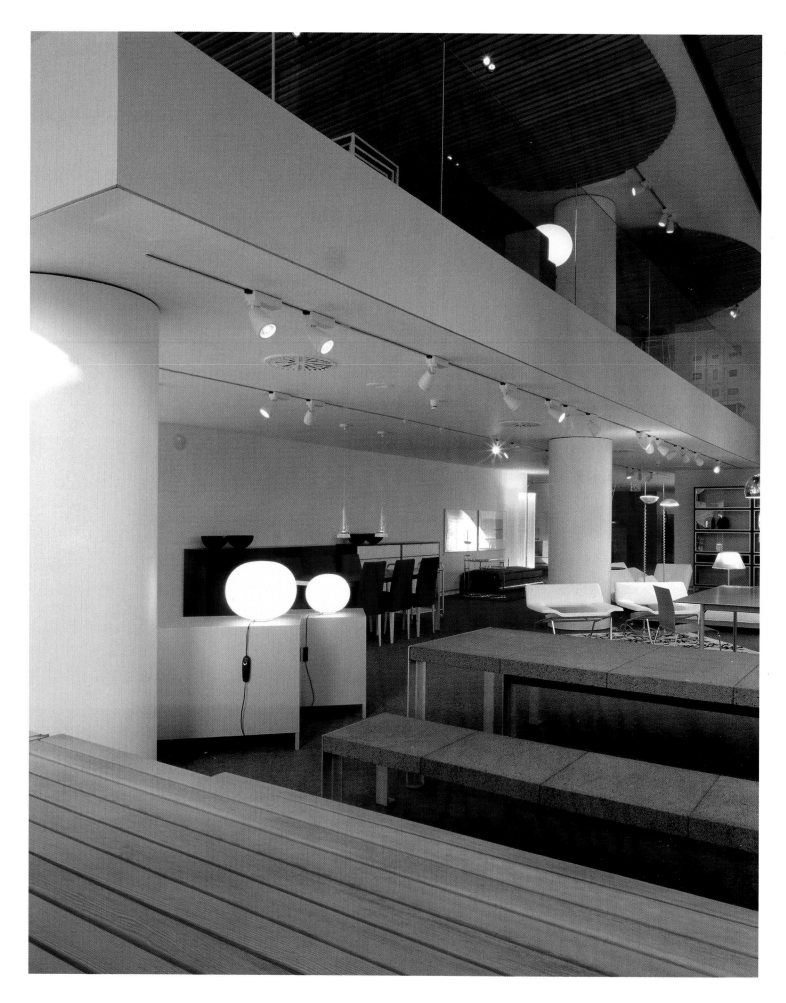

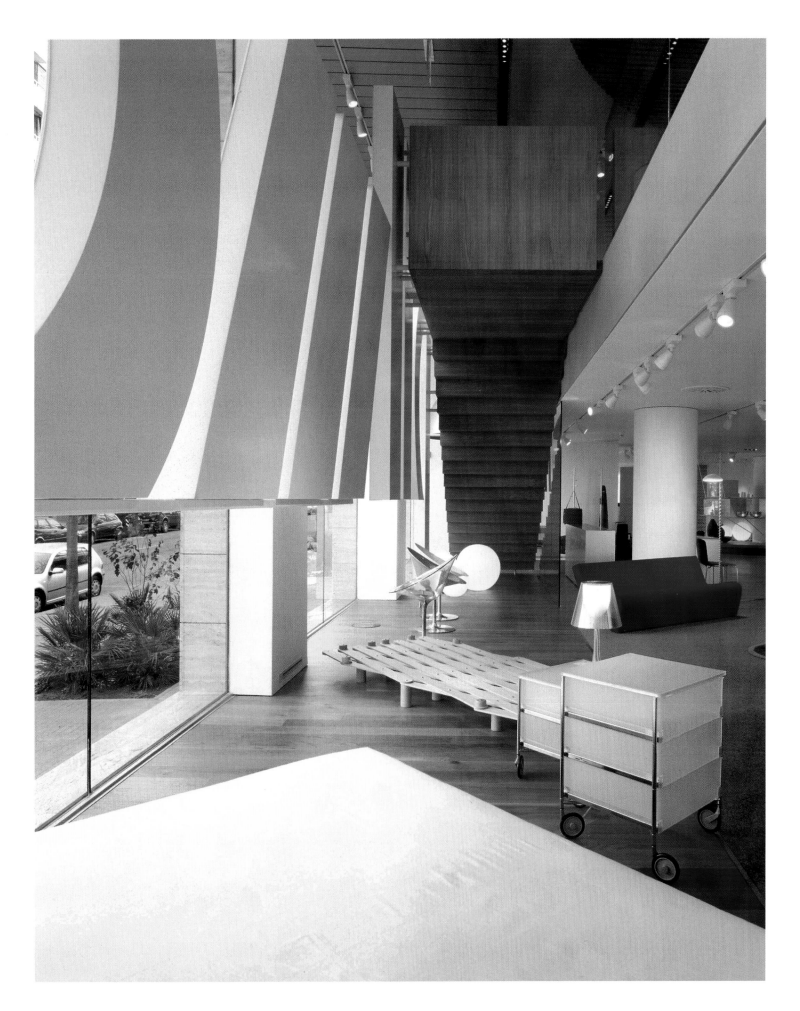

B&B ITALIA

Designer: **Antonio Citterio and Partners**
Photographer: **Fabrizio Bergamo**
Location: **Milan, Italy**
Opening date: **2002**

The new B&B Italia space in Milan occupies 18,300 square feet (1,700 m²) on three levels of a well-known building that was built in 1960 on the Via Durini.

The layout for the displays in the store, designed by the team of Antonio Citterio and Partners, offers the customer several settings in which the furniture is shown in a warm and comfortable context, as if the clients were sitting in a room in their home. The importance of the space is accentuated by the double height of the main level and the reflective finishes of the basement level, which combines opaque and transparent objects.

The black compartment that hangs from the façade displays the Maxalto collections; the green and yellow glass boxes stacked double on the main level divide the available space and indicate the different areas where the products are exhibited. The offices, on the other hand, are located on a mezzanine, their enclosure semi-reflective.

Below the mezzanine, three transparent glass boxes printed with graphic designs are used to show furniture pieces among photographs of daily life. The black cement floor, the thickness of the different colored glass panels, the black shelves, the etched steel, and the aluminum panels installed in the ceiling all generate great contrasts in the store's interior. The provocative use of these hard materials creates an atmosphere based on variety and contrast

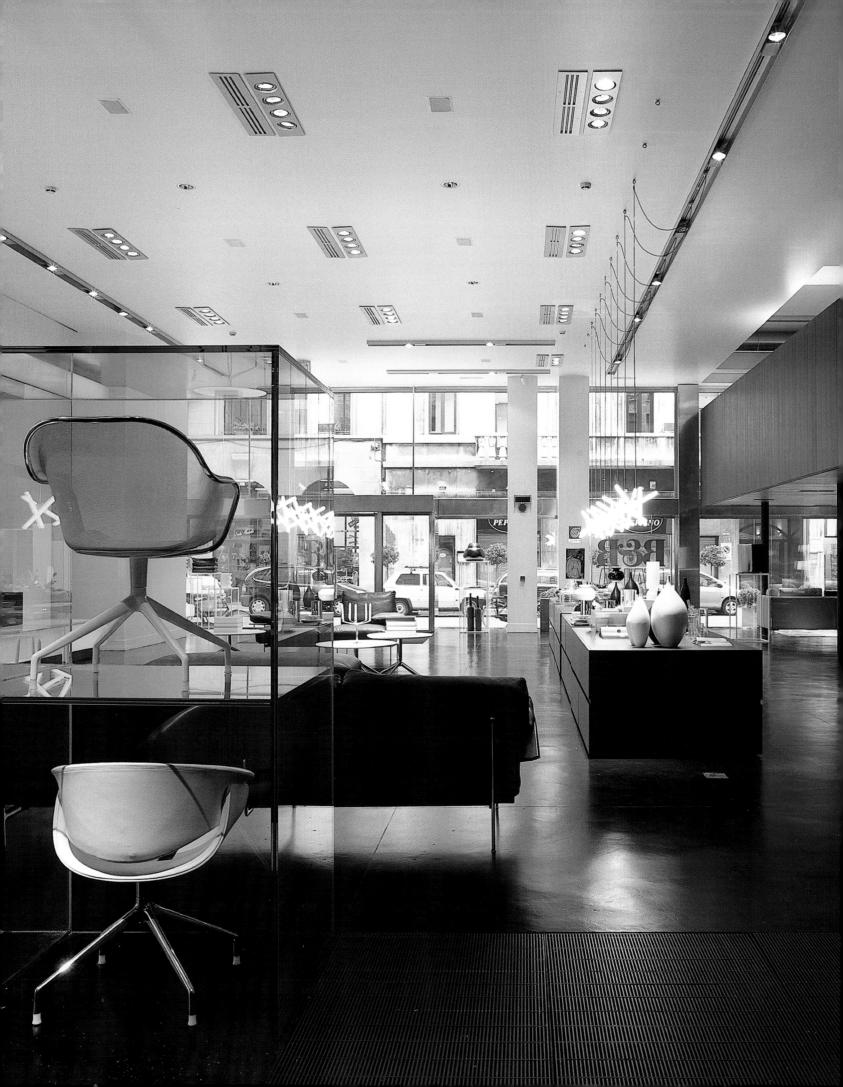

B&B ITALIA

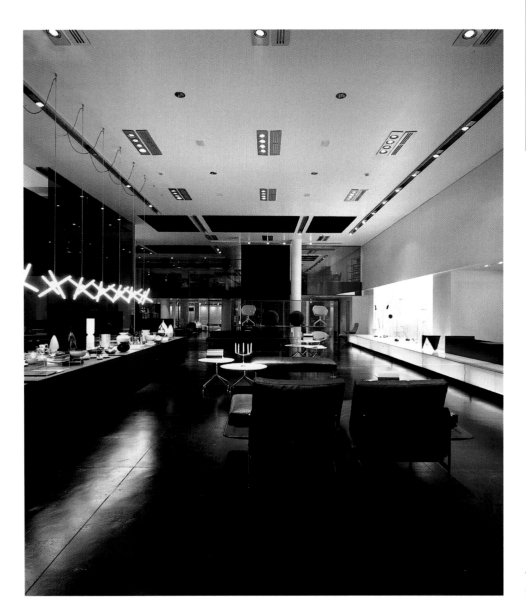

The original light fixtures can be seen hanging from the ceiling in the form of stars.

Floor plan

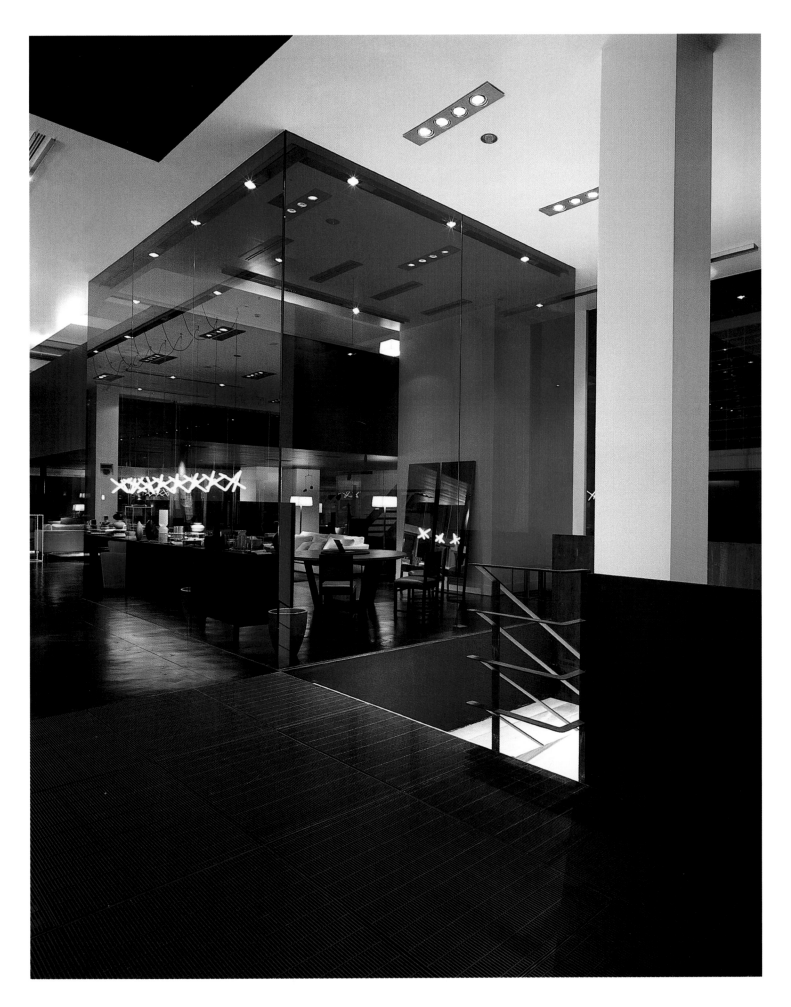

The store extends through three levels, using a great variety of textured materials.

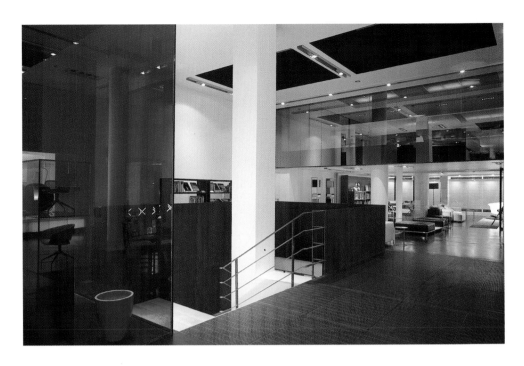

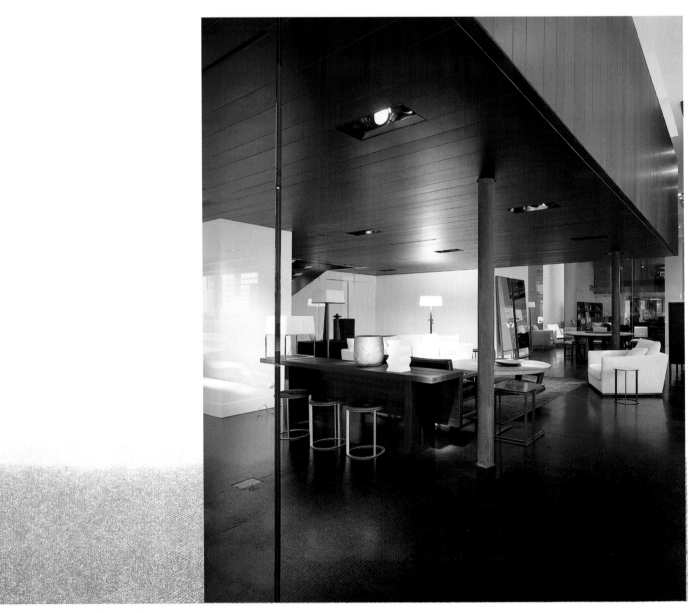

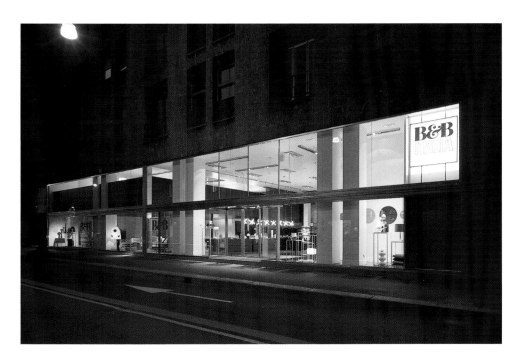

This shop is located in a well-known building constructed in 1960 on the Via Durini in Milan.

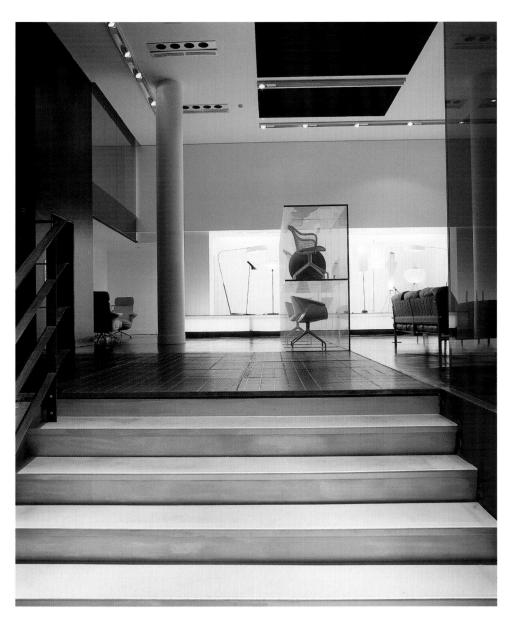

MARKS & SPENCER LIFESTORE HOUSE

Designer: **John Pawson**
Photographer: **Richard Davies**
Location: **London, UK**
Opening date: **2004**

A daring move was made recently by Marks & Spencer with the appointment of Vittorio Radice as the person responsible for the wide range of home products that are sold under their brand. His aim was to create a house within the retail space itself, an architectural work created entirely for the consumer's exploration.

To bring this concept to fruition, Radice relied on a team of the best British designers. The Minimalist architect John Pawson was in charge of designing a white box inside the store that would be turned into a home. Ilse Crawford, former editor of the magazine *Elle Decoration*, was given the task of styling the interior, while Tyler Brûle, founder of the magazine *Wallpaper*, was charged with redesigning the product offerings to add a contemporary touch to the Marks & Spencer Lifestore line.

John Pawson designed two homes in two open spaces, one of them with two levels. The exterior is based on a two-color combination of materials: the main floor, where the entrance is located, is covered in white stucco, contrasting with the upper level, which is covered with cedar wood siding. The architect's intention was to lighten the perception of such a large structure. Inside the house, several details of John Pawson's architectural style can be seen—spaces that seem to purify themselves within the white surroundings offer seemingly exclusive objects that are within the reach of the buyer.

In a very short time Marks & Spencer plans to open twenty Lifestore shops, building upon the favorable reception of the London store.

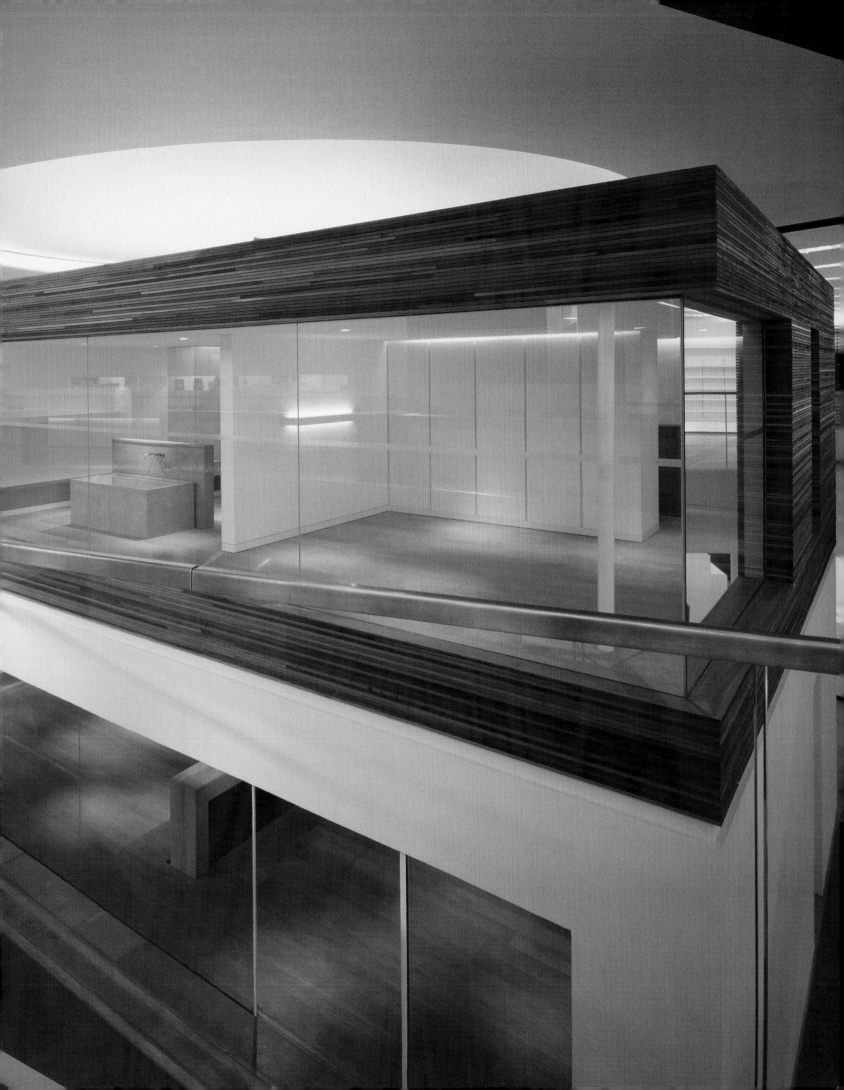

MARKS & SPENCER
LIFESTORE

A model home was built inside the store to encourage consumer exploration.

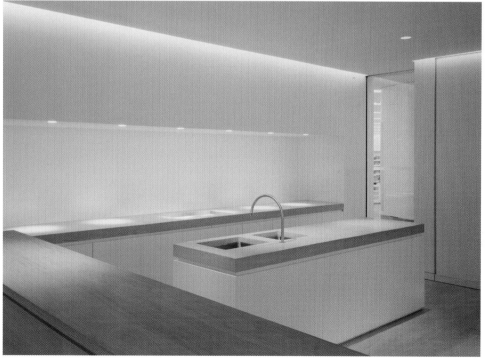

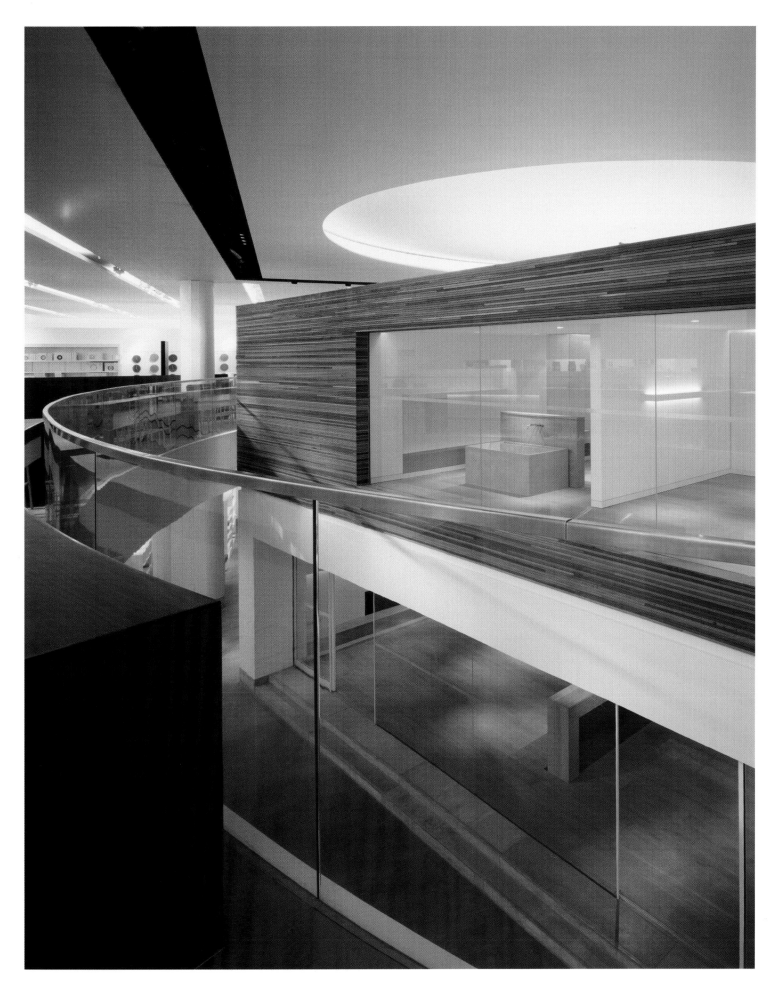

BIOSCA & BOTEY

Designer: **Bonjoch Associats**
Photographer: **Raimon Solà**
Location: **Barcelona, Spain**
Opening date: **2004**

Biosca & Botey treats its lamps as if they were jewels, a concept designed to make each customer feel that the particular and special piece that they are looking for does exist. This new store tries to convey a sense of comfort, to be a place where each client can be personally attended to without sacrificing the modern, relaxed, and contemporary feeling that reflects the evolution in shopping that the firm and its clients have experienced.

Combining the world of lamps with the interior design of the store, Ignasi Bonjoch created a display window in which the background is composed of twenty vertical pieces of glass placed in a line. The characteristics of the glass create bright reflections similar to those created by antique lamps with hanging crystal teardrops.

On the side, six vertical mirrored pieces create a very peculiar optical effect. The store's façade, composed of a window that covers the entire entrance, is simple and dynamic. The outside visually attracts customers to the interior of the shop, which is barely 1,500 square feet (140 m²).

A red carpet guides the visitors. This path becomes a ramp that crosses through part of the store. The ceiling lamps hang parallel to the path on the ramp, while floor lamps are located to the right on an elevated platform.

The highest part of the ramp becomes a viewing area for observing the movement in the store. The visit becomes a pleasant walk through a garden of lights, where each sample has been placed with care.

BIOSCA & BOTEY

A neutral environment was created with a minimum of materials so the space would not be overloaded once the lamps were displayed.

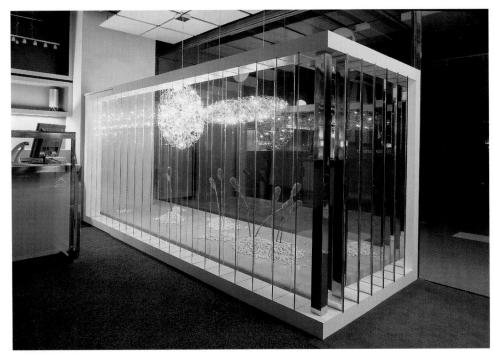

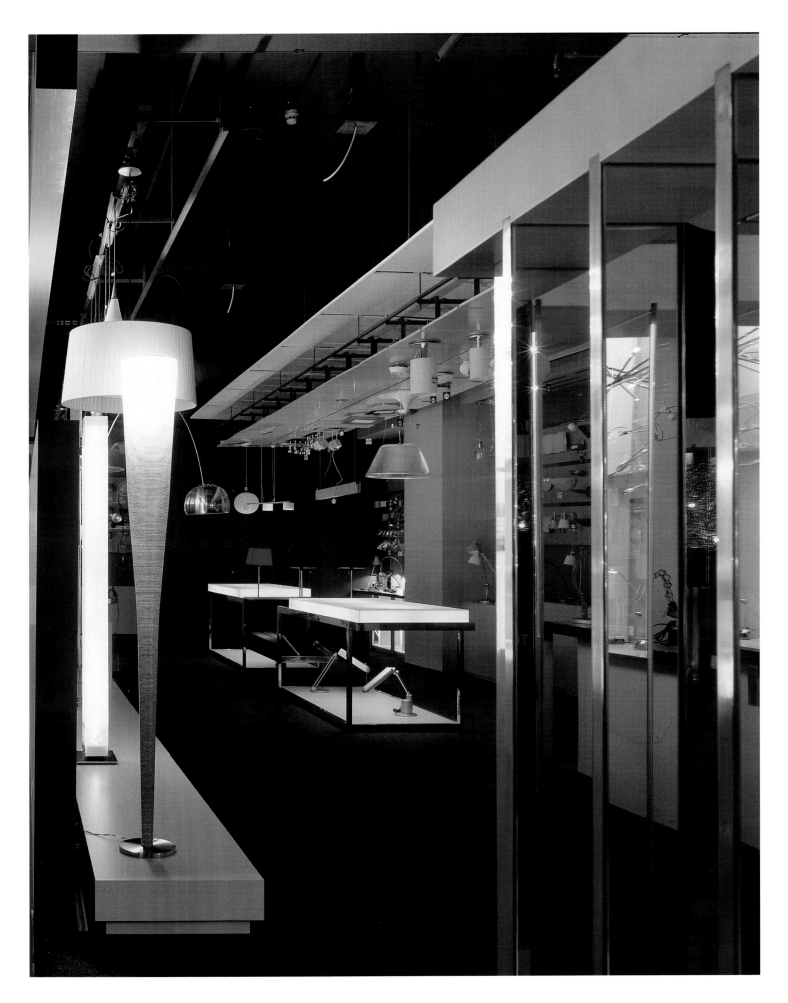

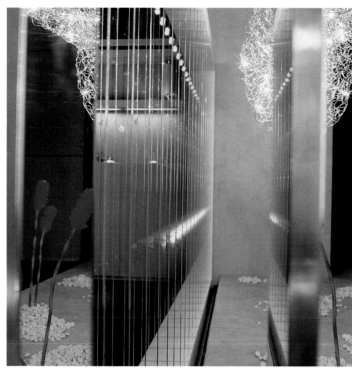

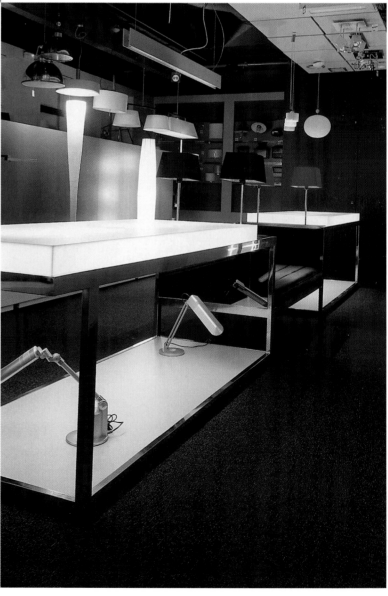

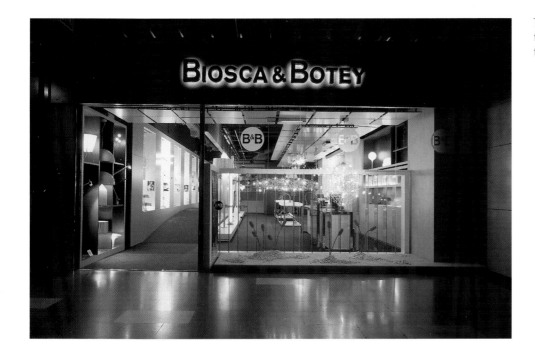

The display window is completely glassed in, except for the space needed for access. Seen from outside, the store is a visual advertisement.

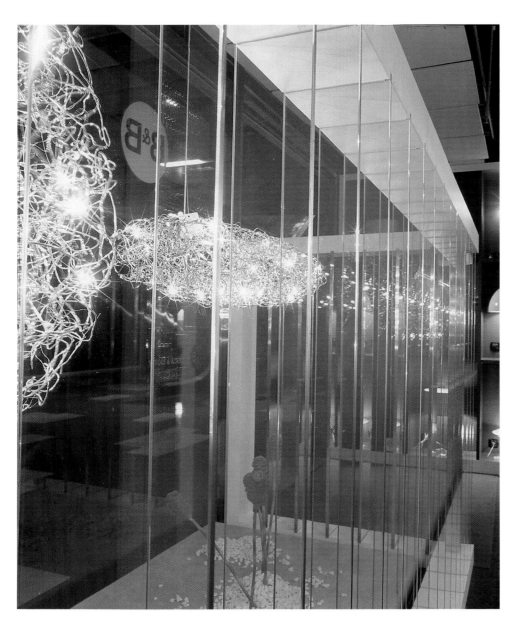

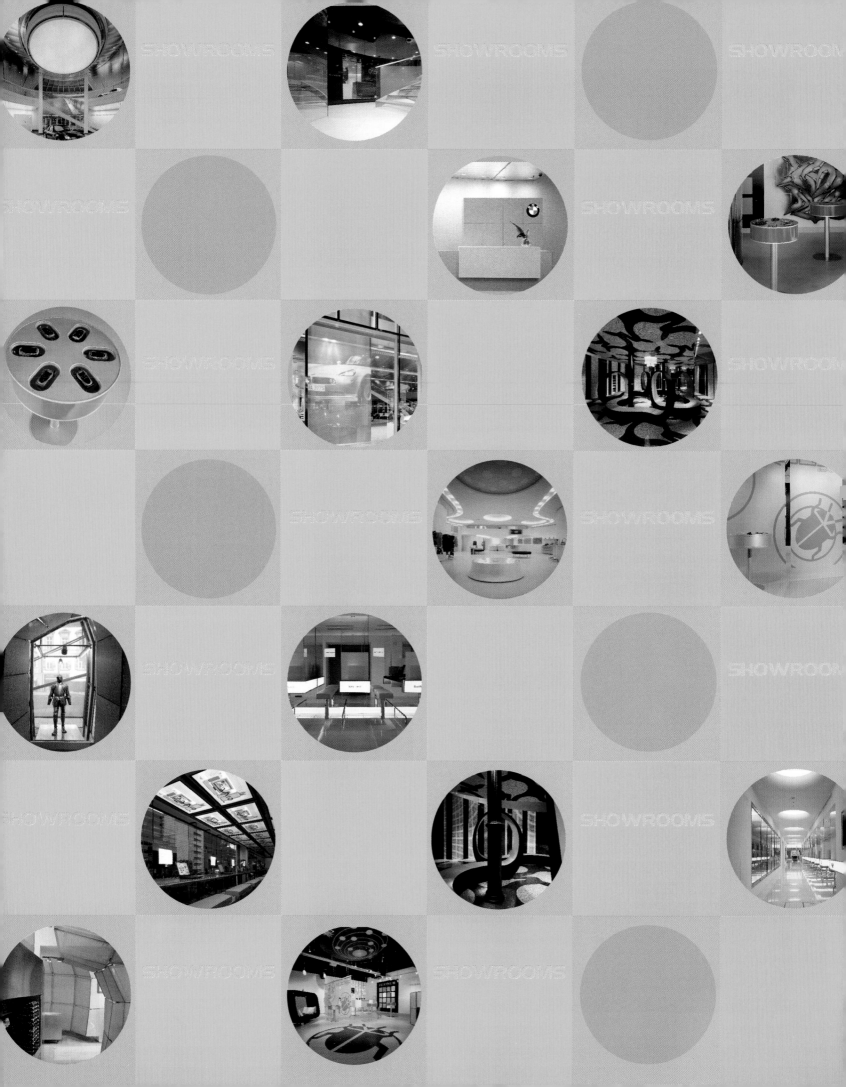

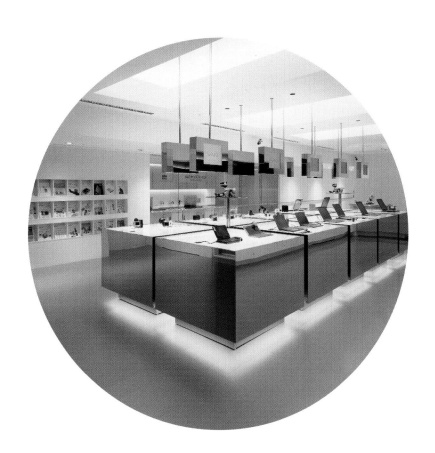

SHOWROOMS

BISAZZA SHOWROOM

Designer: **Fabio Novembre**
Photographer: **Alberto Ferrero**
Location: **New York, USA**
Opening date: **2003**

The art of the mosaic is exhibited in this new showroom that the Italian firm Bisazza opened on Greene Street in New York's Soho neighborhood. Once again, the Milanese designer Fabio Novembre, the man who developed the concept for the latest Bisazza showrooms, winks at the design world with this new project.

The space is located in a classic New York loft with a rectangular floor plan. Novembre created a symmetrical interior in which the columns rise to the ceiling and set the style for a design that flows with total freedom.

The classic façade that surrounds the showroom opens to a stunning interior, behind which is hidden a small, enclosed garden. The volumes, materials, and blue tones of the mosaics surround visitors with a theatrical interior that encourages the contemplation of the product being displayed. Novembre, a master of imaginary landscapes that use the glass tiles of the Italian company, converted the Greene street loft into a fairy-tale interior. The central element of the project is a structure that undulates animatedly, like a projection of the classic figure of Medusa. The serpentine line breaks the symmetry of the surrounding walls. At the same time, some Medusa lamps by Jacopo Foggini hang from the ceiling, and the silhouettes of organic forms are reproduced on the floor in blue and black mosaic pieces. The intensity of the showroom's landscape turns this New York space into a work with one of the most visual impacts in contemporary interior architecture.

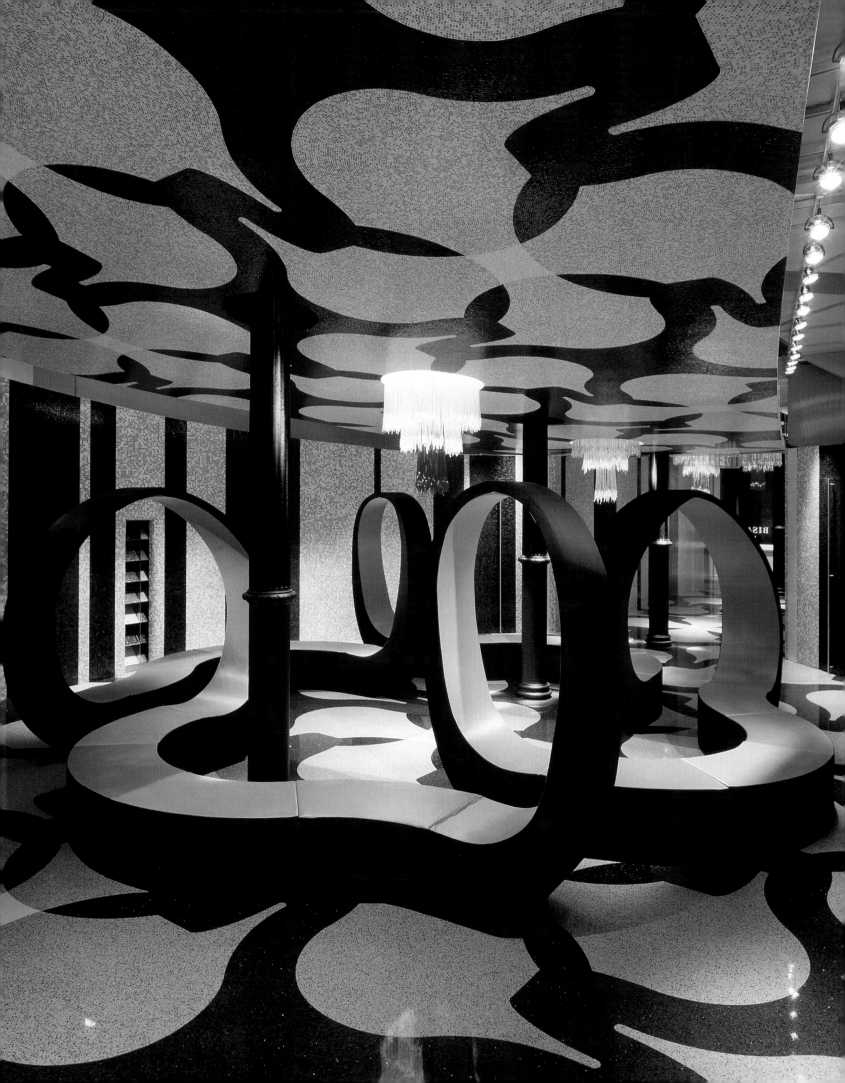

BISAZZA
MOSAICO

The serpentine shape in the center is reminiscent of a lively medusa undulating in the interior.

Elevations

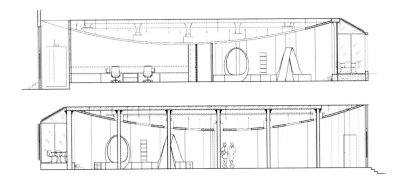

Floor plan

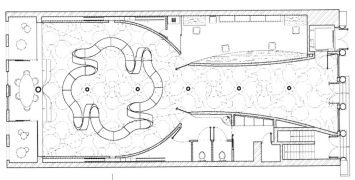

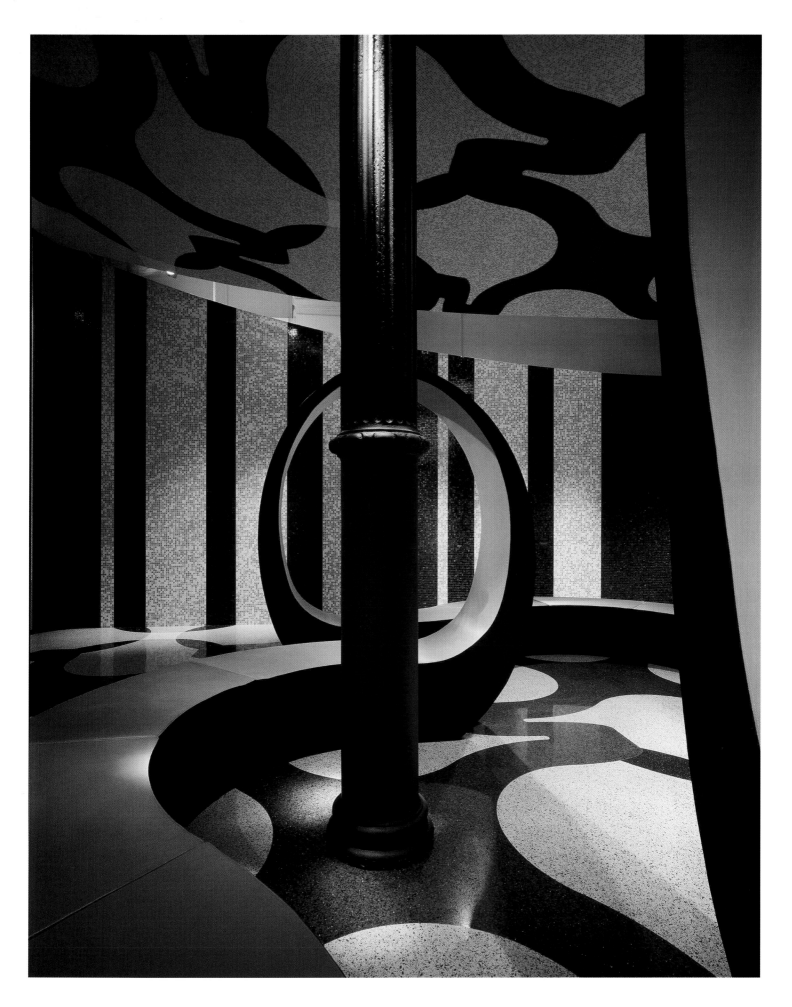

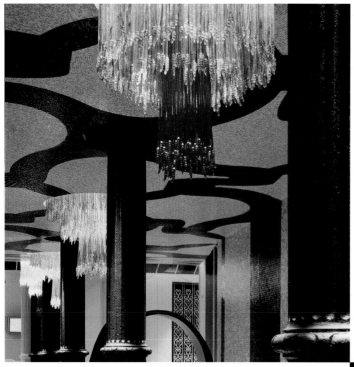

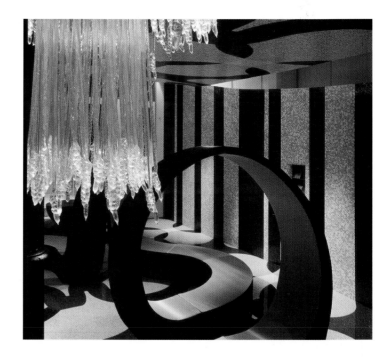

Several medusa-like lamps by Jacopo Foggini illuminate the old loft, which still has its original columns.

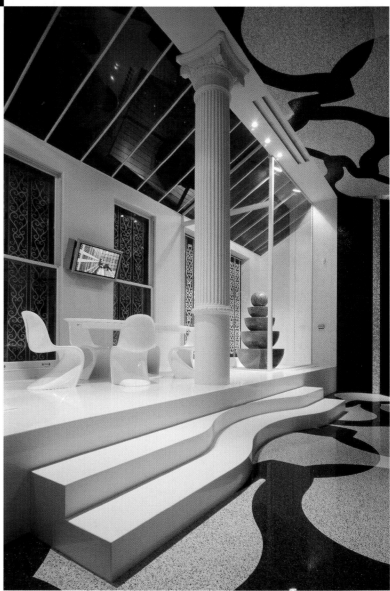

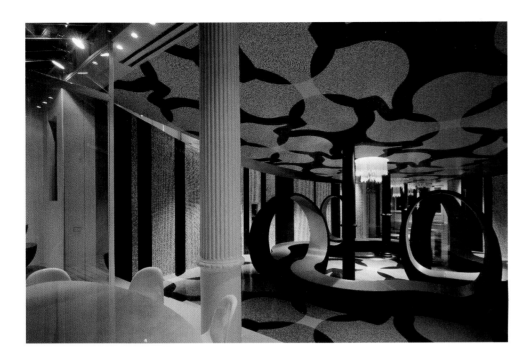

The floor and the walls are covered with blue and black mosaic pieces that depict organic forms.

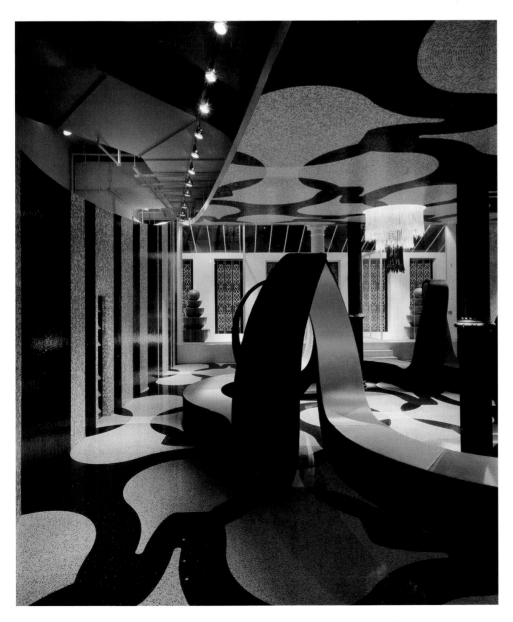

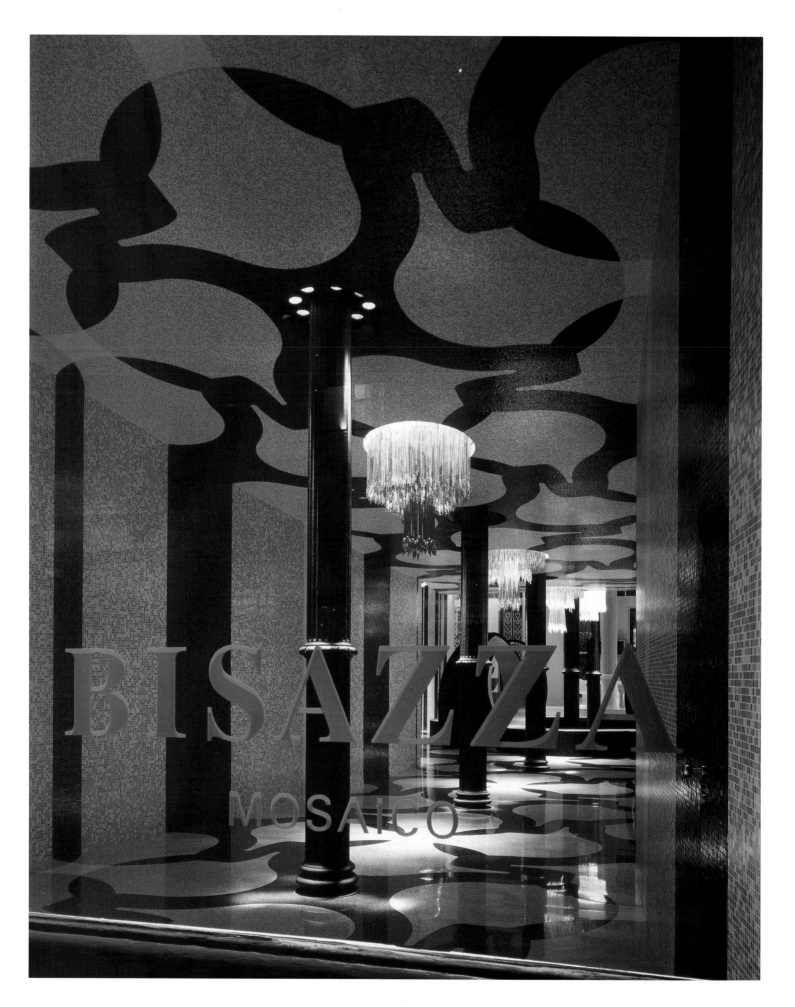

274

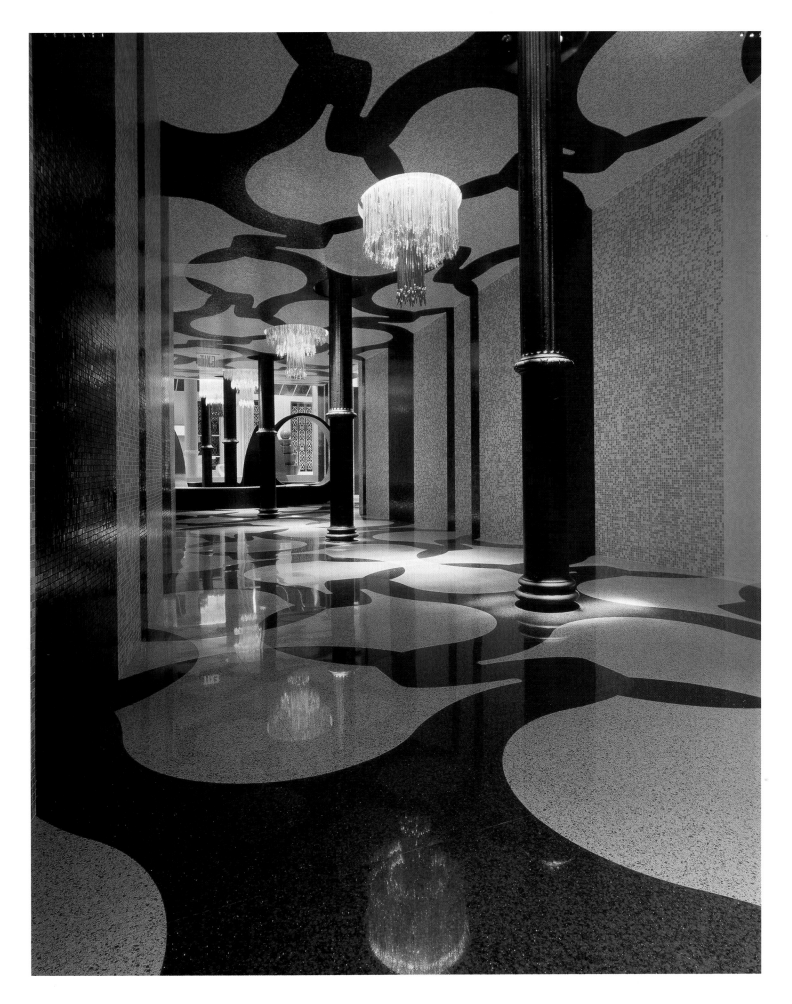

SONY TOWER SHOWROOM

Designer: **WonderWall Inc.**
Photographer: **Kozo Takayama**
Location: **Osaka, Japan**
Opening date: **2001**

Located on the third and fourth floors of a building in Osaka, the Sony Tower Showroom is an excellent futuristic interior for displaying the latest innovations in telecommunications and commercial electronics. The extraordinary space, designed by the team at WonderWall, headed by Masamichi Katayama, highlights the modernity of the products that are displayed. An airy feeling is achieved by using cool materials and transparent lighting in a white setting, which also gives the impression of a world based on simplicity and speed.

On the third floor, WonderWall opted to replace the light fixtures with 34 plasma screens that hang from the ceiling and illuminate the space. At the same time, each one of them is an independent moni-

tor that transmits information to the customer, who has come into Sony's world to find out about the latest technology.

On the fourth floor, Katayama designed stainless steel boxes for displaying the products. Each one of them holds a monitor and is surrounded by mirrored sheets that are also made of stainless steel. One of the best aspects of this level is the lighting design. The designer decided to light each box from the base to show off the surface, displaying the contents as if they were floating in space.

WonderWall did a splendid job on this project, exploiting the virtues of the materials as much as possible: hard, transparent, opaque, and cool textures complement the interesting collection of Sony's most up-to-date technology.

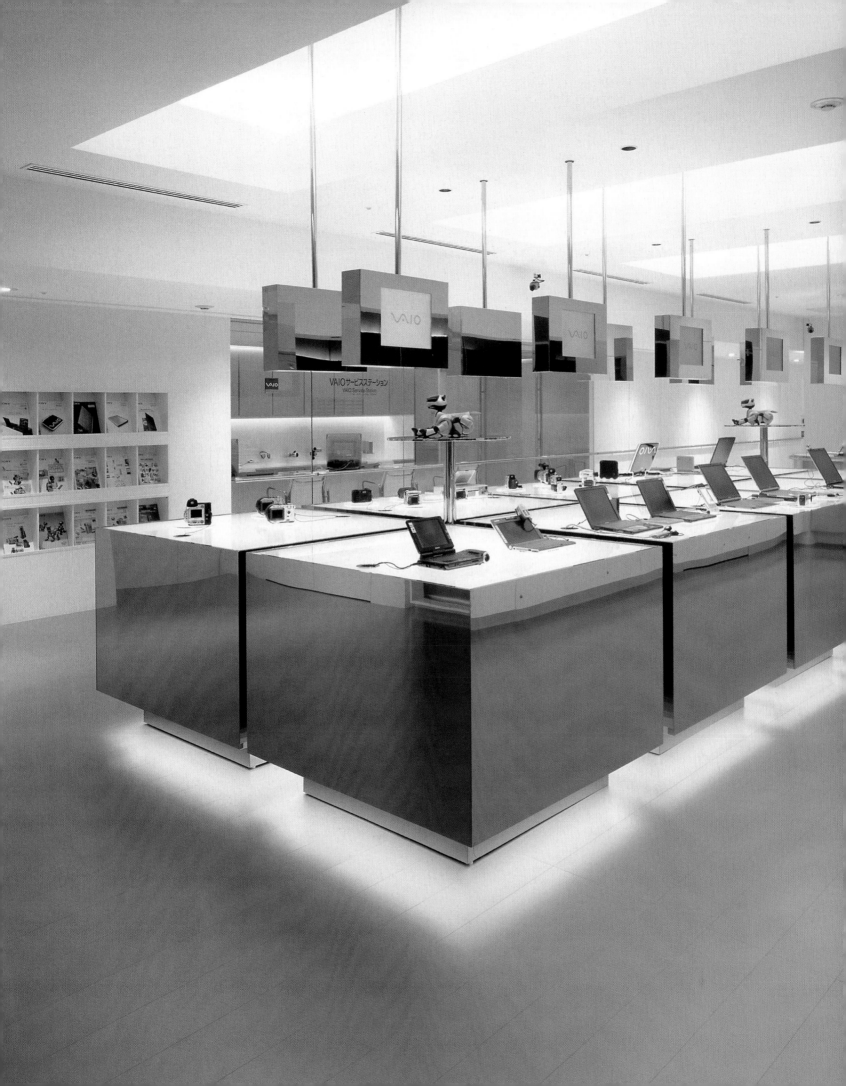

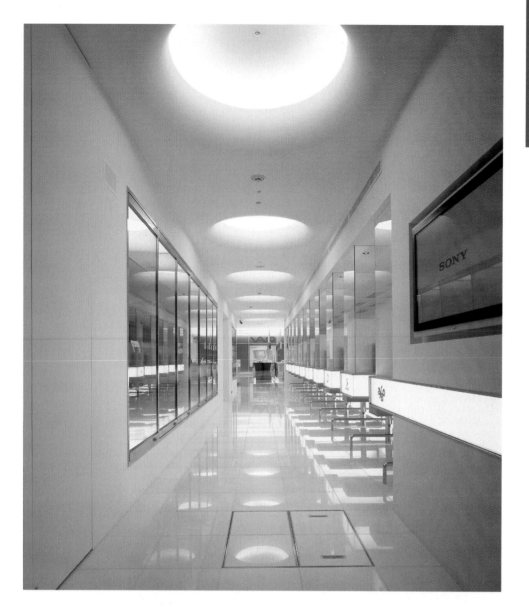

Sony Tower

On the fourth floor, visitors can try out the computers while information is projected from 34 different plasma screens.

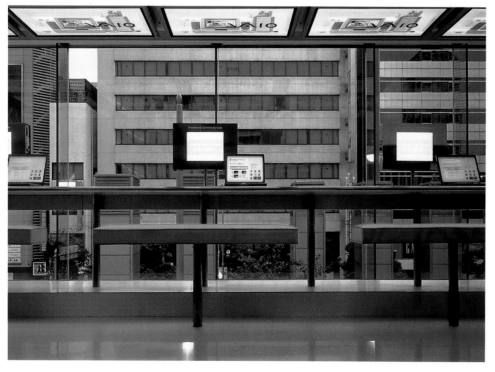

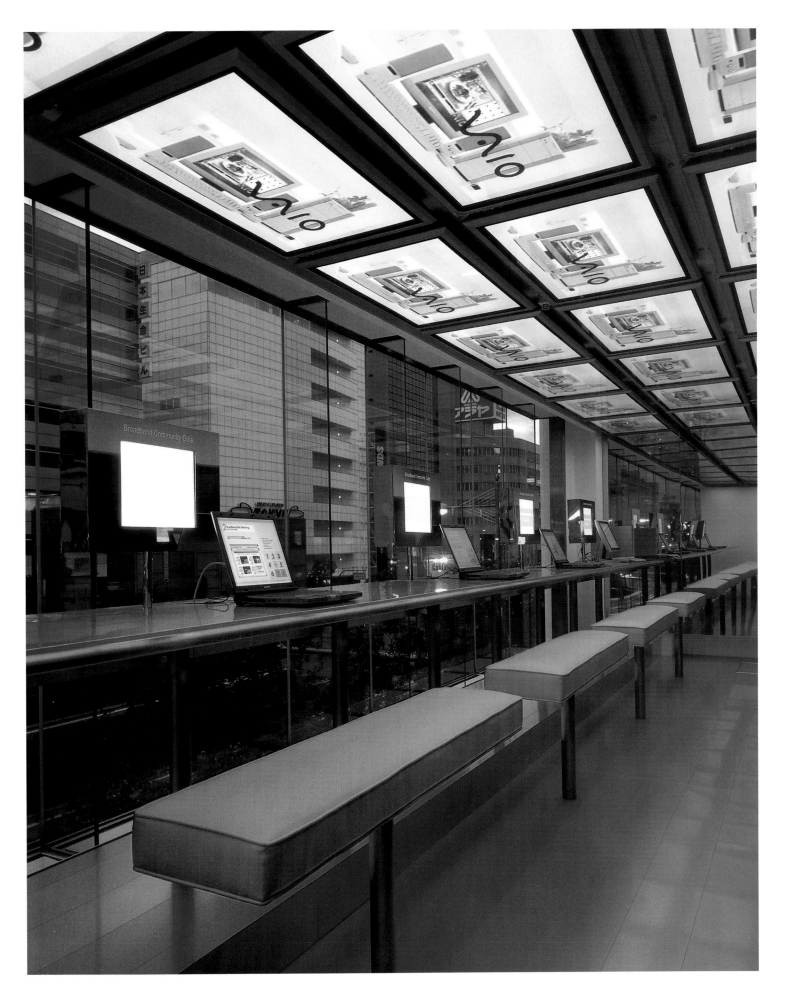

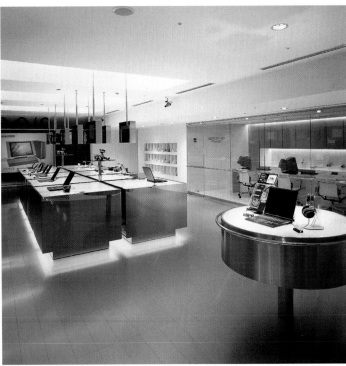

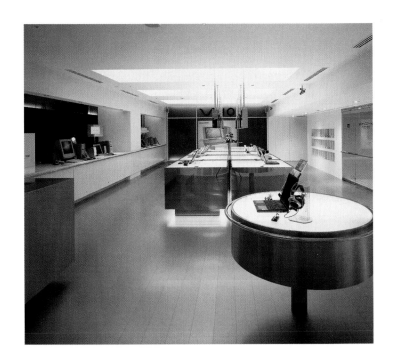

Some of the computers are displayed on top of boxes that are illuminated from below and seem to float above the floor.

The space makes full use of the characteristics of cold, transparent materials, such as the glass surfaces and stainless steel finishes.

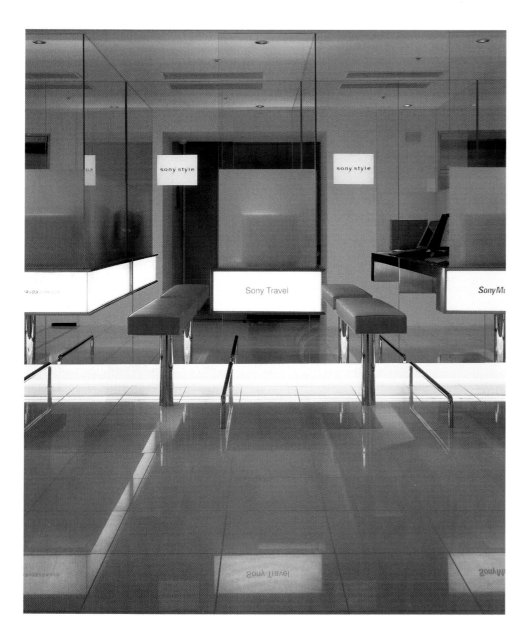

SONY QUALIA SHOWROOM

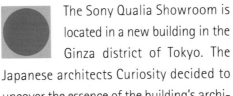

Designer: **Curiosity**
Photographer: **Daici Ano**
Location: **Tokyo, Japan**
Opening date: **2003**

The Sony Qualia Showroom is located in a new building in the Ginza district of Tokyo. The Japanese architects Curiosity decided to uncover the essence of the building's architecture and highlight the innovative strength of Sony products. To do this, it was necessary to emphasize the clarity and dynamism that was evident in the architecture itself.

Inside, the floor was designed to create a sense of spatial infinity. The architects felt they needed to create movement in the interior of the building. The result was a building that appears to move around a central pillar: the stairs, the layout of the display areas, the lighting—all of the elements are based on this axis of movement. Curiosity also wanted the customers to feel captivated by the essence of move-

ment once they were inside, and, attracted by this feeling, to visit each one of the spaces that synergistically wrap around the new showroom.

One area of the building presents Sony's most recent creation: Qualia. This part of the showroom is separated from the rest by a blue glass wall that suggests the exclusivity of Qualia. Most of the display fixtures were designed to adapt themselves to the products being shown. Some are suspended from the ceiling from a double structure in acrylic. A design in Corian stands out, an elongated piece designed to reflect the way Sony products are connected.

With this project, Curiosity created a space that visually seems endless, and where quality stands behind that which is visible, tactile, and audible.

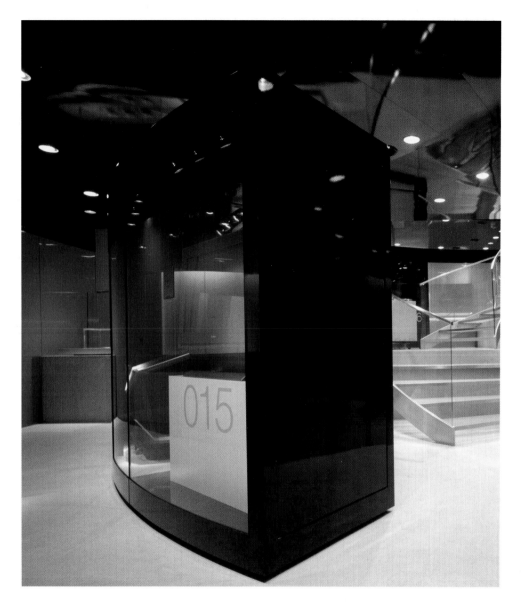

QUALIA

A circular pillar displaying Sony products is the only structural element in the middle of the open space.

Floor plan

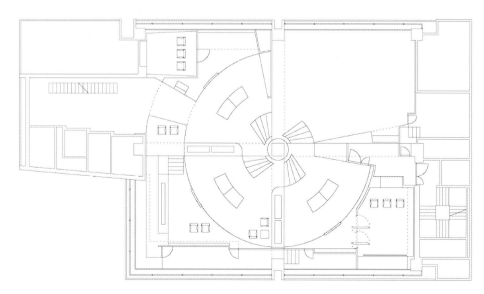

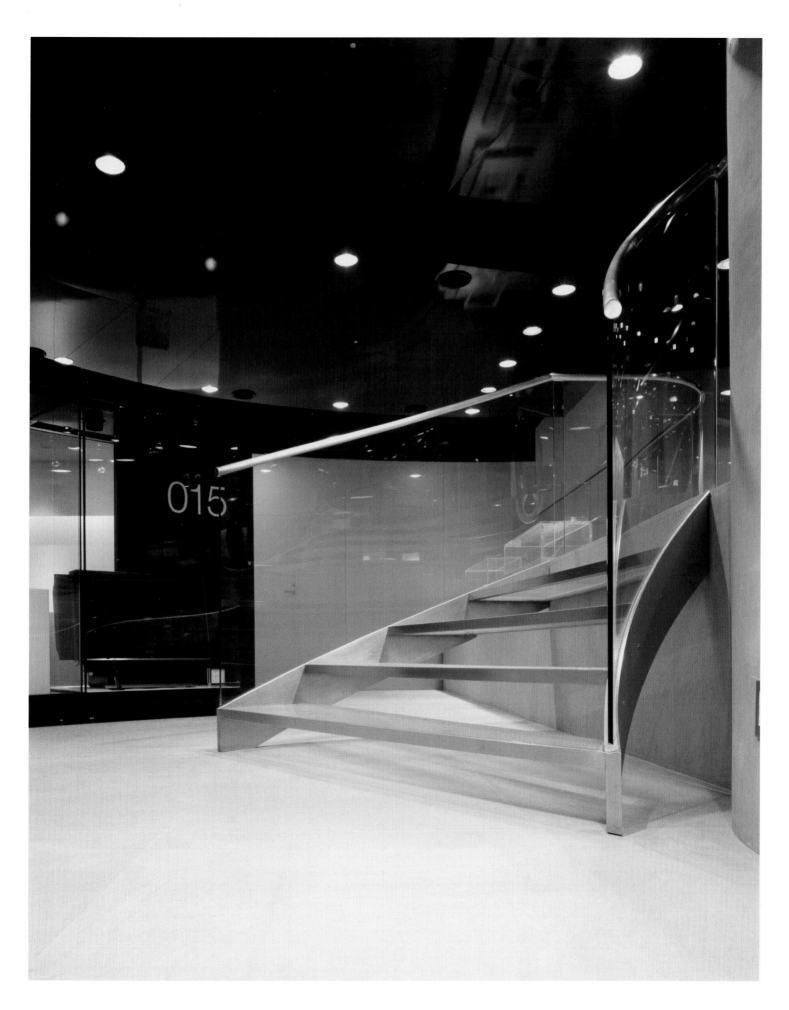

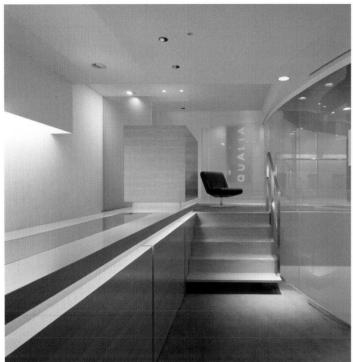

The different display areas were designed to show the exhibited product clearly and to attract the customer's attention.

The composition of the flowing space revolves around a flexible and dynamic structure.

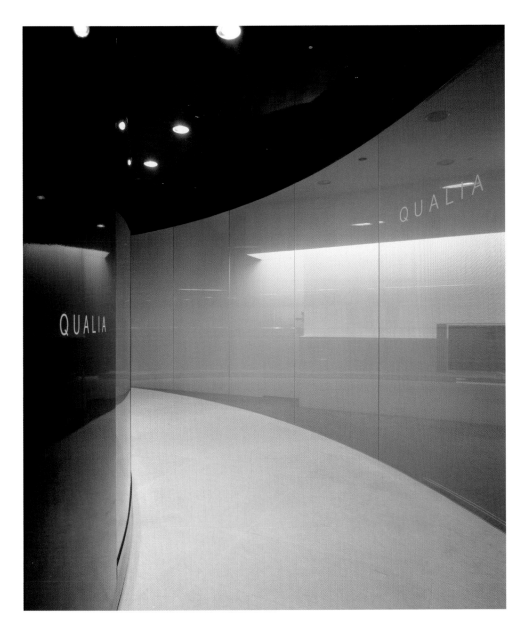

BMW SHOWROOM

Designer: **Plajer & Franz Studio**
Photographer: **Fritz Busam**
Location: **Berlin, Germany**
Opening date: **2002**

BMW recently inaugurated a new showroom in the city of Berlin to kickoff the reintroduction of a classic from the 1960s—the Mini Cooper. The Cooper had become a collector's item ever since celebrities like John Lennon admitted to being die-hard fans of the car, and, in 1994, BMW acquired the rights to introduce a new version. BMW chose the German team of Plajer & Franz to design the interior of the showroom.

It is not easy to translate the feeling of the technical materials that make up a car into a space. However, Plajer & Franz were able to bring together the automotive qualities that most engage the senses: the sight, the sound, and the feel of the materials.

The designers divided the space into four stands, designed so that each one of them would be acoustically sealed once the doors were closed. The main enclosure is the one that best reflects the architects' concepts. In the middle of the setting is an impressive skylight with a system of screens that surrounds the main cell and whose function is to control the light. This approach allows the intensity of the light to be dimmed in the center of the exhibit where the elegance of BMW is omnipresent.

In the exterior, the designers installed a projector that shows scenes related to the motoring world on the glass of the façade. This showroom is one of several new spaces that have been designed to adapt to changes in the products being exhibited, such as this scene where the beauty and elegance of the car is displayed.

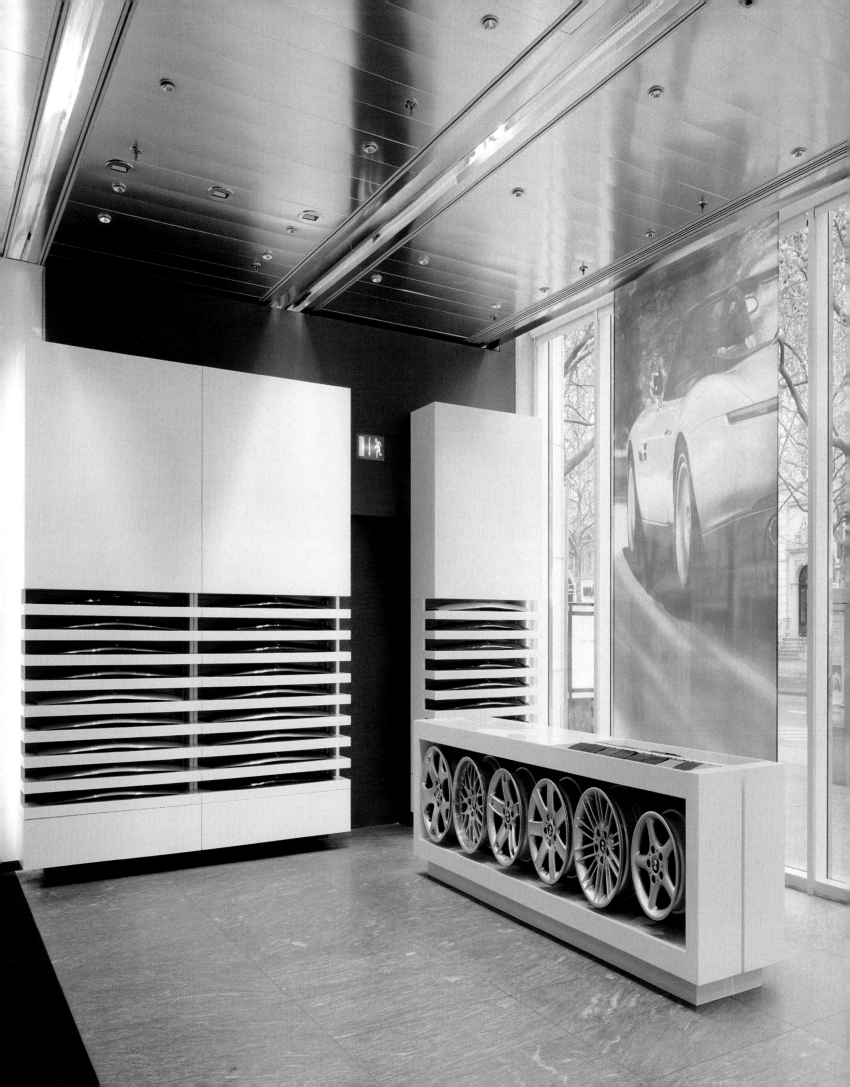

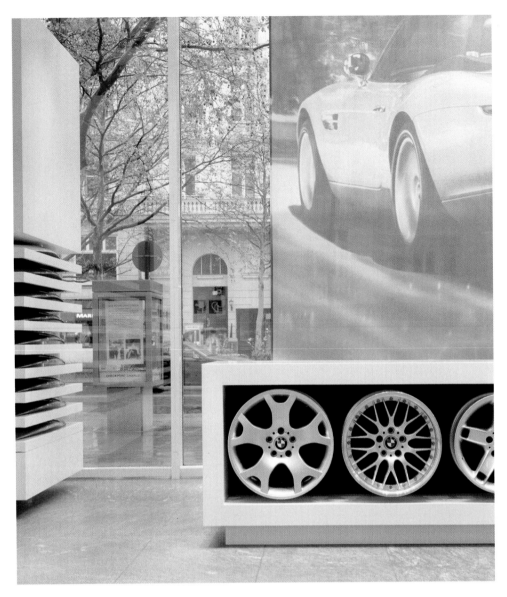

Floor plans

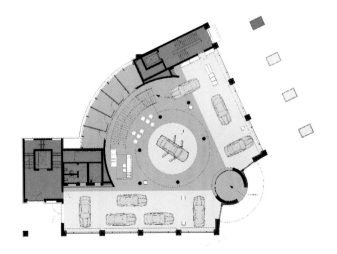 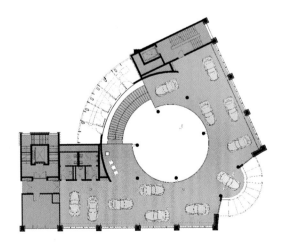

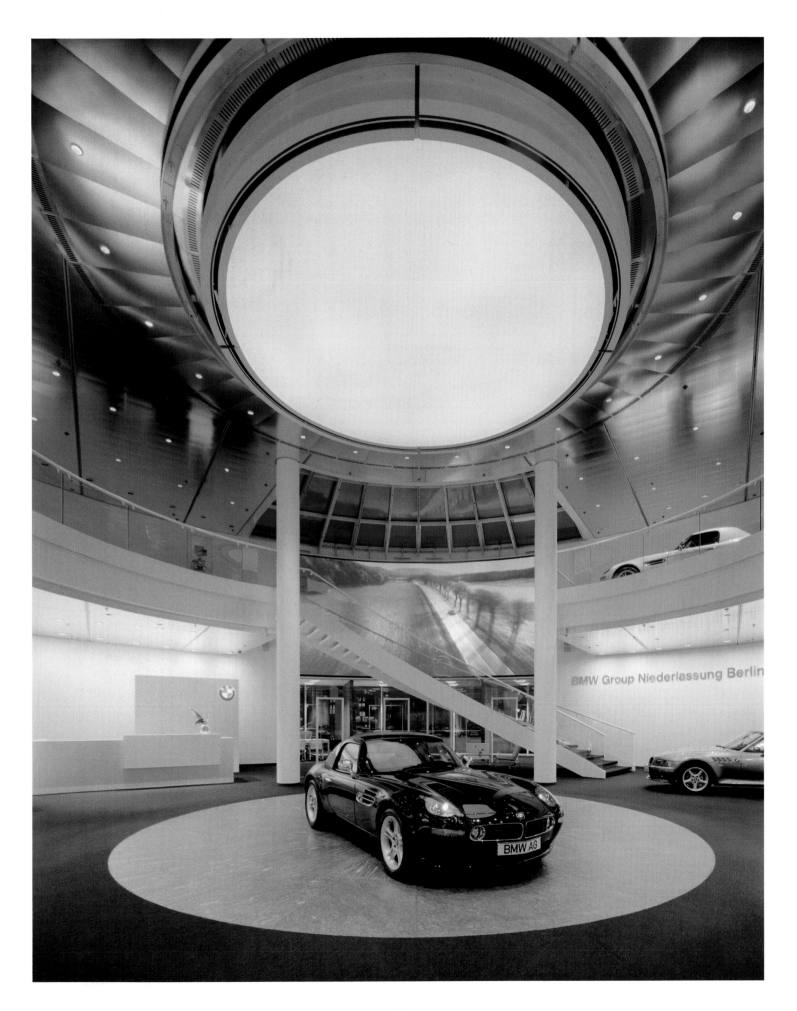

The space makes full use of the characteristics of cold, transparent materials, like the glass surfaces and stainless steel finishes.

On the fourth floor visitors can try out the computers, while information is projected at them from 34 different plasma screens on the ceiling.

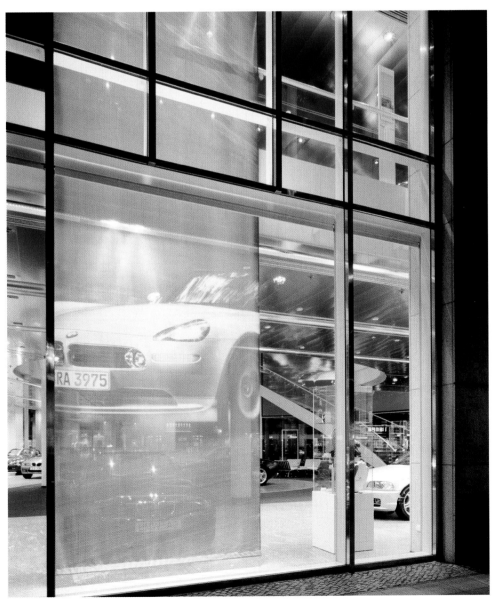

SHOP KUTURHAUPTSTADT

Designer: **Eichinger oder Knechtl**
Photographer: **Rupert Steiner**
Location: **Graz, Austria**
Opening date: **2003**

Shop Kuturhauptstadt, located in Graz, includes the best of modern design in the interior and the most valuable parts of the original building on the exterior. The challenge for Eichinger oder Knechtl, the architects in charge of the renovation, was to create a space that could adapt to the architectural characteristics of the building, and at the same time capture a futuristic and immaterial essence.

From the outside, the theatrical entrance to the store is a preamble to the architects' coordination of two themes—innovation and the past. The irregularly shaped doors are below the two windows of the building's original arcade. Through the doors, the visitor follows a tunnel covered with metal panels that extends throughout the structure with the movement of a fish. The forcefulness of the interior language is a reflection of the type of visual and audio products that the store sells. The elongated and irregular floor plan was a challenge for the architects, who created several focal points within the space. From the entrance, several stainless steel counters extend along the tunnel to display books and other products. The color palette is dominated by metallic tones. However, the firm's logo, an intense green inverted E, breaks the visual continuity to highlight the commercial identity. Due to an absence of openings for natural light, the architects installed a system of spotlights along the upper part to provide sufficient light to the irregular interior.

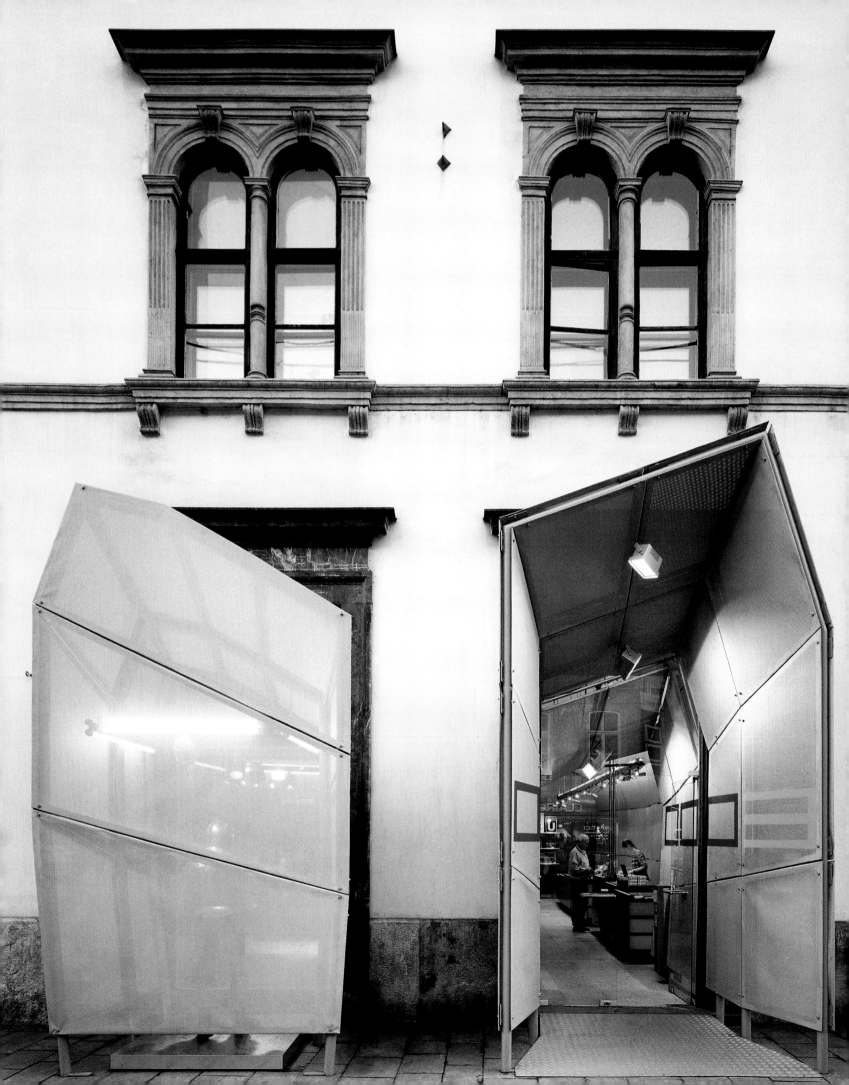

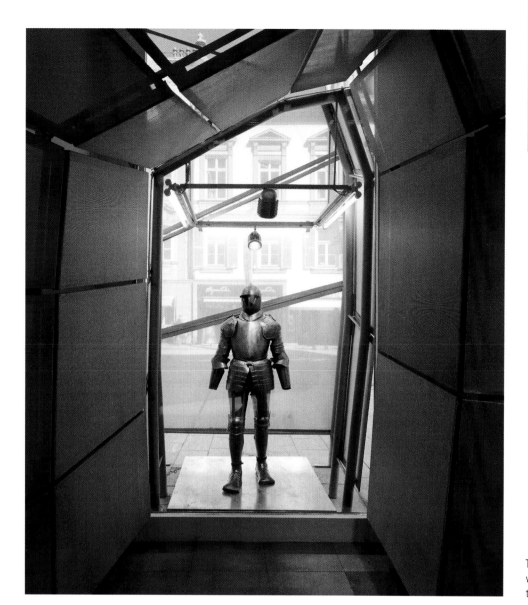

The interior has some surprises, such as this robot, which personifies the future world that the customer is about to enter.

Floor plan

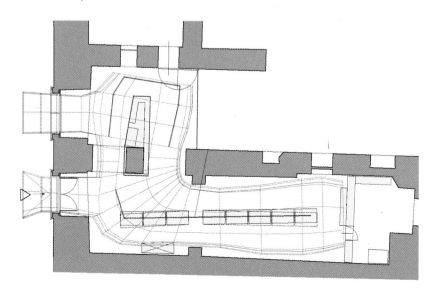

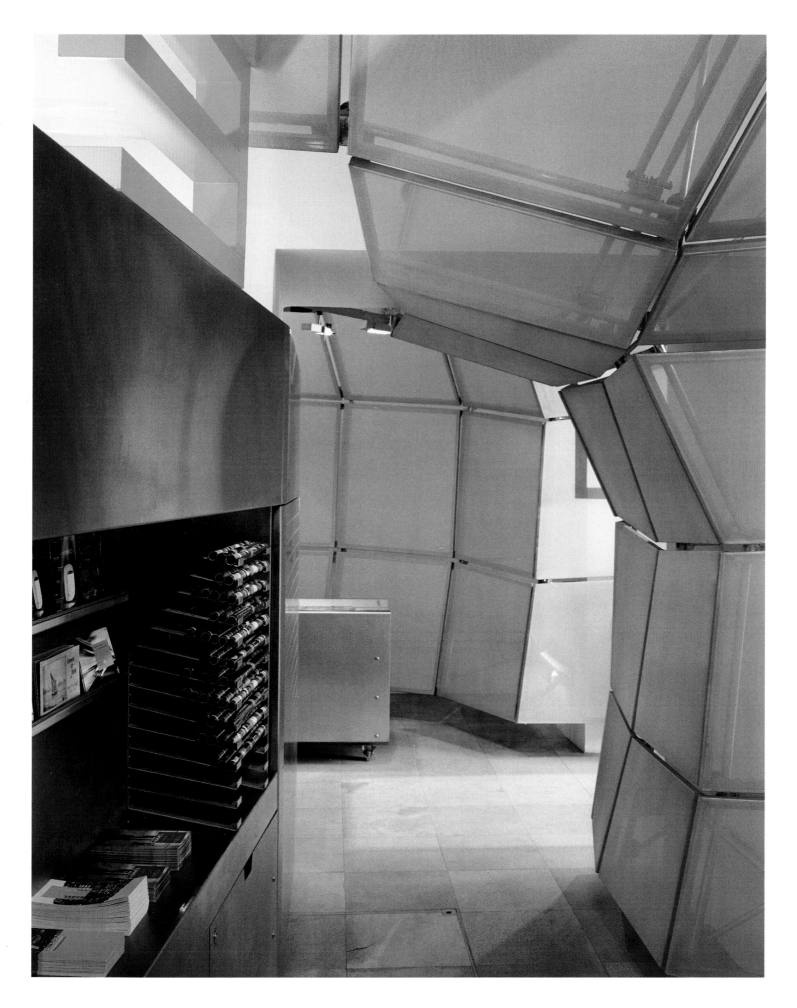

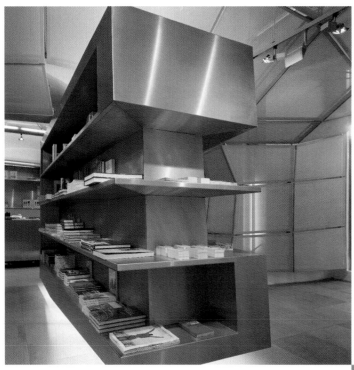

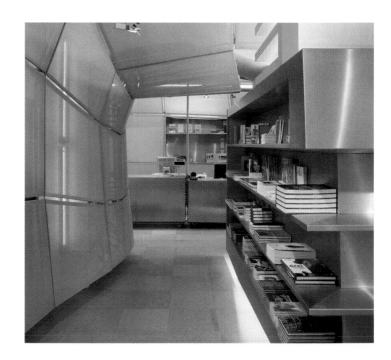

The irregular composition of the interior creates several display spaces for exhibiting the products.

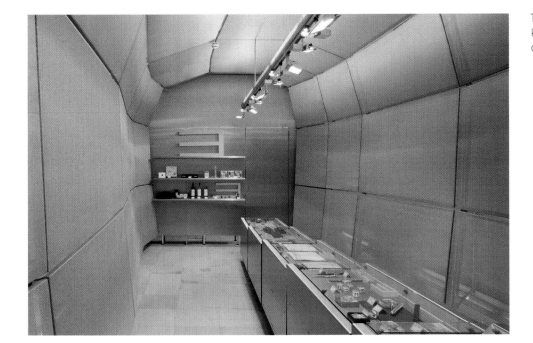

The central stainless steel counter becomes a key piece that helps articulate the different areas of the space.

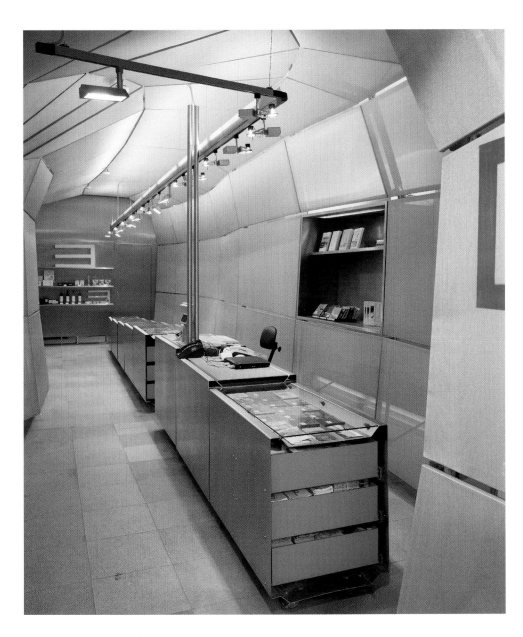

Kode

Designer: **Studio o + a**
Photographer: **David Wakely**
Location: **Sacramento, USA**
Opening date: **2003**

Studio o + a was commissioned to design this store for Kode, a mobile telephone service company that caters to a young market. Keeping in mind the type of customers that were to be served by the store, Studio o + a designed a space intended to appeal to the tastes of adolescents. Local artists painted the walls with graffiti, and the furnishings were designed to create the atmosphere of a discotheque. Kode, located in the city of Sacramento, California, is equipped with pods in which groups of friends can get together in a private and comfortable space. These enclosed "chill-outs" become meeting places, making Kode more of a playful spot than a shop. The main part of the store has an area where a DJ plays music every Friday night .

The designers created a shell that could be recycled each season at the same time that they changed the products on display. A circle with a galactic design was hung from the ceiling against a black background, while the walls were painted white. A new product by Lonseal gave the floor a bright and perfectly polished finish that highlights the beetle painted on the surface. The principals of Studio o + a, Primo Orpilla and Verda Alexander, designed the display system located behind the store's counter.

The lively color, the graphics, and the beetle that is Kode's identifying icon welcome young consumers to an unexpected and uncommon space.

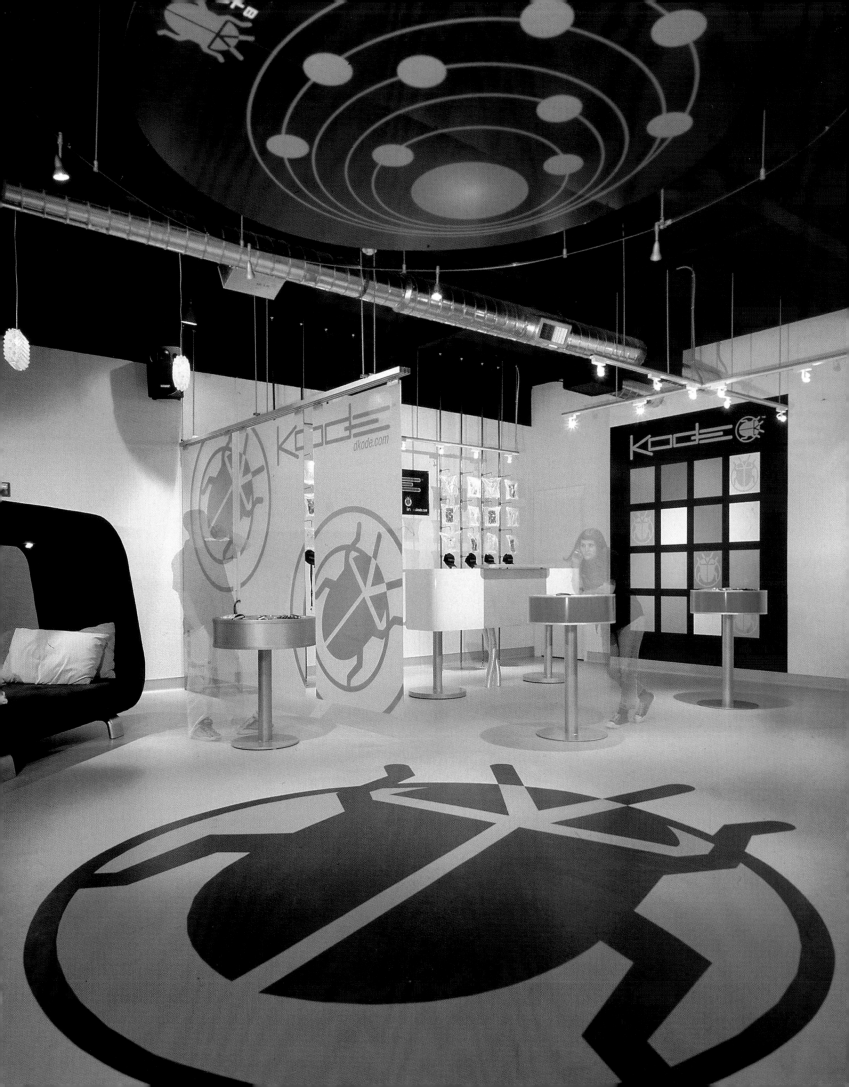

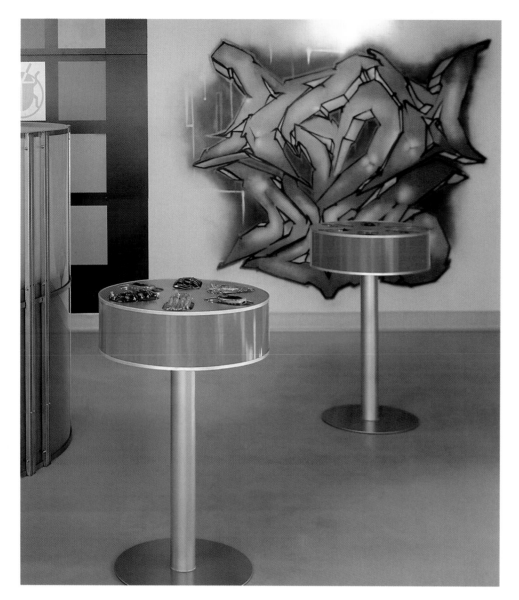

Graffiti painted by Sacramento artists can be seen behind the display fixtures designed by Primo Orpilla and Verda Alexander.

Floor plan

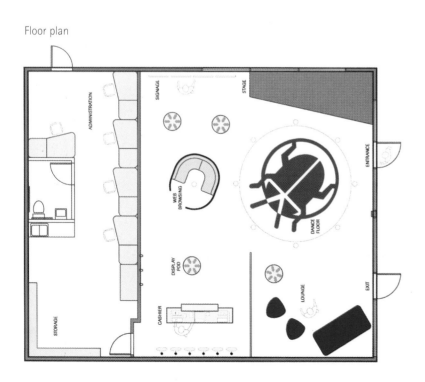

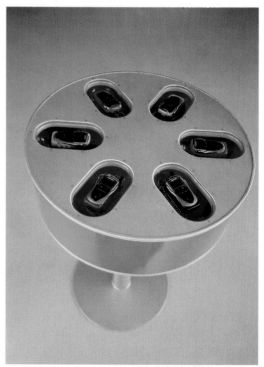

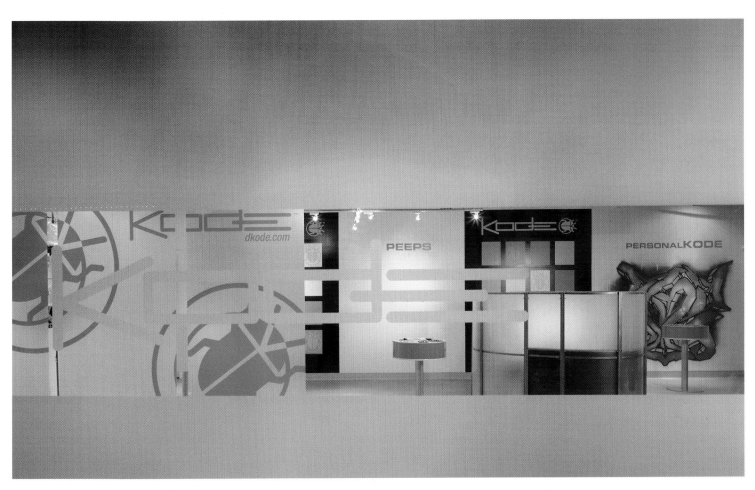

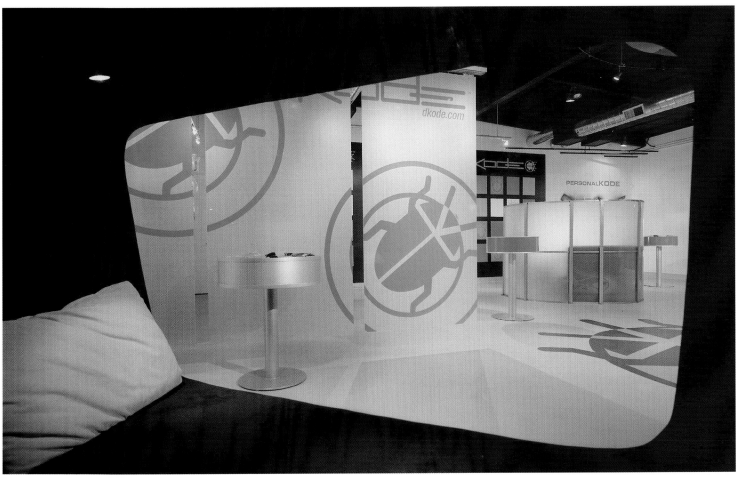

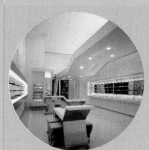

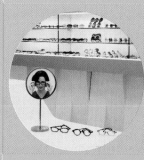

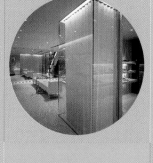

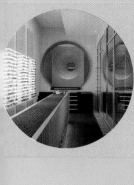

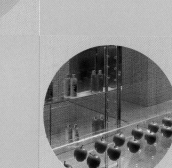

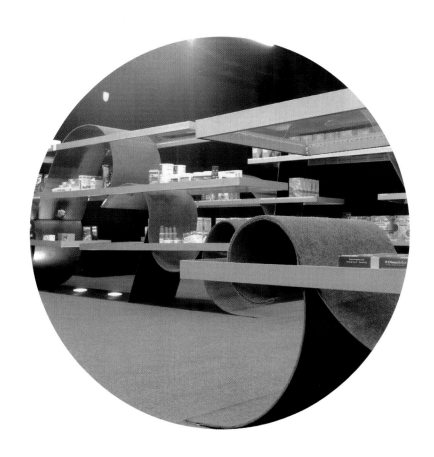

HEALTHCARE

*BAPY AOYAMA

Designer: **WonderWall, Inc.**
Photographer: **Kozo Takayama**
Location: **Omotesando, Japan**
Opening date: **2002**

The concept behind the design of the *Bapy store, developed by Masamichi Katayama's WonderWall team, was the creation of a building that resembles a bathroom. From the architecture to the interior design, *Bapy had to be a reflection of the bath products that are sold in its interior.

Katayama's ingenious concept turned the building into a transparent container with three levels. A stairway leads to the third level, where a large number of the brand's products can be found.

On the second level, one of the most appropriate recurring elements is a glass box covered by a shower curtain that functions as a fitting room. Katayama once again makes use of unusual elements in his design as his imagination and discernment demonstrate that he is a true master of the art of design.

The building design was meant to be contemplated from the outside as well. Katayama's project is a rational architecture, whose elements seem to be arranged with order and restraint to encourage a fluidity. The structure is divided into two totally glass-covered and transparent halves to show the activities that take place inside the store. From the outside, the two halves complement the view of the three levels.

The excellent lighting in the interior is achieved with halogen and several spotlights that increase the intensity of light in important spaces. During the day, abundant, ethereal natural light fills the interior, creating an unexpected experience for the customer.

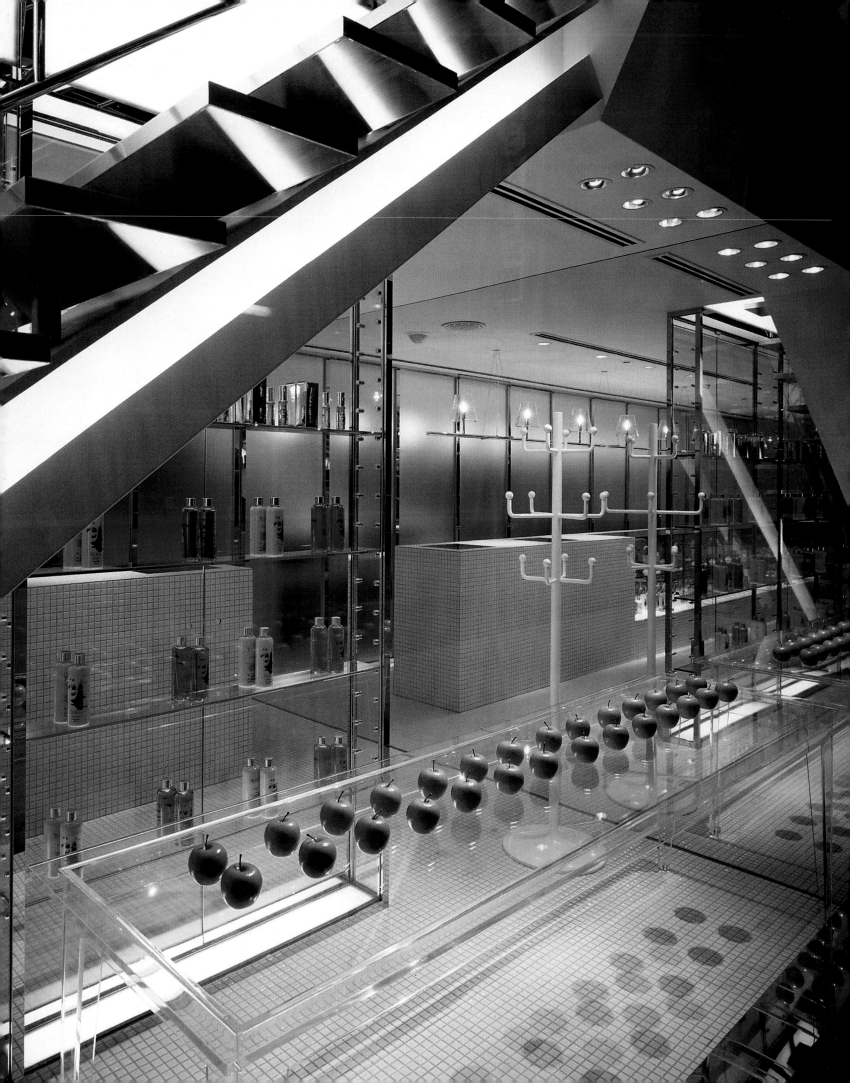

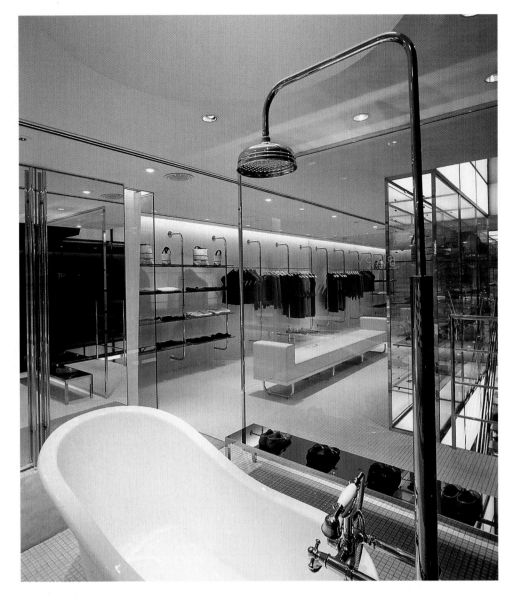

*ƁAPY™
BUSY WORKING LADY

The products are exhibited in a space that recreates a bathroom setting.

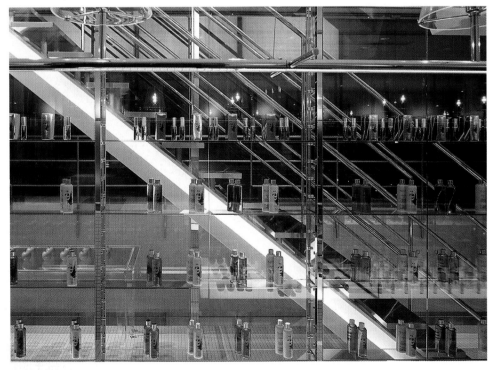

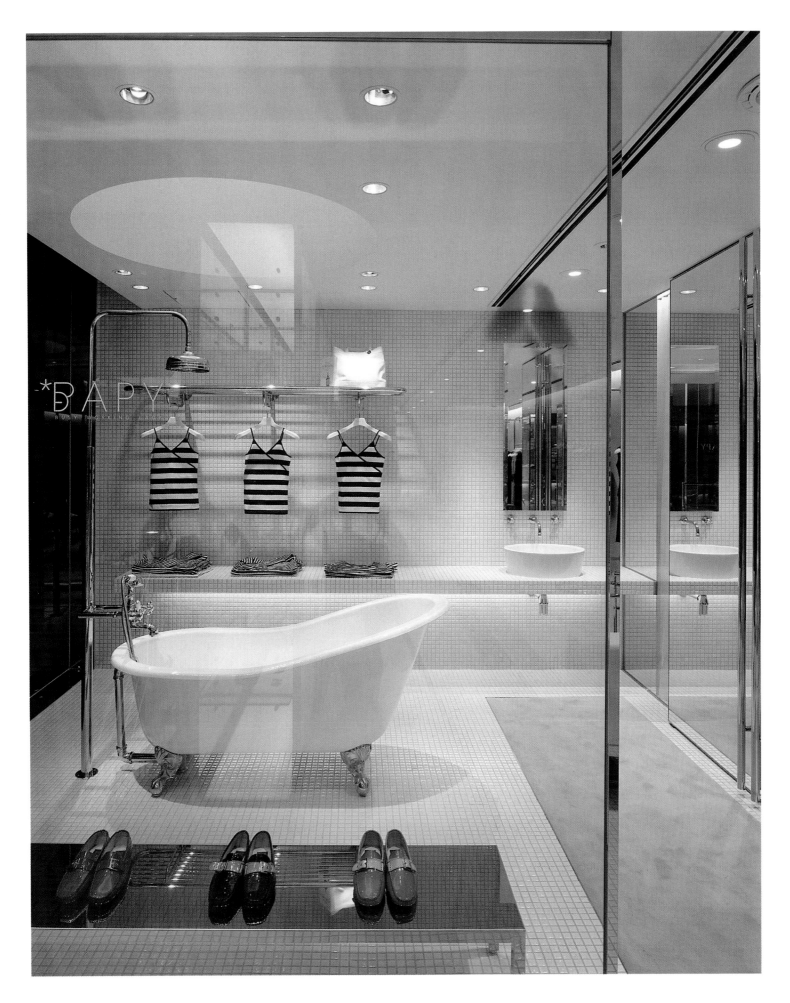

The fitting rooms were designed to look like individual showers, with their own curtains to ensure privacy.

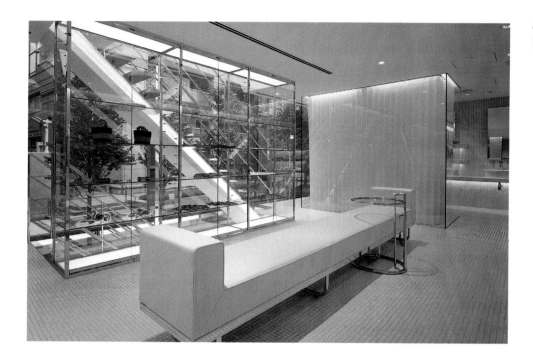

Cool and transparent materials were used in the interior to create a neutral, light-filled space.

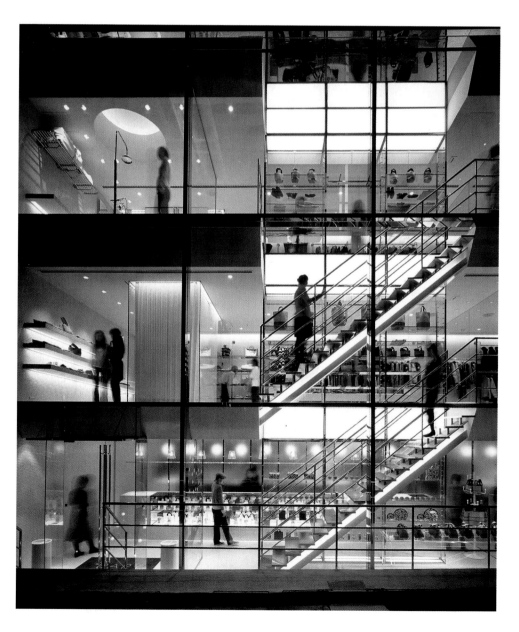

PARAFARMÀCIA

Designer: **Rosa Rull/Manuel Bailo**
Photographer: **Jordi Miralles**
Location: **Castelldefels, Spain**
Opening date: **2003**

For three generations, the family that owns this pharmacy in the coastal town of Castelldefels has managed an old establishment located a few yards from the new one, which was designed by the architects Manuel Bailo and Rosa Rull.

The wrapping paper used in the old pharmacy was designed by the well-known Catalan artist Josep Guinovart. The concept developed by Bailo and Rull for the interior of the new pharmacy was based upon the design of this paper. The resulting interior is a radical departure from the traditional image of a pharmacy.

Inside, the use of metaphors helps define the setting. The blue carpet is a reflection of the sea that borders the town, while the curved forms of Guinovart's letters are symbolic of the waves that advance towards the interior of the store. The design of the shop is reflected in the freestanding counters that represent a sequence of waves. Products are exhibited on the metal shelves of the counters.

The lighting consists of a series of fluorescent lamps in a channel. Their careful arrangement signals the edge of the wavy landscape. Below each of the display areas, spotlights direct additional light toward the products.

The floor is high enough to act as a wall to keep out water, while inviting pedestrians to come into the shop.

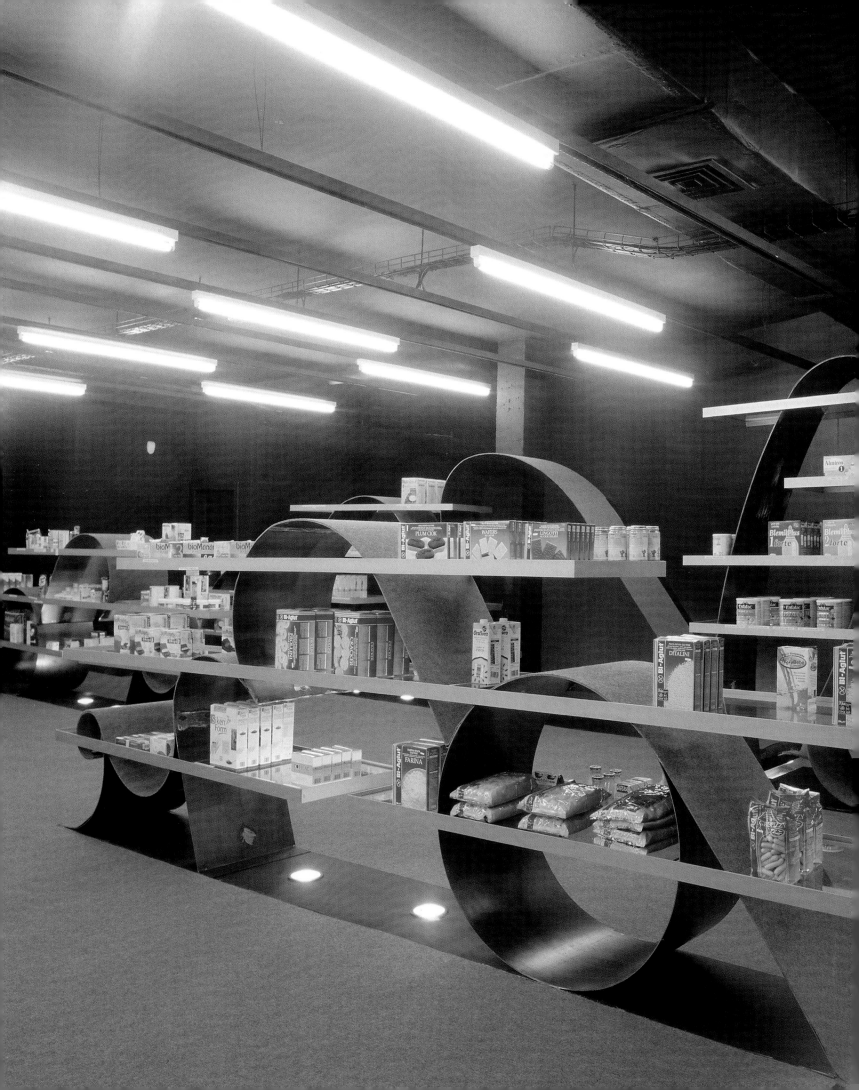

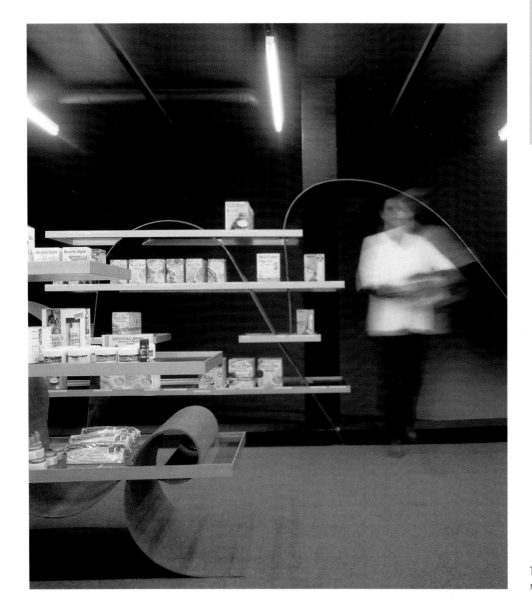

The floor appears to deny its static character and rises in curves as a metaphor for ocean waves.

Floor plan

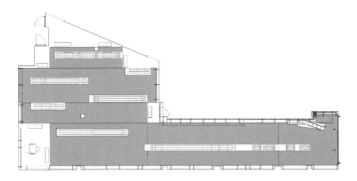

Sections

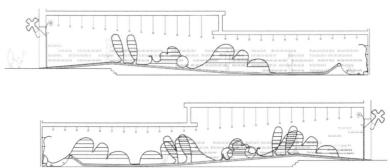

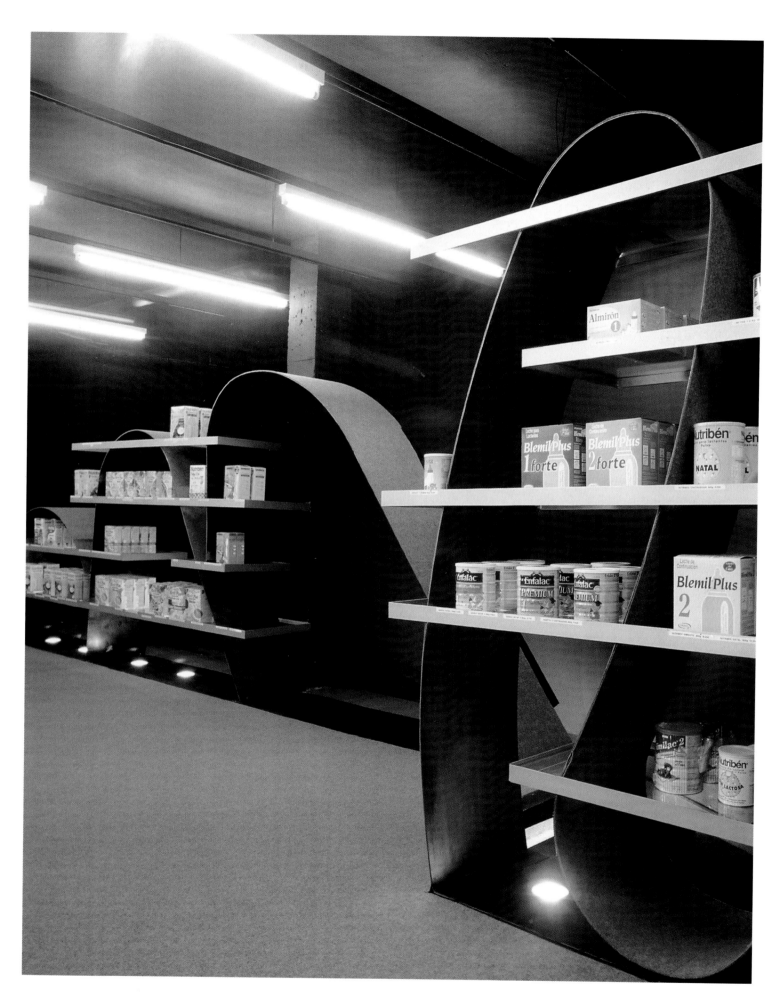

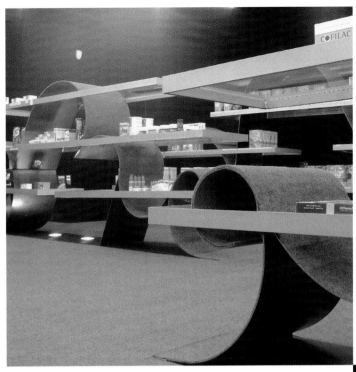

The floor was covered with a blue carpet to make the concept of the ocean inside the store more real.

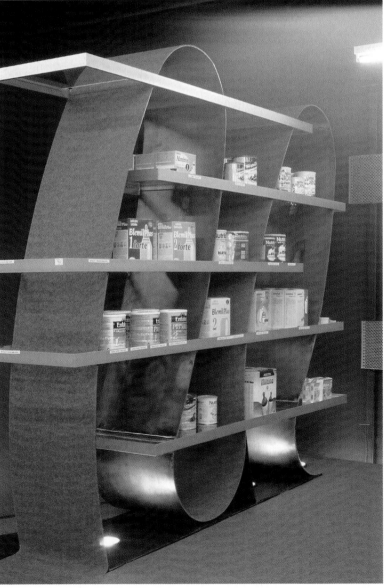

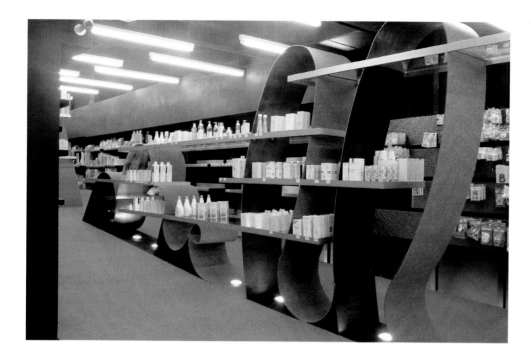

The shelves of the curved displays, made of stainless steel, complement the sinuous shape of the counter.

L.A. Eyeworks

Designer: **Neil Denari Architects, Inc.**
Photographer: **Benny Chan**
Location: **Los Angeles, USA**
Opening date: **2002**

L.A. Eyeworks is located on one of the busiest streets in Los Angeles—the corner of Martel and Beverly Boulevards, where more than 100,000 cars pass by daily. Neil Denari, architect for the project, based his design on the client's concept: the space should reflect the relationship between the interior architecture, a timeless element, and the daily commercial activity, a temporal element. Based on this concept, as refined by Denari, the interior of L.A. Eyeworks illustrates a new concept in commercial space design. The shop is a pioneer in its treatment of the interior as a neutral shell that can be adapted to changes in fashion just like the glasses sold there. The interior neither disappears nor radically changes.

Denari left the upper part of the stucco façade intact and transparent, so the customer can see the products from the outside. In the entrance, blue panels that hold the store's logo line the bottom of the window. In the interior, the needs of the customer are blended with the idea of visual continuity; and the architecture and the glasses fuse into a coordinated design. The furnishings, also designed by Neil Denari Architects, mediate between the permanence and stability of the space and the glasses that are sold there. On one side, a panel designed by Jim Iserman extends along the wall and displays the latest innovations in eyewear. Behind this piece, which acts as a two-dimensional surface, is a woven pattern that accentuates the strength of the architecture.

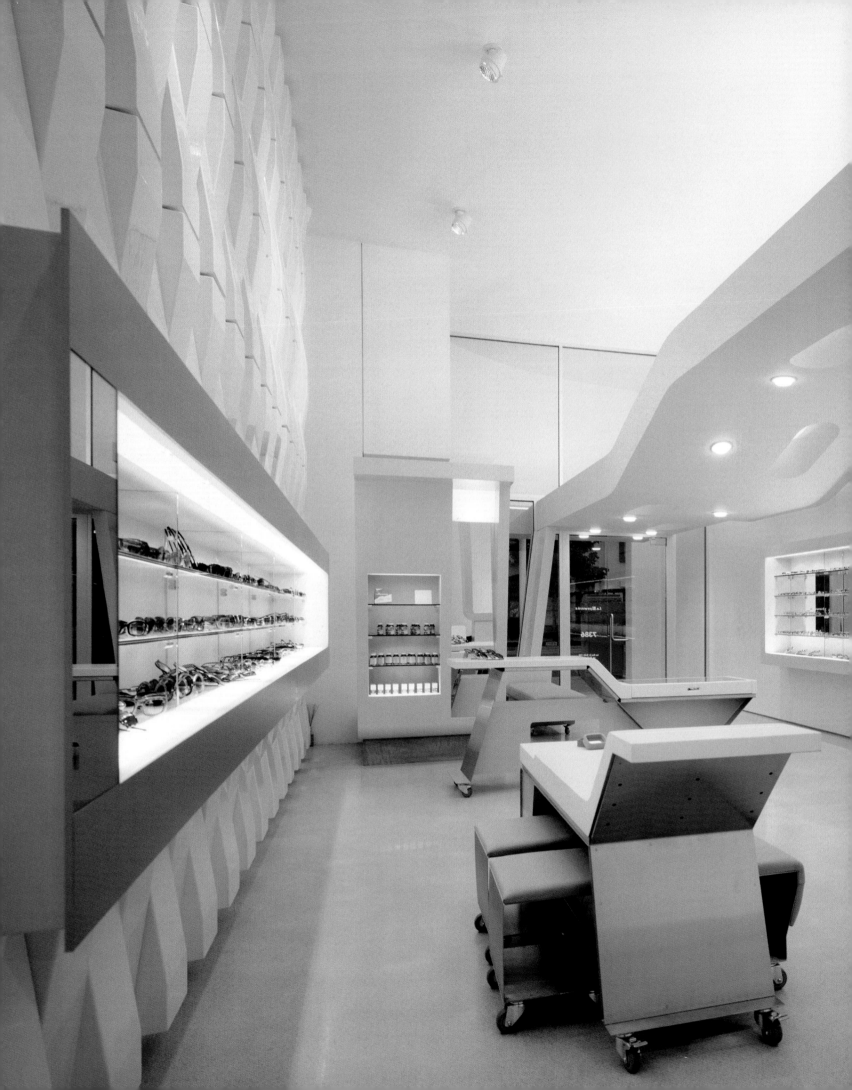

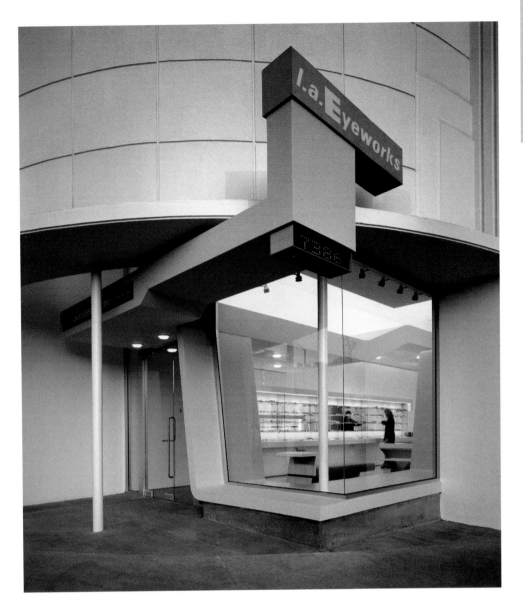

The metal structure on the outside holds the store's logo and welcomes visitors attracted by the interior of the shop.

Floor plans

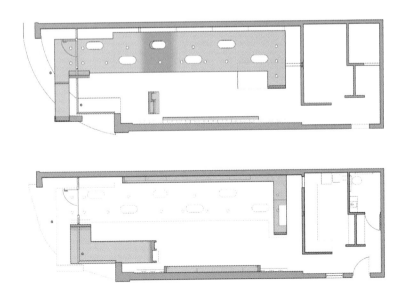

3D plan

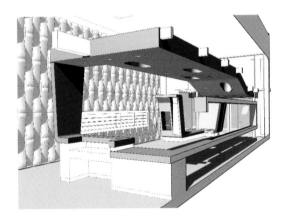

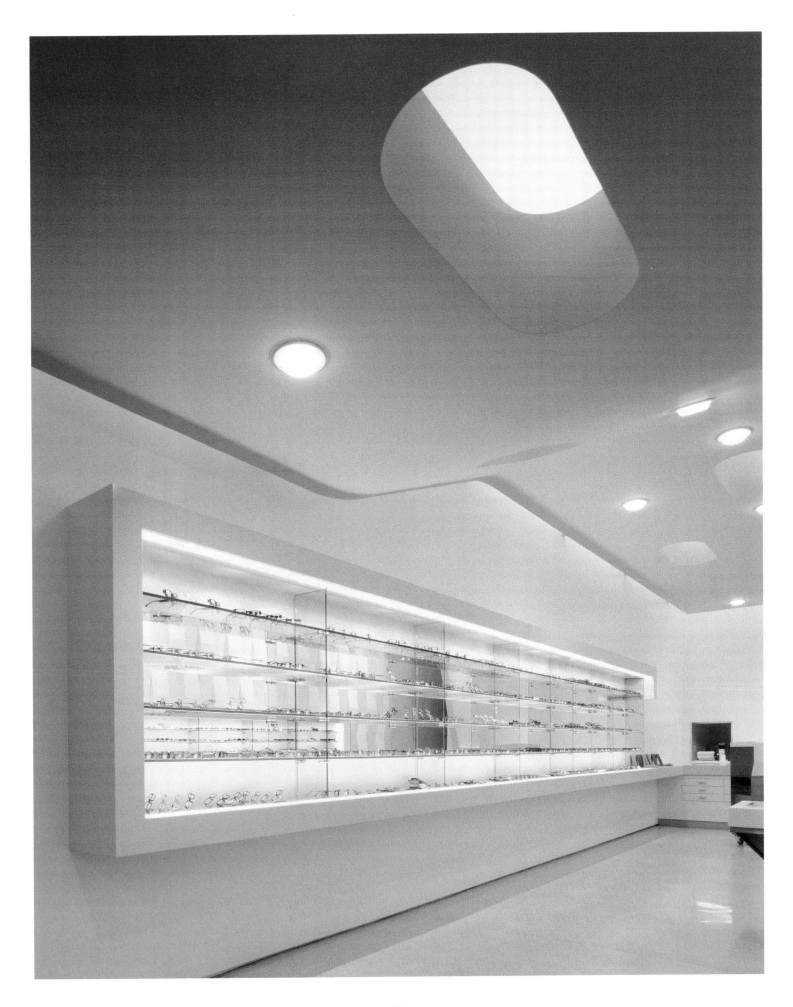

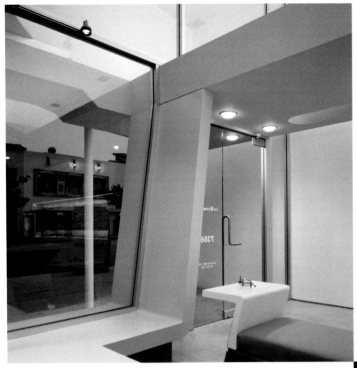

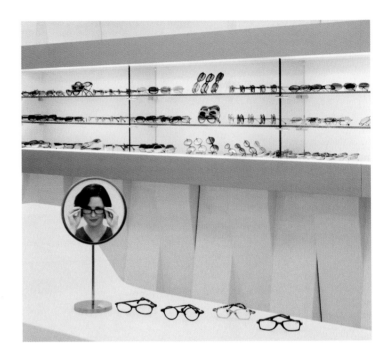

The architecture of the space matches the elegance of the latest eyeglasses sold at L. A. Eyeworks.

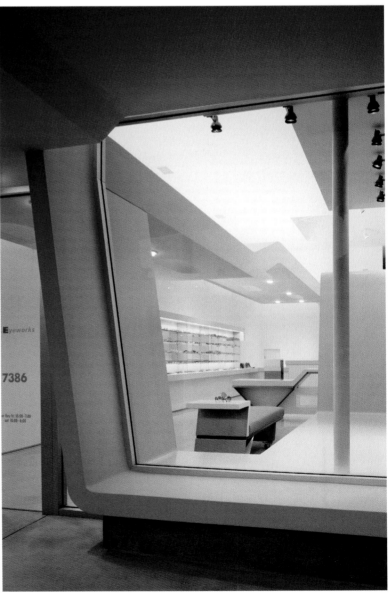

Inside, the totally white store and the neutral lines take advantage of the light coming through the structure's original skylights.

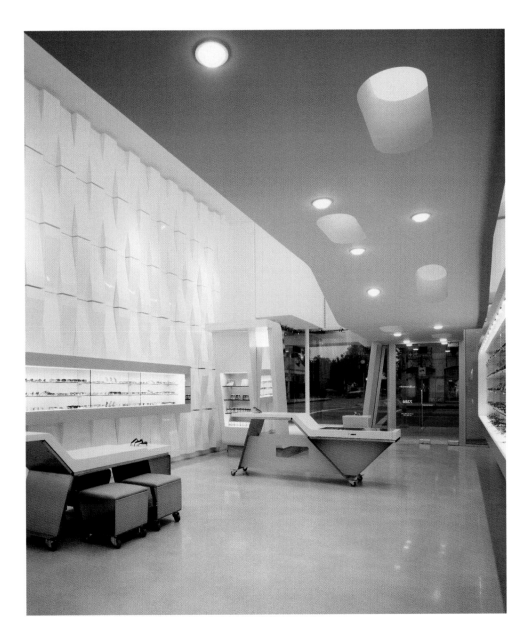

BRILLE 54

Designer: **Plajer & Franz Studio**
Photographer: **Karl Bongartz**
Location: **Berlin, Germany**
Opening date: **2002**

This is the fourth store that German architects Plajer & Franz Studio designed for Brille 54, a well-known optician that has several stores in the city of Berlin.

While each store is different from the other, there is a series of features that reflect the basic concept developed by Plajer & Franz Studio. Orange tones are always used for the stores that sell sunglasses, while an olive color denotes stores that not only sell glasses, but also do eye examinations.

The store, located on Rosenthaler Strasse, has a tunnel through which the visitor can see the glasses he or she should use in the future. The concept of this store is based on a space that interacts with customers through different approaches that elicit an individual response from each of them. For example, the machines for examining eyes that hang from the ceiling also have a mirror for trying contact lenses, meeting the needs of every customer.

All of the installations in the interior and the futuristic tunnel are elements that attract the customer's attention. From the outside, they can see the glasses displayed on glass surfaces. Suspended shelves on each of these glass plaques hold the different models. Inside, the clients find themselves in a world of sensations and optical illusions that help them discover the best solution to their visual problem.

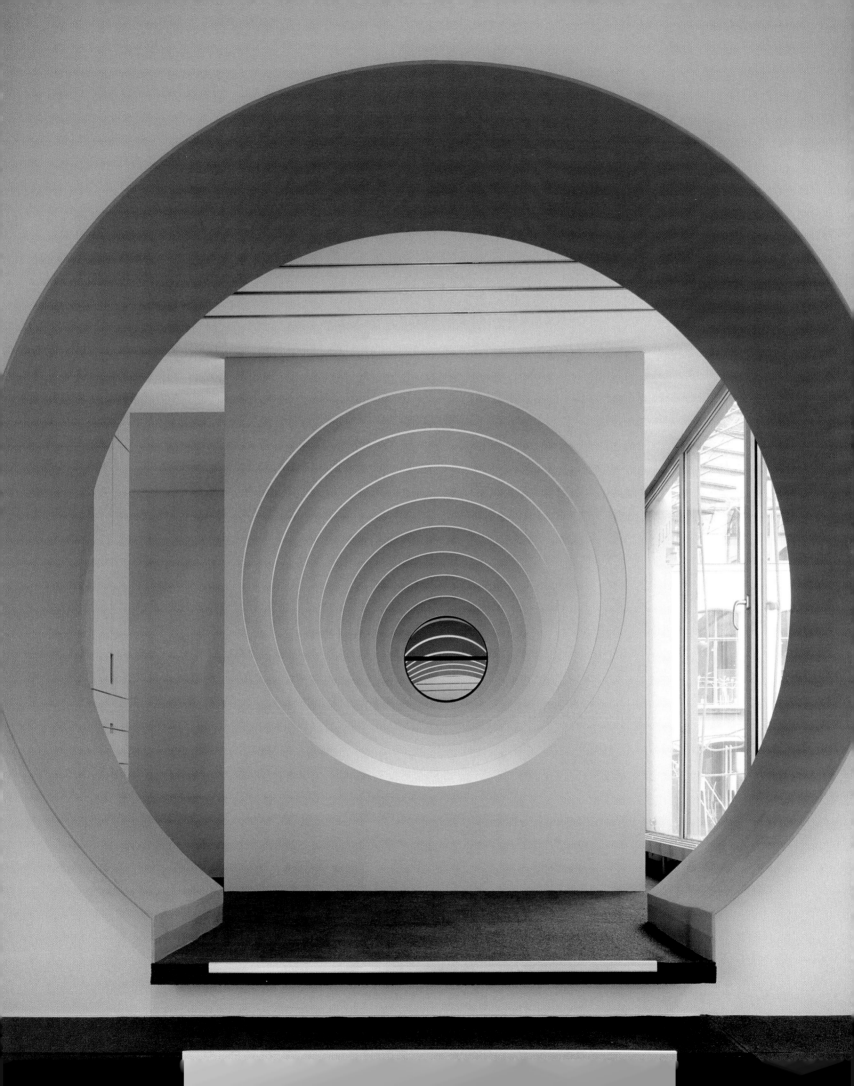

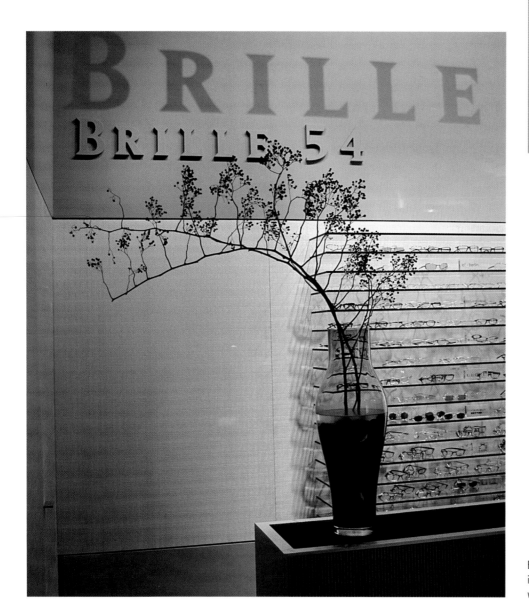

Brille 54 uses an olive color in the interior to indicate the stores that perform eye examinations as well as sell glasses.

Floor plan

Sections

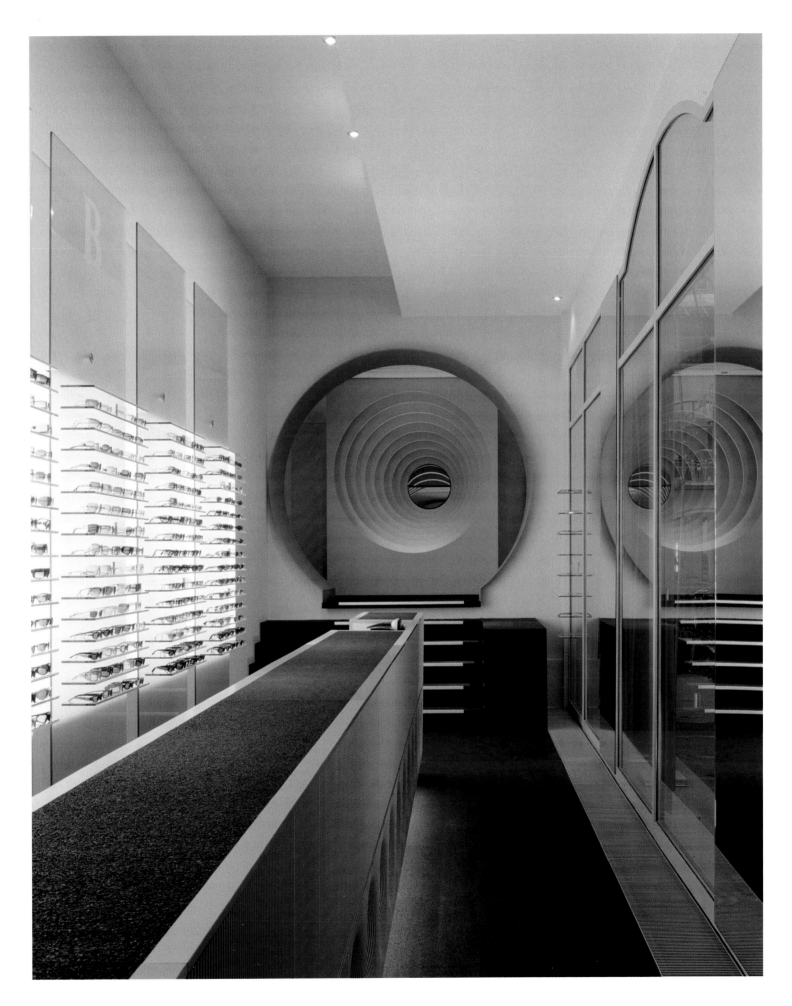

DIRECTORY

1100 Architect
435 Hudson Street
New York, NY 10014
United States
Phone: +1 212 645 1011
contact@1100architect.com
www.1100architect.com

Air-Projects
Pau Claris 179, 3° 1ª
08037 Barcelona
Spain
Phone: +34 93 272 24 27
air@air-projects.com
www.air-projects.com

Antonio Citterio and Partners
Via Cerva 4
20122 Milan
Italy
Phone: +39 02 763 8801
info@antoniocitterioandpartners.it
www.antonio-citterio.it

Wrangelstrasse 75b
20253 Hamburg
Germany
Phone: +49 40 4293 7863
studio@citterio.de
www.antonio-citterio.it

Asymptote
561 Broadway, 5A
New York, NY 10012
United States
Phone: +1 212 343 7333
info@asymptote.net
www.asymptote.ne

Bonjoch Associats
Bonavista 6, int. pral. 4ª
08012 Barcelona
Spain
Phone: +34 93 415 00 07
ignasi@bonjoch.com
www.bonjoch.com

Caps Architects
Stampfenbachstrasse 48
P.O. Box 184, CH-8035 Zurich
Switzerland
Phone: +41 1 365 23 65
info@caps-architects.com
www.caps-architects.com

Claudio Silvestrin Architects
Unit 18 Waterside, 44-48 Wharf Road
London N1 7UX
United Kingdom
Phone: +44 020 7490 7797
c.silvestrin@claudiosilvestrin.com
www.claudiosilvestrin.com

Curiosity
2-45-7 Honmachi, Shibuya
151-0071 Tokyo
Japan
Phone: +81 3 5333 8525
info@curiosity.co.jp
www.curiosity.co.jp

Eduard Samsó
Tallers 77, ático
08001 Barcelona
Spain
Phone: +34 93 342 59 00
samso@coac.net

Eichinger oder Knechtl
Franzjosefskai 29
a-1010 Vienna
Austria
Phone: +43 1 535 54 24
desk@eok.at
www.eok.at

Fabio Novembre
Via Mecenate 76
20138 Milan
Italy
Phone: +39 02 504 104
info@novembre.it
www.novembre.it

Frank O. Gehry
1520 B Cloverfield Boulevard
Santa Monica, CA 90404
United States
Phone: +1 310 828 6088
www.frank-gehry.com

Fumita Design Office
Fukuda Building 1F + B1F, 2-18-2,
Minamiaoyama
Minato-ku, 107-0062, Tokyo
Japan
Phone: +81 3 5414 2880
info@fumitadesign.com
www.fumitadesign.com

G Tects LLC
Gordon Kipping
530 West 25th Street, 503
New York, NY 10001
United States
Phone: +1 212 414 2300
communications@gtects.com
www.gtects.com

John Pawson
Unit B 70-78 York Way
London N1 9AG
United Kingdom
Phone: +44 020 7837 2929
email@johnpawson.com
www.johnpawson.com

José Luis Portillo
Aragó 224, 3°
08011 Barcelona
Spain
Phone: +34 93 451 5751
portillo.prieto@terra.es

Marmol Radziner and Associates
2902 Nebraska Ave.
Santa Monica, CA 90404
United States
Phone: +1 310 264 1814
info@marmol-radziner.com
www.marmol-radziner.com

Martí Guixé
Calàbria 252
08029 Barcelona
Spain
Phone: +34 93 322 59 86
info@guixe.com
www.guixe.com

Massimiliano and Doriana Fuksas
Piazza del Monte di Pieta 30
I-00186 Rome
Italy
Phone: +39 06 6880 7871
office@fuksas.it
www.fuksas.it

Neil Denari Architects, Inc.
12615 Washington Boulevard
Los Angeles, CA 90066
United States
Phone: +1 310 390 3033
info@nmda-inc.com
www.nmda-inc.com

OUT.DeSIGN
2-3-2 Kamiosaki, Shinagawa-ku
141-0021 Tokyo
Japan
Phone: +81 3 5789 0202
info@outdesign.com
www.outdesign.com

Plajer & Franz Studio
Erkelenzdamm 59/61
D-10999 Berlin
Germany
Phone: +49 030 6140 1350
plajer@plajer-franz.de
www.plajer-franz.de

Rosa Rull and Manuel Bailo
Pellaires 30-38, nave G-01
08019 Barcelona
Spain
Phone: +34 93 303 46 60

Studio 63 Associati
Piazza Santa Maria Sopr'Arno 1
50124 Florence
Italy
Phone: +39 055 2001448
info@studio63.it
www.studio63.it

601 West 26 Street, Suite 1510
New York, NY 10001
United States
Phone: +1 212 675 9784
fmflorio@studio63usa.com
www.studio63.it

Studio x Design Group
Via Risorgimento 11
31100 Treviso
Italy
Phone: +39 349 5574571
info@stxdesign.com
www.stxdesign.com

Sybarite
322 Fulham Road
London SW10 9UG
United Kingdom
Phone: +44 020 7352 4900
mail@sybarite-uk.com
www.sybarite-uk.com

WonderWall Inc.
1-21-18 Ebisu Minami, Shibuya-Ku
150-0022 Tokyo
Japan
Phone: +81 3 5725 8989
katayama@wonder-wall.com
www.wonder-wall.com